PAST MEETS FUTURE

PAST MEETS FUTURE

SAVING AMERICA'S HISTORIC ENVIRONMENTS

NATIONAL TRUST FOR HISTORIC PRESERVATION

Edited by Antoinette J. Lee

THE PRESERVATION PRESS

THE PRESERVATION PRESS

National Trust for Historic Preservation
1785 Massachusetts Avenue, N.W.
Washington, D.C. 20036

The National Trust for Historic Preservation in the United States is the only private, nonprofit organization chartered by Congress to encourage public participation in the preservation of sites, buildings, and objects significant in American history and culture. Support is provided by membership dues, endowment funds, contributions and grants from federal agenices, including the U.S. Department of the Interior, under provisions of the National Historic Preservation Act of 1966. The opinions expressed herein do not necessarily reflect the views or policies of the Interior Department. For information about membership in the National Trust, write to Membership at the address above.

Printed in the United States of America
5 4 3 2 1 96 95 94 93 92

Library of Congress Cataloging in Publication Data

Past meets future: saving America's historic environments/
Antoinette J. Lee, editor.
p. cm.
Papers presented at National Trust for Historic Preservation
annual conference in October 1991.
Includes bibliographical references (p.) and index.
ISBN 0-89133-198-0
1. Historic preservation — United States — Congresses.
I. Lee, Antoinette J. (Antoinette Josephine) II. National Trust
for Historic Preservation in the United States.
E159.P34 1992
363.6'9'0973 — dc20 92-25913 CIP

This book was composed in Bembo and Futura at Archetype Press in Washington, D.C., and printed by Arcata Graphics/Halliday, West Hanover, Massachusetts, on 70-pound Glatco Matte Smooth. ∞ This paper meets the minimum requirements of the American National Standard for Information Sciences—Permanence of Paper for Printed Library Materials, ANSI Z39.48–1984.

CONTENTS

FOREWORD

Robert M. Bass

TODAY WE ARE AT AN IMPORTANT THRESHOLD FOR HISTORIC PRESERVATION IN AMERICA. WE ARE CELEBRATING THE 25TH ANNIVERSARY OF THE NATIONAL HISTORIC PRESERVATION ACT OF 1966 AND THE 75TH ANNIVERSARY OF THE NATIONAL PARK SERVICE. WHAT AN OPPORTUNE TIME THIS IS FOR THE PRESERVATION MOVEMENT TO LOOK AHEAD, TO BROADEN AND STRENGTHEN ITSELF, TO ADDRESS AMERICANS' VALUES AND NEEDS FOR THE FUTURE, AND TO BUILD ON THE SUCCESSES OF THE PAST DECADES. OUR ACHIEVEMENTS ARE LEGENDARY IN TERMS OF THE NUMEROUS PRESERVATION BATTLES WON IN THOUSANDS OF COMMUNITIES ACROSS OUR NATION AND THE SHIFTS IN PERCEPTIONS AND DECISION MAKING AMONG MANY CONSTITUENCIES.

As renowned architectural historian Vincent Scully recently told the American Institute of Architects, historic preservation is "the only mass movement to affect critically the course of architecture in this century." The United States is a better nation in which to live because of the work of preservationists. Presentations in the retrospective chapter of this book, "Where Have We Been?," give an inspiring overview of these accomplishments in the past 25 years as well as the challenges that still lie ahead.

The challenges for preservationists in the coming 25 years will be as demanding as they have been in the past. Our world is being transformed by revolutionary changes in telecommunications, transportation, production of goods and services, global finances, and political and economic systems. There is vast competition as we seek to preserve America's diverse cultural heritage and the essential values it represents. One must ask how historic preservation can best make its contributions to the lives of people in the years ahead.

It is this sense of opportunity and urgency that brought together more than 2,000 preservationists at the 1991 National Preservation Conference in San Francisco to grapple with such questions. Specifically, we asked:

■ What do we value and want to preserve?

- How will we live and how will historic preservation be part of our lives?
- What are our visions, goals, and strategies?

To explore these questions, the National Trust for Historic Preservation invited the National Park Service and the Advisory Council on Historic Preservation to join with us in hosting the San Francisco conference. The three cosponsors spent more than a year developing the idea. Twenty-four additional national organizations assisted in the conference. A call for papers resulted in nearly 300 submissions, and a white paper on the key issues was developed. Nationally known speakers joined presenters in setting forth their views on these questions. Some 300 conferees participated in small-group discussions with trained facilitators. Rapporteurs presented findings and recommendations, with an open-microphone discussion. All of this activity resulted in an exhilarating and provocative week.

I am pleased to present this book containing the conference findings, recommendations, and all plenary session presentations, plus additional, specially solicited papers. The essays here address the three overarching questions posed for the conferees.

Because this book explores the challenges for historic preservation in the future, it takes its title from the conference theme: When Past Meets Future. The book's subtitle, *Saving America's Historic Environments,* reflects the broadening commitment of preservationists to think beyond the single historic building or house to the historic neighborhood, community, and surrounding landscape. It suggests the need to think regionally, nationally, and even globally, while acting locally. It recognizes that what we do positively affects a larger arena, making communities more livable.

The phrase "historic environments" also is a key element of the National Trust's mission, which is to foster an appreciation of the diversified character and meaning of our cultural heritage and to preserve and revitalize our communities by leading the nation in saving America's historic environments. This mission statement, adopted by the board of trustees in January 1992, culminated two years of research and introspection by the Trust, a process that included the San Francisco conference and its affirmation of the Trust mandate as we approach the millennium.

We intend this book to be a guide for preservationists who are exploring the future of preservation in their communities. Even more, we hope that it will capture the imagination and support of Americans in the same way that *With Heritage So Rich* did at another crucial time—the passage of the 1966 preservation act itself.

I have long believed that historic preservation will fulfill its potential to contribute to the lives of Americans only if we, as a movement, reach out beyond the truly committed to the merely interested and the sympathetic. We must address values that are important to Americans and articulate them effectively. We must offer solutions and services that add value to Americans' lives. I believe that this book is a worthy beginning of a dialogue to accomplish this. I invite your consideration of the insights and proposals contained herein and, much more, your participation in this ongoing exploration.

ACKNOWLEDGMENTS

This book and the 1991 San Francisco conference were made possible only because of the wholehearted support of the leaders of the sponsoring organizations: Robert M. Bass, chairman of the board of trustees, and J. Jackson Walter, then president, National Trust for Historic Preservation; the Honorable Manuel Lujan, Jr., secretary of the interior; James J. Ridenour, director, and Jerry L. Rogers, associate director for cultural resources, National Park Service; and John F. W. Rogers, then chairman, and Robert D. Bush, executive director, Advisory Council on Historic Preservation.

Initial ideas for the conference came from the Conference Steering Committee: Katherine Adams, Lawrence E. Aten, Constance Beaumont, Peter H. Brink, Kathryn A. Burns, Robert D. Bush, G. Bernard Callan, David Chase, Bonnie Cohen, Katherine A. Cox, H. Grant Dehart, David Doheny, Gerald Dunaway, Paul Edmondson, Larry Goldschmidt, Eric Hertfelder, Carol Jackson, H. Ward Jandl, Elizabeth F. "Penny" Jones, Connie Keys, Antoinette J. Lee, Richard Longstreth, Nellie Longsworth, Dorn McGrath, Jr., Michael Mantell, George Marcou, Nancy Miller, Rafe Parker, Frank Sanchis, Ian Spatz, William Still, Dean Suagee, Jerry L. Rogers, Carol D. Shull, de Teel Patterson Tiller, J. Jackson Walter, Patricia Wilson, and Elizabeth Wood.

The conference would not have been possible without the early financial support provided by the farsighted trustees of the J. M. Kaplan Fund of New York City and the Favrot Fund of Houston.

As ideas for the conference accumulated, a Core Conference Planning Committee was organized to further develop the concepts. Members were Peter H. Brink, Elizabeth F. "Penny" Jones, Kathryn A. Burns, and Katherine A. Cox of the National Trust for Historic Preservation; de Teel Patterson Tiller and Antoinette J. Lee of the National Park Service; and Robert D. Bush of the Advisory Council on Historic Preservation. Three consultants assisted the committee: H. Grant Dehart, then of the Maryland Environmental Trust, and Richard C. Collins and Elizabeth B. Waters of the Institute for Environmental Negotiation, University of Virginia.

To review the nearly 300 abstracts received in response to a national call for papers, the Plenary Speakers Advisory Committee was organized and included Kent Barwick, Ellen Beasley, John Bullard, Kathryn A. Burns, Hester Davis, Kathryn Gualtieri, Robert C. Giebner, Eric Hertfelder, Heather Huyck, Daniel Jordan, Bruce Judd, Stanley Lowe, Nellie Longsworth, George Marcou, Robert Mc-Nulty, John Merritt, William J. Murtagh, Tony Rossman, Robert E. Stipe, and Michael Tomlan.

Content editing of the conference papers and the additional essays commissioned specifically for this publication was performed by Antoinette J. Lee of the National Park Service. Special thanks are due to the National Register of Historic Places for supporting this publication by contributing Dr. Lee's time for its preparation. She was assisted by David M. Banks, also of the National Park Service, and Tanya Velt, a National Council for Preservation Education intern from Cornell University. Marcia Axtmann Smith of the Advisory Council on Historic Preservation additionally deserves special thanks for her advice.

INTRODUCTION

FINDINGS AND RECOMMENDATIONS
Peter H. Brink and H. Grant Dehart

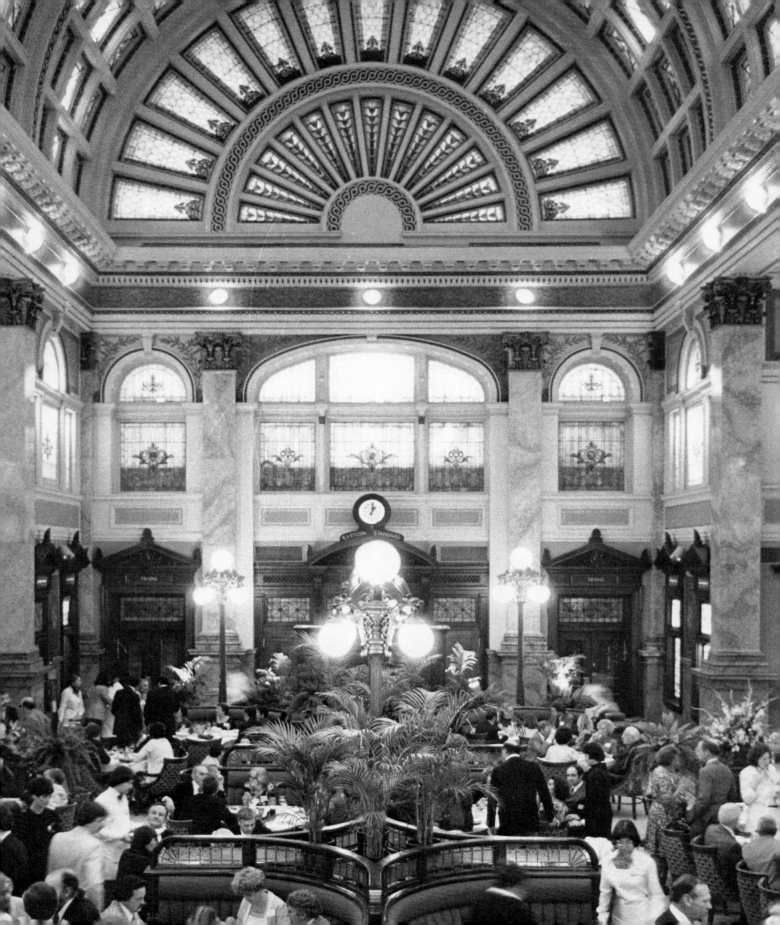

FINDINGS AND RECOMMENDATIONS

Peter H. Brink and H. Grant Dehart

T WO THOUSAND PRESERVATIONISTS FROM ACROSS AMERICA CAME TO SAN FRANCISCO IN 1991 WITHOUT A SCRIPT AND WITHOUT PRECONCEIVED OUTCOMES FOR THE 45TH NATIONAL PRESERVATION CONFERENCE. THEY LEFT THE CITY WITH A CLEARER UNDERSTANDING OF THEIR MOVEMENT, ITS NEEDS, AND ITS FUTURE.

This special conference was designed to review past accomplishments and shortcomings of the movement since the enactment of the National Historic Preservation Act of 1966, as well as to chart a new vision for historic preservation based on expected changes in Americans' values and lives. The conference was organized to allow all participants to debate the issues and the recommendations of the speakers.

To introduce *Past Meets Future,* the findings and recommendations from the conference are summarized here. These points are drawn from the speakers' presentations, invited papers incorporated into this book, facilitated discussions following the presentations, and summary comments made by the rapporteurs. This summary draws heavily on statements made by speakers and participants, but the quotable comments were too numerous to permit attribution or footnotes.

The summary does not necessarily represent the views of the conference sponsors nor does it purport to be a scientific survey of the views of preservationists throughout the United States. The preservation movement is, of course, broader than even this "national town meeting" of more than 2,000 conferees would suggest. Not well represented were archeologists, whose field extends our heritage 20 times beyond America's European-derived history; federal agencies, which manage one-third of the nation's land; American Indians, who are working to launch tribal preservation programs; and other minorities, who do not yet believe that the mainstream preservation movement reflects their heritage.

The summary does, however, reflect the insights of the carefully chosen speakers and of the more than 300 conferees who elected to participate in the discussions. It is, we believe, an excellent beginning to a dialogue, rather than a comprehensive, final answer. Some comments, findings, and recommendations are not clearly consistent with others. The movement's many components, its leadership, and its membership at large will have to sort out such conflicts in modifying future agendas.

GRASS-ROOTS EFFORTS COUNT

Historic preservation has been and should remain a grass-roots movement. Speaker Peter Neill succinctly stated our cause.

"[Grass-roots preservation] is empty pocketbooks, bloody fingers, and private satisfactions. It is long hours, hard work, and no pay. It is a personal dialogue with ghosts. It is a face-to-face confrontation with the past. . . . It is an equation between self and history so powerful that it makes us lie down in front of bulldozers, raise toppled statues, salvage old boats."

As one participant said, "Architectural historians give you information; the neighborhoods give you passion." Passion comes from the grass roots, from the bottom up. Maintaining this passion in the face of an increasingly professionalized and bureaucratized preservation movement was of great concern to conferees. Of the 280 respondents on this issue, 61 percent thought that we should place greater emphasis on grass-roots participation in preservation, compared to 11 percent who thought that preservationists should give greater emphasis to strengthening training and standards for professionals.

Our professionals must know what it is like to stand up to a property owner whose only thought is money and who is intent on destroying a work of art and a piece of our history; to go door-to-door to persuade individual homeowners to support a local historic district designation; or to beg or borrow dollars to fix a roof and save a building too fine to rot. Every student in preservation should have the opportunity to work at the local level. As Michael A. Tomlan suggested, we need a national system of internships to provide this experience to new professionals. This will forge common bonds between professional and grass-roots preservationists, both of whom are essential to our work.

Our systems must be accessible to and usable by local preservationists. Local preservationists should be able to participate more fully in historic resource surveys, in nominating sites to the National Register of Historic Places, and in using Certified Local Government funds for town meetings to identify what they value in their own communities. Governmental systems should encourage and facilitate such participation.

WE NEED A RENEWED SENSE OF RESPONSIBILITY

All preservationists, professional and grass-roots alike, must recognize and recapture the sense of personal responsibility for our heritage and its future that began our movement. "As a member of a community," urged Kathryn A. Burns, "recognize your responsibility to control and shape your future environment. This is not a job for someone else. Every community member must be instilled with that sense of responsibility." David McCullough encouraged us to be willing to think creatively, have confidence in that creativity, and always maintain a willingness to take the risk of being challenged or even losing a preservation battle, because it is the right thing to do. Responsibility must extend to building political support. As Jerry L. Rogers said, "We must build our new strength in the personae of preservation voters."

Our movement and our communities must adopt the concept of "usufruct," the right of using and enjoying the fruits or profits of others' property without impairing the substance—a concept we now call "sustainability." To Kathleen A. Hunter, the real meaning of heritage is "inheritance"—that which previous generations have passed down to us as stewards of the nation's collective memory. This is a meaning that can be taught to children and adults alike.

PEOPLE MATTER

Buildings must serve people, rather than making people serve buildings, urged the Reverend Kenneth B. Smith. J. Jackson Walter, recalling the National Trust's membership research, said, "Not only must we be local, urgent, intimate, and forward-looking as we save buildings, but we must interpret the values that those buildings symbolize. This is a movement, not an academic discipline."

We preservationists should listen, seeking first to understand, and then to be understood. When we start with people, their lives, and what they value, we will tap into a passion that can transform our efforts.

We must seek means whereby historic buildings can be adapted to new uses with a balance of preservation standards and contemporary lifestyle needs. We should "let go and be more flexible in our bureaucratic ways," suggested Kathryn Burns. "We need to make our recognition and protection process work for us," she said. "Even though we are preservationists," noted Arthur P. Ziegler, Jr., "we must always realize that buildings can be improved on through the years, that the first designers are not always perfect, and that adaptations are necessary for our times." We may have created a federal and state bureaucracy that has become too literal in its interpretation of rehabilitation and restoration standards.

Preservation at its best serves people and appeals to the values of Americans of many backgrounds. As the National Trust's membership research tells us, a sense of place, time, and continuity is valued by people everywhere. People

cherish the craftsmanship, human scale, and excellent design of old buildings and communities, as well as the environmental qualities of historic rural areas. They value heritage as a way to understand their identity, and they seek authenticity to gain an honest picture of America's diversified past.

These values must be identified, evaluated, protected, and interpreted by people in their own neighborhoods and on their own terms. When people decide that something should happen in their own neighborhood or community, there is no stopping them. When professionals decide that something should happen in someone's community, it's like pushing on a string.

People care about the things that touch their lives. Initially, they may seek an oasis of heritage and humanity. Ultimately, they will seek a world in which to live, work, and play that speaks to their values.

OUR CONSTELLATION OF VALUES SHOULD APPEAL TO ALL CULTURES

Henry G. Cisneros told us of two Americas on a possible collision course. One is an America of sophisticated technology, extensive education, competition, high living standards, and global interactions. Another is the America of people and changing demographics, with exploding numbers of seniors and minorities. By the year 2000, a third of us will be minorities, and by the end of the 21st century, today's minorities will be in the majority. Historic preservation can help determine whether these two Americas collide or work together for the benefit of each. As Cisneros said, historic preservation can contribute to the "process of multicultural adaptation . . . teaching an ethic of living together." It is, he noted, practical action to solve problems, not elitist, but involved.

Changing demographics in the nation will affect the historic preservation movement because they "will alter the interpretation of American history itself and therefore modify what the nation values, what it wants to preserve, and how it preserves what is seen to be of value," according to Antoinette J. Lee. For historic preservation to be relevant to multicultural groups, preservationists must learn to listen more. In listening, we will begin to understand and appreciate the backgrounds and values of different ethnic groups. We will make room for others to tell their own stories and learn the ways, whether comfortable or unpleasant, in which their stories intertwine to make up America. The Reverend Smith observed that, without listening to and understanding the history and experience of all cultures, we cannot share common values and also understand, appreciate, and respect uncommon values.

History is no longer a "spotlight," said David McCullough. "Now the lights on the stage are coming up, revealing for the first time all of the others who have been on the stage all the time." When we listen, we may come to appreciate that physical places may be illuminated or made sacred because of folklore and the language that contains the lore, and that cultural intangibles such as the Mardi Gras can have a life of their own. We will come to know that a building of no particular architectural merit may lie close to the heart of a people's heritage.

Preservation is seen by the public as a means to preserve human values, not as an end in itself. To Peter Neill, buildings are "chapters in narrative, contexts for history, and places for people." Noted the Reverend Smith, "When people's lives and stories are valued, they will join in the whole."

By starting with people, we will find that our movement broadens naturally. We will expand preservation not by homogenizing, but by appreciating diversity. Our changing demographics will be an opportunity for richness, rather than a threat of destruction.

WE NEED A UNITED MOVEMENT AND WE MUST BUILD PARTNERSHIPS

Judge Randall Shepard implored us to "commit to the idea that we are one preservation movement" and to "be excellent with each other." We can discuss and debate issues passionately, but we must respect and support each other as part of the same movement. We must work toward a single script, one that is broad, diverse, and involves all players. As Jerry Rogers said, "Whoever 'we' are, we had better be good, we had better be strong, and we had better be united." Others who already play important roles in preservation should be embraced, including land-managing agencies, American Indians, archeologists, and minority groups.

At the same time, we must earn our own place at many tables and seek common ground with land conservationists, environmentalists, low-income housing advocates, bankers, lawyers, city and transportation planners, state and local officials, and, yes, developers. We must be involved in real estate, in partnership with real estate people. An overwhelming 87 percent of the 257 respondents on this issue agreed that we will have the greatest odds of fulfilling our agenda for preservation by integrating our agenda with the goals and agendas of other groups; only two percent said that they preferred working independently.

While we should have more empathy with the needs, goals, and motivations of others, we should not compromise our principles or communicate our values only in their language. As Anthony Wood said, "Our camouflage

has become our image." For example, Michael Tomlan recalled one of the most troubling aspects of our movement: "The overheated real estate market and preservationists' willingness to embrace the business community has led to a tendency to 'switch rather than fight.' The most obvious result is facadism—the deliberate demolition of all but one or more elevations of an old building. . . ."

WE SHOULD RECLAIM THE IDEA OF CITIES AS PART OF THE AMERICAN DREAM

The plight of our cities is one of the greatest challenges of our time. We should reclaim the idea of cities as part of the American dream, according to Judge Shepard. The tragic pattern in most of our old cities, said Patricia H. Gay, has been this: population falls, urban poverty increases, education levels decline, crime escalates, and our rich cultural heritage erodes. Racial polarization also is becoming more of a problem.

The overbuilding of the suburbs, the flight of city homeowners, and the movement of department stores and, more recently, offices and industry away from our cities have taken a terrible toll on the historic core of our cities—and more. The "edge city" trend also has had negative impacts on farmland, scenic beauty, wildlife habitats, and other resources within commuting distances of these new rings of growth. The overbuilding of the suburbs and the related savings-and-loan debacle additionally have had devastating effects on our nation's budget and long-term debt.

"Historic preservation gives us tools with which we can combat some of the divisions that exist in our society," suggested Henry Cisneros. Preservationists, according to Patricia Gay, know that building renovations generate jobs and improve property values, that new middle-income and upper middle-income residents support local businesses, that state and federal incentives for historical renovation work, and that new homeowners bring hope and commitment to previously hopeless neighborhoods. Crime is reduced when there is hope and pride in neighborhoods. Nellie Longsworth, president of Preservation Action, said, "Preservationists can become a bridge to reverse urban problems."

Arthur Ziegler cited examples of how historic preservation has improved city economies, boosted property values, and reduced crime in Pittsburgh, Charleston, Galveston, Richmond, Savannah, Seattle, and Washington, D.C., succeeding with a few dollars where urban renewal programs have failed with so many. But Peter Neill warned that "it is not enough to calculate our value in terms of economic measure—inventories saved, dollars invested, main streets renewed, inner cities rehabilitated, tourism promoted, tax dollars derived. . . . " These, he said, "have failed to convert most of those decision makers with whom we lunch." For some, such as William Klein and his family, moving from scenic Nantucket to Southside Chicago was merely "trading up," because of the rich variety of cultural experiences available in a historic urban neighborhood.

We need help. We need new programs of research and advocacy on behalf of cities. Congress should fix the investment tax credits and passive loss rules for historical rehabilitation projects. We need new and sustained sources of funds to reinvest in historic urban neighborhoods before these areas are destroyed. As Nellie Longsworth said, "Face it: Preservation requires money. Regulations must be swallowed, but incentives sweeten the taste."

The successes of historic preservation in maintaining and revitalizing some cities must be more widely understood to serve as models for other cities in need. The Charleston Principles, a set of preservation guidelines for cities that was approved at the National Trust's 1990 National Preservation Conference, should be adopted and implemented by every major city. Mayors who have succeeded with preservation should share their experiences and enthusiasm with leaders of other cities.

HISTORIC PRESERVATION MUST BE INTEGRATED WITH PLANNING AND GROWTH MANAGEMENT

By joining forces, we can strengthen the historic preservation, land conservation, and environmental movements so that the coalition is stronger than its individual parts. We used to say that historic preservation is real estate. Now we are saying that preservation is land use and stewardship. As John F. W. Rogers noted, "Tomorrow preservation will largely be about managing change." William Klein showed how an integrated system of tools, including historic preservation, land conservation, environmental protection, community planning, growth management, affordable housing, and a sane transportation policy, worked for the island of Nantucket. Conservationist Loretta Neumann observed, "In San Francisco, preservation works because it is part of planning; their officials are together, they have strong environmental ethics, and they get support from leaders." Local preservationists responded that it was not always this way—they made it happen; they changed the system in San Francisco with the help of the National Trust.

Tersh Boasberg called for a new paradigm for protection strategies in the nation's cities and rural areas, without scrapping what we have already successfully constructed. This model would incorporate historic preservation in comprehensive downtown plans and rezoning as well as in state

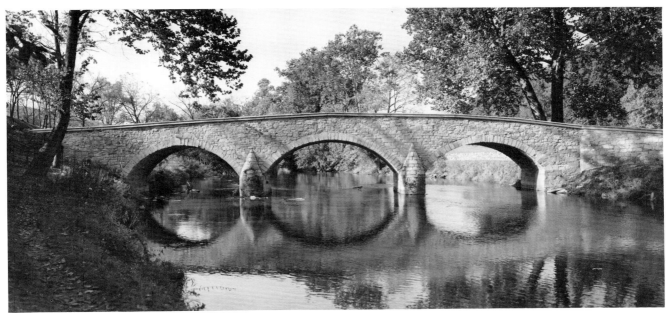

Preservationists are now working to protect the surroundings of structures such as this bridge at Antietam Battlefield in Maryland.

growth-management plans and enabling legislation, where policies should be included to ensure that new development is compatible with the historic environment. Christopher J. Duerksen also proposed that new development must pay its own way.

We should go beyond single structures and traditional districts to whole communities, the countryside, and heritage corridors. The lighter touch of conservation districts may be appropriate where the resource or the neighborhood does not require, or the politics do not support, historic districts. Neil W. Horstman claimed that "a new interest in maintaining or improving the quality and character of our communities and rural landscape affects everything from keeping fast-food restaurants out of certain areas to appreciating the benefits of a house museum."

Of the 154 respondents on this issue, 76 percent said that preservationists should emphasize the integration of preservation into comprehensive plans and zoning ordinances rather than maintain the current emphasis on landmark and historic district designation processes. Three percent disagreed.

HISTORIC PRESERVATION VALUES CAN SHAPE OUR FUTURE

We must share with a broader audience our understanding of human places as a model for future development. Arthur Ziegler said that we "must attempt to give a sense of orientation to our society, using structures and objects of the past to establish values of time and place." To Larry Light, our past is our identity and our character. Our knowledge of preservation values can help us develop models for new communities. We must build cities of the future as we built those we are now trying to preserve.

We should be proud of being the "quality cops" in the planning business, because our movement has, according to Vincent Scully, served as the single greatest influence on architecture and community design in the last half of the 20th century. Christopher Duerksen cited a major trend in America: a search for distinctiveness among communities. He urged us to promote what we already know: that the uniqueness and quality of historic communities provide economic benefits and that "growth management is sound economic policy."

WE MUST COMMUNICATE AND EDUCATE BETTER

Michael Tomlan cited the phenomenal growth of preservation education in the United States. "Make no mistake about it," he said. "This is the largest student body to examine historic preservation of any country in the world." But much of this educational activity is for future professionals in the field, and not enough is for children and their parents.

To instill preservation values in the American public, we need enhanced public education of children, adults, decision makers, and investors. Children and their families count.

Our house museums, tours, and events must be interesting and exciting to them. Preservationists everywhere, public and private, must learn to interpret their historic resources and their preservation struggles to the general public. Neil Horstman refers to house museums as "three-dimensional textbooks into our past."

To many in the field, improving heritage education is far and away the overriding concern. Architectural and cultural heritage should be an integral part of school curricula at all levels. Heritage education should "make the past come alive for young people," said William Delvac, chairman of the California Preservation Foundation.

In all of our work, we must communicate our story better. We have the raw material. We should gather and shape our success stories and contributions and present to people a clear, consistent message that shows how preservation is relevant to their lives. By listening to people, as Larry Light's market research for the National Trust helped us do, we will know what is relevant and we will be relevant.

The communications technology of television, radio, and print can get the story out to people. Computer imaging and information systems show how to fit a new structure into a historic context, how to locate historic, archeological, and landscape resources in a region, and how to share with each other the latest advances in preservation techniques, resources, and opportunities. We must use new technology or risk losing out to competing interests, whether in real estate, planning, or public policy.

WE MUST DEFEND THE PUBLIC INTEREST IN THE USE OF PRIVATE LAND

As members of the general public, we have a right and obligation to preserve historic, cultural, and natural resources of significance to our lives and the lives of future Americans, whether the resources are publicly or privately owned. Joseph L. Sax concluded that property-rights claims do not stand as a significant barrier under the Constitution to protection of cultural properties, given the steadfast support for historic preservation from the U.S. Supreme Court, through liberal and conservative periods alike. The theoretical right to use your land as you wish, provided only that you do no direct harm to others, has given way in practice to a recognition that the public itself has rights, in its cultural heritage as well as in the protection of its landscape and natural resources. Sax revealed that "a major shift has taken place in the balance between private property rights and public claims on the use of land."

The U.S. Supreme Court is not the only tribunal whose decisions are important, however. For example, a recent Pennsylvania Supreme Court decision calls into question whether all historic preservation ordinances in the state will be considered a taking of private property without compensation, as that court ruled in *United Artists Theater Circuit v. City of Philadelphia* in 1991.

J. Jackson Walter called on us to mobilize our movement to forcefully defend public interests in the use of private property, in order to save our history, culture, and architecture, and to seek sensible land stewardship. He identified this as our greatest and most immediate issue as a movement. He saw many related challenges ahead, in state and local courts, in city halls and state legislatures, and from the growing ranks of property-rights advocates who oppose any restrictions on owners' efforts to maximize their own economic gain, regardless of the consequences to the public.

As preservationists, we must be fair and sensitive to the rights and values of others, including those of future generations. Moreover, Joseph Sax claimed, "landowners do have affirmative responsibilities to protect and preserve what 'belongs' to the public, and the effectuation of that protection is not a taking away of something from landowners, but a maintaining of something that is a part of the public patrimony." In the end, the fair balance between public and private rights in the use of property is likely to be weighed in the court of public opinion and by elected public officials who establish planning, zoning, and landmark laws. Preservationists should keep in mind that the political threshold of regulatory authority is often reached long before the constitutional limits are met.

Although we must be wary of political thresholds, which seem ominous at the present time, we can and must affect public opinion on this matter. Even if changes take years of hard work, we should seek to shift the burden of proof to the sponsors of new development that it is needed and compatible with its historic surroundings. As W. Brown Morton III suggested, we should "flip the system" that now places the burden of proof on preservation advocates or local officials to show why a project is not in the public interest or is incompatible with the environment.

PRESERVATION IS POLITICAL

Drawing from his broad international experience, David Lowenthal claimed that "the preservation ethos is more broadly diffused among Americans than in any other major nation. Democratic faith, weakness of class barriers, awareness that lasting success demands widespread accord, and our federal structure all contribute." This democratic nature of America's preservation movement gives us the opportunity to participate more effectively in politics.

Pamela Plumb urged us "to integrate historic preservation into the very heart and psyche of our nation as a public policy, a good life policy." She said that, "To accomplish this, we must become more engaged in politics. . . . We must roll up our sleeves."

We will succeed by being effective politically. Political effectiveness is crucial in integrating preservation and planning, balancing protection of the public interest with private-property interests, and in reclaiming cities, to name but a few areas. To achieve these ends, we must, as Judge Shepard said, "be good allies with politicians." We must have more preservation supporters on key city boards, in state legislatures, and in Congress. We must, when necessary, be willing to run for office ourselves, as Pamela Plumb did to become mayor of Portland, Maine.

A NATIONAL VISION AND AGENDA FOR THE HISTORIC PRESERVATION MOVEMENT ARE NEEDED, AND THEY SHOULD BE DEVELOPED FROM THE GROUND UP

As Brown Morton said, "Our dreams for preservation of the American heritage [are] only partially realized after 25 years of unprecedented effort. . . . Now is the time for action."

Reid Williamson's discussion group agreed that "the results of this conference should help form a national agenda of historic preservation for the future." We need a shared statement of principles and values that can be adopted by all segments of a broader movement, without losing the passion of the individual preservation advocate. For each level of the movement we need a clear statement of goals and objectives with which to measure progress in the next 25 years.

Out of 136 respondents, 66 percent said that we should formulate broad-based, measurable goals and objectives for historic preservation in the nation, rather than continue to use existing goals and objectives for the years ahead. Only eight percent disagreed.

All major players in the movement at the national, state, and local levels should refine their mission statements and rededicate their organizations to carrying out a more specific nationwide action agenda, developed from the ground up. Douglas P. Wheeler shared an exciting preservation initiative, called Resourceful California, that Governor Pete Wilson is supporting. The initiative included a proposed $628 million bond issue for historic preservation and natural resource protection to be submitted to the voters.

Redefining our goals will not be an easy task, but easy tasks have not been distinguishing characteristics of the last 25 years of progress in historic preservation, either. As H. Bryan Mitchell, speaking for the National Conference of State Historic Preservation Officers, aptly noted, "There is

no part of the program that has not involved struggle, disagreement, inefficiency, and frustration." In our new effort, we must follow William J. Murtagh's advice: "Don't let the process dull the vision."

RECOMMENDATIONS

Based on the findings of the 45th National Preservation Conference and comments made by the speakers and discussion group participants, the authors make the following recommendations. We offer these as initial steps in the formulation of a new national agenda for historic preservation for the next 25 years. We believe that these recommendations can stimulate thinking and encourage action. We invite conference participants and other preservationists to review them and initiate their own action steps.

The examples set forth under each major recommendation illustrate how we can move forward from intentions to actions. The action examples thus represent specific means of putting our recommendations to work.

IMPROVE EDUCATION AND COMMUNICATION

Improve and expand heritage education

- Develop a model program and curricula for heritage education in partnership with teachers and other educators
- Establish a heritage education code of ethics to encourage teachers and preservationists to interpret our nation's history honestly and authentically

Establish a nationwide preservation internship program

- Create, through the National Trust in partnership with the National Council for Preservation Education, a program of internships with local and statewide preservation organizations across the country, so that the training of preservation professionals will include an understanding and appreciation of grass-roots preservation

Share preservation information nationwide, using the newest technology

- Improve communication and information exchange by establishing a national electronic information network, building on the preservation bulletin board being developed by the National Trust
- Adapt geographic information systems (GIS), data processing, and imaging systems used in other fields to historic preservation uses. Develop new systems to simulate the impacts of new development in historic areas, and improve historical survey, evaluation, and data processing tasks. To further this effort, use the models being developed by the National Park Service and Advisory Council on Historic Preservation

Communicate and market historic preservation values

- Apply and expand market research to understand the values that Americans see in historic preservation and to help shape the way we communicate with Americans
- Document examples where preservation activities have contributed to the well-being and economic viability of specific communities and neighborhoods, and use these in presentations across the country
- Develop direct-mail and media campaigns to communicate the values and contributions of historic preservation and to gain new members for national, state, and local preservation organizations
- Establish a research program to gather data on the benefits of historic preservation to the American people, the impact of preservation activities, and the cumulative effects of government programs in preserving historic resources

RECOGNIZE THAT GRASS-ROOTS PRESERVATIONISTS REPRESENT THE MOVEMENT'S FRONT LINE

Make governmental support systems more accessible to grass-roots preservationists

- Ensure that national and state registration and local designation processes are more understandable. Simplify these processes where needed
- Establish processes that allow citizens to better identify and achieve public recognition for, and protection of, historic, cultural, architectural, and archeological resources. Such resources could encompass vernacular architectural styles, resources of importance to ethnic groups and various nationalities, folkways and intangible resources, prehistoric archeology, and other community assets

Strengthen technical and financial assistance to and increase input from grass-roots preservationists

- Strengthen services to grass-roots preservationists by the regional offices of the National Trust, statewide organizations, and state historic preservation offices. Develop coordinated goals for each state to achieve such support and encourage grass-roots input
- Establish grass-roots advocacy groups and lobbying networks for historic preservation in each state
- Provide training programs for historic preservation advocacy and lobbying in each state, as well as programs to teach grass-roots preservationists about the federal and state preservation laws available for protection of local resources
- Establish new preservation grant programs for local governments and nonprofit preservation organizations
- Encourage national and state preservation organizations to include grass-roots preservationists in their leadership.

- Establish incentive programs to help defray travel costs for grass-roots preservationists to participate in national meetings, workshops, and conferences
- Have each preservationist recruit at least two new members for the National Trust, their statewide preservation organization, and their local preservation organization

BROADEN MULTICULTURAL PARTICIPATION
AND BUILD PARTNERSHIPS

Broaden participation and leadership to include people of many cultures

- Continue support for cultural programs among American Indian tribes, African Americans, and other ethnic and cultural groups
- Establish programs at the local, state, and national levels to attract, train, and learn from minority preservationists
- Develop an affirmative leadership program to raise consciousness and encourage recruitment of members, board directors, and staff from minority groups
- Establish incentive programs to help defray travel costs for minority community leaders and students to participate in state and national workshops and conferences
- Encourage local governments to include multicultural representatives on historic district and landmark commissions
- Support local cultural groups in identifying their resources of significance and in communicating these to preservation organizations and government agencies
- Expand the agendas of conferences, workshops, seminars, and training programs to include multicultural issues, and work to boost minority attendance
- Publish case studies of community efforts that have succeeded in broadening appreciation of cultural diversity
- Translate key historic preservation information into languages used by people new to America

Strengthen partnerships between preservation and allied groups

- Identify and forge partnerships with allied groups. Such organizations include land trusts; environmentalists; affordable-housing advocates; transportation officials; architects; planners; historians; archeologists; elected state, county, and municipal officials; tourism leaders; farmers; and growth-management advocates
- Develop principles that create common bonds between potential allies and the historic preservation movement. To this end, explore the concepts of sustainability and stewardship. Invite papers and publish literature on these topics to reinforce ties with allied groups
- Establish measurable objectives for increasing the membership of the National Trust so that it can more fully serve the preservation movement

INCORPORATE HISTORIC PRESERVATION INTO PLANNING AND LAND USE REGULATION

Encourage local governments to incorporate historic preservation into planning and zoning ordinances

- Adopt state and national incentives to encourage local governments to incorporate preservation into local comprehensive plans and zoning regulations and to strengthen landmark and historic district ordinances
- Develop a model zoning ordinance, incorporating historic preservation. Publish case studies of local comprehensive plans, zoning ordinances, and conservation and special-use districts to understand what works and what does not
- Provide bonus shares of the Historic Preservation Fund to local governments that enact policies to protect historic resources
- Review standards and guidelines for the Certified Local Government (CLG) program to encourage historic preservation planning and zoning. Provide financial incentives to encourage local governments to exceed the minimum CLG standards by adopting stronger and more comprehensive preservation programs
- Pass state legislation to require historic preservation as an element of local comprehensive plans

Encourage states to integrate historic preservation into statewide planning and growth management

- Develop federal incentives to encourage states to enact growth-management legislation with historic, cultural, and archeological preservation components
- Explore federal legislation to provide such land use incentives, based on experience with the Coastal Zone Management Act, Endangered Species Act, and Clean Water Act, among others
- Develop model state land use legislation, based on successful state programs
- Amend appropriate federal agency guidelines to encourage local governments to enact comprehensive planning and zoning to protect historic resources, and provide federal funding for this purpose. For example, review the Secretary of the Interior's Standards for Preservation Planning and the National Park Service guidelines for Comprehensive State Historic Preservation Plans
- Encourage states to require consistency between local comprehensive plans and zoning ordinances

Implement Section 110 of the National Historic Preservation Act, requiring federal agencies to plan for and manage historic, cultural, and archeological resources under their control

- Ensure that federal agencies evaluate and use eligible historic resources
- Implement the requirement that federal agencies survey and plan for historic, cultural, and archeological resources on federal lands, in advance of actions that might threaten such resources
- Improve federal and tribal protection of archeological resources, especially with respect to looting

MAKE OUR CITIES AND HISTORIC RESOURCES ECONOMICALLY VIABLE

Strengthen economic incentives and eliminate disincentives for the preservation and rehabilitation of historic properties

- Restore the investment tax credits for historical rehabilitation to their pre-1986 potency
- Discourage demolition and encourage reinvestment in cities by eliminating depreciation and the deductibility of capital losses for real estate in the federal tax code
- Enact new tax incentives to encourage the donation of conservation and preservation easements on historic properties and open space, such as an option for heirs to donate easements to reduce the value of an estate
- Establish a National Historic Preservation Revolving Fund of $500 million, with funds contributed by the U.S. government from Outer Continental Shelf and Highway Trust Fund revenues, matched by funds raised from states, major corporate gifts, and individual contributions
- Create new economic incentives and sources of capital for historic preservation, using bond financing, state general revenues (following Florida's example), tax-increment financing, tourism-related fees or taxes, a voluntary income tax-form contribution, lotteries, and other means
- Encourage state and local governments to enact property tax credits and other incentives to encourage historic preservation and land conservation

PROTECT THE PUBLIC INTEREST IN HISTORIC PROPERTY

Strengthen the legal defense fund for historic preservation

- Strengthen legal resources to defend against challenges to historic preservation laws and to advance a reasonable balance between the public interest and private rights in the use of historic property
- Establish a pro-bono network of preservation lawyers
- Develop an electronic network for information on preservation cases and changes in federal, state, and local preservation laws

Strengthen existing laws to protect historic property

- Pass the National Heritage Conservation Act
- Pass the amendments to the National Historic Preservation Act

WHAT DO WE VALUE
AND WANT TO PRESERVE?

DEFINING WHO 'WE' ARE

Jerry L. Rogers

HAT IS IT THAT WE VALUE AND WANT TO PRESERVE? ALL OTHER HISTORIC PRESERVATION DECISIONS FLOW FROM THE ANSWERS TO THIS QUESTION. MUCH OF THE ANSWER WILL TURN ON THE DEFINITION OF "WE."

Is our frame of reference the community or state in which we live, or is it national or global? Are we making ethnocentric assumptions? Do we include new players in preservation? Does "we" include the people who struggle for closely related quality-of-life causes such as scenic beauty, biological diversity, and outdoor recreation? Does "we" include land owners, industrialists, builders, and developers?

Whoever "we" are, we had better be good, we had better be strong, and we had better be united, for there are others who want no part of us. They are growing in organization and audacity, and possibly even in numbers and sophistication. Self-serving rhetoric by politicians in both major parties in the 1970s and 1980s has taken a toll on the ability of Americans to act together in the common interest through representative, democratic local, state, and federal government. Ironically, the recent victory of democracy in once-oppressive systems worldwide seems to have invigorated attacks in our nation on government of all kinds.

Such excesses will eventually run their course, but they are, for now, dangerous. In the name of property rights, these forces have almost destroyed the ability of local governments in Pennsylvania even to list historic properties in their local registers. They have asked Congress to prevent the National Park Service from advising other federal agencies about the historical qualities of a property unless the owner consents. They have asserted a *right* to use for their personal, short-term profit the largess of all the people and keep them in the dark about the resulting harm. They are asking that secondary factors be taken into account in federal decisions about whether a species is endangered. At the moment, you and I are not winning the syntactic battle. Whatever we value and want to preserve, we must remain able to declare that history exists where it does indeed exist.

I have marveled at each new manifestation of the historic preservation movement's ability to absorb and incorporate new sectors of thought and activity. To deal with the problems we face in the near future, we will have to absorb others almost incalculably beyond our past reach. We must broaden the foundation of our strength beyond good law, good lawyers, and good lobbyists, and beyond the prestige of national, state, and local registers. We must build our new strength in the personae of preservation voters.

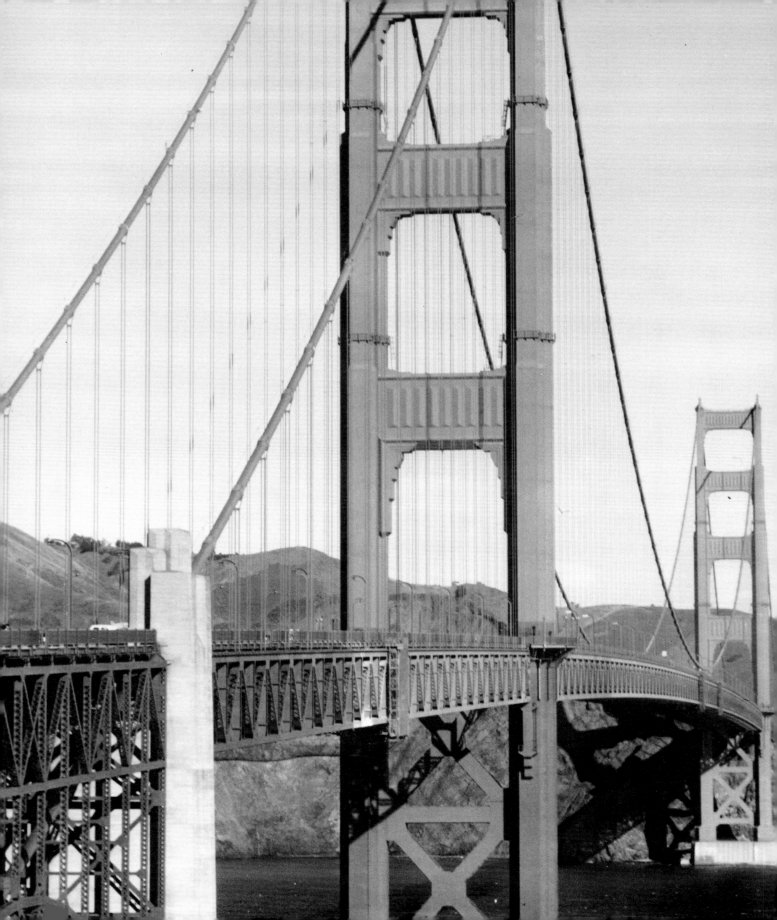

A SENSE OF TIME AND PLACE

David McCullough

WHAT IS THE PULL OF THE PAST? WHY DO WE CARE SO, YOU AND I, ABOUT HISTORY? IS IT JUST BECAUSE WE ARE AMERICANS AND CARE ABOUT OUR COUNTRY AS WE WOULD CARE ABOUT THE PAST OF SOMEONE WE LOVE? OR IS IT LARGER THAN THAT? IS IT STRANGE THAT WE FEEL SUCH A COMMITMENT TO UNDERSTANDING THE PAST?

Let us listen to a voice from the last century who spoke to this feeling. The year is 1878.

And then upon all sides what a clashing of architecture in this one valley where the life of the town goes most busily forward, there may be seen shown above and behind one another by the accidents of the ground buildings in almost every style upon the globe. Egyptian and Greek temples, Venetian palaces and Gothic spires are huddled one over another in a most admired disorder.

But nature is a more indiscriminate patronist than we imagined and in no way frightened of a strong effect. The birds roost as willingly among the Corinthian capitals as in the crannies of the crag. The same atmosphere and daylight clothe the eternal rock and yesterday's portico. And as the soft northern sunshine throws out everything into a glorified distinctness or early mists coming up with the blue evening fuse all of these incongruous features into one. And the lamps begin to glitter along the street and faint lights burn in the high windows across the valley.

The feeling grows upon you that this also is a piece of nature in the most intimate sense. And this profusion of eccentricities, this dream of masonry and living rock is not a drop scene in the theater but a city in the world of everyday reality.[1]

That is Robert Louis Stevenson's evocation of Edinburgh in the heyday of the Victorian city. Note, please, what he says about the intriguing blend of the old and the new, the intriguing pull of past and future, the delight in eccentricities, and the tolerance of difference. The strong point is that this is reality, not, as he says, a drop scene in the theater. Not, as we might say, television.

If it is not strange that we, like Stevenson, feel this way, why are so many out there who do not care? Maybe it is something like having perfect pitch, and they are tone deaf, or something like having an eye for color, and they are color blind? What are we really doing by our efforts to save buildings and record them in books, films, and photographs, by our efforts to care about who we were and where we came from?

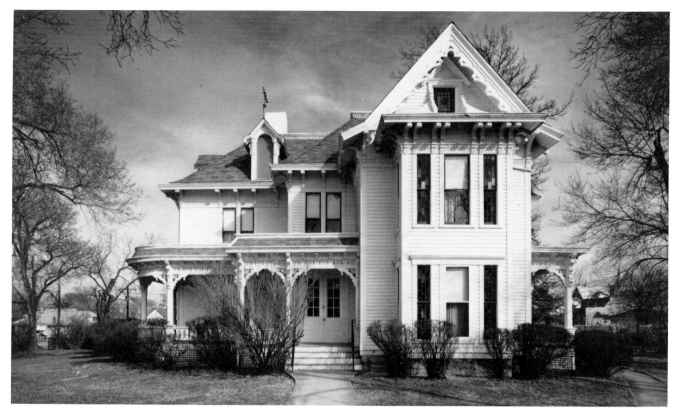

Harry S. Truman's home in Independence, Missouri, reflects the values and attributes of its community.

To begin with, I think we're following an old human instinct—not wanting to be in a rut. We have no more wish to be provincial in time than to be provincial in space. Because fate or God or whatever has placed us in this particular time very briefly, we do not see why the limit of our experience as human beings should be contained within just that time. Why shouldn't we move to the larger stage of the past? Why shouldn't we know how many others have gone before us—the great majority, as they used to say in Stevenson's 19th century?

We are also drawn, of course, because we see so many remnants, so many reminders of the past all around us. And we are drawn, I am convinced, because we are at heart storytellers. We need stories as we need food and water. Consider that for nine-tenths of the time that human beings have existed on this planet, all of their information, all they knew about who they were and how to survive came to them through stories passed down from generation to generation. Our hunger for stories has ensured our survival as a species. It is one of our mechanisms for survival, and we cannot just abandon it. We cannot just pass it by. If we do, we are going to become something less than human.

WHAT CHANGED? WHAT WAS NEW?

But what really draws us to the past, I think, is the idea of change from what is old to what is new. And change is the essence of life. What we are really interested in, what we care about, is life, people, and what happened to them and why. What changed? What was new?

Looming over Florence is the Great Dome by Filippo Brunelleschi: Santa Maria del Fiore, standing 348 feet high. The magnificent structure was built more than 500 years ago, before the sailing of Columbus. And there it is. It is the essence of Florence. It is the Renaissance. And it is a mystery. Nobody knows how it was built. Nobody knows the actual technique used by Brunelleschi to create that great triumph of the Renaissance. When it was finished, it was not Gothic. It was not Romanesque. It was something new, different from anything that had ever been built before. And therein is a huge part of its appeal and its importance. It speaks as much to us about that time as any of the great books, the great paintings, the great statuary.

Almost exactly 500 years later, on the other side of the world, a great bridge was built by a very different people.

The Golden Gate Bridge was begun in 1933 and finished in 1947. We should all, in my view, be grateful that we live at the time of the Golden Gate Bridge.

Both of these monumental and memorable structures stand as symbols of affirmation. They speak of values. Consider that bridge, that magnificent American accomplishment, and what it represents. It was built at the entrance to the greatest sea in the world, subject to high winds, fog, storms, and a tide of seven knots. And it had to have a span, a single span, of more than 4,000 feet. It was to be higher above the water than any other bridge in the world. The bridge does something terribly important. It makes that place more powerful, more meaningful. It gives both scale and a sense of humanity and time to that magnificent, natural wonder of the gateway, the entrance to the harbor.

The environmentalists say any intrusion by humans lessens the power and beauty and meaning of a particular landscape. Anything built on Storm King Mountain, it was said during the great fight over that mountain on the upper Hudson, will denigrate it, diminish it. But as architectural historian Vincent Scully said, "The Greeks would have known what to build on Storm King Mountain."

The Golden Gate Bridge ought to take our breath away for many reasons. But it cannot be seen just in the context of place. Like Brunelleschi's dome, it must also be seen in the context of the time that created it. When the Golden Gate Bridge was built, Franklin Roosevelt was in his first term, Charlie Chaplin was tickling movie audiences in *Modern Times,* and athletes were competing in the Berlin Olympics. It was the time of the Great Depression, the time when the king of England abdicated the throne for "the woman I love," the time when two of the most important events of our century took place, foretelling so much that would change our world. The two events occurred not much more than 100 miles apart.

One event took place in Copenhagen, where Niels Bohr and his colleagues at the Institute of Physics determined that if the uranium atom were split, it would release a power beyond any former understanding or example. The other took place just across the way at a small German fishing village where the Nazi government had instituted the first experimental rocket station under the brilliant young physicist Werner von Braun. The same time that saw this magnificent bridge go up witnessed the beginnings of the nuclear age and the rocket century.

I grew up in Pittsburgh, Pennsylvania, surrounded by old structures. I borrowed books from the Carnegie library. I went downtown and walked by the old Richardson jail—a vision out of Dickens—and absolutely shuddered with fear. My city boasted more bridges than Paris. I have been inter-ested in bridges all my life. I am not an engineer. I am not even a historian. I am an English major. But I am drawn to the past, as you are, because I care to know what happened.

IS THE FUTURE FORESEEABLE?

What is the future for our work, your work, my work? And what will the values be that determine this future? I firmly believe, as an English major, that there ought to be no use of the expression "the foreseeable future." There is no such thing. A historian can no more presume to read the future than anyone else.

Look at some of the things that various historians said about the future, the world of tomorrow, at the time of the 1964 New York World's Fair. Henry Steele Commager, one of our best historians, published a long essay that year in the *New York Times Magazine.* It is fascinating to see how wrong he was. Or take Charles Reich's *The Greening of America,* published in 1970. Writing in the era of the flower children, in the first bloom of environmental consciousness, he predicted a more humane, tender, and green America. And what did we wind up with? Something entirely different. The Reagan years caused momentous changes, which we will be a long time sorting out.

What I am about to tell you concerning the future is not a prediction but a hope. I hope that we will become people who care about the past because we care about the future. I hope that we will become people who are less self-centered, self-conscious, and selfish in terms of our own time now, now, now. I have long felt that the digital watch is the perfect symbol of our time. It tells you only what time it is now, as if there had been no time before and no time to come.

We will need people who understand that history is a spacious realm. There must be no walls. Nothing great or worthwhile happens in isolation. Ever. Never has, never will. Our picture of the past changes almost daily. For a long time the spotlight has been on only a relatively few people—white, male descendants of Western Europeans. Now the lights on the stage are coming up, revealing for the first time all of the others who have been on the stage all the time. We see how many there are, how diverse they are, and how great a contribution they have made to what we call "American civilization." And that means new opportunity for historians, for biographers, for people who want to go out and look at the landscape and decide what should be preserved.

I have spent the last 10 years working on the life and times of Harry S. Truman, who grew up, as everybody knows, in Independence, Missouri. I have been looking at that town and its layout, with its courthouse in the center of the courthouse square, and the square smack in the center of the

town. All roads lead to the courthouse square, with all of the merchants and various enterprises of the town around the square. When Truman lived in Independence, Missouri, in the heyday of the small town, the steeples of the churches were its highest peaks. And the railroad depot was where you went to go out to the wide world, if the wide world was what you wanted, or to go to Kansas City, only 12 miles down the way. If you grew up in Independence, Missouri, before World War I, you knew exactly where you were. You knew exactly by where the courthouse was, where the churches were, where the schools were, what was expected of you, and what the standards were.

And if we want to understand places like Independence, Missouri, or Red Cloud, Nebraska, or Sauk Centre, Minnesota, we have to look at the whole place, not just Harry Truman's house—or the Wallace house, as it is still called by some of the old families—on Delaware Street. Not just at the courthouse, but all of it.

How long did it take Harry Truman to come out of the drugstore where he worked and get back home at night in the dark through the kitchen door? What did he see when he went by? Who were the people, the men and women, who stood as models for behavior and aspiration in such a community? What were the values that such a community drummed into its citizens, like it or not?

Honesty was the best policy. It saved time and worry, because if you always told the truth, you never had to keep track of what you said. Make yourself useful. Anything worthwhile requires effort. This is all in the letters, diaries, the teachings at the schools, the sermons that were preached in the many churches around town. If at first you do not succeed, try, try again. Never, never give up, Harry's father would say. Children are a reflection of their parents. "Now Harry, you be good," his mother would tell him time after time as he went out the door.

He appears not to have questioned such dictates any more than he questioned the established inequality of black people in Independence. "In those days," he would remember, "right was right, and wrong was wrong, and you didn't have to talk about it." Most of the familiar guidelines came directly from the Bible. I taught at Cornell a year or so ago and I found that my very bright, cheerful, very likable students, many of whom had gone to the finest high schools and private schools in the country, were historically illiterate. And they were also almost totally ignorant of the Bible. The Bible is where so many of our American values come from, something these younger members of our civilization do not know. If you read such lines as these to them, they don't know them: "Honor thy father and mother." "A good name is rather to be chosen than great riches." "Seeist thou

a man diligent in his business, he shall stand before kings." "Be of good cheer."

Harry Truman's mother and father would tell their son, "Say what you mean. Mean what you say." "Keep your word." "Never get too big for your britches." "Never forget a friend." They were more than just words to the wise. They were bedrock. Clearly established. As integral to the way of life as those very landmarks of the courthouse tower with its clock, the church steeples, the railroad depot. Not everyone lived up to such precepts, of course, but it was expected that you would at least try.

IT IS NOT TOO LATE

Harry Truman's world is largely gone. Independence Square, a fine example of small-town America, has been greatly changed by well-meaning but ill-suited urban planners, who wanted to gussy it up a little and make it kind of suburban, and by the sweep and spread of suburban Kansas City. But it is not too late. It can be saved. Part of it is being saved.

Red Cloud, Nebraska, is another small-town incubator for another major American figure, Willa Cather. It is also being saved. Outside Red Cloud, the home of a family who would seem to have no place in history whatsoever has been saved by the Nebraska State Historical Society. It, too, has a story, and the house amplifies the story. The resonance of history is amplified every time we maintain, save, and use such structures.

(One night in Washington, D.C., I was walking through the Capitol Rotunda and passed a television newscaster standing in front of the lights, about to do his stand-up, as it is called. He was complaining about the echoes in that room. I thought, "Ah, yes. What echoes!")

A young girl from present-day Czechoslovakia—Bohemia—came to the United States with her illiterate parents. She went by train to the barren prairie of Nebraska and suffered through difficult times. Her father, a city man, killed himself in despair one bleak Nebraska winter. And because he was Catholic, burial was not permitted in the local cemetery, so he was buried by the side of the road. The road took a little jog there at the place where he was buried.

The girl grew up, went into Red Cloud, and got a job as a maid. She was romanced by a railroad worker and went off with him to Denver, where he promised to marry her. A short while later, she came home. He had deserted her, and she was pregnant. She bore an illegitimate child and later met another man from Czechoslovakia, a newly arrived immigrant who had spent some time working in New York. Like her father, he was a city man. They fell in love and married.

They managed to acquire a farm, and she had 10 more

children. She came to America in 1869. She died in 1955. Her name was Anna Pavelka. Her farm and all that she built—because her husband was not much at farm work— still stand outside Red Cloud. The site is a mecca for hundreds of people every summer. Over the years, thousands have come. Why? Why the interest in this woman who did not, by the usual measures of importance, amount to anything special? Because of the transfiguring touch of the genius of Willa Cather. Anna Pavelka is Antonia in Cather's novel *My Antonia*. As Anna Sadilek, she became immortal through that great work. And because her house and farm exist, the novel itself is made more vivid, takes a larger place in American life. Each plays off the other.

PLACES WITHOUT WALLS AND BARRIERS

We have to enlist a broader spectrum of American skill and imagination. We have to be more inclusive. Edinburgh, that wondrous city described by Robert Louis Stevenson, experienced what was essentially an English-Scottish-Western renaissance of its own in the 18th and early 19th centuries. In medicine and philosophy, from people like historian David Hume, came the origins, the beginnings of the whole idea of an Encyclopedia Britannica, not to mention the works of Sir Walter Scott or Robert Louis Stevenson.

And what spawned this renaissance in that bleak place, a tiny northern town, smaller than New Haven, Connecticut? We do not know. But one of the things we do know is that in the Edinburgh of that day, everybody saw everybody. There were clubs, societies, associations. People met almost every night. Lawyers, doctors, engineers, poets—people of all professions and all persuasions—met, talked, worked, and imagined together. Edinburgh was a place without walls, barriers, or status order. We must encourage that.

Filmmakers and photographers must be part of what you do, must be considered the flag bearers. We do not much like television, and for good reason. Most of it is terrible. But it is part of our culture, and we are in its grip, even as we are in the grip of our past. Television can reach a large, appreciative audience if a program is well done.

In my new book, a collection of essays called *Brave Companions*, I write about a photographer named David Plowden, who has spent his life crisscrossing the country, photographing vanishing America. He is one of the most gifted photographers we have as well as a wonderfully intelligent, well-read, perceptive human being. But he brings to his work something more important. What he brings to his work is passion.

"I feel it is essential to do it," he says. "I feel somehow or other that it's a mission that has nothing whatsoever to do with my own being, but that it's something quite apart from me. Somehow or other I happen to have this talent or gift or obsession or fanaticism or madness or whatever to go out and do this. And really, it has very little to do with Plowden the family or Plowden the friend or Plowden anything else. I am doing this and I am absolutely consumed with a sense that it has to be done."

The Pavelka Farmstead, now a house museum in Webster County, Nebraska, was made immortal in Willa Cather's My Antonia.

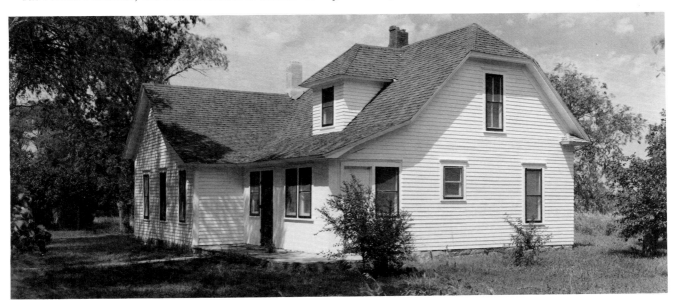

The poet Ralph Waldo Emerson would have understood. "The world is young," said Emerson. "The former great men and women call to us affectionately." There is no such thing as the dead past. The marvelous thing about the past is that it is so full of life. It can even be argued that there is no such thing as the past. There is only somebody else's present. All those people who went before us building bridges, raising great structures, writing books, painting landscapes and portraits, founding industries, all of them shared with us the intriguing question: how is it all going to come out? They did not know any more than we do.

"Past things shed light on the future ones," wrote the 16th-century Italian writer Francesco Guicciardini in *I Ricordi politici e civili*, in Florence in the shadow of the Brunelleschi dome. Guicciardini continues, "The world was always of a kind. What is and will be, was at some other time. The same things come back but under different names and different colors. Not everybody recognizes them but only who is wise and considers them diligently."

Harry Truman of Independence, Missouri, said, "The only new thing in the world is the history you don't know." Same idea. We will, I hope, see a new generation of Americans who are more humane, more tolerant, more eclectic. I hope very much that we will devise an educational system that does far more to reward imagination—originality, spontaneity, call it what you wish— and a willingness to take risks. I have run a test in some of the courses I have taught where I have asked students to take out a piece of paper and write down all the things they can think of to do with a brick. The results are very interesting because there is no correlation between those with high grades in their scholastic careers and those who come up with imaginative or ingenious answers.

Risk taking is another very rare quality that must be encouraged. Students are extremely skilled at reading a teacher's mind and giving back what they think the teacher wants. To avoid this, tests and experiments must be devised in which a student competes against no one but himself or herself.

CONFIDENCE AND CONTINUITY

All great civilizations have had at least two things in common: confidence and a sense of continuity. We gain both from our sense of the past. We are confident because we know who we are, what we have done, and where we have been before. As Winston Churchill once said, "We did not come this far because we are made of sugar candy."

And because we know what has been done in the past, we know what the standards are. We know what we must live up to. And if we have a sense of the past, then we also know that future generations will view our own work as the standard by which to measure their performance. This concept can come only to those who have some sense of measuring themselves against the past. And continuity, of course, is the essence of writing history and caring about the future.

I do not think that human nature is going to change in the future. But certainly we are living in one of the most revolutionary of all times. What we have seen happen in Eastern Europe and the Soviet Union in just the past few years is a tumultuous change that we will not even begin to understand for at least 30 to 50 more years. But it is immensely important, a Krakatoa in history. And that is exciting. That is change. That is what we are interested in: what's new. We say it all the time, we Americans: "What's new?"

In 1964 I went with my young family to the New York World's Fair. And like millions of others, we stood in line to get into the General Motors exhibit. Some of you may remember. It featured shiny new General Motors cars on a conveyor belt to take you into a future of exquisitely shining, glassy, high-rise buildings set in a landscape in which there was virtually nothing of the past. And the centerpieces were magnificent highways, many lanes wide, on which the automobiles traveled without any effort from the driver. They were on conveyor belts or guided by some sort of beams as I remember. There was also a gigantic machine that moved along chewing up the jungle and creating roads as it went.

When, finally it was our turn to take the journey, I asked our little boy, Billy, who was then five years old, if he would like to drive. He got behind the steering wheel, and we climbed into the car, a white Impala with red seats, and on we went through the "World of Tomorrow." After it was over we came out blinking in the sunshine, all saying, "Boy, wasn't that something?"

I turned to my son. "Well, Billy, what did you think?" "I don't know," he answered. "I was too busy driving."

He understood the future better than the people at General Motors. The world of the future as portrayed by General Motors had no bearing on our time. But Billy was saying we must have a sense of responsibility.

If we do not care about our past, if we do not write history and biography, take photographs, make films, save buildings and whole towns, and protect the works, too, of the industry and science of our rich, diverse, and protean culture, then we are being irresponsible in the extreme.

I am a short-range pessimist and a long-range optimist. I sincerely believe that we are emerging out of one of the darkest shadows of all time—the Cold War—and that once we get over the trauma, we may be on the way to a very different and better time. Let us hope so. Let us pray so.

DAVID McCULLOUGH

Designed by H. H. Richardson, Pittsburgh's Allegheny County Courthouse and Jail offers a powerful sense of its time and history.

A SENSE OF TIME AND PLACE

FORGING NEW VALUES IN UNCOMMON TIMES

W. Brown Morton III

I WANT TO TAKE YOU SOMEWHERE WE HAVE NOT YET BEEN. I WANT YOU TO COME WITH ME FROM WHERE WE ARE BUT MUST NOT REMAIN— TO WHERE WE ARE NOT BUT MUST GO TOGETHER.

T. S. Eliot comments in his *Four Quartets:*

> *What might have been and what has been*
> *Point to one end, which is always present.*[1]

Now is the time for new action. Our hopes for preserving the American heritage are only partially realized after 25 years of unprecedented effort.

The preamble to the National Historic Preservation Act of 1966 correctly states that the "historical and cultural foundations of the Nation should be preserved as a living part of our community life and development in order to give a sense of orientation to the American people." This preamble is talking about values—what should be our national values. It is clear to me that many of preservation's most cherished values have failed to penetrate the mainstream of the American consciousness in the last quarter century. A good example of this is the still unsatisfactory relationship between preserving our common heritage and protecting private property rights.

Not only must we instill unrealized older values. We must also forge new values for these uncommon times, marked by such an unprecedented opportunity to turn swords into plowshares, feed the starving, and usher in the new millennium as a golden age of peace and justice. Old wisdom will not, in every case, do. As Eliot says in *Four Quartets:*

> *Last season's fruit is eaten*
> *and the fullfed beast shall kick the empty pail.*
> *For last year's words belong to last year's language*
> *and next year's words await another voice.*[2]

We must exercise extraordinary vision and fearless leadership at this very moment or be overcome by asphalt, ignorance, and greed.

I have a question to put to you: When future generations look back at present-day American preservation, how will your work and mine be judged? Over what parts of our culture and our environment will our grandchildren wish we had exercised more aggressive and informed stewardship? When I think of this question, I am reminded of my own great-grandparents, all of whom came from a slave-owning background. I cannot imagine owning another human

being. I look back at my forebears and I think to myself, "Surely they saw it, surely they saw the monstrous evil of slavery. Why did they not do something about it?" What is it that you and I do not see, or are unwilling to see, because of its possible economic impact on our present existence? What is it? I believe it has something to do with the grim fact that we seem to be killing the planet, both its body and its soul, and we are, as yet, too greedy to do anything substantial about it.

TOWARD A COMMON PHILOSOPHY

Before we drown in poorly planned subdivisions and shopping malls, it is time to articulate a common philosophy to guide the activities of conservationists of all backgrounds, including, but not limited to, preservationists. What might be some basic elements of such a common philosophy? Examining the settings most conducive to successful human development—and integrating a new understanding of the necessity for comprehensive environmental integrity—is, in my view, the right place to start.

Preservation is a quality-of-life issue. As we observe the negative effect of ignorance, injustice, greed, pollution, and loss of cultural memory on individuals, families, communities, and nations, it is time to identify and protect those places where dignity, pride, intimacy, trust, and shared remembering are possible. It is time to integrate fully into all aspects of American preservation recognition of the fundamental contribution of both cultural and natural landscapes to overall environmental integrity and successful human development. It is also time to tell the truth about ourselves. Francis Bacon commented in an essay written in 1625: "What is truth? said jesting Pilate; & would not stay for the answer."

We Americans, almost always in too big a hurry to wait for truth, have become a nation of Pilates. American preservation has, far too often, rushed to create a flattering past. Many historic sites and museums routinely misinform the public because the truth is inconvenient. In most places, slavery and economic exploitation are ignored or rendered trivial. Interpretive programs rarely challenge established American myth. Although the preservation movement is becoming more respectful of our multicultural heritage, there is still marked reluctance to identify and preserve sites that trouble the conscience of the nation.

By its nature, historic preservation is always autobiographical: a person, community, society, or nation paints its own portrait by what it chooses to save. We preserve what we value. The choices we make depend on who we are and on what we perceive our history to be. What portrait have we painted? What values are preeminent in what we have preserved? Webster's defines value as "the quality or fact of being excellent, useful, or desirable." What is "excellent, useful, or desirable" to us and what is not? For some Americans, important symbols of tradition may include Mount Vernon, the Statue of Liberty, the U.S.S. *Arizona,* and the launching tower at Cape Canaveral. For others, the Vietnam Veterans Memorial, a Japanese American internment camp, or the Castro district in San Francisco may be high on the list.

People save the benchmarks they want to remember. What we save depends on who we are and on what we perceive our history to be, just as the answers we want our cultural heritage to provide us depend on the questions we ask.

The National Historic Preservation Act of 1966 approached the idea of value from the perspective of significance in American history, architecture, archeology, and culture. The list was expanded in 1980 to include engineering. Are these enough? It is interesting to note that in 1966 the special committee whose work led to the National Historic Preservation Act recommended another area, subsequently ignored: social significance. I believe that we must restate the claim of social significance and fully embrace the claim of environmental significance as well. If we were to draw a graph of the intellectual development of preservation in the United States over the past 150 years, it might resemble an inverted pyramid. At the bottom would be a narrow initial concern by a small group of people on the East Coast with the country's Revolutionary history, and at today's broader top would be a growing commitment to embrace the cultural heritage of all Americans and all phases of our development. Gone is the notion that American history and culture stepped ashore at Jamestown or Plymouth Rock onto a blank stage. It is now clear that America is, as Carter Hudgins of Mary Washington College has pointed out, "a place of many beginnings," some of them as ancient as our earliest prehistory, others as fresh as yesterday.

The present process of historic preservation is an inclusive process, not an exclusive one. Historic preservation is no longer a question of the few saving the best. There is no longer a favored time or favored style or favored culture. Historic preservation now involves everyone: individuals, families, neighborhood associations, historical societies, the business community, and schools and universities.

In the United States, the understanding that historic preservation is, essentially, an environmental issue began to coalesce in the decades immediately following World War II,

Opposite: The cobbled Stowe Alley in Nantucket, Massachusetts, is a place of both historical and scenic value.

as Americans recoiled from the destructive edge of post-war prosperity, epitomized by three federal programs: urban renewal, the interstate highway system, and water impoundment. The death rattle of so much of our cultural heritage, as bulldozers swept unchecked across the urban and rural landscapes, renewed public interest in American history and the sights, sounds, tastes, and activities of the past. More and more groups, at all levels of society, felt capable of fighting back. This was the do-it-yourself generation. Increasing numbers of families searching for suitable housing discovered the joys and benefits of fixing up old houses.

Before the war, such activity had been limited, for the most part, to the artistic and the rich. However, almost as a counterpoint to the wasteful roar of the bulldozers, people began returning to old neighborhoods. The lure was not Fourth of July patriotism or pulp history, but the more elusive conservation ethic inherent in the recycling of old buildings and the quality of life a historic neighborhood could provide because of its echoes.

Perhaps it had something to do with the razing of Warsaw, the destruction of Dresden, the agony of Auschwitz, or the horror of Hiroshima. Perhaps the Cold War, Korea, and McCarthy segued too quickly into gunfire in Dallas, Memphis, Los Angeles, and Vietnam. Whatever it was, something moved, deep in the nation's spirit. Call it the end of unquestioning belief in the American Dream. Call it the beginning of wisdom. A reflectiveness, a hint of hesitation was in the air. The fins fell off the Cadillacs, and millions of Americans pondered for the first time the inevitable results of poor stewardship of natural and cultural resources. We saw that we, too, could become displaced persons, displaced by our own stupidity. The idea grew that conservation of our natural environment and preservation of our cultural heritage were part and parcel of the same call to global responsibility.

The World Heritage Convention in 1973 began to reshape the structure of American preservation along these lines. We are now struggling across the threshold of a new understanding. The justification for devoting time and scarce resources to the protection of our cultural heritage is being couched less and less in purely historical and antiquarian terms. Increasingly, preservation is being perceived and advanced as an exercise in environmental integrity. The focus is no longer the past, nor even the present, but the future. It is clear that geographic displacement, social estrangement, and the loss of cultural memory seriously erode the possibility of successful human development for millions of Americans—individuals, families, communities, and the nation. More and more, we are

striving to preserve what has survived from the past, not to idolize that past, but to inform the present and to ensure the quality of the future.

NEW WAYS OF THINKING

I want to change the way that America thinks about historic preservation. I want to do this in two ways.

First, I want to change the way most Americans currently understand the closing phrase of the Fifth Amendment to the Constitution: " . . . nor shall private property be taken for public use without just compensation." I want to change the way Americans think about "just compensation" once and for all. What is just compensation? Is money the only just compensation? Could it be that clean air, clean water, scenic beauty, and the preservation of a sense of place could also be just compensation? A Supreme Court justice in the 1950s, William O. Douglas, seemed to think so. Would it not be just compensation if the action of local government ensured the protection of an environment for you, for me, for our families, and for our community, conducive to our successful human development? I want America to be a place where we have a chance to burst into full bloom. I am reminded of a saying of the Sufis, "The hen does not lay eggs in the marketplace." I believe it is just compensation if the result of the action is to preserve a place where dignity is possible, where pride is possible, where intimacy and trust are possible, where the abundant rewards of shared remembering are also possible. I need your help to pull this off.

The second way I want to change how America thinks about preservation is to change the way we protect historic places while we still have some left. Our present system, for all of its qualities, is not working in all of its dimensions. Despite its outstanding contributions to American preservation, the National Register of Historic Places has, in my view, failed in one of its most fundamental missions. It has not become a comprehensive inventory of the American cultural heritage. Only a small fraction of actual resources of national, state, and local significance are listed in the National Register a quarter century after its inception. This is, in part, because survey work is expensive and time-consuming. It is also because we have escalated a successfully completed National Register nomination form into a minithesis that requires months of research, a high degree of professional training, and a fat wallet, thereby slowing down the registration process to a trickle.

Whatever the reason, here's the rub: Under our present system, we are obliged to demonstrate that a given place is of historical or scenic value and to fight for its inclusion in some sort of national, state, or local register to justify its

Destructive urban renewal projects after World War II sparked new interest in American history and a return to old neighborhoods.

preservation. We must flip the system. We must inaugurate a new system whereby one is obliged to demonstrate that a place is *not* of historical or scenic value in order to get permission to change it. Imagine the liveliness of the community dialogue that would ensue with such a new system! Surely the burden of proof must rest with the party whose action might adversely affect irreplaceable and nonrenewable resources.

In closing, I also believe we must redouble our efforts to create a national system of heritage education to foster responsible preservation values in our citizens from childhood. Why wait until we are grownups to introduce right thinking and right action? What do we really value? What do we want to keep from the present for the future? For whom? Why?

Moving forward means asking these questions anew and forming new alliances to protect our answers. Our answers will not be the same answers we have grown used to since 1966. Every passing day gives new meaning to old places and new character to our nation. We must forge new values in these uncommon times. We have a new job to do. Let's do it.

As Eliot said at Little Gidding:

We cannot restore old policies or follow an antique drum . . .
A people without history is not redeemed from time,
For history is a pattern of timeless moments . . .
Quick now, here, now, always.[3]

PERSONAL DIALOGUES WITH GHOSTS

Peter Neill

I N THE PREFACE TO *TYPEE,* HERMAN MELVILLE WRITES, "SAILORS ARE THE ONLY CLASS OF MEN WHO NOW-A-DAYS SEE ANYTHING LIKE STIRRING ADVENTURE; AND MANY THINGS WHICH TO FIRESIDE PEOPLE APPEAR STRANGE AND ROMANTIC, TO THEM SEEM AS COMMONPLACE AS A JACKET OUT AT ELBOWS."

I march among the fireside ranks, doing what most folks call steady work among the administrators and bureaucrats of preservation. Foolish business, some might suppose, soft-headed, soft-handed. Maybe so. The challenge, of course, defies the commonplace: how to convince my city, my state, and my country that the sea and its cultural and commercial history have some meaning still? How, in a world of rapid change, poverty, and confrontation, can the preservation of maritime tradition—its artifacts, skills, and values—justify our attention and financial resources? How can we extract from this past or any past—from a time so viscerally disconnected from this present—some wisdom and guidance for the future?

Allow me to be provocative. I submit that over the last 25 years preservation has moved little beyond its impetus, that the so-called movement has become intellectually benign, culturally separate, and methodologically paralyzed. I argue that preservation has *earned* public indifference by its own history of exclusionary complacency and failed imagination. How can we point with such satisfaction at our achievements when, with the modification of tax incentives, preservation collapses? Surely the difficulty we experience persuading local governments or philanthropic donors of the merits of our work is another poignant signal.

In my view, this failure is based on our fascination with objects, our insistence on seeing buildings as ends in themselves rather than as chapters in narrative, contexts for history, places for people. It is not enough to calculate our value in economic terms—inventories saved, dollars invested, main streets renewed, inner cities rehabilitated, tourism promoted, tax dollars derived. Whether we like it or not, our record, our elaborate formulas, and our policy arguments have failed to convert most of those decision makers with whom we lunch.

To continue with a maritime metaphor, a successful riverboat pilot must know the shape of the river—every bar, bank, and snag. Mark Twain wrote that "narrative should flow as flows the river down through the hills and the leafy woodlands, its course changed by every boulder it comes across . . . a book that never goes straight for a minute, but

goes . . . always going . . . loyal to the law of narrative, which has no law." I argue that such dynamism is absent from historic preservation as we define it today. How do I know? Because the membership of the National Trust is *only* 250,000; because minority response to the movement is rare; because those looking for cultural cohesion and individual identity find only the biased patrimony that we preserve.

FOG ON THE RIVER OF HISTORY

Once, descending the Yangtze River, I interviewed a real river-boat pilot. I told him about Mark Twain who, in *Life on the Mississippi*, describes how he could close his eyes and see from source to mouth, every bar, every bank and snag. Could Captain Cho do that? "In China," came the response, "we navigate with our eyes open." At best, preservation has seen near, not far. Only recently have we begun to look inside the building to see who lived there, who worked there, and how. Only recently have we begun to look outside the building to the context in which it sits, to the literal *and* cultural landscape that surrounds it.

Suddenly we come face to face with paradox, those dynamic contradictions that only history can provide. We landmark the mundane facade of the motel in which Martin Luther King was killed. We reject landmark status for the house in which Anton Dvořák composed his "New World Symphony" in order to construct a hospice for AIDS patients. We preserve the boyhood home of Louis Armstrong, but we question preservation of that of Lawrence Welk. Congregations that once built architectural monuments to their spiritual aspirations now tear them down to finance their worldly commitments. These are the kinds of boulders around which the river of history flows. Fog rises off the water. Visibility is limited. Danger is everywhere.

But there are hopeful signs—even within the dry and lightless realm of administrators and bureaucrats.

Working a knot on the Elissa, *a restored maritime laboratory and living museum in Galveston, Texas, provides skills in self-reliance.*

When I look closely at my colleagues' office walls, I see trophies discreetly placed: a frostbiting dinghy championship or a regatta win in San Francisco Bay. I see photographs of solo kayaking in the San Juan Islands and recognize the director of personnel. Comes the realization: these folks are not as fireside as they seem; by God, they're sailors!

On the surface, we are all commonplace, as ragtag a collection of jackets out at elbows as the world has ever seen. We are rich and we are poor. We are red, yellow, black, white, and we are grayed by whatever our personal desperation. We live huddled along the coasts or wherever along the inland waterways our ancestors set down to rest. We navigate the turbulent waters of experience — we sail, we power, we lie becalmed; we sink, we swim, we put to sea!

If, 100 years ago, water meant transportation and commerce, then today it means recreation—recreation in the sense of "re-create," a method by which we can form something anew with our energy and imagination. Whether we mean by it the lucid beauty of Penobscot Bay or the turgid reality of the Harlem River, water is an uncommon place in which to link past to present. Herein lies the essence of a new definition of preservation.

Water is release, from tyrannical order and disorienting conflict, from confusing circumstance, from too many too compelling questions. Water is wilderness, a landscape of contradictory adjectives like quiet and turbulent, translucent and opaque, life-giving and life-taking. And water is history, the palpable link to our forebears and their innumerable narratives of love and loss. There is no more dynamic place on earth than the sea, its constant change a redeeming antidote to the social change that disrupts our world.

Several years ago, the *Marquez*, a sail-training vessel en route from Bermuda to Halifax, was lost. Days after this tragic accident, a postcard was received by the parents of one of the 19 souls who did not survive. The card was written in the shorthand exuberance of such things. It told of a glorious passage and proclaimed their daughter's exhilaration at the beauty she saw and the freedom she felt at sea. This young woman claimed to have been made anew, recreated through the authenticity of experience. Her new sense of self was derived from a personal identification with her heritage. She spoke not just of the ship, the artifact, the building; she spoke of the timeless skills she had learned and of her sense of place within a *tradition*. She spoke of the value of work and competence, of self-reliance and cooperation, of teaching and learning. She had joined Melville's "class of men" who had seen stirring adventure, and she was *connected*. Had she lived, who knows what wisdom she might have spoken or what changes she might have wrought.

CONFRONTATIONS WITH THE PAST

What is historic preservation? Preservation is uncommonplace. It is individualistic and eccentric. It is motivated by psychological forces that bureaucrats will never understand and policy they can never control. It is empty pocketbooks, bloody fingers, and private satisfactions. It is long hours, hard work, and no pay. It is a personal dialogue with ghosts. It is a face-to-face confrontation with the past. It is an epiphany as enthralling as a new metaphor. It is an equation between self and history so powerful that it makes us lie down in front of bulldozers, raise toppled statues, salvage old boats.

This force takes curious forms. It drives, for example, the passionate commitment of grass-roots preservationists— the urban, suburban, and rural homesteaders who restore old buildings with compulsive care, sweat equity, and growing sophistication. These uncommon folk preside over the frequently belittled accomplishments of local house museums and historical societies. They are the founders of the historic preservation movement, and they are still its heart. They are the membership core of the National Trust, and they are the community activists who keep preservation a credible item on the American agenda. The "professionalization" of the preservation movement over the last decade threatens to disenfranchise them, to reduce them to little more than magazine address labels or fund-raising targets. We allow this to happen at our peril.

The front page of a recent *New York Times* provides a startling profile of one such preservationist. Dateline: Port Gibson, Mississippi (population: 2,600). Bill Lum, a Methodist married to a Catholic, has saved from the wrecking ball and lovingly restored at his own expense Temple Gemiluth Chassed, the Moorish Byzantine synagogue on Church Street, built in 1892. Port Gibson has no Jewish community left to worship there. What follows is a fascinating account of Jewish immigration to small towns in the South, of discrimination, and of pressure to assimilate, intermarry, and abandon Jewish identity. This process is certainly not unique. The present controversy over multicultural curricula in the public schools focuses on the very same sociohistorical experience of other ethnic, national, and racial groups. The narrative transcends generations; the building is threatened by a parking lot. Enter the remarkable Bill Lum. The building, preserved, has now celebrated its 100th anniversary. Will Jews worship again in Port Gibson? Can preservation revive this religious community for the future? The story continues, never straight for a moment.

There are hundreds and thousands of Bill Lums, but they may not be part of official preservation. Foot soldiers in Civil War reenactments number in the tens of thousands. Subscribers to history magazines and book clubs number in the hundreds of thousands. Participants in ethnic parades and cultural festivals number in the millions. Viewers of television programs on historical subjects number in the tens of millions. Who are all these people? And why aren't they part of the preservation movement?

Preservationists may have to share their level of hell with historians. In a recent essay, Harvard professor Steven Schama laments the loss of historians' "power to make a reader live within vanished moments, to feel for a while the past to be more real, more urgent than the present. . . . " And you can make room for museum directors there, too; that our exhibits and interpretation plans are as deadly as they seem is not history's fault.

The enthusiasm and involvement of the greater public is at stake. Our real challenge is to convert policy to practice. And to do so, we may now have to turn the entire preservation *apparat* upside down. Maritime may serve as an instructive model. Ever outside the mainstream of preservation, we have per force retained our institutional independence and individual authenticity. We have no national subsidies, no national museum, no national ship trust; rather, we are a loosely knit net of regional enterprises, ranging from traditional museums to sail-training vessels, from apprenticeship programs to inner-city vocational training schools, from dude schooners Down East to owners of antique and classic boats nationwide. When we have joined together, it has usually been to achieve a narrowly defined need such as the Secretary of the Interior's Standards for the Preservation of Large Ships. We have looked to national organizations more for practical assistance and service than for theory and leadership. Frankly, we have not often found our needs understood, much less met, at the top, so we have gone our maverick ways, seeking our own appropriations, writing our own bills, sharing our experience, and serving each other.

This notion of service is pivotal to the future of preservation. It should be the *only* purpose of the National Trust for Historic Preservation and should result in a radical decentralization of the National Trust's administration, grants, and programs. Regional offices should be directed to strengthen state historic preservation through aggressive collaboration with the state historic preservation offices, a chapter system, comprehensive technical support, and shared financial resources. Every effort should be made to broaden the institutional base of preservation as much as possible, capitalizing on local passion, local expertise, local fund raising, and local government.

Preservation must take its place as a contributor to democratic culture. It must become inclusive, rather than exclusive, affirming by its actions and its organization the complex nature of the American social environment. It must reform itself from within, breaking down institutional barriers, uniting its intellectual and philanthropic activity with populist action, and infusing itself into all aspects of contemporary life.

THE BEAUTIFUL MOSAIC

America has faced time and again its pluralistic demography, the impact of encounter as immigrants challenge or displace natives. In 1492 Europeans confronted native inhabitants; in 1992 Asians confront "natives" who are really descendants of former immigrants. These are times of conflict and creativity, of decline and incline, evinced through the cacophony of language, the changing face of neighborhoods, and the admixture of spiritual values. New York City Mayor David Dinkins calls it "the beautiful mosaic," just as he faces extraordinary clashes of race and religion in a city of intensified change. This is not a time for paralysis and morose regret; it is a time for energy and imagination, high risk and new ideas.

Consider two curious visions of the future. The first is Seaside, the 80-acre planned residential community in Florida designed by Andrés Duany and Elizabeth Plater-Zyberk. As these designers claim, "Architecture has the power to affect behavior." But what architecture? And whose behavior? Their concept that "the newest idea in planning is the 19th-century town" draws on that misbegotten sense that somehow the past was more humane and civil than the present, more genteel and livable. A comparable sentiment links romance with the sea, as if Richard Henry Dana found during his years before the mast a comfortable v-berth and a fellow alumnus of Harvard instead of sickness, abuse, and a polyglot crew. Here again, we are being deluded by the object. To me, Seaside smacks of aesthetic zoning and intellectual redlining, more sophisticated than many such experiments but nonetheless an arbitrary solution that contradicts the organic nature of community.

A far more stimulating vision of the future can be found in Northbrook, Illinois, where a controversial ecological restoration project is under way to recreate a natural savannah, a grasslands ecosystem long vanished beneath brush and weeds. Using volunteers, Nature Conservancy scientists

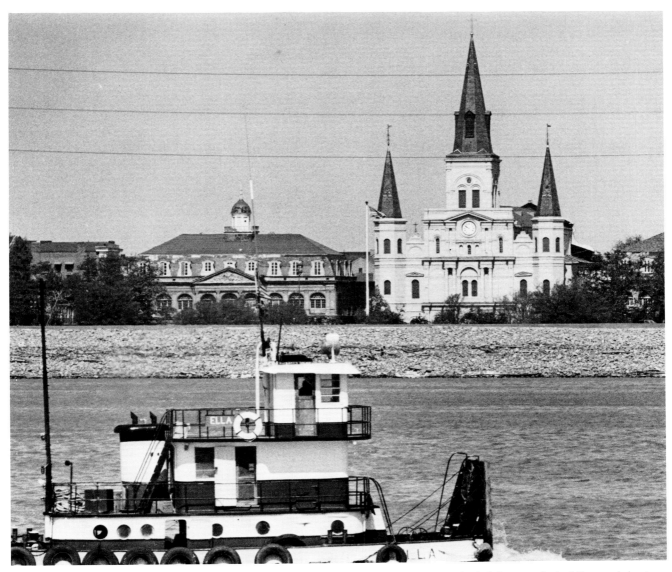

The tug Ella *chugs past Jackson Square along the Mississippi in New Orleans, underscoring the link between the buildings and the river.*

cleared the obliterating flora and planted seeds of the original grasses and flowers. In two years these have evolved into a resurrected habitat, to which was drawn a wonderful catalog of wildlife, long absent from the region. Amazingly enough, other plant species appropriate to the system suddenly emerged without seeding, supporting the theory that "ecosystems assemble and develop not haphazardly, as if by accident, but in special patterns and sequences, according to *specific affinities.*"

What is historic preservation? Seeds planted in the apparent wilderness. Habitat naturally more complicated than envisioned by the planters. Relationships inherently more complex, results inherently more surprising, because of the unpredictable nature of affinity, however specific.

Affinity is common ground. Today we are all seeking it desperately. As individuals, we are looking to be united by shared values. We are seeking ideology, tribe, family, the power we feel when connected by a cause, or a building, or even an old boat. History is the most fertile habitat for affinity; it offers an endless opportunity by which to connect in disconnected times.

There is no limit to how far affinity can take preservationists toward civility and mutual understanding. Preservation is the common ground among us uncommon people.

WHERE HAVE WE BEEN?

JANUS NEVER SLEEPS
William J. Murtagh

THE EARLY YEARS
Arthur P. Ziegler, Jr.

THE STATES: 25 YEARS IN THE MIDDLE
H. Bryan Mitchell

PRESERVATION PRACTICE COMES OF AGE
Michael A. Tomlan

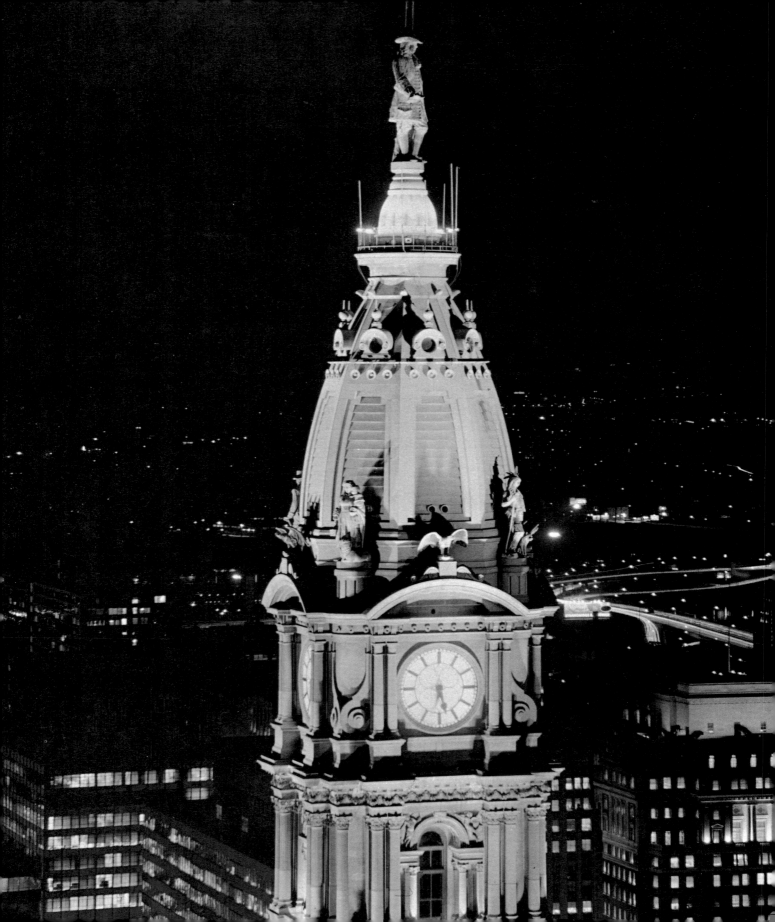

JANUS NEVER SLEEPS

William J. Murtagh

As the pace of change has quickened in the 20th century, so, in response, have preservation initiatives. This century has seen an accelerating parade of preservation strategies intended to ensure a sense of continuity to the dynamic, changing society we call America. Along the way, there have been gross failures as well as exhilarating successes.

But since passage of the National Historic Preservation Act in 1966, preservationists have increasingly reached out beyond the traditional preservation sphere to affect many areas of activity in our country. As the following brief chronology shows, however, preservationists—like Janus at the gates—have had to be ever vigilant.

The Antiquities Act of 1906 first codified the federal government's concern for preserving archeological sites. Ten years later, the creation of the National Park Service marked Washington's recognition of the need for a federal office whose sole responsibility was conserving and preserving resources of special value to American society.

The 1920s witnessed John D. Rockefeller's effort to preserve, *in toto*, the once-royal capital of Williamsburg, Virginia. This effort created an instant professional expertise previously lacking in our country. Henry Ford was able to take advantage of this expertise in creating his Greenfield Village in Dearborn, Michigan, shortly thereafter. Thus was born the second major form of preservation in the United States: the outdoor museum, which joined the house-museum concept epitomized by Ann Pamela Cunningham's success in the mid-19th century when she saved Mount Vernon. Both solutions to the question of how to deal with old buildings involved creating museums for educational purposes.

In 1931 the city of Charleston, South Carolina, created a new, protective zoning for a local neighborhood called the Battery. Designation of the Battery as an Old and Historic District restricted to an unprecedented level the changes that private owners could make to their own properties. With this new tool, the preservation movement established a third way of preserving old buildings: through rehabilitation and planning. The approach marked a major juncture in American preservation thinking, firmly establishing concern for a nonmuseum environment as a valid preservation premise. This thinking created a basis for the more recent linking of preservation and natural environmental protection.

The foundation of the 1966 National Historic Preservation Act was laid in 1935 when Congress passed the Historic Sites Act. The 1935 law directed the secretary of the interior to make surveys, develop data, engage in research, acquire properties, restore buildings, enter into contracts, erect markers, and develop educational programs—all in the interest of preservation.

World War II brought a temporary lull in preservation interest as Americans faced their enemies abroad and societal dislocation at home. Along with the postwar building boom came new federal assistance programs—notably urban renewal and construction of a national interstate highway network. Both of these well-intentioned programs, in attempting to meet rising needs for housing and mobility, created havoc with the historic fabric of cities, towns, and villages across the country. It was in this crisis atmosphere of mass destruction for "progress" that the National Trust for Historic Preservation was founded in 1949.

A small change of attitude occurred in 1954, when the U.S. Supreme Court ruled in *Berman v. Parker* that a city had a right to be beautiful as well as safe and clean. And in the College Hill report of 1957, preservationists scored a breakthrough when the Urban Renewal Administration gave a one-time demonstration grant to the city of Providence, Rhode Island, to study the feasibility of retaining and recycling its existing building stock instead of demolishing it to achieve renewal.

But the preservation movement was still essentially a museum-oriented, volunteer-dominated movement, and it would remain so for years to come. Recognizing this, the National Trust and Colonial Williamsburg teamed up to create an experimental five-year pilot program called the Seminar for Historical Administration. The program was conceived as a vehicle to attract qualified graduate students to the preservation field and to explore preservation involvement as an alternative to teaching.

THE PRESERVATION DECADE

With the advent of the Johnson administration and the Great Society programs of the 1960s, change in the preservation field became more pronounced.

An invitational conference sponsored by the National Trust and Colonial Williamsburg was held in Williamsburg in 1963 to analyze preservation then and in the future. Interestingly, discussions during that conference, published as *Historic Preservation Today* and *Historic Preservation Tomorrow,* called for the equivalents of an advisory council on historic preservation and a national register of historic places, concepts that were soon refined further by Gordon Gray, George B. Hertzog, Jr., Carl

Feiss, FAIA, and other members of a Special Committee on Historic Preservation of the United States Conference of Mayors in their work leading to the 1966 act. Prompted perhaps by the Williamsburg conference, Columbia University and the University of Virginia soon became—almost simultaneously—the country's first institutions of higher learning to offer course work in preservation.

In May 1965 an audience of about 1,000 invited guests attended a White House Conference on Natural Beauty at the State Department auditorium in Washington, D.C. Despite its title, the conference dealt in large degree with the built environment, addressing the proliferation of ugly highway billboards, overhead utility wires, and other detritus on both city streets and the open countryside. Out of that meeting came the fact-finding preservation committee under the United States Conference of Mayors. The National Trust played a major role in staffing the committee.

On February 23, 1966, President Lyndon Johnson spoke out for preservation in his message to Congress—the first time, to my knowledge, that any chief executive of the United States had ever brought up the subject in a State of the Union address.

The Conference of Mayors's Special Committee on Historic Preservation was sent abroad, east and west of the Iron Curtain, to meet with key individuals in the governments of European nations about their efforts to preserve their national patrimony. The trip resulted in the publication of *With Heritage So Rich,* a book instrumental in the introduction of the first comprehensive preservation legislation in Congress. The book's conclusion lays the blueprint for the direction of the preservation movement since the passage of the National Historic Preservation Act on October 15, 1966.

The pace of urbanization is accelerating and the threat to our environmental heritage is mounting; it will take more than the sounding of periodic alarms to stem the tide.

The United States is a nation and a people on the move. It is an era of mobility and change. Every year 20 percent of the population moves from its place of residence. The result is a feeling of rootlessness combined with a longing for those landmarks of the past which give us a sense of stability and belonging.

If the preservation movement is to be successful, it must go beyond saving bricks and mortar. It must go beyond saving occasional historic houses and opening museums. It must be more than a cult of antiquarians. It must do more than revere a few precious national shrines. It must attempt to give a sense of orientation to our society, using structures and objects of the past to establish values of time and place.

This means a reorientation of outlook and effort in several ways. First, the preservation movement must recognize the importance

of architecture, design and esthetics as well as historic and cultural values. Those who treasure a building for its pleasing appearance or local sentiment do not find it less important because it lacks "proper" historic credentials.

Second, the new preservation must look beyond the individual building and individual landmark and concern itself with the historic and architecturally valued areas and districts which contain a special meaning for the community. A historic neighborhood, a fine old street of houses, a village green, a colorful marketplace, a courthouse square, an esthetic quality of the townscape—all must fall within the concern of the preservation movement. It makes little sense to fight for the preservation of a historic house set between two service stations, and at the same time to ignore an entire area of special charm or importance in the community which is being nibbled away by incompatible uses or slow decay.

Third, if the effort to preserve historic and architecturally significant areas as well as individual buildings is to succeed, intensive thought and study must be given to economic conditions and tax policies which will affect our efforts to preserve such areas as living parts of the community.

In sum, if we wish to have a future with greater meaning, we must concern ourselves not only with the historic highlights, but we must be concerned with the total heritage of the nation and all that is worth preserving from our past as a living part of the present.

With this call to action in hand, the 89th Congress (subsequently known as the "Preservation Congress") passed three major pieces of legislation: the National Historic Preservation Act, the Department of Transportation Act, and the Demonstration Cities and Metropolitan Development Act. The National Historic Preservation Act directed the secretary of the interior to draw up a list of properties and structures worth protecting (now known as the National Register of Historic Places); authorized grants to the states and National Trust; and created the Advisory Council on Historic Preservation, with its Section 106 review procedures for federal activities that may adversely affect protected properties. The National Park Service, through its new Office of Archeology and Historic Preservation, became the locus for implementation of these new initiatives.

Section 4(f) of the Department of Transportation Act constituted undoubtedly the strongest preservation directive in all three of these laws. It directed the secretary of transportation to identify and avoid infringing on parkland, wildlife refuges, and other invaluable resources in developing our national road network. These places had previously received no such consideration. The Demonstration Cities and Metropolitan Development Act gave the new Housing and Urban Development agency a potential to support preservation that it had not previously enjoyed.

The euphoria following the passage of the National Historic Preservation Act prompted National Trust Chairman Gordon Gray to title his speech at the annual membership meeting "Decade of Decision." And so it became for preservation nationwide.

With the passage of the act, Secretary of the Interior Stewart L. Udall decided to decentralize the preservation program under his authority and wrote to the governors of the states and territories, asking each of them to appoint an individual to carry out the law's new responsibilities. Thus came into being the national network of state liaison officers, subsequently known as state historic preservation officers (SHPOs).

Preservationists began to reach out to other groups in American society as never before. As a result of the 1966 efforts, there was an increased awareness of the importance of political alliances—and their limitations. Public education became a clear need, and to that end the Department of Housing and Urban Development, in cooperation with the National Trust, produced the first film on preservation for national distribution in 1968.

The year saw other important preservation developments. John Costonis, a lawyer concerned with preserving the early high-rise structures concentrated in Chicago's Loop, developed a plan for the transfer of development rights, a preservation concept that would be first implemented in New York City. Also in 1968, American and Canadian preservationists jointly founded the Association for Preservation Technology, an international organization dedicated to applying emerging conservation technologies to restoration in this hemisphere. The organization's establishment was stimulated by UNESCO's newly created International Centre for the Study of the Preservation and Restoration of Cultural Property (ICCROM) in Rome, Italy.

The first National Register was not published until 1969, although a mimeographed list had been produced the year before. The new Office of Archeology and Historic Preservation recognized the importance of America's industrial heritage the same year when it created the Historic American Engineering Record (HAER) to be a sister documentation program to the Historic American Buildings Survey (HABS), which had been in operation since 1933 and is now the oldest federal preservation program.

The year saw other preservation achievements: the National Park Service made its first grants to the states; the National Conference of State Historic Preservation Officers was founded; and the concept of a World Heritage Convention was drafted.

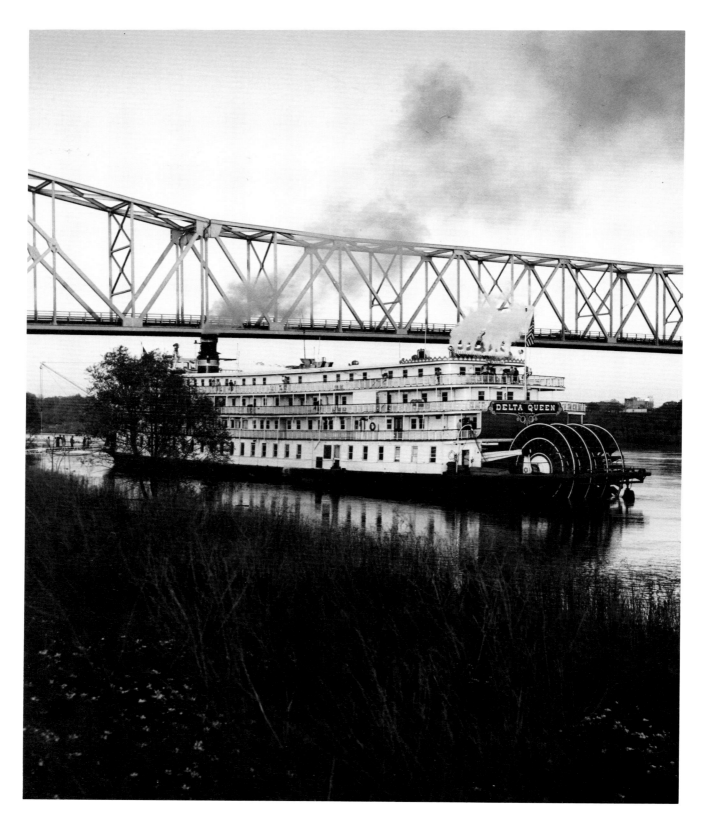

WILLIAM J. MURTAGH

The years that followed could be called an era of legislative progress. The National Environmental Policy Act of 1969 became law in 1970, requiring the filing of environmental impact statements for government-assisted activities affecting natural and other irreplaceable resources. The next year gave us Executive Order 11593, requiring every federal agency to survey and identify cultural resources that they administer. This created an entire new infrastructure of preservation respondents in each federal agency and gave the Advisory Council on Historic Preservation the prerogative to monitor change when historic resources were potentially threatened.

In 1971 the National Trust established its first regional office in San Francisco, thus initiating its existing organizational network to better serve its preservation constituency.

In 1972 a protracted fight to save the Old Post Office in St. Louis prompted an amendment to the Federal Properties Administration Services Act of 1949. The change permitted transfers of unwanted federal properties so that they could be recycled and thus saved for continued use.

The next year saw the implementation of an Urban Renewal Homesteading Program in Wilmington, Delaware. The concept was conceived in Philadelphia in 1968 to help low-income residents acquire properties to be rehabilitated within specified periods of time.

New challenges appeared, inside and outside. The Landmarks Preservation Commission of New York City began to address the question of preserving interior public spaces. In 1974 a large valley in Green Springs, Virginia, was threatened when the governor chose it as the site of a maximum-security prison. The secretary of the interior ultimately accepted easements on about 7,000 of the 14,000 acres that make up the valley, with its many historic houses and places, and the prison was never constructed there.

Preservation Action came into being at this time, providing a vital voice for the preservation movement in the halls of Congress. And Seattle, Washington, set a precedent by appointing the first city conservator in the United States.

Other important developments occurred in the second half of the decade. The Advisory Council on Historic Preservation separated from the National Park Service in 1976 and became an independent agency. In the same year, an amendment to the Land and Water Conservation Fund of 1965 established a Historic Preservation Fund, designed to be supported by a small contribution from the increased income generated by stepped-up offshore oil drilling on public lands, stimulated by the oil crisis.

It was also in 1976 that the federal Tax Reform Act first balanced the incentives and disincentives of owning depreciable historic property. In essence, these changes made it economically attractive for a developer to recycle existing historic building stock rather than demolish it for reimbursement, which previous tax laws allowed. As a result, approximately $15 billion worth of investment in the rehabilitation of historic structures was ultimately leveraged, although changes in the 1980s have decreased use of the incentives. The new tax law also prompted the secretary of the interior in 1977 to develop the Standards for Rehabilitation and Guidelines for Rehabilitating Historic Buildings. These have become the basis for much restoration and rehabilitation practice around the country.

A pivotal U.S. Supreme Court decision in 1978 preserved a visual symbol of New York City: Grand Central Terminal. The owner's development plans would have profoundly altered the landmark's character. Placing itself on the side of preservation, the Court ruled that while owners are entitled to a reasonable financial return on their property, the law does not necessarily guarantee them a maximum return.

Over time, amendments to the 1966 act strengthened its reach. Changes in 1979 made Section 106 fully a part of federal regulations, thereby binding all federal agencies to its check-and-balance provisions. Technical amendments in 1981 codified the role of the SHPOs and added the president of the National Conference of State Historic Preservation Officers to the composition of the Advisory Council on Historic Preservation, providing the SHPOs a legal role they previously lacked. The amendments also introduced the World Heritage concept and codified the provisions of the 1971 Executive Order 11593. Most important, it introduced a new section to the act, concerning special consideration for National Historic Landmarks.

The most publicly discussed amendment, however, involved what came to be known as the "owner consent" issue. The need for owner consent to listings in the National Register of Historic Places made it difficult for SHPOs and their staffs to carry out the directive of the 1966 legislation to survey and inventory all of a state or territory's cultural resources. Today even eligible properties that are unlisted because of the lack of owner consent have some protection from threats by federal activities.

Two court decisions in 1991 put historic preservation on a legal seesaw. Early in the year the U.S. Supreme Court refused to let St. Bartholomew's Church in New

Opposite: The Delta Queen, *a beloved wooden-hulled steamboat, was saved in 1971 by unified public and private efforts.*

York City demolish part of its historic property for a high-rise building. The case tested how far a nonprofit church organization could go in acting as a for-profit developer. In this instance, the court confirmed that churches have no special rights as developers. Taking a different stand, the Pennsylvania Supreme Court in July 1991 issued an anti-preservation decision regarding the designation of Philadelphia's Boyd Theater. Writing for the court, Justice Rolf Larsen held that historical designation of the theater would constitute a taking of property rights without compensation.

Currently, there is a growing concern for identifying ways in which potential entries to the National Register—including potential National Historic Landmarks—can be protected. The concern has been prompted by threats to such important sites as Manassas Battlefield in Virginia. Many found the costly acquisition of the pivotal Civil War battlefield a less than acceptable solution to eradicate development threats. While other solutions are desirable, we should also avoid focusing on national landmarks and ignoring the cultural contributions of state and local sites. We did that before 1966. Broadening our view of what constitutes our national patrimony was one of the basic thrusts of the 1966 legislation. For many Americans, what they see daily in their local communities *is* their national patrimony. This should not be forgotten.

PRESERVATIONISTS AT THE TABLE

A goal of the 1966 act was to bring preservationists, philosophically and legally, into the dialogue at the planning table before tax dollars were spent or federal licenses were issued to affect our environment. Also, by broadening the scope of what is worth saving from places of national significance to those of state and local significance, a comfortable basis for sharing environmentalists' concerns with land use and local significance could be built.

If these were the basic visions and goals of the 1966 National Historic Preservation Act, what have we achieved in the ensuing 25 years? In my considered opinion, *With Heritage So Rich* told us what we needed to do. We have further developed a whole spectrum of legislative building blocks on which we operate. And, with our state historic preservation offices and staffs, we have established the equivalent of a miniature French Monument Service in each of the 50 states, territories, and the District of Columbia. Whether one believes that an individual office operates well or badly, we and our cause are better served because the offices exist. In the most successful and active state offices, there is already a noticeable trend to delegate further to the local level. Fi-

nally, we have established formal preservation education. Through education programs, mostly at the graduate level, we are developing a critical mass of individuals who will be tomorrow's leaders not just in the preservation movement but in society at large, helping us to move preservation from an elective action and to internalize it as part of the planning process.

If these are some of our achievements, what are our shortcomings? There are primarily two, in my opinion. First, I think we have continued to fail to sell our cause. If one compares the organizational membership levels of the preservation movement to that of the conservation movement, there are indeed major differences. We have also failed to sell our case as far as funding on meaningful levels is concerned. Preservation activities have never enjoyed a congressional funding level that approaches that of such organizations as the National Endowment for the Humanities or the National Endowment for the Arts, for example.

Second, I think that we have failed to reach out and develop the type of multicultural potential that is ours in the United States. We are fortunate to have developed a socioeconomic level with sufficient disposable income to generate leadership to support the preservation movement. This is what helps make preservation so unique in our country compared to others, which rely primarily on the governmental process. We all know that the longevity of the American preservation movement is the result of private citizen action, first demonstrated by Ann Pamela Cunningham in her 19th-century drive to save Mount Vernon.

We are increasingly a multicultural nation. Having lived in Hawaii, where there is such a rich potpourri of ethnic identities, each of which contributes to the culture of that state, I am more sensitive than ever to this issue. We must do more in this regard.

What are our long-term needs? We need a renewed commitment to human resources. The 1966 National Historic Preservation Act is now a generation old. We should look at retraining existing professionals and improving the training for newcomers to the field. Institutions such as the National Park Service and the National Trust, the leaders of preservation's public and private sectors, must devote more attention and more of their budgets to this type of activity. We also should reinstate what I call Civics 101 at the preparatory school level and make preservation concerns a part of the curriculum. We should foster the nascent marriage between the preservation and conservation movements—it is no longer acceptable in our country to intellectually, verbally, or physically separate preservation from conservation. We should take a lead from our British

Members of the University of Delaware's historic preservation program represent the emergence of formal professional training.

cousins who use the word "conservation" to mean both the natural and the built environments. And we continue to need a national land use policy and ultimately a cabinet-level post of cultural affairs. I am fully aware that we put preservation in competition with performing arts, fine arts, and museums when I say that. Few humanistic interests and endeavors are, or ever will be, justifiable on the open market, but the voices of the cultural, civilizing elements of our society must be part of the dialogue at the topmost level of government.

Finally, we must revise our concept of real estate, prop-

erty ownership, and public rights in property as we did for groups of properties in the neighborhoods of Charleston in 1931. This means shifting the burden of proof to the property owner interested in developing private property on sites of proven historical and cultural significance (whether the significance is national, state, or local).

In a changing society, preservation is a stabilizing force, a continuum that provides us visual and psychological evidence of where we have been—as a guide to where we might go. We have achieved much in a relatively short period of time. This, however, should be seen only as prologue.

THE EARLY YEARS

Arthur P. Ziegler, Jr.

HEN I ENTERED THE PRESERVATION MOVE-
MENT IN SEPTEMBER 1964, I HAD NOT HEARD OF THE TERM "HISTORIC PRESERVATION," DID NOT
YET REALIZE THAT THERE WAS A NATIONAL TRUST, AND HAD NO IDEA THAT I WAS JOINING A
NATIONAL CAUSE.

A friend and I inadvertently came across a block of mar-
velous Victorian buildings only to learn that the block and
another 1,500 Victorian buildings in the Manchester neigh-
borhood of Pittsburgh were slated for demolition by the Ur-
ban Redevelopment Authority. The URA, we learned,
planned to demolish six additional large neighborhoods in
our city's North Side and run an elevated highway through
the park in the area. As we got deeper into the work to save
these magnificent neighborhoods, we learned quickly about
the pressures on individual buildings and historic districts in
urban areas. Essentially they were these:

■ Neglect had already taken a toll on individual landmark
buildings and monuments, including our famous Richard-
son courthouse, our great conservatory, the Fourth Av-
enue post office, the Allegheny post office, and Union
Station

■ The city suffered from the combined pressures of down-
town high-rise development and suburban flight. Old
commercial buildings were being squeezed out of the
Golden Triangle, while surrounding neighborhoods

were being abandoned by those who could not afford
to maintain them

■ Inner-city housing stock was deteriorating. Its condition
was best summed up by poet Ogden Nash, who wrote:

> *A primal termite knocked on wood;*
> *and tasted it and found it good.*
> *And that is why your cousin May*
> *fell through the parlour floor today!*

■ Two nightmare solutions to all of these problems—high-
way construction and so-called urban renewal—were
promulgated and vigorously implemented by government
agencies and often supported by the civic and commer-
cial sectors. Edmund Bacon of Philadelphia, a former ur-
ban renewal man who later became a preservationist,
compared the approach to solving the problem of garlic
growing in a cow pasture by bulldozing the land down
to bedrock. It got rid of the garlic all right, but there was
not much left for the cows to eat

The problems were monumental. One unique area after

another fell to the bulldozer as the city applied what *New York Times* architecture critic Ada Louise Huxtable derisively called the "New York paradox." She defined its principle as: "Anything worth doing, is worth doing wrong." In the *New York Times* she wrote:

The appalling price paid to the Urban Expert Carpetbaggers delivering patent-medicine renewal in the 1960s can never be calculated in the terms of the loss of unique and irreplaceable assets. It took acres of bulldozer desolation to teach us that a living organism was being destroyed.

Even the urban renewal leaders were daunted by the task.

Pittsburgh's director of city planning told me in the mid-1960s, "Pittsburgh in 20 years has redeveloped 2,000 acres. At that pace, we will need 20 more years to redevelop the remaining 12,000 acres that need redeveloping today." That allowed for nothing further to deteriorate! On top of that, what he called redeveloping was simply leveling and putting up some generally unattractive and often hideous modern buildings that fared about as well economically as they did architecturally.

THE STATE OF THE NATION

We quickly learned that the condition of Pittsburgh was the state of the nation. However, the preservation movement was picking up steam. Around the country, some individual landmark buildings had been saved and interest in legally protected historic districts, designated by local governments, was growing. Charleston and New Orleans had led the way in establishing such districts; there were still few models elsewhere. Preservation was largely an effort carried out by individual leaders native to their city—people such as St. Clair Wright in Annapolis, Frances Edmunds in Charleston, and Lee Adler in Savannah. But the horrors of urban renewal drove the preservation movement's rapid growth. The more urban renewal was adopted by cities, the more preservationists grew in numbers to oppose it. Because urban renewal targeted city areas ranging in size from 50 to several hundred acres at a time, preservationists were compelled to think big. As preservationists tried to save neighborhoods, they found themselves at a loss for financing tools. The only way to really restore a neighborhood at that time was to try to replace the poor with a more well-to-do population; no government subsidies for housing renewal were available.

In 1966 came the publication of a marvelous book, *With Heritage So Rich*, from the Special Committee on Historic Preservation of the United States Conference of Mayors. The book contained these important words:

If the preservation movement is to be successful, it must go beyond saving bricks and mortar. It must go beyond saving an occasional historic house and opening museums. It must be more than a cult of antiquarians. It must do more than revere a few precious national shrines. It must attempt to give a sense of orientation to our society, using structures and objects of the past to establish values of time and place.

Preservationists took these words to heart, together with J. Paul Getty's reminder that "the meek shall inherit the earth, but *not* its mineral rights." In other words, if we were to become leaders in giving direction to our society, we would have to fight hard. And fight we did. Although we often were standing in the rubble, we began to chalk up notable victories. The National Historic Preservation Act of 1966 and the *Penn Central* case of 1978 were signal triumphs.

In Pittsburgh we experimented with the preservation of neighborhoods as well as individual monuments, trying to preserve the neighborhoods with and for the people who lived in them. As *Preservation News* said in 1972:

The real objectives of historic preservation [are] a decent living environment, equal access, mobility for housing without regard to skin color and architectural preservation when appropriate. This is the essence of the Pittsburgh approach.

Federal housing programs were beginning to develop, and we seized on them for use in new ways—to subsidize restoration rather than new construction.

Acceptance did not come easily. The architectural, planning, and public services professions all exhibited little interest in preservation. Preservationists were pariahs, fighting alone against the federal government and assorted city powers, with few resources other than a belief in historic buildings and their social value. But a strange thing happened. Because we preservationists were cash-poor and isolated, we were forced to be practical. We had to design programs that could operate cheaply and successfully. Unlike the urban renewal experts, we could not afford to waste a penny. As our message and our methods reached more people, our constituency grew. We began to save single buildings, and then blocks of buildings, and then neighborhoods of buildings. Our growing optimism paralleled a growing disillusionment with urban renewal. Leading exponents of renewal through clearance began to illustrate Chicago's Mayor Richard Daley's wonderful remark about his own administration: "We shall reach greater and greater platitudes of achievement."

Opposite: Decorative wooden porches on Liverpool Street attracted early interest in restoring Pittsburgh's neighborhoods.

ARTHUR P. ZIEGLER, JR.

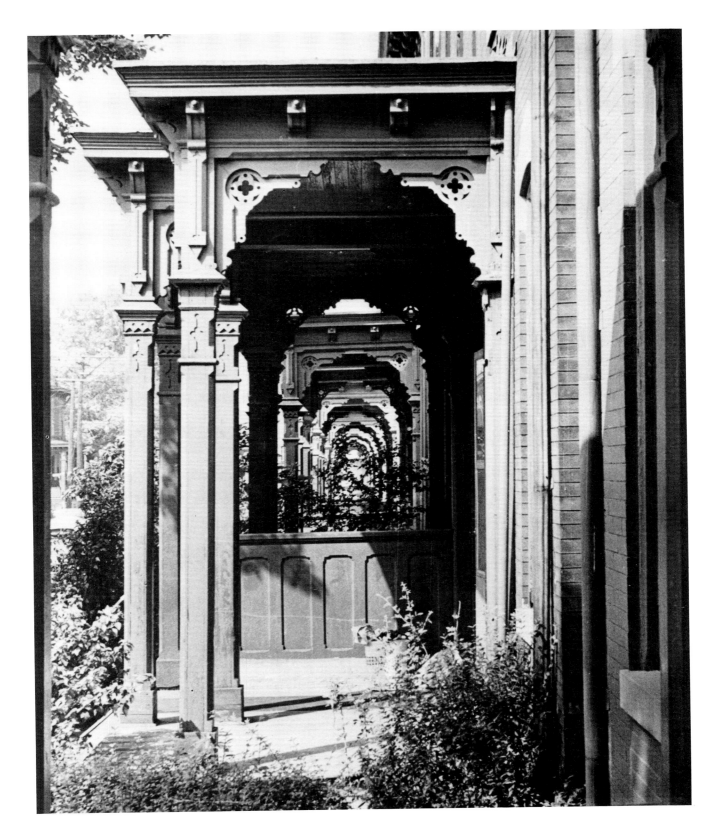

THE EARLY YEARS

61

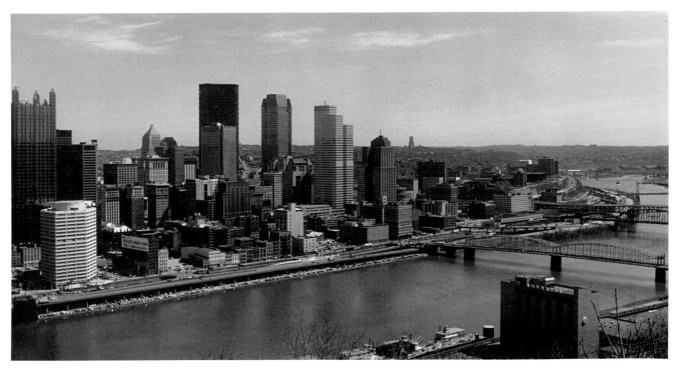

Reclaimed from decay and pollution, the new skyline of Pittsburgh mixes old and new as a prototype for other American cities.

BEGINNING TO PAY OFF

Economically, preservation was paying off. In Washington, D.C., an acre of land was generally valued at $547,000 (in 1950 and 1960 dollars), while an acre in the historic area called Georgetown was valued at $1.6 million—nearly three times as much. In Richmond, general land values rose 30 percent from 1955 to 1963, but in the historic district they rose 163 percent. Meanwhile, visitors to historic Savannah were generating $60 million in tourist dollars for the city coffers. In Pioneer Square in Seattle, tax values rose 800 percent and crime dropped from 15 percent of the city's total to 0.5 percent.

It was the same story all over. I remember learning from Peter H. Brink that in The Strand in Galveston, Texas, property values shot up 208 percent in three years, compared to 85 percent for the city as a whole; in the same three years, the historic area's crime decreased 73 percent, compared to 17 percent citywide. My own study of Charleston found that Frances Edmunds's seed fund of $100,000 had generated $12 million worth of restoration, and that while the city tax base had declined 22 percent in 10 years, the tax base in the historic district went up 100 percent.

That we were reaping such results from a shoestring budget was all the more remarkable. The government had no

grants for preservation at that time, and we were grateful for what donations we could get. We learned to appreciate Tennessee Williams's immortal words, "The very rich have such a touching faith in the efficacy of small sums." What seemed to us like generous gifts of $10,000 or $50,000 or even $100,000 were all the preservationists had. Pittsburgh's first revolving fund held $100,000—a pittance with which we had to battle the deterioration of a great many inner-city neighborhoods and counter an estimated $400 million urban renewal effort.

In spite of our weak finances, we strengthened rapidly as our ideas spread. Through Preservation Action and its president, Nellie Longsworth, we learned how to lobby at every government level. Preservation laws proliferated, including tax credit provisions that fostered nationwide restoration projects supported by real estate developers. Never before or since have we seen preservation activities carried out so diligently by so many with such excellent results.

Robert McNulty, director of the Design Arts Program at the National Endowment for the Arts, gave preservation and urban planning a broader and more intellectual framework. Through NEA, preservationists began dealing with city edges, waterfronts, parks, sculpture, and street furnishings as well as buildings. The National Trust reached out to communities across the country with its Main Street pro-

gram, committed to helping small towns, and its regional offices. Universities launched graduate programs in preservation, and university schools of architecture began once again to teach fledgling architects about historic styles.

In Pittsburgh we recognized the truth of Irish critic Sir Shane Leslie's observation that "the American sign of civic progress is to tear down the familiar and erect the monstrous." To promote a rethinking of our values, we launched a heritage education effort in both public and private schools at the elementary and high school levels. Our program also helps teachers take back to the classroom lessons on local history, architecture, landscape architecture, and urban planning. We issue a stream of publications and books; work with our public television station to produce half-hour broadcasts dealing with local architecture; and follow these broadcasts with tours and more publications.

We Pittsburgh preservationists also took a leaf from our own book; we had been telling the business community that it was possible to generate profits without demolishing and constructing anew. Station Square on the site of the old Pittsburgh and Lake Erie Railroad Station became our demonstration project. If successful, the project will provide us with a steady, reliable stream of income with which to support our activities, along with fund raising. We will, in fact, create a living endowment by putting our own principles to work in the marketplace.

DIFFICULTIES AND MISTAKES

Have we had difficulties as a movement? Yes. For one thing, because we often oppose the plans of our city powers, we cannot position ourselves to be supported by these powers on a steady and reliable basis. We all depend on angels, fund-raising events, and special projects so that we are not co-opted by "the system." For another, we have never fully or successfully allied ourselves with the conservation movement, although our own network is more unified than theirs. Efforts continue here. In Pittsburgh both movements are now cooperating to promote the development of a Heritage Walking and Bicycling Trail that will have historical markers along the way. A third problem has been our inability to communicate adequately the astonishing economic benefits of preservation.

Have we preservationists made mistakes? Surely, we have. I will cite just two. First, through the National Historic Preservation Act of 1966 and the tax acts, we created a federal and state bureaucracy that interpreted historic preservation too literally. At times preservation-minded owners have been astonished to learn that they cannot adaptively restore buildings; their proposed interior modifications have been disallowed because the bureaucracy has demanded the impossible. Even though we are preservationists, we must always realize that buildings can be improved on through the years, that the first designers are not always perfect, and that adaptations are necessary for our times. Recently we were advocating the continuation of lighting we had placed on the historic Smithfield Street Bridge in Pittsburgh, lighting that has been universally loved by residents and visitors. I was nonplused and amused when someone in the state historic preservation office said that the lighting was not there when the bridge was built in the 1880s, and, therefore, it should not be there today. If we followed that principle, we should also ban all of the automotive traffic from the bridge and make everyone go across on foot or horse and wagon.

The second mistake, if that is the right word, is really one that I would call "slow learning." We have often blamed developers or government leaders for specific problems that create preservation challenges. We have failed to realize that what we, as citizens, have done to our cities has been deliberate and well thought out by our planning establishment and passed by our elected officials. As Andrés Duany, Elizabeth Plater-Zyberk, and Chester E. Chellman state in *New Classicism* (New York: Rizzoli International Publications, 1990):

The congested, fragmented, unsatisfying suburbs and the disintegrating urban centers of today are not the products of laissez-faire, nor the results of mindless greed. They are thoroughly planned to be as they are: The direct result of zoning and subdivision ordinances zealously administered by thousands of planning departments. America since the war is the result of these ordinances. . . . If the results are dismaying, it is because the current model of the city being projected is dismal. Today's ordinances dictate only four critia for urbanism: the free and rapid flow of traffic; parking in quantity; the vigorous separation of uses; and relatively low-density of building. The latter two demand an amorphous waste of land and car traffic has become the central, unavoidable experience of the public realm. The traditional pattern of walkable, mixed-use neighborhoods is not encouraged, and more often not inadvertently proscribed by some of the provisions of these ordinances. Designers find themselves in the ironic situation of being forbidden from building in the manner of our most admired historic places. One cannot propose a new Charleston or New Orleans without seeking substantial variances from current codes.

Preservationists must begin to address and influence the future as we do the past. It is we who know the values of the Charlestons and the New Orleanses and the San Franciscos. It is we who, therefore, shoulder the burden to deliver the message that will change the hearts and minds of the builders and governors of our country.

THE STATES: 25 YEARS IN THE MIDDLE

H. Bryan Mitchell

OVER THE 25-YEAR HISTORY OF THE NATIONAL HISTORIC PRESERVATION ACT, STATE HISTORIC PRESERVATION OFFICES HAVE BEEN THE LINCHPINS IN A PROGRAM DESIGNED TO DELIVER NATIONALLY DEFINED SERVICE TO LOCAL GOVERNMENTS, PUBLIC AGENCIES, PRIVATE ORGANIZATIONS, AND INDIVIDUALS.

For much of the preservation program's history, its agents and advocates have ballyhooed it as a model of federalism: the federal government sets programmatic standards and provides at least partial funding; the state government follows those standards, adds funding of its own, and carries out a work program of statewide activities based on carefully determined goals and objectives; local governments and the citizenry at large benefit from the delivery of these services, enabling them to carry out preservation activities important in their communities.

Those who consider themselves intimately familiar with this program may feel constrained to smile tolerantly or even chuckle at so rosy a description, but there can be no denying that the description embodies the ideal for which the program should strive. True, there is no part of the program that has not involved struggle, disagreement, inefficiency, and frustration, but these elements grow inescapably out of the checks and balances inherent in the federalism we invoke so positively in defending the program. While we cannot avoid the frustrations of the moment, and while we

would not be worth our salt if we were not always trying to "fix" the program, there is a reasonable body of evidence that the program actually works.

While I greatly admire the work of colleagues in the federal government, at the National Trust for Historic Preservation, at the many other national and statewide organizations, and in the trenches of local preservation efforts, I think that the state historic preservation offices are at the heart of the national preservation program, as embodied in the National Historic Preservation Act of 1966.

Why? While the National Park Service has been busy adopting and monitoring national standards, and while the National Trust and Preservation Action staff have been acting as preservation's political and legal advocates, for the last 25 years it has been the state historic preservation officer (SHPO) who has decided what part of the national program will get done and when. To the extent that a SHPO's activities are determined by state-level priorities, the SHPO decides what those priorities are and how they will be addressed. To the extent that the national program is driven

by clients who seek rehabilitation tax credits or need Section 106 clearance, the SHPO is their point of access. To the extent that federal dollars fund a variety of preservation projects, the SHPO decides who gets how much and what they will do with it. In short, the program is designed elementally at the national level, but it is tailored and delivered by the state. While organizations such as the National Trust or statewide nonprofit preservation groups maintain an interest in a state's preservation happenings and deliver some services and assistance on request, these organizations generally do not have the range of resources that a SHPO has at its command. More important, those organizations are not legally accountable, as the SHPO is, for carrying out the full range of public programs across the state.

TENSION OF THE MIDDLEMAN

Because it is squarely in the middle of the program, the state office experiences all of the tension of the middleman. On one hand, it must deal effectively with those agents at the national level who seek to influence the structure, resources, and administration of the national program. On the other hand, the middleman must deliver that program, day in and day out, to a wide range of clients, some of whom have legitimate needs and insatiable appetites for service, others of whom have difficulty controlling their anger at the mere mention of the dreaded and reviled SHPO.

A look back at the national program's 25-year history from the viewpoint of a SHPO reveals a program characterized by almost constant change. Some of that change was predictable. The rehabilitation tax credit program was first added in 1976, and its rules have changed several times since then; the Certified Local Government program was a product of the 1980 amendments to the 1966 act and took several years to get up and running. The bricks-and-mortar grants that were a staple of the SHPO diet had the budget rug pulled out from under them in about 1981. The Section 106 environmental review program has grown spectacularly both in workload and in sophistication. (Virginia, for instance, had two technicians devoted to Section 106 when I arrived in 1977. Today five full-time professional staff and two part-time staffers cannot keep up with the caseload.)

Even such old standbys as surveys and registration have had their elements defined, redefined, and redefined again. Here, unfortunately, the changes have undeniably made the program more complicated, less accessible to the lay person, and more burdensome even for trained SHPO staff. On the positive side, however, the changes have greatly improved the quality of information gathered in state archives on the nation's historic and archeological resources. That information on tens of thousands of sites is also now being computerized, an idea most of us were not wrestling with 25 years ago.

The constant change has required some retooling and a considerable amount of adaptation every time something is redefined. Accomplishing these tasks without necessarily being able to hire more staff to do new work has also meant, from time to time, that we simply have not done as well as we would wish. This has been frustrating and has accounted, no doubt, for a tendency to resist further changes. I suspect that few outside of our little federalist bureaucracy can imagine how much energy has been spent arguing over some of the following:

- just what constitutes an adequate survey entry
- how much information is needed for a National Register report
- exactly when the Advisory Council on Historic Preservation should be brought into a Section 106 consultation
- what a statewide preservation plan should include
- or, worst of all, just how the federal dollars should be apportioned among the states

It may be tempting to look on such bureaucratic nit-picking as unimportant or irrelevant for the larger preservation movement, but the standards growing out of these deliberations inevitably influence many of the expectations of the movement.

CYCLES OF CHANGE

Anyone fortunate enough to have been a part of the creation of some organization that has managed to live for at least 25 years should have no difficulty describing how different age has made the organization. Almost any organization built around a cause, like the preservation movement, probably went through an identifiable cycle: It began life dominated by highly motivated people scurrying from one crisis to the next, making up the game as they played, and thriving on the excitement. As it matured, members began to want more predictability, more learning from past mistakes, more policies and procedures to guide the organization's work and that of others in its universe. Members began to think more of the long haul than of the moment, began to care not just about the organization's cause but about its competence, and began to understand that they would not be around to run it forever. Some may have regretted the loss of the movement's initial fervor and even wished for a return to the excitement of the good old days. But if they reflected on why there seemed to be fewer crises lately, they may have realized that it was because their efforts had met with some success.

Like these Elk Avenue storefronts in Crested Butte, Colorado, main streets are being revitalized in almost every state.

That explains some of the change to the national preservation program. But only some of it. Remember that frustrating federalism. Change for a SHPO has not always come from enlightened self-awareness or from evolution; sometimes it has been thrust on us while we were unready, unwilling, and unconvinced. On the other hand, SHPOs have sometimes argued for more flexibility at the state level, only to be referred to the contrary chapter and verse in the federal grant manual, or worse, to be faced with a national funding formula that offered no incentive for innovation. While SHPOs have sometimes believed that the National Park Service bureaucracy has treated us as a subordinate extension of itself, the highly professional Park Service staff has no doubt often viewed the state offices as intransigent, unresponsive, and parochial. If only, the states have argued, the Park Service had to deliver this program to real clients, it would understand the unreasonableness of its demands. If only, the Park Service has countered, the states could see the big picture, acknowledge their own faults, and stop being so critical of the Park Service, we

would all be better off. Federalism is a wonderful concept, but working within it is hard. Add to this mixture the fairly stunning collection of personalities and strong wills that have made up our small community, and you have a recipe for adventure that is hard to beat. That we have come through that adventure thus far is testimony to the power of the idea that binds us together.

Meanwhile, the larger preservation movement has also undergone profound change over the last 25 years. We have greatly broadened our notion of significant resources, so that today's battles are being fought over vernacular 20th-century neighborhoods, warehouses, World War II facilities, cultural landscapes, industrial archeology, and early garden apartment complexes. We have refocused our attention, so that we care not only about the biggest, best, and most important, but also about the more typical resources that have broadly defined us as a society. Now we look not just at the factory owner's mansion on the hilltop, but at the rows of workers' cottages down below. We want our movement and our program to tell the whole story of

our society. The recent Pennsylvania Supreme Court case involving city regulation of a 1928 movie palace, the Boyd Theater in Philadelphia, has rocked the preservation community by challenging the legality of the city's preservation ordinance. It is interesting to note here that the building at the heart of the controversy probably would have drawn little interest from preservationists—and certainly no government protection—in 1966. The city of Philadelphia did not impose its preservation regulations on the building until 1987.

What does this kind of change mean? Within the state office, it means we have to know a lot more about many more things than we did in 1966. In 1977 the staff demands were for another historian, architect, and archeologist. Today I hear requests for landscape architects, planners, folklorists, and cultural geographers. For any bureaucracy, change is difficult. Reorganizing is hard enough, but trying to accommodate broader thinking and come to grips with something beyond your professional training or experience is quite literally mind-boggling. Still, most of us who have lived through this sea change in preservation would say that having our minds boggled has been good; we have learned and grown, and we are excited by our expanded horizons.

MORE NOSES IN THE WAY

Of course, all preservationists are affected by the expanded definition of significant cultural resources. There is an old saying that my right to swing my elbows ends where my neighbor's nose begins. As the sweep of the preservationist elbow grows ever wider, we find many more noses in the way. Property owners who once had nothing to fear from preservationists, because we preservationists were not interested, now feel threatened. Local government decision makers who were more than happy to protect the 18th-century tavern where George Washington supped scratch their heads when we seek the same protection for a 1935 apartment complex that was "the first large-scale Federal Housing Administration-insured rental housing project erected in the United States"—a project that we say exemplifies "the early application of innovative garden-city planning concepts to low-density superblock development for low- and middle-income renters."

If our elbows are hitting more noses, if we are entering into competitive arenas that seemed unimportant to us 25 years ago, we must have the skills to compete in those arenas. Not only must we be compelling in our arguments about the value of a cultural landscape or a worker's cottage,

we must have the talent and training to succeed at the bargaining table, in the real estate market, in land use decision making, and in the courts. Development of those skills for preservation is well under way.

GO ON OR GIVE WAY?

Looking ahead, we must ask whether state historic preservation offices can continue to function effectively in a preservation world that demands these new skills, or whether, having performed its duties reasonably well, the state preservation program now should give way to some other program better equipped to protect the most important landmarks.

The pessimistic view of state preservation programs is that their broad-based efforts to locate, record, designate, and protect properties must give way to more specifically targeted protection efforts. One set of targets—nationally significant landmarks—could be protected through direct federal intervention; the other set of targets—resources that generate interest within their local communities (and that meet whatever standards are set by the federal government)—could be protected through financial assistance directly from the federal government to the local government. This new vision sees correctly that historic preservation is essentially a land use issue, so that preservationists must focus more on local governments, where the land use decisions are made. Part of this vision's answer to the challenge is to establish a direct federal-local axis for the delivery of preservation services.

I am reminded of another vision that was founded on the belief that state governments simply were not equipped to grapple with local problems. That vision was urban renewal; the resulting destruction of wide swaths of our urban fabric has been decried by preservationists and urban theorists ever since. Revitalization strategies based on preservation rather than on demolition have generally proven far more successful in the years since urban renewal. The object lesson here is not that the failure of urban renewal necessarily argues against the setting up of any subsequent federal-local axis. The lesson is rather that it is a mistake to confront current and future preservation challenges by first dismissing the states' ability to help meet them.

It is not surprising that the president of the National Conference of State Historic Preservation Officers rejects the notion that the national preservation program of the future should lessen its commitment to the broad fabric of cultural

Opposite: Preservation's broadened scope now encompasses structures such as this Russian Orthodox bell tower on Spruce Island, Alaska.

H. BRYAN MITCHELL

resources in order to concentrate on the targeted few. It is not surprising that SHPOs have difficulty generating enthusiasm for a program structure in which the states step aside altogether or become the mere ministerial go-betweens that process the paper needed to move money from one place to another. Finally, it is not surprising that SHPOs have problems with the idea that only those states with federally approved statewide growth-management programs in place should receive any federal assistance for historic preservation.

Those who advocate changing the way the country does its preservation business raise some valid points—challenges to which the states must respond—but miss some equally important points. Some of the proponents of increased protection for nationally significant resources underestimate the importance of statewide and locally significant resources in building a preservation ethos in this country. But even if we all agreed that the program should target dollars at certain significant and threatened sites, I cannot believe that a staff in a regional or central office of the federal government will do as good a job of targeting the money as a similarly trained staff in each of the states can do. Also, moving to a program that deemphasizes continuing survey, registration, Section 106 review, and tax incentive programs grossly underestimates the resource protection that is accomplished by these programs.

There is a pragmatic consideration, as well. At current funding levels, such a targeting strategy will accomplish little. For example, back home in Virginia, the cost of meeting the threat at the Manassas Battlefield is in the tens of millions of dollars and still counting—more than the entire national appropriation for the preservation program. At another threatened National Historic Landmark, Waterford, Virginia, the strategy to stop encroachment is simply to buy at market value the open space that surrounds the historic village. The cost of that solution is more than 10 times Virginia's current annual allotment of federal historic preservation dollars. How many non-Virginians are willing to say that their state programs should be shut down for a year or two so that the preservation challenge at Waterford can be met? Scrapping an entire statewide program of measurable results to provide inadequate assistance to one or two specific sites a year strikes me as a step backwards. After all, funding for the national preservation program today is only about one-half of what it was more than a decade ago. If the national historic preservation program is to become the banker for direct intervention at numerous threatened sites across the country, that program must have dramatically increased funding, not simply a shifting of priorities within today's meager allotment.

REALISTIC INCENTIVES

I am a strong advocate of statewide growth-management and land use planning. Furthermore, I believe that states should mandate protection for historic and archeological resources of statewide and national importance and assist local governments in obtaining that protection. However, I do not believe that implementation of such state systems can be effectively used as the minimum threshold for eligibility for federal historic preservation funds. To put it bluntly, preservation is not a life-or-death issue, and the current level of federal funding is far from an adequate incentive to influence a growth-management debate in any state. States already must meet a full set of standards for their historic preservation programs to receive federal preservation funds. Adding the extraordinary standard of statewide growth-management efforts or mandatory resource protection in order to continue receiving preservation funds will mean only that most states will say "no, thank you" and abandon their federally funded preservation efforts.

My own experience with the Certified Local Government program in Virginia is a case in point. Initially, we set a very high standard—maybe even the highest in the country—for local participation in the program, in return for which we offered the possibility of a matching grant of anywhere from $5,000 to $20,000. There were no takers. Our high standards, commendable though they may have been, were out of line with the small incentives we offered in return. Sticking to our lofty standards would have accomplished nothing in the communities and would have resulted in the reassignment of Virginia's CLG funds to other states. We relaxed our eligibility standards a bit and now have 10 CLGs (still not very many), and we are getting good preservation work done in those 10 communities.

What about the idea that land use decisions have the most critical effect on historic resources, that land use is a local matter, and that preservationists consequently must focus on those local decisions? I agree. My experience as chairman of a local planning commission for several years has taught me firsthand how many local decisions have an immediate impact on historic resources. That experience, along with my state work, has also taught me that, without additional assistance, encouragement, and advocacy, local governments are unlikely to protect and manage their historic resources in a manner that is adequate to ensure their survival. Not only is technical knowledge often insufficient among hard-pressed local planning staffs, but political pressure for development or redevelopment is often too great to allow the locality to ensure careful resource protection within sensitive development. Reliance on local land use decisions leaves us

with a preservation program that defines resources as being of statewide, national, or even international significance, but then leaves the fate of those resources to local governments whose priorities may be at odds with the cultural value of a resource that transcends the local boundaries.

STATES AS CENTRAL PLAYERS

If these local decisions are critical, and if we must reluctantly conclude that preservationists have not yet succeeded in inculcating their values into that local decision process, how then do we effectively focus our attention on that arena? Some suggest that national land use legislation must be the goal. I believe that state governments represent the best hope, and not simply because I happen to work for one or because I am supposed to stand up for my colleagues in state historic preservation offices. Instead, I think some larger forces are at work that make the states a logical first choice.

The first force is structural: Local governments are political subdivisions of the state; they are creatures of the state. While this country's governmental system leaves basic land use decisions to local government—on the theory that such decisions are best made by the government closest to the land and its people—that local power is granted to the localities *by the states.* State governments have the power to say how localities will make their decisions and the responsibility for ensuring that local decisions are consistent with state mandates. Within this fundamental structure, the challenge facing the states is whether they can recognize the need for better resource protection, and whether they can summon the political will to change the land use decision-making process. That challenge is both difficult and crucial.

The second force is political: The states are beginning—and I emphasize that word "beginning"—to respond to the challenges noted above. A handful of states have already instituted more stringent statewide standards for local land use decisions and planning efforts. While we value the notion of government decision making by the government closest to the people, there is a growing awareness that some problems do not lend themselves to purely local decisions. More and more people are coming to realize that some resources—the environmental ones are perhaps easier for the politicians to see than the cultural ones—are too important regionally or statewide to be left to the vagaries of erratic decisions by one or more localities.

While many of these leading states wear "progressive" labels, even my conservative home state of Virginia has begun to grapple with the problem. It has already enacted legislation and promulgated regulations to ensure that local land use actions along the Chesapeake Bay and its tributaries are consistent with the state's interest in dramatically lowering pollutants entering the bay. Now the state is working through its Commission on Population Growth and Management to find new ways to handle the problems brought on by growth. It is fair to say that the commission sees the need for a more active state voice in land use decision making. It is also fair to say that resource protection—including historic resource protection—is high on its list of areas where improvement must be made.

Can historic preservation lead the way in improving state government efforts in land use and resource protection? I would love to think so, but I doubt it as a general proposition. Can preservation be an important member of the chorus calling for improvements? Absolutely. If preservation interests fail to seize such opportunities, they will seal their own fate. The trick comes in understanding that land use, while critical to preservation, is a far larger issue with far more powerful players, many of whom do not share our understanding of preservation as a land use issue. The best strategies would seem to be careful work to identify the centers of power interested in improving the system, and subsequent willingness to be a part of a larger effort. While the prospects for success at the state level may be mixed at best, the prospects for political acceptance of national land use legislation appear remote.

In summary, the national preservation program—with SHPOs squarely in the middle—has changed over the last 25 years to meet changing needs and to experiment with innovative techniques. The program is better than it was. It will continue to change as we face new challenges, including those brought on by our own rising expectations. The program will continue to get better. There is much in the last 25 years of which we can be proud; there will be much about the next 25 years that will be exciting and challenging. In an era when the fashionable political dogma—one that every candidate for every office seems to run on—is antigovernment, the national historic preservation program as implemented by the SHPOs makes me proud to be a public servant. It is a program that reminds me daily of the power of people of good will to come together through their government to say what is important to them and to be a vibrant force for the common good.

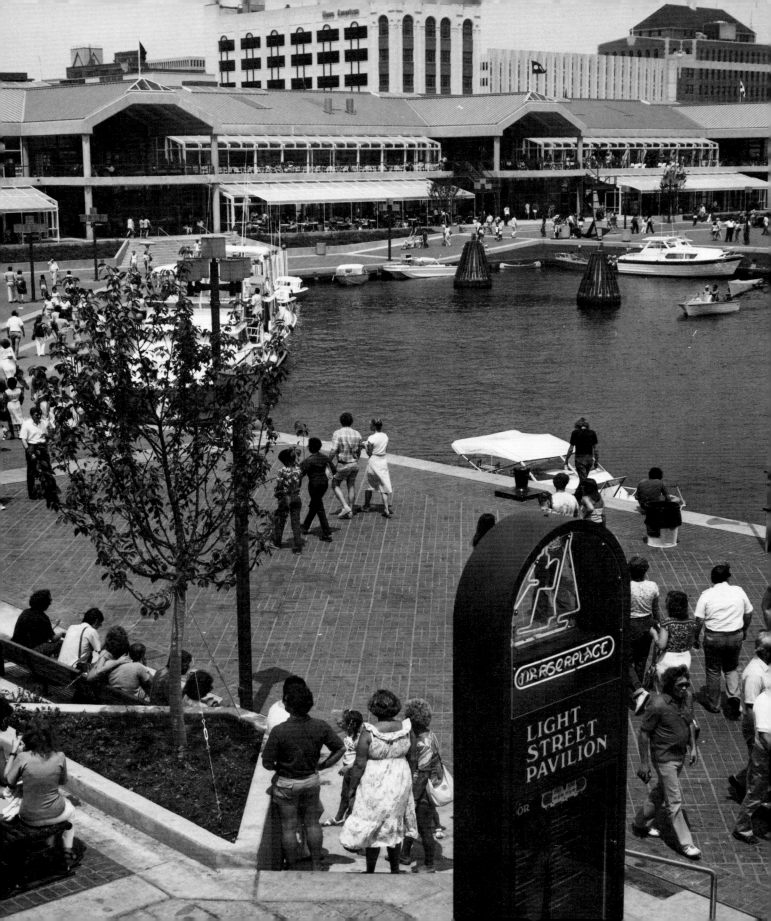

PRESERVATION PRACTICE COMES OF AGE

Michael A. Tomlan

W HEN CHARLES HOSMER WROTE *PRESERVA-
TION COMES OF AGE*, HIS TWO-VOLUME HISTORY OF THE PRESERVATION MOVEMENT IN THE FIRST
HALF OF THE 20TH CENTURY, HE CONCLUDED WITH A CHAPTER ENTITLED "PRESERVATION THEORY
COMES OF AGE."[1] HE NOTED THAT BY THE TIME THE NATIONAL TRUST FOR HISTORIC PRESERVA-
TION WAS FOUNDED IN 1949, STANDARDS FOR SCHOLARLY RESTORATION AND GUIDELINES FOR
AN EMBRYONIC SURVEY OF HISTORIC RESOURCES HAD ALREADY BEEN DEVELOPED. ALTHOUGH A
RUDIMENTARY *THEORY* MAY HAVE DEVELOPED RELATIVELY EARLY, ONLY IN THE LAST 10 TO 12
YEARS HAS PRESERVATION *PRACTICE* COME OF AGE.

During this period the number of people involved in preservation has grown enormously. The increase in membership of the National Trust, from 125,000 in 1982 to about double that at present, is but one indication. The diversity of the field, suggested by the number of organizations and the increasing complexity and sophistication of the movement, almost seems to defy characterization. Nevertheless, the principal trends of the last 10 to 15 years stand out clearly.

Our identity as preservationists continues to be defined more by our activities than by our strong association with any theory or circumscribed body of knowledge. The majority of those who joined the movement saw it as a crusade to protect this country's architectural and historic resources. Preservationists first became known for causing controver-

sies by stopping "progress," whether on the street or in court. During the 1970s the emphasis was on identifying and protecting historic resources on a scale never before undertaken, with considerable financial assistance from the Department of Housing and Urban Development, often in the form of Community Development Block Grants. Then, during the Bicentennial, the preservation community paused to celebrate the significance of our history and the built environment with tremendous pride at having conserved neighborhoods, recycled industrial warehouses, and refurbished waterfronts.

With the turning off of the Bicentennial spotlight, however, came a shift of emphasis. As a popular president promoted the accelerated defederalization of domestic programs,

the Tax Reform Act of 1976 seemed the key to stimulate private-sector investment that would offset the loss of federal aid. New provisions in the Economic Recovery Tax Act of 1981 attracted wealthier developers and financiers, eclipsing the work of small investors,[2] a trend made more conspicuous by a construction slump.[3] Soon, many preservationists sought to extend their rapport with the business community and focused their efforts exclusively on the rehabilitation of commercial property, working with developers on tax incentive projects. The results were impressive.

In retrospect, the rehabilitation of inner-city commercial properties stands as the most obvious accomplishment of the 1980s. This is not to minimize the importance of the conservation of state capitols,[4] county courthouses, and city halls or the restoration of house museums. But these activities and others were overshadowed as preservationists left behind their image as advocates and agitators dressed in jeans to assume a new role. Attired in stylish business suits, they became the yuppie associates of developers and subjects of new interest for newspaper reporters who monitor real estate affairs.

It was in the 1980s that preservationists launched feverishly into the "business" of preservation. The move was not without its irony: on one hand we preservationists continued to try to control development, while on the other we promoted business interests. However, the drastic alteration of the Internal Revenue Code in the Tax Reform Act of 1986, secretly crafted by the Treasury Department and then deftly moved through Congress with the support of the press,[5] so thoroughly altered the passive investment rules that it caused an almost immediate downturn in the number and size of certified rehabilitations.[6] It is not surprising that the pace of this new market slowed, especially considering the cooling of the economy.

THE BUSINESS OF PRESERVATION

Overall, the preservation movement's past 15 years have been marked by both explosive growth and downturn, conflict and compromise. The most measured progress, however, came as a result of having designed programs and poured efforts into them, with the help of a new breed of professionals.

The rise of the business of preservation can be traced to the recycling of downtown industrial and commercial waterfront buildings undertaken in the 1970s. Projects such as those in Seattle and Boston were extremely important because they were the first public-private partnerships to prove downtown revitalization was possible.[7] Maverick developers and enterprising mayors joined hands to undertake what seemed to be an impossible task of bringing people back to the inner city. Preservationists joined other city watchers in applauding developer James Rouse, who in 1981 was canonized as "an urban visionary" by *Time* magazine.[8] Although Rouse's festival marketplaces were not intended primarily as historic preservation projects and were occasionally decried as relocated suburban malls,[9] many professionals in the field longed to be able to assemble the resources to "play with the big boys" in urban redevelopment.[10]

With enhanced tax incentives, investors helped launch a new era in historic preservation.[11] By the early 1980s it was possible not only to take on similar projects but also to dream of even the most daunting rehabilitations.[12] Soaring skyscrapers, enormous hotels, and scores of vacant school buildings were revived. By the mid-1980s the preservation industry had expanded to include a wide variety of business activities, such as masonry cleaning, product manufacturing, publishing, and merchandising.[13] The November 23, 1987, issue of *Time*, entitled "Bringing the City Back to Life," remarked that it was almost obligatory for every city to have an old train station, office building, or theater put back in use, although some were overbearingly clean and cute. Northwestern University urbanologist Louis Masotti noted that "almost every city down to the third tier—places like Dayton and Toledo—has done something. . . . It's not a fad. It's a demographic phenomenon."[14] The 1980s had become the decade in which the commercial core of the city was revived.

PRESERVATION IN DOWNTOWNS

This revival, however, was part of a much greater building boom. In many large cities, the major projects that required political and economic support often left aside preservation concerns. In response, new master plans, zoning initiatives, and preservation ordinances were undertaken.

The best example occurred in San Francisco, where an overheated market for office space in the late 1970s and early 1980s led to the construction of ubiquitous high-rises, and the prospect of more building threatened the image and function of the city. A number of protests led to popular initiatives that effectively halted vertical growth. A new downtown plan, two years in the making, was adopted by the board of supervisors in 1985. As if that was not enough, San Franciscans for Reasonable Growth promoted a measure in late 1986 that effectively made this city the most restrictive of any in the United States with regard to height and bulk of new construction.[15]

Elsewhere, the results were mixed. By 1984 Boston was overbuilt with new towers sponsored by office space developers and banks entering the real estate industry,[16] amid widespread talk of reaching record-breaking heights. A

The facadism of Red Lion Row in Washington, D.C., testifies to the conflict between low-rise buildings and high-density zoning.

report issued by the chamber of commerce and the Boston Society of Architects called for controls on the growth of the downtown hub,[17] as the city seemed to be suffering from what architecture critic Robert Campbell called "parachute architecture"—design dropped on the city by a famous and busy out-of-town architect from a plane flying overhead.[18]

More troubling news came from New York City, where the local preservation commission, once cited as a model for other cities in the nation, was repeatedly attacked as inefficient, elitist, and obstructionist by members of the real estate community, various church groups, and politicians. As the commission's activities were examined in study after study, citizen activists were alternately exhausted by their own efforts and frustrated by what they read and heard.[19]

Atlanta's newly enacted historic preservation ordinance lends hope. As a result of some of the most skilled conflict negotiation our field has ever seen, the role of the Urban Design Commission was expanded in 1990 and its members appointed via a new process designed to limit the influence of politics.[20] Within months of the installation of this new commission, however, the fate of Atlanta's oldest shopping center, Rhodes Center, was cited as an illustration of the continued uphill struggle that remains against the "wrecking ball crowd."[21]

The tendency to negotiate and compromise with finan-cial and community interests became most apparent in the business district of Washington, D.C.[22] Because our nation's capital enjoys congressionally mandated height limits and an unusually strong local preservation ordinance, developers found it expedient to negotiate with various interests in the preservation community before seeking local approvals and permits. Over the course of the last decade, no city has seen more dramatic change in its downtown commercial core.

SWITCHING RATHER THAN FIGHTING

The overheated real estate market and preservationists' willingness to embrace the business community has led to a tendency to "switch rather than fight" that has been one of the most troubling aspects of our movement. The most obvious result is facadism—the deliberate demolition of all but one or more elevations of an old building that are then held in place while a larger new structure is erected behind. This procedure has often been presented as the best alternative; saving half a loaf, defenders have argued, is better than none. Indeed, the history of architecture and urban design contains dozens of examples where abandoned archeological fragments or stolen ornaments were incorporated into new buildings. Preservationists were slow to recognize that facadism is little short of demolition. In Washington, Red

Lion Row provided a model that architects and developers put forth again and again, in no fewer than 50 projects in that city alone. Today examples of this unfortunate practice can be seen in almost every large city in the country: it began in San Francisco with the diminutive White Investment Company Building and the Crocker Bank; in Boston with the Stock Exchange Building; and in New York with the Villard Houses-turned-Helmsley Palace.

Facadism has not been preservation's only unhappy compromise in the past 15 years. Numerous accommodations also have been made by landmark commissions, planning boards, and local advocacy groups in reaction to conflicts within and without the historic preservation community. The trend to compromise has infected even the landmark nomination process, the very core of the movement. Perhaps the most egregious example occurred in Chicago. When the Chicago landmark ordinance was revised in March 1987, the local commission declared an end to the practice of designating parts of buildings. But the commission did an about-face in early November 1988, when owners of the Tribune Building objected. Under pressure, commissioners agreed to a partial designation of the building's tower, limited to the west facade, 85 percent of the northern and southern facades, the east facade above the 23rd floor, and the first floor of the lobby.[23] The commissioners, it is true, made these decisions against a grim political background. In October 1988 the Illinois Supreme Court ruled against the National Trust, Illinois Landmarks Preservation Council, and Chicago chapter of the American Institute of Architects, upholding the city's right to rescind a landmark designation without consulting the landmark commission. But the commission undermined its very reason for being when it considered future changes to a building while it deliberated the building's landmark status.

SMALL-TOWN PRESERVATION

To provide a conceptual framework for examining preservation activity in small towns, we need turn only to Ron Powers's new book, *Far From Home*.[24] The author compares two emblematic towns—Cairo, Illinois, and Kent, Connecticut. The first is a former riverboat town, devastated by race riots in the 1960s and devoid of an economic base, that is pinning its hopes for revival on a new community development consultant. The second is a once-remote farming village quickly being transformed by condominium development as a weekend retreat for New Yorkers. Over the course of the last 12 years, the preservation community has devised programs for the Cairos of the country, while the Kents have been allowed to fend for themselves. The most

obvious example is the Main Street program, the most successful initiative the National Trust has ever undertaken. Begun in 1978, the program is widely emulated for its effectiveness in combining public and private support.[25] More than 600 small towns across the nation have adopted rehabilitation programs based on the work of the Main Street Center, testimony to its success.[26]

By contrast, preservationists have had less success with rural problems. Preservationists at several levels did unite in protest when mall construction threatened the Manassas Civil War battlefield.[27] On the other hand, hundreds of less well-recognized sites of state and local importance receive little attention. Rural, agrarian buildings are more difficult to save than the structures in our cities and on our main streets. The political constituency of rural areas is more scattered. In addition, our society has little contact with the decreasing number of people who turn the soil or raise livestock. And the average American who drives through or flies over rural landscapes has only a vague idea of the activities that were carried on in them.

Two National Trust programs show as-yet-unrealized potential for dealing with these problems: the demonstration for rural communities launched in 1979[28] and, more recently, the Barn Again program. The latter is notable for its insistence on understanding regional agricultural economics before considering new uses for an agrarian structure.[29] Preservationists must better understand the differences among the rural economies in various regions of the country, however, if this program is to be truly effective. In this regard, it is important to note that "growth management" discussions, devoted to containing suburban sprawl, rarely consider the weakness of the local farm economy.

TIES WITH THE ENVIRONMENTAL MOVEMENT

One obvious negative result of our preoccupation with the business of preservation, mentioned earlier, has been an almost complete loss of contact with the environmental movement. In the late 1970s the rise and demise of the Heritage Conservation and Recreation Service in the National Park Service showed that a shotgun marriage with environmental interests was not going to work. However, even today many preservationists in Washington continue to believe that there is a natural union between the conservation of natural resources and the preservation of our built environment.[30] In theory, there should be a union. In fact, however, ample evidence demonstrates that, while both movements begin with the idea of protection, for preservationists the preferred alternative is the continued use of the resource, while for conservationists this is less than a desirable

choice. True, there is a wide diversity of opinion among environmentalists about how much can be saved. It is equally true, however, that when preservationists moved to embrace the development community over the course of the last decade, they increased the ideological distance between themselves and conservationists by fueling demand for more oil, gas, and wood. Further, as preservationists increased their inherent bias toward urban and suburban concerns, alliances with conservationists seemed less fruitful. This was clearly reflected in the results of a 1987 National Trust nationwide survey.[31]

Over the course of the last decade, preservationists have continued to expand the scope of their interests. Vernacular architecture has become an area of study, while the 20th-century suburban commercial strip has received book-length treatment for the first time.[32] The attention to these and other monuments of the recent past has bothered many professionals, particularly those charged with deciding how to "separate the cultural sheep from the goats."[33] However, there should be no limits to preservationists' concern. The 20th-century English philosopher Robin G. Collingwood gave the best advice on judging a good or bad example: "The definition of any given kind of thing," he said, "is also the definition of a good thing of that kind."[34]

Our unbridled appreciation for all aspects of the environment is deeply rooted in American thought. The early 20th-century educator John Dewey believed that art was not only contained in museums and art galleries but also resided in whatever object or environmental context embodies or communicates human meaning.[35] The recent resurgence of interest in this theory attests to its power. In contemporary preservation thinking, the theory undergirds the work of preservation attorney John Costonis.[36] Decrying the attempt to use narrowly constructed local historic preservation legislation as a growth-management tool, Costonis writes: "Beauty is off the mark as a force behind aesthetics laws [used in the preservation field]. In its place I propose to substitute our individual and social needs for stability and reassurance in the face of environmental changes that we perceive as threats to these values."[37] Using examples from New York City, Costonis divides the built environment into two classes of objects. First, there are icons, structures invested with a special character, whose architectural, historical, or social values confirm our sense of order. Second, there are aliens, structures that threaten icons and their values. Costonis argues that preservationists must use community values to protect our icons and better defend them in court.

The trend in recent land use planning and zoning legislation has been to combine aesthetics with, for example, the need for affordable housing, efficient transportation, and handicapped accessibility. All are legitimate concerns to be weighed as community interests. For those working at the local level, the need to integrate preservation into every aspect of decision making has been evident for years. The present legislative trend merely reinforces the fact that tradeoffs will be made and a balance of interests will be struck. We should be there when that negotiation takes place.

PRESERVING RELIGIOUS STRUCTURES

The most recent emerging nationwide initiative is one that has been launched to coordinate programs dealing with the preservation of sacred sites. These programs are especially noteworthy because they represent a departure; preservationists traditionally have shied away from involvement with religious structures. The American preservation movement began by saving the homes of our major political figures, and not, as in France and England, the great cathedrals and churches of established religions.

Friction between the owners of religious properties and preservationists has long been obvious. One of the hottest cases of the decade began in 1983, when St. Bartholomew's Episcopal Church in Manhattan sought permission from the Landmarks Preservation Commission of New York City to demolish part of the church's historic property to build a high-rise. When the commission refused, the church appealed to the courts. The recent decision of the U.S. Supreme Court, affirming the commission's right to control St. Bart's, was widely hailed as a cause for celebration in the preservation community.[38] Unfortunately, other state court decisions have not been as favorable.

Until recently, in fact, preservationists have viewed the problem of saving sacred sites as being too large to tackle. Yet the need to address this problem is clear. In Detroit, the Roman Catholic archdiocese recently ordered the closing of 43 of its 112 churches.[39] The story is similar in New York City, where, despite a steady stream of immigrants from Central and South America, the mounting deficits in poor neighborhoods have led church administrators to predict that as many as 30 of the archdiocese's 312 schools will close in the next few years.[40] In cities across the country, hundreds of downtown properties are for sale by different denominations. Even more recently established religions such as the Christian Scientists, committed to the importance of an urban ministry, are suffering from declining congregations, in some cases having lost more than 60 percent of their numbers since the early 20th century.

A few pioneering organizations have begun efforts to preserve sacred sites. In 1984 the New York City Landmarks Conservancy launched a newsletter, *Common Bond*, devoted

This addition to St. Bartholomew's met its match in the New York Landmarks Preservation Commission and U.S. Supreme Court.

MICHAEL A. TOMLAN

to maintaining and protecting religious properties. The following year the Philadelphia Historic Preservation Corporation produced the newsletter *Inspired*. Broader efforts in New Mexico, Minnesota, and the Dakotas have complemented this early urban focus.

More exciting yet is the formation of a new nationwide nonprofit, Partners for Sacred Places, a preservation organization that understands both the cultural importance of church buildings and the problems of religious property management. Partners begins by trying to assist the people in the buildings, not simply focusing on the structures alone. In the words of Codirector A. Robert Jaeger, "If you believe that the whole range of services that religious institutions provide is important, in fact essential, to a healthy city, then this is not a tactic but a necessary first step in the preservation of our sacred sites."[41] Hence, just as the Main Street program began to address the revitalization of downtown commercial districts by forging a partnership between preservationists and a community's business interests, these new centers have begun to develop specialized programs, addressing an audience outside the preservation field. This is a mark of maturity in preservation thinking.

MARKS OF MATURITY

There are other marks of maturity. The growth of preservation education at all levels in the United States has been as phenomenal over the last decade as the expansion of the field itself. Whereas the "Preservation Education" supplement in the October 1978 issue of *Preservation News* listed 15 programs, the 1991 listing includes more than 40 programs, together enrolling about 1,200 students. Equally important is student distribution. The 1,200 students are almost equally divided among undergraduate programs, graduate majors in preservation, and graduates majoring in allied disciplines. This is the largest student body to examine historic preservation in any country in the world. In addition, two-year community colleges and technical schools have joined their brethren in the National Council for Preservation Education as interest in the field grows at all levels. Ideally, these programs will promote heritage education in elementary and secondary schools, for there is a common vital interest at all levels in a hands-on, experiential approach.

As the field has matured, preservation education has become more sophisticated. One indicator is the teaching material. The mimeographed handouts of the 1960s and the photocopies of the 1970s have been replaced by case-study catalogs and textbooks. The interest in the economic benefits of preserving old buildings, spurred on by the tax incentive legislation, accelerated a no-nonsense business-school approach in the classroom. Of course, case studies are also commonplace in preservation law, but the growing empiricism in preservation education is perhaps most evident in building-materials conservation, where laboratory exercises were developed.

Where do the graduates of these programs go? Many return home—not always in the United States. In some programs, at least one-fourth of those enrolled are foreign students here to take advantage of the expanding preservation movement and carry its lessons back to their native countries. The cross-cultural exchange of preservation ideas is further promoted by programs including internships, archeological digs, study tours, and seminars abroad sponsored by about half of the preservation programs in the country.

When seeking employment, most recent alumni have not gone to Washington, for there has been little, if any, expansion in the number of available federal positions. Students also know that the state historic preservation offices have hardly grown. For the most part, graduates have gone to work at the regional, county, and local levels in government, private practice, and nonprofit organizations. Wherever government has expanded, preservationists have been hired.[42] Whereas in 1976 there were about 500 historic district commissions, today there are some 1,700, although this is only one measure of growth. Main street programs, planning, and local economic development agencies provide opportunities for hundreds of professionals. Unfortunately, recent cuts in federal and state funding to cities have resulted in staff reductions on several city historic district commissions. However, recent graduates are still being hired in suburban communities and in county governments concerned with growth management.[43] In the mid- to late 1980s private nonprofit organizations began to absorb a number of young professionals. In fact, some of the most striking changes in the field have occurred in the management of nonprofit organizations, as more people educated in preservation have taken the helm, balancing fund raising with advocacy and carrying forward values and programs that government can no longer afford.[44]

The preservation movement has seen enormous growth and increasing diversity over the last 10 or 12 years. Its catholic interests have led it in new directions, following the idea that the preservation ethic should be integrated into every area of economic and political decision making. The movement has accomplished much more than many once thought possible. However, trying to integrate preservation concerns with other causes has, in some instances, simply meant accommodating those other causes. Yet there can be no turning back to a simpler era. Preservation practice has come of age. With experience to guide us, and with the help of the best new talent, we must look forward to even greater challenges.

HOW WILL PRESERVATION ADAPT TO A CHANGING WORLD?

A LARGER UMBRELLA

John F. W. Rogers

TOMORROW PRESERVATION WILL LARGELY BE ABOUT MANAGING CHANGE. WE ARE IN FOR CHANGES THAT WILL AFFECT DEMOGRAPHICS, TECHNOLOGY, LAND USE PATTERNS, DECISION MAKING, FUNDING, PROPERTY RIGHTS, AND OUR OWN ALLIANCES WITH EACH OTHER.

Our most basic values are evolving: people values may no longer be subordinated to architectural values, as they have been in the traditional preservation credo. This much seems clear: we will never be quite the same again, and those who can manage change will prevail.

To cope with change, we will invent new tools, revamp old ones, and experiment with radical innovations. Some of our old tools will survive and adapt better than others. There will be new fiscal constraints, and we will have to be creative about finding money. The federal government will surely be an important source of support, but perhaps through new avenues—affordable housing, public infrastructure, community development, transportation, and preservation education. There will be federal involvement in land use, planning, resource management, and a thousand other areas.

The inevitability of a federal role ensures that the Advisory Council on Historic Preservation will be there to help impose preservation sensibilities on federal actions and goals. Its regulatory system, Section 106 of the 1966 act, supplies a quality-control mechanism, a public-participation mechanism, a coalition-building mechanism for protecting historic properties from needless harm as a result of federal action.

I have said many times that preservation should move under a larger umbrella—an umbrella of preserving America's heritage and culture, including the natural environment. Our broader message must appeal to the people forces that are going to change America's demographic landscape. I am reminded of the vision of the future presented in the movie *Blade Runner,* in which sophisticated creatures are developed who are completely human in every way, except for one: they lack a past. They lack a heritage. They lack being. These "replicants" search to create a past and an identity. They surround themselves with photographs and mementoes of family, home, community, and heritage.

If we do not recognize the importance of multiculturalism, I firmly believe we risk having a nation of "replicants," emulating America but cut off from its past, lacking a heritage, and searching in all the wrong places for an identity. Let our larger umbrella include all the peoples of America.

BRIDGING AMERICA'S VISIONS

Henry G. Cisneros

THE HISTORIC PRESERVATION MOVEMENT HAS MEANT A GREAT DEAL TO MY CITY. I WAS BORN IN SAN ANTONIO, RAISED IN SAN ANTONIO, AND HAD THE GREAT HONOR OF SERVING AS MY HOMETOWN'S COUNCIL MEMBER AND, LATER, AS ITS MAYOR FOR EIGHT YEARS. I WATCHED MY CITY CHANGE AND CAME TO RECOGNIZE THAT THE LEGACY OF THE COMMUNITY COULD BECOME A POWERFUL ECONOMIC MAGNET. HOW PHE-NOMENAL IT WAS TO WATCH THAT PROCESS UNFOLD AND RESULT IN A PLACE THAT PEOPLE CAN ENJOY! THE CONSENSUS TODAY IS THAT AN ESSENTIAL ELEMENT OF SAN ANTONIO'S CHARAC-TER IS THE ATTENTION GIVEN TO ITS HISTORICAL REALITY AND ITS HISTORIC DETAILS.

Preservationists have produced lasting contributions not just to San Antonio but to our entire nation. The movement has made cities more livable, enabling all of us to reflect on our origins, our antecedents, and, most important, our values.

Let us reflect on a juxtaposition of preservation work: the careful stewardship of legacy and change. The change we face is massive in scale, rapid in pace, and, ironically, continuous. Change is the single most relentless feature of the landscape of the world in which we live. As we con-sider change, we are prompted to look at our country and envision the logical trajectory of the changes that we see and envision some outcomes. This is difficult to do because one can take many telescopes, many templates, and apply them to the American future. We can look at the future from the perspective of geography, race, income, or gen-erational change.

But as I have traveled around the country, I have found that it is essential for me to divide the country into two vi-sions. These visions are the result of forces that are pulling America in different directions. These forces cause Ameri-cans to live in two completely different worlds—two dif-ferent societies—formed by sets of realities that are unique in character and origin.

I see two Americas. One is the America of technological imperatives and economic rationality. It is a powerhouse. It is a pioneering nation. This America has the ability to com-pete in every way with every nation in the world. Infor-mation is drawn globally and made instantaneously available

to people across the country by the speed of communications and telecommunications. As we sleep, decisions are being made in Tokyo that affect that city's stock market. As we awake, those decisions are reflected in the London markets. Over the course of the day, this information influences New York markets and main street, as interest rates and unemployment numbers are calculated and financial decisions are made.

It is a world that is linked together by high-speed transportation that makes it possible for people to meet in different parts of a continent within hours and dash across the country in the course of a day. This world is very complex. The kinds of products and services that are offered today require a level of specialization. Arcane software programs and financial models look at options and descriptions of the financial future. Biomedical and bioengineering strategies require not just an education but years of experience to achieve mastery.

This world places a real premium on quality and education. Other characteristics take a back seat because what really is desired is the utmost functioning of the human capacity for rationality and thought. It is a world that rewards decentralization, not the bureaucratic behavior of the past. No more Man in the Gray Flannel Suit—the organization person who is rewarded for doing only the minimum and staying put. This new order requires people who are creative, innovative, and able to make decisions quickly. This changed emphasis favors an organization of small, often physically distant, units, linked by technology that they use in entrepreneurial ways.

When I use the word "entrepreneurial," I do not mean just business—particularly small business—as we think of it generally. The characteristics of entrepreneurship are being reflected in the society at large. It is not possible for people to behave one way in their office setting and a different way at home. Therefore, people organize their homes with the same principles of speed, efficiency, accountability, and connectedness. Of course, they require the same of their governments. As a result, individuals are less patient with large bureaucratic organizations that behave in the old ways. The values here are efficiency, speed, and innovation. Individuals are expected to be organized, technically literate, and competitive.

I am absolutely certain that this world exists. Pick a building, pick a floor in downtown San Francisco, for example, and you can see this world at work right this very minute. You can see it at work in the financial firms. You can see it in the law firms. You can see it at work in the computer back offices. You can see this world in the accounting transactions and management of large enterprises headquartered

there. You can see it in the Pacific trade relationships. This world is real. It is competitive. But it is not the whole picture of what is happening in America.

There is another America, formed by forces just as relentless as these. That America is an America of people realities and people forces. Over the next 15 years, we will witness a dramatic collision between two major demographic forces in our country. It is almost as if there are two locomotives heading toward each other; we can see them barreling ahead and know that they will collide.

One force is growing out of the aging of a large segment of the American populace, particularly mainstream American populations. This aging population is so important a force that it is hard to describe the significance it will have. And the other force is growing out of a different demographic reality: the increasing diversity of the younger American population. There will be an increasing minority population: Asian, Hispanic, and African American. And it will change the very complexion of our country over the coming years.

With respect to the population's aging, the U.S. Census tells us that for the first time in American history, those 65 years of age and older outnumber teenagers. It tells us that people entering their 80th year made up the fastest-growing age group in the country in the 1980s. According to the census, in the last century the average American male spent about three percent of his adult life in retirement. In the new century, it is expected that the average American male may spend as much as 30 percent of his adult life in retirement, as we continue to prolong the average life span.

"Old" will be redefined as more people function in society at advanced ages—people such as James Rouse, chairman of the Enterprise Foundation, who is still building community projects; and Peter Drucker, who is still writing genius-quality work on management; and Bob Hope, who is still entertaining the troops; and George Burns, who is still doing commercials. You could cite other people prominent in our society who are breaking the traditional age rules.

People will work for 40 years and retire for 20, thus spending a third of their 60 adult years in retirement. The implications of this massive aging process are profound. Not only will there be more people of advanced age as people live longer, but the elderly also will make up a greater percentage of the population as the birth rate declines. Contributing to the decline, common in prosperous societies,

are women's decisions to work longer, postpone childbearing, and have fewer children.

In the 1990 Democratic primary in Florida, 47 percent—almost half—of the voters were more than 65 years of age. The implications in business, industry, leisure, housing, electrical appliances, and food are going to be immense. The elderly constitute the largest voting block, with voter participation rates of 75 percent, compared to 20 percent in younger age groups.

The largest implication will be for the country's sociology and self-image. Whether or not the country still views itself as having its best days ahead will determine its willingness to invest in the future: in education, in infrastructure, and in the diverse young population.

The next young generation will be increasingly Hispanic, Asian, and African American. It is not an accident that 300 cities in the United States, including the two largest, New York City and Los Angeles, have mayors who are African American. It is not an accident that the largest cities of the Old South—Atlanta, Birmingham, and New Orleans—also have African American mayors.

The increasing numbers of African American leaders reflect the fundamentally new demographic realities of the nation's cities. In time, the same trends will alter whole states and regions. It took more than 200 years of American history for the Hispanic population in this country to reach, through birth and immigration, 15 million in the year 1980. But just one decade later, the Hispanic population had jumped 53 percent to more than 22 million.

It is understandable why that rate of population growth exists and why it is going to continue and be more important in society. It has to do with the flip side of the aging demographics. The average population for the country is about 32 years old, but the average age for the country's Hispanic population is about 22 years of age.

During the same period, from 1980 to 1990, the Asian American population grew by 103 percent, that is, it doubled. It follows that Asian Americans will play increasingly important roles in society. The growth of minorities is going to reshape regions. Nowhere is that clearer than in the state of California.

California is not just another state; it is the largest state in America, with 30 million people. New York, the second largest state, has only 17 million. California has expanded its congressional delegation by seven members. If it were ranked as a nation in economic terms, California would be the sixth most powerful nation in the world, with an economy slightly smaller than that of France or Italy. In this decade, California's majority population will be Hispanic, Asian, and African American.

THE PEOPLE REALITIES

The future of our country is going to be determined by the way in which these two different Americas relate. Will they pull apart, leaving large masses of people in the chasm between them? Or will they be harnessed together? Will these two Americas collide in chaos or will they provide the new synthesis through which new public policy—new answers for building a civil society—can emerge?

There are several directions that we can see from this configuration of society. The first is that the relationship between these two worlds will shape the prosperity of the United States. Today 32 million Americans live in poverty, a huge and disturbing number. Worse, the number is six million higher than it was 10 years ago. Half of those in poverty—some 16 million people—work full time. One can work for a minimum wage in our country and make about $6,000 to $7,000 a year. The average income to escape poverty for a family of three is about $10,000.

But an even more disturbing statistic is that 12.5 million of these poor Americans are children. One out of every five children is born into poverty. Among Latino children, the ratio is higher: one out of three. Among African American children, it is higher still: one out of two.

The key question is whether or not the prosperous, pioneering America can be harnessed in such a way that it meets the people realities of our country. An unprecedented commitment to education will be required to link up the forward-pulling engine of the American technological juggernaut with those outside the economic and educational mainstream.

A second issue that the relationship between these two worlds will define is whether or not we will have a civil relationship in our society between races and ethnic groups. Will we as a society be able to overcome a tradition of racial tension and bring our people together? Or will economic polarization continue to divide our society into different camps?

It is no longer possible to deal with matters of race, ethnicity, and diversity in the traditional ways. It is not good enough to say, "We are doing this. We are trying to be thoughtful and proactive here because the government requires it, because there will be sanctions from the federal government if we do not."

And it is not good enough any longer to say, "We are doing this because our Judeo-Christian tradition teaches us compassion and charity for these poor folks." That really is not good enough any longer either. We have come to the point where we must realize as a country that what is on the line now is our ability to compete, our ability to

The preserved facade of the Maverick Building in downtown San Antonio provides continuity in the commercial streetscape.

prosper, and our ability to survive as the society we know.

The truth of the matter is that we cannot be a civil society by carrying on our shoulders 10, 15, or 20 million people as a permanent underclass. Trying to do so spreads crime and fear. We begin to experience the breakdown of an orderly discourse on matters of public policy. How these two conflicting Americas sort out their relationship will determine how we fare on those scores.

The relationship between these two Americas will also determine the vigor of our democracy—whether or not we will be able to deal with the seeming apathy toward voting. This apathy results from politics of attack; negative, 30-second sound-bite campaigns; and the lack of what passes for real debate on issues. The technological world breeds habits of impatience in dealing with more complex human realities. The tendency is to solve complex problems in simple ways. We even ask to be lied to by political figures because we demand simple answers to complex questions. The resulting disconnectedness removes us not only from politics, but also from a sense of community.

What we need here is to harness the technological imperatives of one world—for example, the use of television and cable television—in more effective ways to conduct a civil discourse. The process will lead to a sense of civic, or citizen, democracy in which individuals reengage in the political process.

REINVIGORATING GREAT AMERICAN CITIES

Still another issue in the balance is the question of our urban form as a society. Too often across the country, we see the decline of our central cities—their physical resources, their people, and their tax bases—as we watch the growth of the suburban rings. Several years ago, our central cities were clearly the engines of economic vitality for their entire regions, providing 60 or 70 percent of the jobs and boasting a like percentage of residents. This was the case for our great American cities.

Today most central cities hold 25 to 30 percent of the people and jobs in their metropolitan areas. The people

have moved out to suburban communities. The jobs have moved out as well. A completely new form of urban development—the suburban city—has arisen. Rockville, Maryland, and Alexandria, Virginia, are examples. The communities outside Chicago, which serve as headquarters of national companies, replaced manufacturing plants and headquarters in the central city of Chicago. In Detroit, the research centers for the automobile companies have moved to the region's outskirts over the years and cemented their roles away from the central city.

This urban form is commensurate with the decline in function of the central-city economy. The manufacturing roles that accounted for 25 to 30 percent of the jobs in cities today account for 12 to 14 percent. Along with the decline of American manufacturing, many central cities have lost their reason for existence. There is a racial impact, too. As people leave cities, the proportion of African Americans and other minorities left behind increases. The affluent seek schools in the suburbs, leaving central-city schools to decline further.

Another issue relates to intergovernmental realities. The point of focus has shifted away from a federal government that no longer has the money to be proactive on issues of social change and urban development. The point of responsibility and action has moved away from the oak-paneled, chandeliered conference rooms of Washington, D.C., through the state capitals, to the local levels. Increasingly, communities that are going to survive must develop strategies at the local level. Communities will have to be masters of their own destinies.

This governing reality cries for new models or ideologies of local action, neither Republican nor Democratic nor conservative nor liberal. These labels do not apply here; it is a question of what works. A new pragmatism blurs not only ideological lines, but also the lines between what is public and private. The public sector now takes responsibility for providing land for hotels adjacent to convention centers, for example. The private sector concerns itself with what used to be clearly public realm—schools, airports, industrial facilities, and others.

What does this have to do with historic preservation? Six themes spell out preservation's role as it relates to the direction of our country.

PRESERVATION AND OUR CULTURES

Historic preservation has a role to play in the process of multicultural adaptation. Historic preservation gives us tools with which we can combat some of the divisions that exist in our society. It is inspiring to see the commitment in Atlanta, Memphis, and Savannah to telling true stories about the past. The story is told so people can make judgments for themselves about what has occurred.

This approach can be seen in Memphis at the new museum at the site of Martin Luther King's assassination; in Atlanta, in the neighborhood where King worked and grew up; and in Savannah, at the port and docks where Africans were brought in by ship and sold as property. Because of their associations with these events, these places are invested with power.

I have had personal experience in watching the role that history plays in teaching an ethic of living together. I am Mexican American. I grew up in San Antonio. I was the first Hispanic mayor of the city since Juan Segine, who served at the time of the fall of the Alamo in 1836.

I served as mayor during the years of the sesquicentennial in 1986 and had to attend the ceremonies at the Alamo. I have always regarded myself as an American first. Frankly, I do not know what I would have done if, in 1836, I had been forced to choose between my nation that was part of Mexico and the new forces that had come to Texas to rebel against the oppressiveness of Santa Anna's dictatorship. But I know that I am an American, and I had to come to terms with myself as people quietly criticized my role in some of those events. There were Hispanics who said, "Why are you there commemorating what resulted in the dismemberment of Mexico?" But the battle that occurred was a human event, with Mexicans on both sides. Inside the Alamo with the Texan forces were Texans of Mexican descent—Desavala and others. Obviously, there were Mexicans on the other side. It is not my place to judge. It is for me to learn from the event and try to explain to others our place in history.

Historic preservation provides forums for negotiation. The most important negotiating processes that I was involved in during my years as mayor concerned historic preservation. I had to sit for hours, night after night, to try to save the Texas Theater when a banking group wanted to tear it down and put a bank in its place. The result was a compromise: we saved the facade of the building, juxtaposed against the bank building that eventually was built. But the process was just as important as the results. We won some, we lost some. People talked to each other and tried to teach each other. The process that has been created in many communities for historic preservation can be applied to many other situations in our multicultural future.

THE HUMANIZING INFLUENCES

Historic preservation is going to be important in our nation's future because it provides a way to reach for the humanizing influences in our society. It entails a respect for

antecedents. Historic preservation offers an intelligent way of relating people to their human origins. It is a metaphysical process of finding not only enjoyment, but also meaning, in historic places.

As they walk through a historic room, people can associate themselves with, and draw inspiration and even ambition from, the lives of people who have gone before. As visitors retrace their footsteps, they link themselves not only to past human achievement, but to human foibles and failures as well. People realize that they, too, can achieve—that all people have the capacity to make a contribution.

We see places that touch the human spirit in Indian ruins, Civil War sites, the sod houses of the Great Plains, and the architectural signatures of various periods of civilization. The simple reality of these physical places gives a moment of respite to the human spirit, just as important as the process of respecting human antecedents.

At the juncture between urban planning and historic preservation is a field of study called amenity planning. Its practitioners include an organization named Partners for Livable Places. Partners defines amenity planning as the business of building quality cities to a human scale and with places for human comfort. The concept takes in cultural planning, green spaces, open spaces, places for recreation that can support neighborhood identity, waterfronts, and river walks.

Amenity planning includes animation. The strategy of bringing liveliness to a neighborhood, by means of festivals, ethnic pride celebrations, and a thousand other ways to draw people, can be applied to whole communities. Jim Rouse of the Enterprise Foundation says that what makes his projects successful is not architectural brilliance or uniqueness of design, but the fact that they provide a magnet for people to come and see other people.

Neighborhood preservation is another facet of amenity planning that brings revenue and cultural rewards. Design competitions that focus on community aesthetics—for example, by converting eyesores such as parking lots and utilities into community gateways—build on a community's assets.

I was very proud of two unique studies we employed in the years that I was mayor of San Antonio. One was called "The Shades and Shadows Study." This study used a computerized model to determine which building heights should be allowed along the San Antonio River, taking into account the angle of the sun at various times of the day and year. The object was to protect the view of the foliage along the river and to prevent the river's canyonization or Manhattanization by new development. Another study dealt with preserving street vistas and preventing their obstruction. Vistas are invaluable assets that define the community in special ways. Amenities such as libraries, museums, historical societies, interpretative centers, and education centers are part of the process of building community.

In San Antonio, the River Walk was once slated to become a paved-over underground sewer. Instead, it has become the central defining characteristic of San Antonio, key to the city's success as a tourist center. It is the second most visited place in Texas after the Alamo. There is now a linkage between the Alamo and the river through the Hyatt Hotel lobby. It is a phenomenal development that I would encourage you to see.

The river is important in San Antonio, not just for tourism and commerce, but for escape. It is a place where people go to get away from the street-level noise, the asphalt, and the summer heat, and sit under a shade tree in an isolated place. The River Walk is one of those places that lifts the human spirit and is an important dimension of preservation work.

Author John Naisbitt tells us that in an era of high technology, human beings reach for high touch. The movement toward the recognition of humanity in preservation will be increasingly important as we acknowledge the quest for spirituality among Americans. It is no accident that we are seeing an explosion of experimentation with forms of religion. Perhaps a thousand entrepreneurial models of providing religion exist today.

The trend is a reflection of people's reaching. They reach for nature, for air and space, and for greenery. San Antonio's river and its greenery make an oasis of this dry, hot city on the edge of the south Texas brush country. These features are what defined it as a human settlement 300 years ago, when Indians lived there and called it "Yannaguana"—place of the peaceful water.

When the Spaniards came, their diaries show that they found this to be the most beautiful spot that they had seen in their long trek across northern Mexico and south Texas. They were delighted by this oasis with its cypress and pecan trees hanging over a small stream of water. Today San Antonio is a city of one million people. Yet it is still held together by water, foliage, and inviting places.

HUMAN CAPITAL

A third theme is the relationship of historic preservation to human capital. There is no greater challenge in our country than education. Education will define how we bridge the two worlds I described earlier, how we settle the question of

what America can be. A community in Ohio has a sign at the city limits that states, "A city is known by the schools that it keeps." I would argue that those schools are the result of a sense of community. Schools are the product of a public ethic of caring as much for antecedents as for posterity and for the human story.

Teaching sites that are part of the city amenities and preservation ethic include museums, interpretive centers, historic places, and cultural centers. Examples include Chicago's lakefront museums, Boston's children's museums, and the Institute of Texas Cultures in San Antonio. These places stimulate a sense of intellectual inquiry, excitement, curiosity, and hunger for continuous learning. Trips to historic sites can help foster in students a connection to and appreciation for the past.

TECHNOLOGICAL NEEDS

A fourth theme is the adaptive use of historic sites for technological ends, so that the worlds of preservation and technology are not compartmentalized. The blending of preservation and technology in Lowell, Massachusetts, where old mills have been converted into computer headquarters, has been effective. In San Antonio's sister city, Kumomoto, Japan, business owners have put the most up-to-date computer facilities in historic buildings in old neighborhoods. Purposes, goals, and functions have been mixed in effective and interesting ways.

CITIES AND REGIONS

A fifth theme is the role of historical awareness and appreciation in strategic thinking about the larger goals and missions in cities and regions. Some cities are going to be victims of the changes that I have just described. Others will prosper. Those that prosper will most likely be communities that have planned. By planning, I do not mean just how they are going to zone a piece of property next week or how they are going to reorganize a department in the city. A plan asks the big-picture questions: What is the job base in the Baltimore region for the year 2010? What is the job base in San Francisco for the year 2020? What kind of educational institutions will have to be put into place? What kind of human services will there be for social need? In those big-picture questions is the role of historic preservation. Historic preservation should not be thought of as a sidelight but should be inserted into the political dialogue concerning regional survival. It should be inserted proactively, in advance, as a part of a conscious and definable strategy.

PROBLEM SOLVING

Finally, the sixth theme of historic preservation in the future is its role in problem solving. Historic preservation plays a cooperative, creative, and productive role in solving existing community problems. In Savannah, a partnership created a brilliant model of preserving old housing stock and, at the same time, making it available for the low-income people of that region.

Historic preservation can offer practical solutions to larger development needs as well. In Washington, D.C., several years ago, Pennsylvania Avenue, which connects the Capitol and the White House, was in decline. A major process of redevelopment was guided by attention to historical realities, which included restoring the historic Willard Hotel and Old Post Office to their former grandeur. These and other projects were part of a larger urban development answer that preserved an important national asset in Washington.

These six themes are essential as we think about the challenges that confront our country, particularly as we bridge the two different visions of the country. I do not relate this in a spirit of flattery. These are not compliments brought to you by someone who wants to make you feel good about your work. Rather, I have seen what historic preservation can do for a multicultural community, one striving to come to terms with its past even as it defines its place in a more energetic future.

OPTIMISM AND RESPONSIBILITY

Let me recall some words that speak to the future in a very American way. They are the words of Senator Robert F. Kennedy, who was killed almost 25 years ago in a hotel in California. These words speak of two things: optimism for America's future and the acceptance of individual responsibility for creating it.

Our future may lie beyond our vision but it is not entirely beyond our control. It is the shaping impulse of America that it is not fate nor is it chance. Nor is it the irreversible tides of history that determine our destiny as individuals or as a nation. Rather, it is reason and it is principle and it is the work of our own hands.

Robert Kennedy went on to say, "There is pride in that, even arrogance. But there is also truth and experience. And in any event, it is the only way we can live."[1]

As we think about the future, we will create it in a more enlightened way if it is grounded in a respect for our history, our antecedents, our realities.

MULTICULTURAL BUILDING BLOCKS

Antoinette J. Lee

OVER THE PAST DECADE THE NATION HAS WRESTLED WITH THE PHENOMENON THAT IS VARIOUSLY CALLED CULTURAL DIVERSITY, MULTICULTURALISM, THE EMERGING MAJORITY OF MINORITIES, AND THE "BROWNING" OF THE NATION. THIS PHENOMENON IS EVIDENT ALL AROUND US. IT WAS DULY RECORDED IN THE 1990 CENSUS, CONTINUES TO BE ANALYZED BY DEMOGRAPHERS AND SOCIAL SCIENTISTS, AND IS GIVEN HUMAN DIMENSION IN THE MASS MEDIA. ONE ANALYSIS PREDICTS THAT BY THE YEAR 2000, ONE OF THREE AMERICANS WILL BE A MINORITY. THE SPEED OF CULTURAL CHANGE IN THE NATION BROUGHT ABOUT BY BOTH IMMIGRATION AND MIGRATION HAS PROMPTED ONE OBSERVER TO DESCRIBE AMERICA IN 1991 AS POISED AT THE "DAWNING OF THE FIRST UNIVERSAL NATION."[1]

The increasing diversity of the nation will affect the historic preservation field because it will alter the interpretation of American history itself and therefore modify what the nation values, what it wants to preserve, and how it preserves what is seen to be of value. Historic preservation itself can facilitate the process by which new participants assert their views and exercise control over cultural values important to them. Protected and preserved historic properties can provide a cohesive and stabilizing force to a society experiencing a dramatic transformation.

While most social scientists view the changing cultural contours of the nation as portending significant adjustments in American life, this view is not universal. Some observers believe that the current upheaval is a temporary phenomenon, somewhat like the wave of immigration from Eastern Europe at the turn of the century. Within a few decades after that era, the fear of deluge by seemingly alien cultures gave way to a reassuring sense that the melting pot had again triumphed.

Another view is that the influx of culturally diverse groups will result in a different kind of America, in which a European-inspired culture will share center stage with values from Asia, Africa, and Latin America. The United States will emerge, not as a melting pot, but as an American salad

bowl when these disparate ingredients are thrown together and made more palatable through a thin binder of oil. What is not clear is whether America will continue to present to the world a consistent society from ocean to ocean or whether it will evolve into a collection of hostile tribes in a strife-torn nation and resemble a crumbling Soviet Union or Yugoslavia.

The more desirable outcome is for cultural diversity to be recognized and honored, and for a unity to emerge from these differences. A recent *New York Times* editorial stated that our nation needs both more *pluribus* and more *unum*.[2] We must learn more about the many cultures that contributed to the development of the nation. America was founded as a nation of immigrants and continues to find its strength and coherence in this unique heritage.

Cultural diversity has resulted not only from immigration but also from barriers to full participation in the promise of America. America represents unifying themes such as equal justice, freedom, and the pursuit of happiness. For some groups in American society, however, these ideals have taken on the character of myth. Throughout American history, groups have been excluded from participation in the promise of America. The Japanese internment camp Manzanar is one glaring example of the denial of citizen rights to Americans. The history of African Americans in the United States is replete with other examples. As Langston Hughes once said, "America never was America to me."[3] Measuring the American reality against American ideals underscores the complexities and contradictions of the American experience.

Few institutions of government or the private sector will remain immune from the cultural changes taking place, many of which grow out of the social upheavals and U.S. foreign policy of the past quarter century. The reality of cultural diversity is fueling debates about appropriate education curricula. Multicultural-awareness programs are now an integral part of corporate training efforts, university orientation classes, and programs of state and local government.

Let me offer a few definitions. "Cultural diversity" is a fairly benign term that encompasses the celebration of the nation's ethnic roots. The popular autumn tradition of Oktoberfest, for example, celebrates cultural diversity. The term "minority preservation" most often is used when addressing the preservation of buildings and places associated with African Americans. It encompasses the struggles, triumphs, and tragedies of citizens of African descent in American history. The Stevens School in Washington, D.C., is an example of minority preservation; it was one of several historic school buildings constructed to serve black children as

part of the city's segregated public school system. In this discussion, I emphasize the word "multiculturalism" because it best expresses the issues of policy, control, and direction in the historic preservation field.

PRESERVATION'S TRACK RECORD

The historic preservation movement has a proven track record in recognizing and adjusting to multicultural forces. However, of all the measuring sticks used to assess the achievements of the past quarter century, the inclusion of the nation's minority groups in the national historic preservation movement has been one of the most challenging. Progress in this area can be gauged by the growing numbers of minority individuals involved and ethnic and minority projects supported. But because minority participation in the movement has not matched the pace of social change since 1966, many preservationists regard it as meager and have urged further action. However, we must ask, is it just the numbers of participants and projects that should be increased? Should not the preservation field instead assess the special requirements of the nation's culturally diverse groups and then decide how the field will allocate its resources to meet these needs?

Multiculturalism is not an entirely new phenomenon in preservation. The 1966 act first prompted interest in multicultural studies by recognizing properties of local significance. The trend gained steam nationwide during the Bicentennial in 1976, marked by the Smithsonian Institution's *A Nation of Nations* exhibit and numerous local history studies. In succeeding decades, preservationists have faced the need to address more than America's European roots and to fully explore local history and all of its ramifications.

Today the field incorporates a fuller social context for the understanding of our beginnings as a nation. The reconstructed slave quarters at Carter's Grove, just outside Williamsburg, Virginia, is one such example. Another is Weeksville in Brooklyn, New York, where the history of the Weeksville community was restored and interpreted to give young people a tangible reminder of the special place in which some of their ancestors lived. In Washington, D.C., the historic Sumner School—for many years the headquarters of the separate black school system—has been restored and converted into a public school cultural center.

Preservation today also embraces the new social history: community history, vernacular architecture, and artifacts of popular culture. New publications have been issued to assist the preservation field with understanding historic resources of minority ethnic groups. These included *Historic Black Resources*, published by the Historic Preservation

In the segregated South of 1940, this cafe in Durham, North Carolina, featured separate entrances for white and black patrons.

Section of the Georgia Department of Natural Resources, and *Five Views: An Ethnic Sites Survey for California*, from the California Office of Historic Preservation. In recent years, cultural conservation studies have outlined the need to protect both tangible and intangible cultural resources.

FACING THE FUTURE

These are essential building blocks for even greater multicultural historic preservation efforts. During the next quarter century, multicultural documentation and participation efforts will increase. However, if the historic preservation field is to fully meet the challenge of multiculturalism, it must anticipate changes in the environment in which the preservation process operates.

For example, while the United States has long been characterized as a land of immigrants who fled oppression, wars, and economic hardship, much of the multicultural phenomenon relates to the past 40 years. For example, the area of Arlington County, Virginia, known as Little Saigon contains the region's first concentration of Vietnamese immigrants, who set up businesses in the Clarendon neighborhood in the mid-1970s. Multiculturalism will require a greater focus on recent history and potentially historic places of that time period, encompassing the Korean War era, the Eisenhower years, the Cold War, the Kennedy-Johnson era, Vietnam, and the eve of the Nixon administration. All of these witnessed foreign and domestic upheavals that changed the nature of immigration to, and settlement in, the United States. More recent events, too, have had an impact. For example, the New Florida Bakery in the Miami neighborhood called Little Haiti exhibits the imprint of the very recent immigrant experience of America's Haitian community. Although the marks of such recent immigrants have yet to meet conventional standards of history, we must ask: should the historic preservation field

be recording these initial adaptations to the American scene?

The focus on the recent past will pick up the threads of earlier American history, including the arrival of other ethnic groups and the experience of American Indians throughout the past four centuries. Together with the old places, newer communities offer glimpses into numerous ethnic pasts. Chinatowns across the nation are common evidence of the early Chinese in America. Butte, Montana, still holds evidence of its rich ethnic stew—the Italians, Finns, Irish, Welsh, Chinese, and Serbians who were all drawn to the area's rich copper mines at the turn of the century. The enclaves these groups created endure today and illustrate how a degree of voluntary cultural separatism enriches a community's character.

Multiculturalism is a topic that can be identified in nearly every corner of the nation. However, according to the report of the United Way of America, *What Lies Ahead: Countdown to the 21st Century*,[4] multiculturalism as a phenomenon will not be evenly spread throughout the nation or confined to cities. The greatest growth in immigrant population will be concentrated in states such as California, Texas, Florida, Illinois, New York, Connecticut, and Rhode Island. It is estimated that the African American population will be concentrated in a few states.

The historic preservation field should better understand the geographic distribution of recent immigrants who identify with the multicultural phenomenon. If real progress is to be made in this area, preservationists also should see that a greater proportion of resources is allocated to states with the greatest concentrations of foreign-born and minority citizens.

The increased demands of minority and other ethnic groups for an equal place at the preservation table will require a clarification of the groups that can claim this status. Because of their long history in the United States, African Americans have long been the best organized and readiest minority participants in the historic preservation movement. However, the field must also embrace those who trace their heritage to Southeast Asia, Eastern Europe, Central and Latin America, and the Caribbean. These groups not only represent powerful forces in a community, but they also are creating their own architectural forms. In Miami's Little Haiti, for example, a new market structure takes its inspiration from similar market buildings in Haiti.

The nature of professional work in the preservation movement also promises to change because of multiculturalism. There is little that traditional architectural and historical analysis can bring to a purely functional building, such as the Eden Center in Falls Church, Virginia, where a significant Vietnamese community has concentrated its businesses and social and cultural activities. The historical resources of ethnic groups may be best addressed by the entry into the historic preservation professions of more social historians, anthropologists, and ethnographers. A more interdisciplinary view of culture may also help in documenting, evaluating, registering, and protecting significant properties or reminders of the immigrant experience.[5]

As the historic preservation movement grows and embraces more historical themes, special-interest groups will assert competing claims to limited historic preservation resources. They will lobby for programs to benefit their own cultural groups rather than the national historic preservation program as a whole. They also will ask the historic preservation movement to make difficult choices, such as which of two equally compelling projects to fund: one, a community history of a European-settled, midwestern town such as Linden, Michigan, or the other, a study of historic resources of the Cuban community in Miami.

DIVISION OR UNITY?

The most crucial issue associated with multiculturalism is to what extent it supports or hinders national unity. Most observers acknowledge the need to recognize the contributions of the nation's many cultural groups while at the same time adhering to basic Western ideals on which the nation was founded. This also appears to be the historic preservation movement's general approach to cultural diversity.

The moderate point of view is challenged by two extreme positions. One supports a monolithic, collective identity and argues that it is the Western-oriented culture that has held together the diverse nation. This view suggests that challenging the supremacy of Western culture and heritage will reduce America to a loose confederation of hostile tribes, unable to agree on common principles.

At the other extreme is radical individualism, as represented by advocates of Afrocentrism and revisionist history. Proponents of Afrocentrism contend that the education of African Americans should be based on African history and culture. Only then, they say, can African Americans gain the confidence and self-esteem needed to function effectively in contemporary society. Revisionist historians want to impute the darkest of motives to the explorations of Christopher Columbus and the conquest and settlement of the American West, both formerly unifying themes in American history.

The answer lies somewhere between the two extremes, on the middle ground held by many professionals involved in cultural conservation activities. *Who* is formulating policy is as important as *what* is being conserved. There is gen-

eral agreement that people of color must be included in policy matters and that standards must be adjusted to gain what has been termed "cultural equity."

Multiculturalism need not be equated with social discord. It may offer important lessons in the adaptation of human beings to a complex, industrial society. Some theorists draw a parallel between the recognition of cultural diversity and the protection of biological diversity. The latter generally is believed to be essential to the sustenance of life on this planet. Support of cultural diversity may be similarly critical to the continuing vitality of our social and economic life, because local cultures tend to exhibit superior resiliency. Cultural diversity celebrates those traditions that have successfully eluded an oppressive cultural uniformity. It affirms people's right to preserve their cultural identity and to control their own cultural development. With control of cultural resources resting in the hands of those most affected, cultural diversity promises productive and positive lives.[6]

Back in 1976 the Smithsonian Institution's Bicentennial exhibit, A Nation of Nations, marked a memorable watershed in the recognition of America's diverse cultural roots. In its timing, the exhibit ushered in the dramatic change in the nation's cultural makeup. Since that same time period,

when minority projects made up a small fraction of preservation efforts, a comparative flood of cultural diversity efforts has washed over the historic preservation field.

While these projects still represent only a small segment of preservation activities, as a group they acknowledge the diversity of voices that make up the American nation. These multicultural projects convey the message that to be an American, one must acknowledge the pluralistic nature of American culture. Only with this understanding can citizens fully appreciate the rich and varied tapestry of their national heritage. Only then can the nation transcend one group's experiences and acknowledge the larger, shared identity.

Historic preservation addresses the most public of reminders of the American past. Protected historic districts, historic house museums, battlefield parks, and survivors of innovative technology of the past serve as touchstones of a common national experience. This past is not just history, but the foundations of the dynamic American culture of the present. American culture continues to demonstrate its power across the great expanse of the United States and in all corners of the globe. It is this foundation that will transport Americans, regardless of national origin, together through shared experiences to a common future.

CARING FOR OUR COMMUNITIES

Kenneth B. Smith

Historic preservation has a vital role to play in our inner cities. I know, because that is where I have spent all of my professional life. Although I now serve a theological seminary, I have spent 25 years of my ministry as a parish minister in one or more neighborhoods in Chicago. The 16 years before my current post were devoted to serving a local church in a devastated area of Chicago's Mid-Southside.

Over the course of my years in the city, I have seen Chicago change graphically, in terms of both its neighborhoods and its people. I have seen once thriving neighborhoods become vast wastelands, and a city grow as divided by class as it is by race. I have observed the transformation of the dialogue on race from one that primarily involved African Americans and whites to one that now also includes the rapidly growing Hispanic and Asian populations. Managing this diversity has become an elusive, sometimes painful, and challenging enterprise. Like most urban centers, Chicago faces enormous problems. While my experiences have been in urban America, I have seen some of the same decay in small towns and rural communities. In all such areas I have observed the decline of the sense of community, the loss of a collective memory and wonder, and—too often—an inability to engage in civil discourse amid competitive forces.

Writing in *Urban America: Crisis and Opportunity* more than 25 years ago, the editors, Jim Chard and John York, said:

The city, as such urban commentators as Jane Jacobs, Lewis Mumford, and Victor Gruen have pointed out, is nothing without diversity. Indeed, perhaps the magnetic force which draws people to the metropolis is the freedom it provides for the wondrous, myriad human energies and inspirations. The whirl of colors, cultures, surprises, fashions, and enterprises lend support to and take inspiration from one another. But somehow the ideal of a harmonious relationship between men/women and their creations has been distorted.[1]

The words in this passage from more than two decades ago still ring true.

I have always believed that we are called on as thinking, feeling, and engaging human beings to share in the building of the human spirit and to work for an improved quality of life. As a churchman and minority, I have spent my life

trying to do both, sometimes succeeding modestly and at other times failing grandly. I learned long ago that whatever modest successes one experiences come out of engagement with others. I have also learned that at the heart of my efforts are a search for community—for collective memory, heritage, and wonder—and an effort to restore civil discourse.

To begin the search for community, we must first agree on what it means to be human and how to engage in human action. In his essay "Enlarging Human Freedom," Joseph Hough of the Graduate Theological Union in Claremont, California, discusses the insights of the late Swiss theologian Karl Barth. He reminds us of Barth's three conditions for truly human action:

First: *Is the eye to eye relationship. We have to see one another in order to be human in relation to one another.*

Second: *We have to engage in mutual speech and hearing. We would have never gotten out of the cradle if we had not had someone to hear us and someone to whom we could address ourselves.*

And the third *is mutual assistance. None of us can exist by our own efforts alone.*[2]

"Mutual assistance," Hough goes on to say, "means more than simply helping the beggar on the street corner. It also means addressing ourselves to the large social questions of our times which act as limitations on human freedom."[3]

Therefore, as a churchman and minority person attempting to build community, I have had to engage not only my brothers and sisters, but the larger community as well. This has meant speaking and listening. It has meant providing mutual assistance as we addressed and continue to address the larger social issues.

And what are these problems, these issues that appear so intractable, that rob persons of humanity, and that make it so difficult to achieve genuine community? They are

- disintegration of family life
- economic deprivation, resulting in widespread joblessness and dependency
- overburdening of public schools by "at-risk" children, whose problems they are neither equipped nor funded to meet
- inadequate health care and ignorance of preventive health (both of which have led to recent new outbreaks of measles in young children and tuberculosis in adults)
- violence and crime, which render entire neighborhoods unsafe for children and adults alike

Marian Wright Edelman, president of the Children's Defense Fund, writes in her volume *Families in Peril: An Agenda for Social Change*:

Change requires very hard work that must be sustained by a deep caring about the needs of those who lack a voice in our society and

about our national mission in a world plagued by hunger, joblessness and malnutrition.[4]

The first step in bringing about change, says Edelman, is "caring."

The second step is trying to see a problem whole and then breaking it into manageable pieces for action. The third step in being effective is recognizing that affecting change is not a one-shot effort.[5]

PRESERVATION AS CARING

Building community has always led me and others to focus on some of the problems mentioned above, and I, like Edelman, have learned that solutions cannot be achieved with a one-shot effort. The importance of caring, however, cannot be stressed enough. It is in this caring category that the historic preservation movement can be most helpful in marginal, minority neighborhoods. The preservation movement is not designed to tackle many of the social problems confronting residents of these areas. I would not want to see us get involved in education or health-care reform. There are many groups already working on these agendas. But preservation could make a contribution to housing and economic restoration. Within the preservation movement, there are those who know how to restore housing and even small commercial districts. Focusing on these two areas alone could help stimulate economic development and reduce crime. Crime festers in areas of economic desperation. People who have a choice will not stay in these areas for long.

We already know what one block of restoration can do for a neighborhood. It creates a ripple effect. A good example is a one-block area of West Jackson Boulevard on the city's west side. Another example of intervention is a project in our city pioneered by the National Trust for Historic Preservation and called Inspired Partnerships. This project helps leaders of local churches and religious institutions care for their buildings. Preserving these institutions, which serve as centers for community life, will enable them and their members to work on neighborhood problems.

What all of this "caring" means is that we must explore anew ways to develop coalitions with groups such as churches and community-based organizations if we are to have greater impact in minority communities. We must come down on the side of building community as an expression of our caring. The preservation movement can contribute to the building of community, to the building of relationships among people, to the infusion of a sense of pride in who people are and where they live.

Indeed, we do not live by bread alone. To be fully human means caring for one another and the environment

Joblessness resulting from economic deprivation is a major obstacle to rebuilding America's historic communities.

in which we live. We live by caring, hoping, showing courage, and sharing, among other things, our common memory and heritage. Building community then means sharing in the mutual feeding of the spirit and confronting sores that eat away at it.

YEARNINGS OF THE SOUL

Why am I—a clergyman, theological educator, and minority person—involved in the historic preservation movement? I am involved, as others are, because preservation provides a channel to connect with a heritage that I can share with others. It enables me to connect with a history of a period that I share with other citizens. It speaks to the yearnings of the soul. It enables me to satisfy my cultural and aesthetic needs. A historic building, estate, or district offers me concrete evidence of some of the noble dreams of individuals who have passed on. Preservationist W. Brown Morton III was correct when he said:

We must come to understand that historic properties taken together constitute the cultural heritage of the nation, and form, therefore, a common trust.[6]

To dream is to wonder. Wondering is at the heart of the question: Who am I? This is a profoundly theological and psychological question. People have always searched for identity, for their roots. Knowing who we are and from whence we have come provides authentic affirmation.

History is not "bunk," as Henry Ford is thought to have said. History is the record of the past, of people's interrelationships, of our humanity and inhumanity toward one another. People who do not know their history will likely repeat the same mistakes. Conversely, people who know their history find that tapping into the deep reservoirs of their cultural traditions gives meaning to their being and their pilgrimage. People who know their history recognize that we never lived by bread alone.

Preserving our national treasures in the form of buildings is one of the ways in which we can nourish our souls. Preserving districts does the same for us. Such activity not only preserves a heritage but also promotes a common memory and excites our sense of wonder.

The challenge that we face in the preservation movement is whether we can pursue such work while helping minorities instead of proceeding at their expense. Like residents of all neighborhoods and communities, minorities must connect in their search for meaning. This search for rootedness, this quest for wonder, is part of what philosopher Martin Buber identifies as the "I-Thou" relationship. Every religious building, whether or not it is a historic or architec-

tural jewel, and every place where authentic worship takes place symbolizes this search.

Robert Lynn, the retired vice president of the Lilly Endowment, once said, "The church and the tavern are most often the last institutions to leave a neighborhood." He was commenting on something more than their physical presence; he was speaking to the spiritual and emotional signs of community in otherwise despairing neighborhoods.

RECAPTURING THE CIVIC DISCOURSE

Finally, how do we revive the civic discourse in what is rapidly emerging as a multicultural nation? A strong critique of multiculturalism and its literature has emerged in none other than Arthur Schlesinger, Jr., noted historian of the development of these United States. The author of 14 books including *The Disuniting of America*, Schlesinger argues that "multiculturalism threatens the ideal that binds America." He goes on to state that "the United States escaped the divisiveness of a multiethnic society by the creation of a brand-new national identity. The point of America was not to preserve the old cultures, but to forge a new American culture."[7] Schlesinger readily admits that our relatively young national experiment has always been multiethnic. He quotes Hector St. John de Crevecour, "who came from France in the 18th century, who marveled at the astonishing diversity of the settlers—'a mixture of English, Scotch, Irish, French, Dutch, Germans, and Swedes.'"[8] Schlesinger also readily admits the presence of deep-rooted racism toward all people of color, and ends his essay with this challenge:

The growing diversity of the American population makes the quest for the unifying ideals and a common culture all the more urgent. In a world savagely rent by ethnic and racial antagonisms, the United States must continue as an example of how a highly differentiated society holds itself together.[9]

The historic preservation movement can play a major role in recapturing the civic discourse. It can help by doing what it knows how to do best. It can join with people and communities of color and share its expertise in helping them preserve what is of essential and historical value to them—and, by extension, to the whole of our nation.

What critics of the current multiethnic discussion miss is that when people feel left out of history by design, when they and their achievements are ignored, treated as though they were invisible or nonexistent, they will create enclaves of their own. Such enclaves, with their appropriate rituals, provide a context for self-affirmation and esteem. When a people and a community believe that who they are and what they

have created—in literature, organizations, buildings, and neighborhoods—are important to the whole, they can then bring them as gifts to the table and share in the civic discourse.

Paul Gray, writing in *Time*, raised this series of questions:

Do Americans still have faith in the vision of their country as a cradle of individual rights and liberties, or must they relinquish the teachings of some of these freedoms to further the goals of the ethnic and social groups to which they belong? Is America's social contract—a vision of self-determination that continues to reverberate around the world—fatally tainted by its origins in Western European thought?[10]

These questions point us toward the issue of the civic discourse. I mention this issue repeatedly because I earnestly wish to have all of us share in such discourse. I wish to have us appreciate the multifaceted history and heritage of the peoples who make up these United States. I yearn for all the people of this nation to share the continuing effort to build what colonial Massachusetts Governor John Winthrop called "the shining city on a hill."

BUILDING THE SHINING CITY

The preservation movement, with its concentration on the jewels of our heritage, can be in the forefront of initiating not only the civic discourse, but also the continuing effort to build in this land "the shining city on the hill." Here's how:

- It can understand and help redress the pressing social problems that confront many minority neighborhoods
- It can introduce the history and values of preservation to historically African American colleges and universities. These institutions are repositories of both the local and national history of a people
- It can work to make certain that restoration and preservation do not automatically mean removal of minority persons
- It can encourage the development of local government policies that are sensitive to low-income and elderly minorities
- It can help local communities discover that preservation can contribute to affordable housing and revived commercial districts
- It can work to change the widely held perception that historic preservation belongs exclusively to the elite and the affluent

These suggestions could go a long way toward helping this movement widen its circle of participants, thereby making it stronger and more representative.

In our rapidly growing multicultural nation, we must work at having civil discourse. This cannot happen if there is no genuine respect for difference and for people of color, with their pain and their promise.

I agree with H. Grant Dehart that we are talking about values in the historic preservation movement. As a clergyman and one involved in theological education, I am particularly interested in the issue of values. Values, however, must consider the experiences and history of people. These shape their values.

But the preservation movement is also about the building of the human spirit. Our need is for more than the material, more than the concrete. In the larger sense, our need is spiritual. Preserving significant architecture or buildings of historical importance satisfies the same need as listening to good music and admiring beautiful paintings. Such experiences feed our souls. We need to dream dreams.

In his series of lectures at Trinity College in Hartford, Connecticut, contained in a little book entitled *Between Dystopia and Utopia*, Constantinos A. Doxiadis, the Greek architect-philosopher, had this to say about dreams:

. . . Dreams are necessary and they must precede the technological achievements. Progress is based upon dreams which mobilize the mind, cause discussions, start movements, and lead to realizations.

But we do not dream a whole, although the common man always dreams and has no chance to see his dreams realized. In a New Yorker cartoon, a man in a travel agency, with depression on his face, was asking for a ticket to Shangri-La, and the agent, turning to his colleague, asked 'How can I tell him that there is no such place?' Our society does not dream although we badly need common dreams and their realization.[11]

The historic preservation movement is in part about preserving the dreams of men and women of the past for the benefit of those in the present and future. This movement has rightly recognized the importance of preserving these expressions of the human spirit because they uplift us and society in general. What the historic preservation movement does for us is more than preserve our heritage, our past. It nourishes the spirit. It can be joy! We want it to be the same for all groups as they consider preserving the richness of their history.

In his *Surprised by Joy*, C. S. Lewis closes out his marvelous account of his conversion:

When we are lost in the woods, the sight of a signpost is a great matter. He who first sees it cries, 'Look!' The whole party gathers round and stares. But when we have found the road and are passing signposts every few miles, we shall not stop and stare. They will encourage us and we shall be grateful to the authority that set them up.[12]

The historic preservation movement provides the signposts, and when we see them, we too are "surprised by joy!"

THE URGENCY OF URBAN PRESERVATION

Patricia H. Gay

IN 25 YEARS THE URGENCY OF HISTORIC PRESERVATION HAS GREATLY INTENSIFIED. CONTINUED DESTRUCTION OF THE HISTORIC URBAN ENVIRONMENT HAS PUT AMERICAN CITIES, AND THUS OUR CIVILIZATION, AT RISK. PRESERVATION IS AN UNDERUSED SOLUTION FOR MANY URBAN PROBLEMS. ITS EFFECTIVENESS IN STEMMING THE DECLINE OF SMALL TOWNS AND BIG CITIES SHOULD BE MORE FORCEFULLY ARTICULATED.

With the urgent need for preservation comes urgent challenges for nonprofit preservation organizations. It was not enough in 1966 to stop further federal government-sponsored destruction of our nation's historic urban environment. The impact of the destruction already complete still has not been addressed and continues to cause more blight and disinvestment. In New Orleans, for example, the racially mixed Creole neighborhoods did not die immediately when they were bisected in the mid-1960s by an elevated expressway that also destroyed the longest stand of live oak trees in the world. Neither did they breathe their last when 11 square blocks were bulldozed for a cultural center that was never built. But the neighborhoods have been bleeding ever since from these wounds.

The assault-and-neglect cycle has so accelerated in most of our cities that a national news magazine recently headlined the question, "Are Our Cities Obsolete?" Certainly San Francisco is not. Why does this city thrive? The built environment and the density and diversity of its population are the two most critical factors in its viability and the success of its largest industry: tourism. Examining how much residents fuel the economy in San Francisco and other successful cities may offer a lesson for less viable cities.

To its discredit, the news magazine article did not address the fact that our civilization is imbedded in our cities, and that without them *all* people will suffer, not just the urban poor. There was no mention of the historic built environment— no regret over its destruction, no understanding of its loss as a cause of urban decay, no vision of its potential for reversing decline. Such distorted national coverage cannot be ignored. It makes the efforts of local preservation organizations more difficult and can lead only to more disinvestment.

The failure of local entities to understand the needs of the city as a whole and the role of its buildings has also increased the burden on local nonprofit preservation organizations. These problems are typical:

- Downtown development organizations have little to do with surrounding neighborhoods, and few have succeeded in saving or reviving their main streets
- Chamber of commerce groups focus on generating jobs, often without considering that when the unemployed get jobs, they will move out, and when new employees move to town, they really move to the suburbs
- Low-income home ownership groups steer home buyers away from "risky" neighborhoods
- Welfare and social service organizations provide stopgap services to the poor, with no real impact on the problems inherent in the city
- Community development corporations, although they use a commendable "bottom-up" strategy, tend to inhibit their own efforts by ignoring the crux of the problem—the exodus of middle-income residents who once supported now-defunct businesses and maintained now-vacant properties
- City planning reflects only what citizens want, which is often uninspired, uninformed, and ineffectual

FILLING THE VOID IN THE "DOUGHNUT"

So there it is. In its dedication to the historic built environment, the citywide preservation group, filling a void, has emerged in the past two decades as the group most committed to saving the city and the group most likely to counter the "doughnut" concept of city planning, perhaps better described as the "sinkhole" or "retreat to the hills" concept. By encouraging renovations in urban neighborhoods, regardless of residents' income or race, preservation nonprofits are also the only organizations working against the emergence of what urban affairs columnist Neal R. Peirce has called our own form of apartheid. Either the fight continues or we must accept what Atlanta Mayor Maynard Jackson recently said on national television: "We are a nation of failing cities; therefore, we are a failing nation."

European architect-philosopher Leon Krier called American cities "places of damnation," and apparently there has been no great hue and cry to dispute this allegation. After all, most of our old cities continue to lose population as urban poverty grows, education levels decline, crime escalates, and our rich cultural heritage erodes further. Racial polarization, including hate-mongering and violence, is becoming more and more of a problem in our cities and metropolitan areas.

Dismissing American cities, Krier maintains that the real issue is how our cities "impinge" on other cities. Those more fortunate American towns and cities that may not actually be places of damnation should be concerned that the problems of others might indeed impinge on their own vi-

ability. Problems and trends travel, neighborhood to neighborhood, city to suburb, city to city, and even country to country, according to Krier. In fact, many problems in San Francisco—the shrinking middle class, the rise in crime and homelessness, and the negative impacts of tourism—might well be attributed to national trends. What spoils the Vieux Carré, Krier contends, are the suburbs—not just in New Orleans but everywhere—as hordes of people visit, but do not chose to live in, the few cities with living centers.

PRESERVATION AS THE STRATEGY

Preservationists always knew that more than the fate of buildings was at stake. We now have many local and national historic districts; in fact, the historic districts of New Orleans alone contain 40,000 buildings. But this is not enough! Destruction of historic buildings and neighborhoods continues to be a major factor in almost all urban problems. Conversely, preservation of historic buildings provides a strategy to alleviate the problems. Preservationists know that
- building renovations generate jobs
- building renovations improve property values
- new residents support local businesses, generating more jobs
- incentives for historical renovation work
- new homeowners bring hope and commitment to previously hopeless neighborhoods
- crime is reduced when there is hope and pride in neighborhoods
- the middle class can be increased by using historic buildings to attract homeowners and businesses to the city
- healthy historic neighborhoods improve a city's business, tourism, and residential image
 Here is a strategy that works:
1. Stop destroying neighborhoods
2. Make a commitment to saving neighborhoods by giving homeowners, regardless of income, even a minor incentive to renovate. Focus on the middle class
3. Market the architecture, the conveniences, the spirit and the rich cultural heritage of historic neighborhoods

This is how our Operation Comeback program works in New Orleans. Another step is to articulate more forcefully the impact and potential of HUD and FHA programs. Both have contributed to the failure of our cities and continue to do so. Both have potential to help.

Unfortunately, civic leaders seldom use historic preservation as a strategy and are just as likely to oppose it. We are all aware of the ways a city can destroy a neighborhood. Civic leaders' failure to grasp the potential of the remaining historic urban environment for economic development and

an improved quality of life for all citizens is alarming. It is unconscionable not to use every resource available to help our failing cities and the urban poor, who are more and more abandoned in cities with fewer and fewer resources.

There is no groundswell of preservation understanding and support among the American people, their leaders, and the media, even though the federal Section 106 review process is now in place, the number of local preservation commissions has grown from just over 100 in 1966 to about 1,700 in 1991, and federal preservation incentives have worked as hoped and better. After all, the successful tax incentives were almost lost, and of course, the bricks-and-mortar grants are, for the most part, long gone.

NONPROFITS AT THE BARRICADES

Fortunately, nonprofit preservation organizations, working on their own and in partnerships, have redoubled their efforts and can claim remarkable accomplishments over the past quarter century. Nonprofits usually operate in four program areas: actual building renovations and special projects, assistance to others, advocacy, and community awareness. Because all program areas reinforce each other, the best nonprofits include each. By far the easiest to fund are special projects, but these have limited effectiveness without increased community awareness and advocacy.

For all of their efforts, however, most local nonprofits today face increasingly deteriorated main streets and neighborhoods. In New Orleans, commission budgets have been cut, even though additional National Register neighborhoods seek local protection. Even neighborhoods saved from destruction are at risk—because of overuse. The Vieux Carré district, established in 1936 (when New Orleans became the second city in the country to create a local historic district), is a case in point. Today the overcommercialized tourist area is one of the few arenas—including riverfront festival marketplaces and urban automobile races—to draw suburbanites who apparently long to come together in cities they have fled. City planners and the tourism industry fail to apply successful preservation principles of the Vieux Carré to other historic neighborhoods. They increase public funds for marketing tourism in a single National Historic Landmark neighborhood, blind to the potential of the other historic neighborhoods and the problems of confining more and more tourists to a single area.

Other ironies impede preservation efforts at the local level. These include the failure to use historic housing renovation as an economic development tool when most cities are desperately searching for ways to improve the economy. In most cities, the housing office, where many preservation incentives might be implemented, is totally separate from the economic development office; economic development and preservation are rarely goals in housing programs.

It is also ironic that preservation programs are perceived as irrelevant—or detrimental—to the plight of the poor. The poor stand to benefit most from the improved neighborhoods, economic development, and city services that a successful preservation program would generate. Perhaps even more critical is the social mobility that a middle class provides, essential to alleviating poverty and homelessness.

The issue of displacement provides another irony. Displacement occurs when neighborhoods are not stable and when buildings deteriorate to an uninhabitable state. Displacement occurs when residents of any income level are forced to move out because of crime. Historic preservation is a means of stabilizing neighborhoods and putting people in decent housing. Even though we very well may have become, as Mayor Jackson says, a nation of failing cities, we rarely acknowledge that the decline of the urban middle class is a major factor. We almost never take action to increase the urban middle class, because of the risk of displacement.

Fear of displacing the poor is sometimes carried to extremes. Grass-roots preservationists face opposition when they propose attracting home buyers—any home buyers—to blighted historic neighborhoods, even though this would be the single most beneficial means to reverse poverty and decline and the least likely to accelerate property values, causing displacement. This problem must be debated openly. Just what is the position of those who oppose efforts to help individuals buy and renovate a house in a deteriorated neighborhood? The implications are that they

- oppose diversity, because failure to stem decline results in the spread of poverty and the likelihood of a segregated, homogenous neighborhood, polarized against others
- condone the outright destruction or carving up of valuable historic property too large to be affordable by low-income buyers
- believe that they have a right to deny others the opportunity to buy and renovate a historic house and enjoy the convenience of urban living

The urgency of the problem demands that we become more outspoken about our cause as we formulate our program goals in the coming years.

The immediate future of our cities is crucial if they are to survive. Preservation can and must play a role in urban revitalization. The need right now is for more outspoken discussion about the potential for using the remaining historic built environment as a resource to save our nation's cities, to prevent social and economic polarization, and to perpetuate the best of our civilization for future generations.

THE PENNSYLVANIA
FIRE INSURANCE COMPANY

MANAGING GROWTH WITH PRESERVATION

Christopher J. Duerksen

AS PRESERVATIONISTS LOOK TO THE NEXT 25 YEARS AND PONDER HOW THEY CAN SHAPE COMMUNITIES IN A POSITIVE, IMPORTANT FASHION, THERE WILL BE A GREAT TEMPTATION TO SET STRATEGIES BASED ON PROGNOSTICATIONS ABOUT WHAT THE WORLD WILL LOOK LIKE IN THE YEAR 2015. BUT IF THE LAST 25 YEARS TEACH US ANYTHING, IT IS TO BE EXTREMELY WARY OF POSITIONING OURSELVES BASED ON WHAT THE EXPERTS THINK WILL HAPPEN.

After all, the track record of demographic and economic forecasters in the 1970s and 1980s is breathtakingly bad. Here are just a few of the more egregious miscalculations that erstwhile crystal-ball readers offered—and many communities relied on in crafting growth-management and development plans:

- People will flee from the suburbs and cities to rural areas—the so-called back-to-the-farm movement. They will search for their roots and settle in small towns. They will revitalize these areas. (In truth, the migration to rural areas ended about as quickly as it started. Today the United States is more urban than at any time in its history, and most growth is taking place in the suburbs. Many rural areas are dying.)
- The energy boom will continue. It will pump billions of dollars into oil-producing states in the West and South. (Of course, the energy boom faded as the price of oil dropped. States such as Louisiana and Oklahoma lost population in the 1980s and faced huge budget deficits.)

The list could go on, but the message is clear: preservationists and their communities must plan for change—boom, bust, or even both—in the next 25 years, rather than trust the confident projections of those who seemed to have missed the most important trends of the past two decades. National and international economics, demographics, and politics are all too unsettled to base community planning efforts on them with any modicum of certainty. After all, who would have predicted in 1980 that by 1991, peace would have broken out? If preservationists want to be effective, they must position themselves and their programs to react nimbly and flexibly to a changing world.

Does the lack of predictability in the country argue against any sort of planning or setting of preservation strategies? Not

necessarily. But we must move forward carefully and ask: What are some of the forces that we can expect to continue to shape our communities? And what realistically can we do to position preservation policies to succeed? These trends, at least, are fairly clear:

- Immigration and population growth will continue. We can expect at least another 20 million Americans by the year 2000. The population will be aging, as well
- Economics will become more global. Our economy and those of other countries will become increasingly interdependent and increasingly decentralized
- Governmental fiscal constraints will be a given. Not only will the federal government continue to grapple with huge deficits, but state governments—43 of which are running significant deficits this year—also will not be able to pick up the slack as they did in the 1980s
- New technologies will continue to have an impact. Increasing computerization and high-tech communications will alter working and living patterns. Other technologies, such as microseptic systems, may enable people to live in remote areas but may put increasing growth pressure on sensitive environments

As in the 1980s, changes over the next 25 years will be uneven. Some areas will boom, some will bust, and more than a few will do both in the 1990s. California expects its population to grow beyond 40 million—more than twice that of any other state—by the year 2010. Oklahoma, like many rural areas, lost population in the 1980s, and the prognosis for the 1990s is more of the same. And in many states such as Colorado, existing population centers along the Front Range will grow while more remote agricultural areas will wither.

Not surprisingly, local and state governments will respond differently in different places in an attempt to manage change. Their adroitness in managing this change will separate the winners from the losers. This challenge seems daunting to citizens concerned with wise land use and preservation policies.

Powerful attitudes towards growth and change that have been formed since 1970 will continue to exert a powerful influence on development patterns. These attitudes include
- a hunger for distinctiveness
- a gnawing dissatisfaction with the quality of new development to an extent that in many places, old is reflexively preferred over new
- a recognition that development must "pay its own way," given the end of federal subsidies for development and state tax limitation efforts

- a growing resolve that uniqueness and quality can be translated into an economic advantage

PRESERVATION'S QUIET REVOLUTION

What do these trends and attitudes signal for future preservation efforts? First, in the face of a supposed antigovernment uprising in the 1980s, growth management and land use planning remain alive and well in most places. Doubters need only look to Houston, where zoning has been embraced and scores of land use planners are being hired by the city. While few communities say no to development, more are seeing sound growth management as smart policy, not only to maintain or improve the quality of life, but also to foster a sound economic development climate.

An important fact is that preservation seems to have thrived more than any other area of land use management. While there is widespread lamentation over the scaling back of federal tax credits for rehabilitation, in reality this was a minor setback. The real story since 1980 is a quiet revolution in preservation, one of enormous import. Here is the proof:
- Hundreds of new local preservation ordinances have been enacted and hundreds more given real teeth to protect historic resources
- State preservation laws have mushroomed, including many that give state agencies real authority. One example is recent legislation enacted in Kansas that is as strong as any federal preservation law. Moreover, a growing number of states call for historic preservation elements in local land use plans
- A bevy of new state and local financial incentives runs the gamut from income tax incentives for preservation (Colorado) to property tax reductions for historic properties (Oregon)
- Efforts have increased so tremendously to protect archeological sites, particularly at the federal level, that archeology has become a growth industry, especially in western states

Perhaps the real litmus test of the movement's success is the recognition it has received in popular literature. In a scene in Tom Wolfe's best-selling *Bonfire of the Vanities* (New York: Bantam Books, 1988), the main character is engaged in a political battle with a church official. To get back at the churchman for crossing him, our hero calls a friend at city hall and says, "Mort? You know that church, St. Timothy's? . . . Right . . . Landmark the son of a bitch!!"

Opposite: This proud Gothic Revival office building in San Antonio underscores the powerful economic potential of preservation.

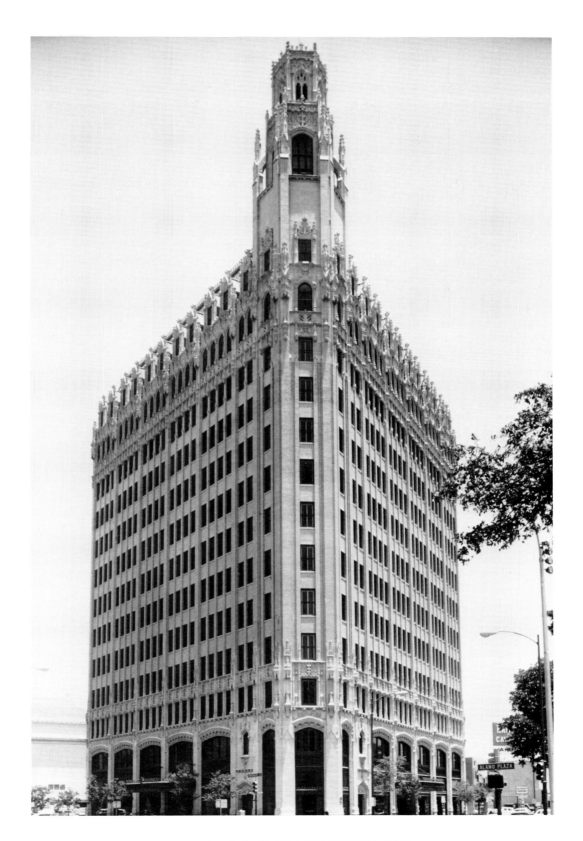

Can we expect similar progress in the next decade? Will strong people quake at the mention of preservation? Can we expect any breakthroughs or startling developments in the coming years? More likely, we will see a continuing series of small victories in a continuing quiet preservation revolution at the state and local levels. But there are areas where we have great opportunities to break new ground.

There is a growing recognition among preservationists that we are not an integral part of the process of managing change in most communities and states. Preservation ordinances and commissions are, more often than not, appendages of the growth-management systems rather than integral, coordinated parts.

In the 1970s and 1980s, we swept local preservation matters out of the dusty corners of historical museums and brought them to the more sophisticated world of preservation commissions. The advance was important, but now we see its shortcomings. We have found that it does little good, for example, to have strong landmark regulations in a downtown when the underlying zoning densities encourage demolition. We have learned that our energies are wasted in protecting a historic mansion in the countryside when local growth-management laws allow creeping suburban sprawl to clutter the environs with fast-food restaurants and car-repair shops. The movement's major thrust in the next decade must be to deeply imbed preservation values, goals, and tools into the land use management and zoning systems at the state and local levels.

We must also think of new ways—short of the traditional command-and-control approach of most preservation ordinances—to preserve what we value. This is not to say that strong laws are not needed in many situations. However, many old neighborhoods rate our attention and protection, but not the often excruciatingly detailed control that traditional preservation ordinances require. There have been some promising experiments in a number of places with conservation districts that address only a few key design features, such as height and setbacks. These experiments avoid the nit-picking syndrome, a congenital disease that all of us preservationists seem to carry in our genes.

We also must not shy away from trying to shape suburban growth and "edge cities" in a more humane and efficient fashion. After all, this is where the bulk of growth will occur in the 1990s, just as it did in the 1970s and 1980s. Here, we must be careful not to be condescending in our efforts, because like it or not, people are moving to the suburbs for a reason—better schools, more open space, or less crime.

But the design patterns of historic areas have great potential to act as templates to shape suburban development in a way to make these newer communities more pleasing and more livable. Imagine suburbs with grid street patterns and real street addresses to guide visitors. Imagine buildings that embrace the street rather that sit on the horizon in a sea of parking. Imagine handsome parkways that people actually enjoy strolling along, and jobs and shops located near homes—some even within walking distance. These are the living elements of our best historic districts; these districts can be living laboratories of neighborhoods that work, worthy of emulation. This is important stuff, for after all, the best suburbs of today will be our historic districts of tomorrow.

Another area offers tremendous promise: the powerful economic potential of preservation and heritage has been tapped fully only in a few places. There is much talk and debate today in the preservation world about tax incentives and other direct inducements to stimulate preservation. These will continue to play an important role, but new initiatives will be difficult to come by in an era of stringent financial constraints at all levels of government. The federal government is strapped; most major states must cut huge deficits to balance their budgets; and our big cities are edging once again into serious fiscal trouble.

But significant pots of money wait to be tapped, just the same. Think of the preservation windfall if preservationists could only tap into just a small percentage of the hundreds of millions of dollars state and local governments spend every year on tourism promotion; these dollars could be used to preserve and make more accessible the historic sites tourists dearly love to visit. We must search for other hidden sources of funds—lotteries, housing subsidies, and the like.

These efforts are not without political risk. The people of Colorado voted overwhelmingly in the 1980s to create a lottery to buy open space and provide recreational facilities. The state legislature has subsequently siphoned off a huge chunk of these funds to build prisons. You have heard of the national rails-to-trails program? In Colorado, we have dubbed ours the "trails-to-jails" project.

OPPORTUNITIES AWAITING

There are other exciting opportunities for preservationists if we can make our programs part and parcel of larger efforts. Low-income housing is but one area where the crying need to house the millions of homeless and near-homeless in fit and livable homes offers preservationists a great opening. More than 32 million people are living in poverty, with several million homeless on the streets. The vast majority of the poor live in housing more than 25 years old, with much of it either historic or worthy of conservation

from an urban design point of view. We have a particularly golden opportunity because housing groups are finding that renovation is often cheaper than new construction *if* we as preservationists do not insist on a Cadillac renovation when a Chevy will do.

Unfortunately, most housing advocates view preservation as irrelevant at best and a hindrance at worst. This is puzzling when the preservation movement has such successful models in places such as Savannah and Pittsburgh. It is high time preservationists teamed up with national low-income housing groups, including the Enterprise Foundation and the Local Support Initiative Corporation, and proved the doubters wrong with a major national effort. Moreover, we have, as a movement, missed the boat for too many years when national housing legislation has been forged. We must do better in the coming decades.

Other areas of promise come to mind, such as transportation and recreation, both heavyweights in the national policy arena. But in both again, preservation is often viewed as irrelevant or worse. Plugging in to the growing national greenway and heritage-corridor movement is but one example of how preservation can gain allies and strength. Historic sites can become the jewels on the alluring strands of a national system of trails and corridors. We must join with others to carry our banner to higher places.

As the land preservation community has done, the historic preservation movement must go beyond regulation and purchase more endangered sites and properties. We have nothing to compare to the tremendous inventory being acquired by groups such as the Nature Conservancy. This is odd, be-

cause unlike many natural areas, historic structures can be used for economically lucrative purposes instead of being put off limits to public use. Why not support a national bond issue of, say, $1 billion to start a revolving fund to finance the purchase and renovation of endangered properties? Once renovated, these properties could be resold, where possible, to recoup our investment and to put them back into productive use. Successful models for us to emulate include the California Coastal Conservancy, an agency that has protected thousands of acres of farmland and sensitive natural areas in this innovative fashion.

To be sure, there may be some tiger pits along the way. One is an increasingly conservative judiciary, especially in some states such as Pennsylvania. But the vast majority of courts, especially at the federal level, have been exceedingly kind to preservation.

We are also witnessing a nascent backlash against environmental regulation when property rights are involved. The recent weakening of federal wetlands regulations and the continuing failure of Congress to crack down on billboards—litter on a stick—are but two illustrations.

Overall, however, preservation has a bright future as a vehicle to help communities deal more adroitly with change. In my opinion, the biggest threat is that we will lose our nerve, our passion, our willingness to take risks. Our movement is graying. I remember most of our preservation leaders before they had gray hair, and they remember me when I had some. Will we have the energy and the grittiness over the next 25 years that has served us so well during the past 25? I have great hope and optimism that we will.

WHICH GOALS AND STRATEGIES WILL FULFILL OUR VISIONS?

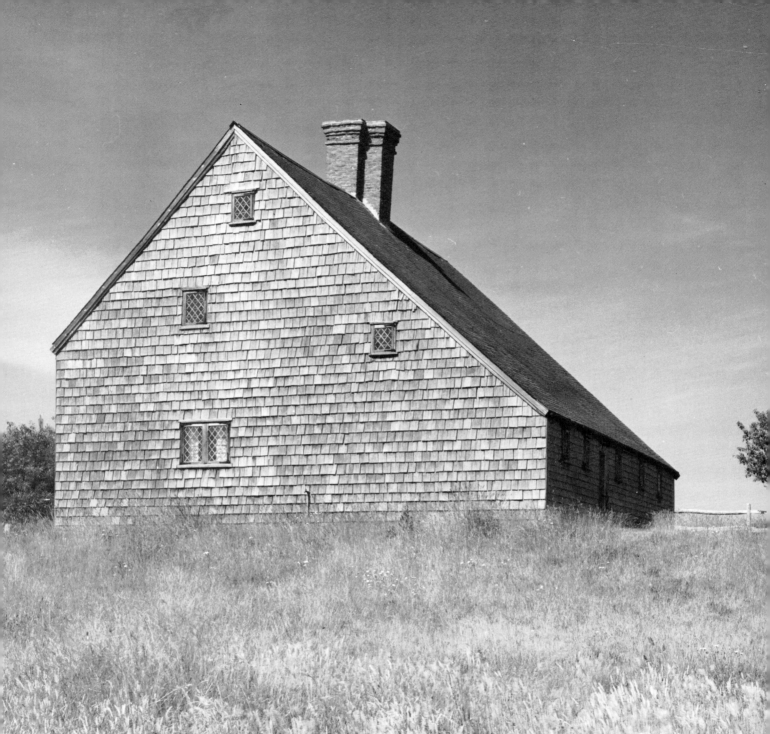

TWO VIEWS OF THE FUTURE

J. Jackson Walter

Twenty-five years ago, a group of visionaries gave form to their dreams in a book entitled *WITH HERITAGE SO RICH*. It had the twofold purpose of giving preservationists intellectual sustenance while directing us to take a number of practical steps to make historic preservation a more powerful force in this country. It worked. Relying on the book's recommendations for guidance and inspiration, we have succeeded in putting in place nearly all of the tangible programs these pioneers called for.

But there has been a price. Twenty-five years of drawing on the vision of *With Heritage So Rich* has depleted the fund. It is up to us to repay it. Now is the time, this is the place, and we are the people charged with honoring the debt to those authors. To pay back this debt, we must decide on a new vision that will be equally successful in guiding the preservation movement for the next 25 years.

How much of a debt do we owe these men and women? Let us briefly review what they imagined and what the reality is today.

- They called for a national register of historic properties. Today we have a large and ever-growing one
- They called for the creation of an advisory council on historic preservation that would review federal agency activities. The council is a vital player in preservation today

- They called for preservation officers in every state. Today we have them in every state and territory
- They called for a federal-state preservation partnership and a strong National Trust for Historic Preservation to join that partnership. Today we certainly have that
- And last, but not least, they called for federal laws that would support the goals of historic preservation nationwide. This year we celebrate the 25th anniversary of the National Historic Preservation Act

True, not all of what they called for and helped create works perfectly or is funded as well as it could be. But for the most part, the vision of 25 years ago is a reality. And what about the next 25 years? On this, our silver anniversary, we need to consider what vision we want to see become a reality on our golden anniversary. At first glance,

there seem to be two distinct schools of thought about our direction.

One school of thought, which I call the traditional school, says that we must stick with our vision of the past quarter century, only do it better. Its proponents believe that we must use every tool at our disposal to identify, inventory, and protect historic properties, sites, and districts. One legislative tool that would certainly help here is the National Heritage Conservation Act, which would greatly strengthen federal protection of historic places. We have been working with interested members of Congress—principally Representative Bruce Vento, chairman of the Subcommittee on National Parks and Public Lands—on this act, which is at the top of Representative Vento's legislative agenda. In the Senate, Senator Dale Bumpers is sponsoring his version of this measure. We are ready to deliver support to each of them because the proposed law will be invaluable to us in our age-old task of preserving the best of our nation's past—which is exactly what traditional preservationists insist that we should be doing. They are right.

The other school of thought, which I call the progressive school, believes that we must develop a brand new and much broader vision. While its proponents appreciate the contribution of the traditional activities, they think that we should join with environmentalists, city planners, conservationists, and the like to address issues such as urban renewal, economic growth, affordable housing, management, and future design. They see the Charleston Principles, a truly progressive plan to incorporate preservation into grass-roots urban planning, as representative of the kind of work we should be doing. They are right, and I am extremely proud that these principles, created at the 1990 National Preservation Conference in Charleston, South Carolina, have been adopted by the United States Conference of Mayors.

Both schools make strong arguments, and their debate is healthy. But the key to resolving the debate is to remember that the theme of the 45th National Preservation Conference is When Past Meets Future, not When Past Is Replaced by Future. The point is that what went on in the past 25 years has great bearing on what will happen in the next 25 years. What must be resolved is how much, and in which ways.

The vision the authors of *With Heritage So Rich* had 25 years ago—the one today's traditionalists seek to preserve—was actually quite progressive at the time. In fact, the architects of the vision wanted preservation to broaden its traditional role of protecting famous homes and landmarks and take steps to protect everyday historic properties throughout the nation. But to broaden is not to leave behind; it is to include. Today protecting famous homes and landmarks is still a big part of what we do.

BROADENING WHILE INCLUDING

The idea of broadening, while including, is best exemplified in the marketing-research report that we at the National Trust initiated some time ago. We expected it to do two things—one practical, one idealistic. Practically, we wanted the report to tell us how to attract new members to the National Trust and preservation. And idealistically, we hoped that this report would help shape our vision of the future, just the way the book *With Heritage So Rich* shaped it in our past. In effect, we used the research to say to the American people, "We hope you'll be our new visionaries. You have witnessed 25 years of preservation based on our original vision. What do you think of it?" And they replied, "It was wonderful, and don't leave it behind. But push it further. Make preservation more of an active part of my community, my life, and the lives of my children."

That is exactly what we are going to do. We are going to make preservation more of an active part of people's lives. Let me give you an example of how.

The National Trust owns 18 historic properties throughout the country. But there are also historic sites in almost every hometown. A great many of them have been successfully preserved and restored. But how successfully have they been interpreted? Probably not as well as they could be, which means that we are missing a golden opportunity to excite people about the history of these structures and the people who lived in them. This is learning by experiencing, which is the most effective way of all. But to do it right, the property must be presented in a way that is interesting and fun. Consider, for instance, the National Trust's newest property, Kykuit, the Rockefeller family estate in Pocantico, New York. That it is a magnificent home will certainly be evident when we open it to the public in 1994. But to interpret it solely as the home of a wealthy American family misses a crucial point. It is also the home of a family that, through its philanthropy, touched the lives of millions, and that is a story we ought to tell. And we ought to tell the incredible, exasperating, but ultimately engrossing story of how we acquired and preserved this home as well.

This is what I mean by making preservation more active in people's lives. Our task is to get local groups, developers, and civic and business leaders everywhere to interpret these places in ways that tell the history of not just the house but also the connection of that house to people's lives. After all, only when people feel connected to something can they love it. And only if they love it will they work to save it. If the public has communicated anything to us about preservation, it is surely that.

Speaking of communication, we must get better at it on

a nationwide basis, or all our other preservation activities will be hampered. We must address the goal of improved communication and find practical ways to achieve it. We must develop an information network that goes beyond our present bulletin board and database systems. Information-wise, preservation is in the dark ages. It is high time we brought it into the 21st century. In fact, the more we communicate with the American people, the better we will resolve the question of how far and in what ways we should develop a newer, broader vision without abandoning our old one. At the very least, the exercise should teach our traditionalists and progressives that they have more in common than they think.

HELPING THE CITIES

One of the most important issues facing us, and one that seems to divide our traditional and progressive schools more than any other, is what role we should play in our nation's cities. These, as we all know, are in big trouble. They desperately need the help of the preservation movement. But to agree on what role to play, we must agree on our vision.

The traditionalists—as I label them—think that preservationists working on urban issues must be independent of city officials to be honest watchdogs over them. They fear that to join with those in charge of urban planning, economic development, and the like is to risk seeing preservation take a back seat to these interests. And besides, traditionalists say, we will never have the financial resources to undertake a project as extensive as urban planning.

My so-called progressives, on the other hand, believe that the issue of the cities is the most critical of this decade and that preservation must be on its cutting edge. This is why they favor getting involved in city planning, economic development, and affordable housing, as well as the design of buildings and cities. And yes, progressives agree with the traditionalists that we do not have the resources to get involved in this broad agenda, which is why they want to join forces with the conservation and environmental movements.

But what do our new visionaries, the American people, have to say about the role preservation should play in the future of our cities? The answer is: plenty, and it is consistent with their belief that broadening our vision of preservation does not mean leaving behind the traditional.

First, Americans agree that traditional historic preservation always has been and always will be integral to our cities. After all, if it had not been for the traditional activity of saving buildings, many of America's most famous cities would look radically different today. Increasingly, the public appreciates that fact, which is why they

do not want us to leave our traditional endeavors behind.

But the public also agrees with a progressive vision that insists that preservation should affect the way future buildings and cities are designed. As Vincent Scully, the renowned architectural historian, has said, historic preservation is the only popular movement to critically affect the course of architecture in this century. He means that preservation has become more than just a grass-roots movement to protect our heritage by preventing the old from being destroyed. It has also come to mean protecting our heritage by preventing the new from being built in ways that are inconsistent with more traditional values, values that demand that our buildings and cities be "beautiful, livable, and of human scale." Those are the words of Joseph Riley, Charleston's mayor and a National Preservation Honor Award winner, and I cannot think of a better vision for our cities, our towns, our neighborhoods, and our communities. Let us make them all beautiful, livable, and of human scale.

It will not be easy. There is much work to do, and it must be done in a time of scarce money and hard choices. That is the bad news. But the good news is that our new visionaries, the American people, are willing to pitch in. Literally by the millions, they are ready to join us, if we can shape the preservation movement of the next 25 years so that it is active, immediate, and fulfilling, and so that it is relevant to the quality of their lives and the lives of their children.

RELYING ON PARTNERSHIPS

This is the challenge facing traditionalists, progressives, and all those in between. What we are really talking about is a partnership. If the right vision is the key to the success of the preservation movement in the future, partnerships are the key to implementing it. That is true of the public-private partnership imagined by *With Heritage So Rich*. It is true of the partnership between the National Trust and citizens envisioned in our marketing research. And it is true of the partnership between the traditionalists and progressives.

We can learn from the long and successful partnership of the National Trust, National Park Service (which turned 75 in 1991), and the Advisory Council on Historic Preservation. This partnership has survived and thrived because we helped each other and listened to each other. On issue after issue, we debated, compromised, and finally reached a consensus that we all thought was in the best interests of America's historic preservation movement.

If preservation traditionalists and progressives meet in a spirit of partnership, we will surely end up with the right vision, the vision that will further the best interests of the historic preservation movement over the next 25 years.

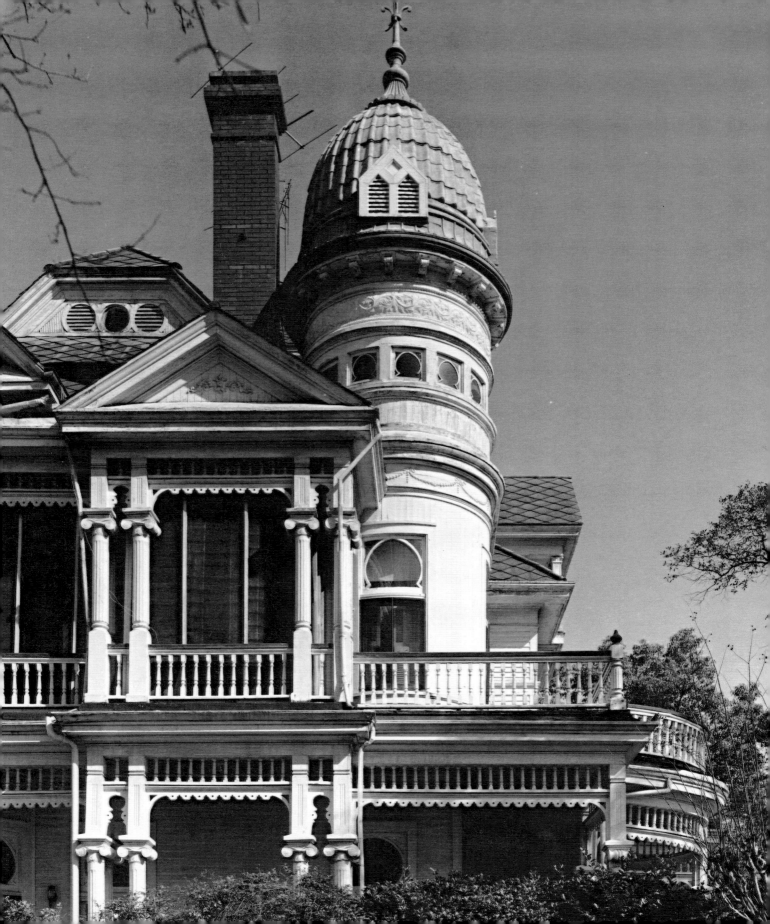

SOME STRATEGIES AND GOALS

Randall T. Shepard

TWO YEARS AFTER THE LOMA PRIETA EARTHQUAKE IN 1989, SAN FRANCISCO'S PUBLIC RADIO STATION BROADCAST A STORY ABOUT DELAYS IN REPAIRING THE DAMAGE. THE REPORTER ASKED THE PUBLIC OFFICIAL WHO WAS BEING INTERVIEWED, "WHAT IS THE DELAY?" AND THE OFFICIAL REPLIED, "THIS IS GOING TO TAKE A WHILE BECAUSE SO MANY OF THE BUILDINGS THAT WERE DAMAGED ARE HISTORIC STRUCTURES, AND WE HAVE TO BE VERY CAREFUL ABOUT WHAT WE DO IN PUTTING THOSE STRUCTURES BACK TOGETHER SO THAT THEY ARE PRESERVED FOR FUTURE GENERATIONS OF CALIFORNIANS." AND THE REPORTER SAID, "THANK YOU VERY MUCH. YOU'VE JUST HEARD FROM MR. SMITH, THE DIRECTOR OF PUBLIC WORKS."

Twenty-five years ago, these words might have come from a city's preservation officer or its planning director or even a mayor. But when they come from the director of public works, we are making progress. This story is an excellent backdrop for the conversation that began 25 years ago, when a group of people met in New York City's Hotel Pierre to put the finishing touches on *With Heritage So Rich*, the book that resulted in the adoption of the 1966 National Historic Preservation Act. People who were preservation stalwarts in 1966— among them William J. Murtagh, Arthur P. Ziegler, Jr., and W. Brown Morton III—are still continuing that conversation, giving the rest of us a wonderful lesson in staying power.

In my hometown we recently had a tremendous demonstration of the rewards of staying power. A decade ago, three wonderful little houses on a corner in a historic district were bought by the church across the street. The church wanted a permit to demolish the houses to build a parking lot. People in the neighborhood, preservation community, city, and other parts of the state fought this demolition for nine years—four times in front of the preservation commission. The fourth time the commission voted to permit demolition, and the preservation community sued the commission. It was a little awkward, but we won. We won in court, but the empty buildings continued to deteriorate.

Last spring the other guy blinked. The church leaders said, "We had a meeting of the church board. Would you guys like to buy this after all?" The local revolving fund stepped forward and said, "We would really like to, but we do not have any cash." They called the Historic Landmarks Foundation of Indiana, and we said, "We have a little cash and we are going to send it." And now those three buildings at the corner of Third and Blackford are under the protection of our covenants and are being rehabilitated. Rescues like that help me understand why people like Arthur Ziegler still are on the deck of this ship along with new-generation preservationists.

On the 25th anniversary of that earlier conversation, it is time to talk about the need for new visions for the preservation movement. Identifying current strategies and goals may help provide some insight. Here are the strategies I think we must adopt.

RESPONDING TO A SHIFT IN GOVERNMENT POWER

We must come to terms with a shift in government power, with the decline of central government. The phrase "decline of central government" comes from my friend Mitch Daniels, who spoke after the Berlin Wall came down about the centrifugal force that was going to take Eastern Europe out of Moscow's orbit and create new societies in that part of the continent. He could not possibly have been more clairvoyant. He could just as easily have said that the same centrifugal force would drive parts of the Soviet Union itself out of the same orbit. Every time I think that the world has slowed down long enough so that people can give speeches about these things, I am proven wrong. Now the Communist Party in Cambodia has decided what that country really needs is liberal democracy and capitalism. It is hard to plan in a world like that.

Of course, in using the phrase "decline of central government," Mitch was talking not just about the Soviet Union or Eastern Europe. He was also talking about the United States. Think about the differences between our national government today and the one in 1966—when the preservation movement's leaders met in New York. In 1966 President Johnson was still very much in control of the national agenda and proving that the central government was fully capable of supplying both guns and butter at the same time. He demonstrated that the country could send an army of half a million people to the other side of the world and sustain it year after year, while waging at home a far-reaching domestic campaign, the Great Society and the War on Poverty.

What image, in comparison, would most Americans have of the national government in the early 1990s—the 1991 Judiciary Committee hearings on Clarence Thomas's nomination to the U.S. Supreme Court? The diminished nature of the national government as compared to state and local governments will become more obvious as the country recovers from the recession of the 1990s. When the nation will have recovered the government in Washington, D.C., will still be bankrupt—more bankrupt, in fact, than it is now. The governments of New York State and California, on the other hand, will be getting healthier.

This suggests that preservationists must make use of state and local governments. Those governments are more accessible, easier to penetrate politically, and more flexible. They are not bound up by the incredible paperwork and other baggage that comes along with federal action. They are the keepers of real resources. These resources allow New York's state historic preservation office to write checks for repairing state historic structures in the middle of a recession, using environmental bond money.

In my state of Indiana, with tax increment financing, the tallest insurance building in downtown Indianapolis is now generating $2 million a year for downtown development and redevelopment, a part of which is historic preservation. That is six times what Indiana receives from the federal Historic Preservation Fund. And it is going to be there this year, and it is going to be there next year, and it is going to be there the year after. So the first thing preservationists should do is come to terms with the fundamental shift in government power in this country.

BECOMING ALLIES OF POLITICIANS

Many people involved in historic preservation are well positioned to be good allies of politicians. People of affluence and influence are interested in preservation, and they have access to the political structure. A second group of preservationists capable of political action are the grass-roots activists. They knock on doors and gain support for causes. They are the same people who run political campaigns, register voters, and organize fund drives. And they are the same people to whom elected officials look for help when election time comes around.

In Evansville, Indiana, we had an example of that in the same neighborhood where the three houses were saved. The Shrine Social Club, consisting of 300 members, owned an enormous 1870 Italianate brick clubhouse. The club decided that it needed more publicity, so it bought a sign used at fast-food restaurants—white plastic, backlighted with neon, with little black letters hanging on it. The club put

it up without a permit in the preservation district. The neighbors organized and sued, demanding that the club either get a permit or take down the sign. The club thought that it had the trump card. It would go to the city council and ask that the clubhouse be gerrymandered out of the district. It was fully confident that its 300 members had the necessary political clout. The preservation community proved that it was capable of rising to the occasion. It got more signatures on its petition than the social club did. The preservationists also lobbied the council through its network of political allies. The club's lawyers called up and asked to settle the lawsuit.

Preservationists can take advantage of these kinds of alliances all over the United States in a whole host of settings. The Charleston Principles adopted at the National Preservation Conference in 1990 can provide the basis for any local preservation program. The kinds of allies that preservationists had last year and continue to have are going to put us in good stead.

ACTING AS ONE MOVEMENT

The preservation movement in this country has always been fragmented. Part of it is government and part of it is private. Part of it is different kinds of government. Part of it is national, part of it is state, and part of it is local. And even the nonprofit side is divided up in a million ways.

Preservationists love to bash other preservationists—pass around rumors about what other people are trying to do that they ought not to be doing or how they are not really doing what they could be doing. It is both great fun and very counterproductive. The movement is not big enough to permit that kind of internal divisiveness. We are the same people. The best piece of advice here comes from the cinema, from something George Carlin told Bill and Ted: be excellent with each other.

There should be a unified agenda for preservation in this country. There should be a commitment to a single script. And there should be a mechanism by which we hold discussions more often so that everybody in the constituency can come together to form a unified agenda.

TELLING OUR STORY BETTER

We do not tell our story very well; we must do better. Punching through the consciousness of Americans is tougher today than it has ever been. That is because the traditional forms of communication that we have tried to master over the years are not as mass as they used to be. At one time, the best thing you could do for your program

was to get yourself on the network news. Today television network viewing in this country is down to 65 percent and still falling. The debates we had about how to get ourselves off the social page and onto the business page of newspapers have to be put in context with the fact that the percentage of American newspaper readers has declined every year for 20 years. And it is going to get worse because the surveys indicate that people in their 20s hardly read newspapers at all. American elites get their news from public radio, but many Americans do not get any news at all. This means that preservationists have to be smarter than we have ever been about how to convey our message to Americans.

Along with our strategies—plans for how to proceed— we must set some clear goals that these strategies will help us attain. Here are some of the chief ones:

RECLAIMING THE IDEA OF CITIES

Cities are a theme of American life. It was an article of faith in American public policy from the time of Dwight D. Eisenhower until Jimmy Carter that America had to build and rebuild cities. We must reassert this article of faith to the president, to the cabinet, to Congress. We must stand up and say, "What are we going to do about American cities?" Cities have to be at the top of the list for the federal resources that remain. Washington will continue, after all, to spend money on transportation, housing, agriculture, and rural development. Reaffirming the value of cities is critical to seeing that they get their share of government largesse. On this subject, we will have many allies. And we have a beginning, in that the National Trust for Historic Preservation is initiating a new program of research and advocacy on behalf of American cities.

REVIVING THE TAX CREDITS

The second goal is to fix the investment tax credits and the passive loss rules. At the height of the tax credit activity, tax credits were generating $2 billion a year of investment in old buildings. Even a single month's worth of investments netted more than all of the bake sales, street fairs, and membership campaigns that we have held since Ann Pamela Cunningham and her colleagues saved Mount Vernon. Although the rate of investment has declined by 65 percent, tax credits are still generating a lot of money: $500 to $600 million a year. But the figure could be more like $2 billion again. There will be a moment, place, and time when we can get that done. We must be ready to take advantage of that moment when it comes.

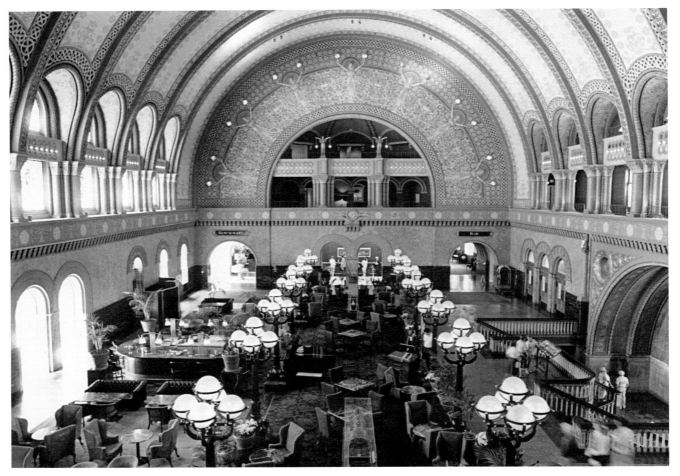

Brought back to life, the main waiting room of Union Station in St. Louis explains why preservation works.

NOT SHYING AWAY FROM REAL ESTATE

The third goal is to get comfortable with the idea of being in real estate and being around real estate people. It is easy for us to see how we compete with real estate developers for resources. It has been harder for us to see how we can cooperate with them to corral resources for center cities. Most of what happens in the economy that helps real estate developers helps everybody: it helps new construction; it helps rehabilitation; it helps everybody who is interested in center-city real estate. We can see this mutual benefit easily when it comes to interest rates, for everybody benefits when interest rates go down.

A recent news story related that the price of recycled aluminum had shot up so much that, in some cities, people had been caught tearing aluminum siding off old buildings so they could sell it to the recycler. Now that is the kind of crime wave I can get excited about. And I am all ready for

the first case. The prosecutor brings in the perpetrator. What is he charged with? Theft. In our state that is punishable by four years in jail. What did he do? Tore aluminum siding off an old building. What is my verdict? Not guilty for reason of sanity!

The programs that help real estate people help us as well, programs such as tax increment financing and enterprise zones. We have in our state now a remarkable idea called "dinosaur legislation." What do you do with great old industrial buildings in the Rust Belt that have lost their original use? We have favorable tax treatment for their rescue. This is good for developers and good for preservationists. Real estate people are potential partners in many kinds of ventures. They include people who would be willing to talk to us about protecting old neighborhoods that have character but are not of historic quality. These folks are easier to talk to when real estate is in a slump.

We are going to succeed in part if we begin to understand

that what affects the economies of cities affects us and creates opportunities. We should support our land trusts. Every time those organizations put an easement on an acre in the suburbs, they take an acre off the market for suburban sprawl and they make our job as preservationists easier.

EARNING SEATS AT MANY TABLES

The fourth goal is to earn seats at many tables. As we preservationists grow stronger, more sophisticated, and larger in number, people will request our involvement in issues we may consider peripheral to preservation. But they are important enough to warrant our taking part. These allied issues include zoning, low-income housing, and shelter of the homeless. If we have an opportunity to effect solutions to these problems, preservationists should be there.

The Historic Landmarks Foundation of Indiana recently was asked to be on a committee to oversee design of the Vietnam veterans memorial in the city. The foundation very much wanted a seat at that table. The fight for those kinds of opportunities reminds us of what some people say to historic district commissions. The story goes like this: You walk down the street and see somebody painting, and he does not have a certificate and you know it. And what does he say? "What are you guys, the good taste police?" And the answer is, yes, sometimes. But in the broader context, preservationists are the quality cops for urban development. And preservationists ought to be proud of that.

We take an interest not just in the physical place, old or new, but in many other factors that will determine what sorts of American cities we are going to live in during the next generation. We contribute to the quality of thinking on that subject.

ASKING WHY WE ARE HERE

The strategies and goals described here cause us to ask important questions about who we are. Why do we keep serving on boards, coming to meetings, running the street fairs, working on newsletters, and contributing money? I am going to suggest an answer.

At the 1980 National Preservation Conference in New York City, one of the innovations was the stewardship luncheon. The luncheon involved engaging a famous person and charging a pretty good price to hear a great lecture and watch slides. The speaker at this stewardship luncheon was author Brendan Gill. I managed to get a seat at the back of the grand ballroom of the Waldorf-Astoria Hotel. That ballroom has to be one of the greatest commercial urban spaces in this country. It is a magnificent three-story oval room with crystal chandeliers, a beautiful domed glass ceiling, and balconies all the way around. When Gill was introduced, he stepped up and paused just a moment, observing the setting. As he did, the rest of us looked up as well, and Gill said with a sort of New York diffidence, "I think I have been called here under false pretenses. They told me I was to speak in the *grand* ballroom." That sense of warm appreciation makes us remember less about the lunch and more about the place.

A few years ago, I spent a long day with some members of the National Trust's Board of Advisors and the program council in St. Louis. We spent the whole day doing long-range planning. The meeting generated important dialogue. At the end of the day, something happened to us as we wandered out of the meeting. It was very much like what happened at the Waldorf-Astoria. We were meeting in St. Louis Union Station. And we came out of the meeting rooms and somebody said, "Would you like to go have something to eat?" We walked out into the main waiting room of that fully restored station, which is 80 feet tall and has a barrel ceiling—and in which you can now sit down to eat. Everybody around the table had the same thought. This is why we are here. The glory of this space explains why we are preservationists.

It is not because we like debating policy or because we are fascinated by position papers. We are here because of the excitement of old buildings. That excitement is stirred not just by grand commercial structures but by a little worker's cottage that escapes the threat of intersection improvement by being moved elsewhere in the neighborhood and reoccupied. It is that excitement that makes us come to meetings, makes us pay our dues, and lets us believe that there is value in coming together. What moves us, as Brendan Gill said, is our desire to be in the *grand* ballroom, big or small.

AFFECTING PUBLIC POLICY

Pamela Plumb

OUR CHALLENGE FOR THE NEXT DECADE WILL BE TO INTEGRATE HISTORIC PRESERVATION INTO THE VERY HEART AND PSYCHE OF OUR COMMUNITIES AND OUR NATION. IT MUST BECOME AN INTEGRAL PART OF OUR DIVERSE POPULATION'S EXPECTATION OF THE GOOD LIFE, AS WELL AS OF OUR PUBLIC POLICY. THIS IS A TALL ORDER, A CHALLENGING VISION FOR THE FUTURE. IT REQUIRES ACTION ON MANY FRONTS, INCLUDING EDUCATION, REVOLVING FUNDS, PROPERTY MANAGEMENT, AND PROPERTY OWNERSHIP. PUBLIC POLICY IS ONLY ONE PIECE OF THAT PRESERVATION VISION.

Why public policy? Whether you applaud it or whether you hate it, you have to acknowledge that the government has a powerful impact on our lives and the success of historic preservation. Public policy action created the National Historic Preservation Act 25 years ago.

Public policy has the power to create rehabilitation tax credits for historic structures. The tax credit legislation revitalized my city of Portland, Maine. Although preservation activists from Greater Portland Landmarks inspired, educated, and converted people to the importance of preservation, it was the legislation of 1976 that actually generated the rehabilitation of our entire 19th-century downtown. That is the kind of power that positive public policy can have.

Government also has the power to take away those tax credits, which it has done. Government affects preservation in powerful ways. It can regulate. It can provide incentives. It can directly control. It can use its considerable resources to foster historic preservation—or to thwart it.

Even if we were willing to forego all possible government assistance in order to be spared the bother of dealing with the regulations—which is what a lot of people would like to say—there would be no guarantee that some misguided legislation would not come and undermine us. It is important for preservation that we be involved and that we pay attention.

But for preservationists, public policy should mean more than individual grants, tax policies, or protective legislation. For us, public policy is an integral part of the larger goal of instilling the values of historic preservation into the heart and psyche of the general public. Therefore, in

addition to all that we in our organizations do privately, we must give time, thought, and effort to affecting public policy as well.

IN THE FEDERAL ARENA

Each level of government has its own role, its own potential, and its own problems. In the federal government, the overriding issue is rekindling a serious commitment to the domestic agenda, in which preservation has a real stake. Without renewed investment at home in inner cities or in rural communities, there will be little incentive and few resources for preservation. Without reinvestment, communities will decay and die, and so will their history. We, as preservationists, have a big stake in solving the issues of poverty, of dilapidated housing, of drug wars that make wastelands of inner cities, and of economic shifts that empty out or overrun rural communities.

It is not just buildings we are preserving; it is community fabric and community life—roots, consistency, the ability to believe in some immortality. That is what we are in the business of preserving. This work gives us many natural allies— low-income advocates, housing advocates, city rehabilitation advocates, mayors of cities and towns, and rural rehabilitation specialists. We all want to build a new commitment of resources, energy, thought, and time in the domestic agenda.

There are, of course, dozens of more specific reasons to be active on the federal level. The rehabilitation tax credits themselves should be rehabilitated. New housing legislation may finally be written, and preservation should be a part of it. We should check the inventory of the Resolution Trust Corporation for any historic properties that may be for sale. There are certain advantages to these difficult times. We can afford to be back in the real estate business again. This is just a sampling of the things to be watching for at the federal level.

AT THE STATE AND LOCAL LEVELS

Involvement at the state level is also important. The comprehensive planning process of every state should be infused with historic preservation ideas. Home-rule or enabling legislation must be in place so that local communities can create the kind of historic districts and site plan and design control ordinances they want.

States can have their own tax incentives or grant and loan programs. They can use state historic preservation offices in a variety of ways to coordinate or provide technical assistance for local ordinance administration. States own and care for historic sites and buildings. There are lots of good reasons for each of us to know our state legislators well.

We are probably more familiar with the local aspects of public policy than any others. Local impacts are direct and immediate and involve more than historic district ordinances. If historic preservation can be integral to a community's vision of the future and to its comprehensive plan, then it can be aided by community tools: zoning, inventories, Housing and Community Development Act dollars, grant and loan programs, and design review committees. Many positive opportunities will follow if historic preservation is a part of that comprehensive plan.

MAKING DEMOCRACY WORK

Given the importance of being involved in public policy, how can we do it? Affecting public policy or making democracy work takes time and energy. It cannot be done from our armchairs in the commercial breaks from the nightly news. We have to get out of the house. We have to meet people. We have to be involved and engaged.

One way to be involved is by building coalitions. Historic preservation is interdependent with many other community goals, such as maintaining housing stock, retaining local character, attracting tourists, and encouraging economic development. Henry G. Cisneros, for example, explains in his essay in this book how the preservation of the River Walk has been the key economic engine in San Antonio's tourism business. He describes preservation as a central part of that city's economic development plan.

Historic preservation can play a part in enhancing a community for investment and in building the regulatory mechanism that manages excessive or incompatible development. All of these aspects of preservation have their own groups and their own constituencies. Our goals and their goals are parallel. We should be building coalitions at every level: with neighborhoods and local grass-roots organizations, with chambers of commerce and tourist bureaus. Historic preservation must work with them and share their goals, so that we can move forward together.

We also must build coalitions on the national level, with organizations such as the National League of Cities, United States Conference of Mayors, National Housing Coalition, and others. The National League of Cities's goals for preserving and enhancing cities, large and small, are parallel to the goals of the National Trust for Historic Preservation. We ought to be marching arm in arm around the country, selling our common wares. It is the same with Partners for Livable Places and the Inspired Partnerships with churches in inner-city communities. Coalition building broadens our base of support. It gives greater power. It creates a louder voice and greater impact. It is also part

of the process of integrating preservation goals into the larger community goals. The future of the preservation movement is in that integration.

GENERATING A POSITIVE POLICY

What is the best way to affect legislation, to help make or change public policy? How can we be more effective in generating a positive preservation policy and in getting it passed?

Educate ourselves. We first must know who our elected representatives are and what their individual and collective issues are. Ask yourself: Do you know all of your city council members? Do you even know their names, much less their specific interests? How about your state legislators? Can you name all of the state legislators in your community? Do you know what is important to them? What issues make them respond with enthusiasm? How about your congressional delegation? How long has it been since you have taken them by the hand and showed them a local project or learned from them what their important issues are? What makes them react? We should do homework and be prepared. We should know those individuals and what is going to make them vote one way or another.

In Maine, our governor's favorite issue is economic development. So when we talk with the governor about historic preservation, we talk about the economic development aspects of historic preservation. We have to know what is going to make our policy makers sit up and listen.

Educate our elected officials and their staffs. Do not forget their staffs and any other ancillary boards that play key roles, such as zoning boards and planning boards. We cannot assume that they know anything about our specific issues in historic preservation. We must begin from the beginning.

We also have to begin well in advance. The person who shows up on a politician's doorstep the night before a vote with a 15-page paper on why the politician ought to change his mind tomorrow or how she ought to vote will be summarily dismissed. We must begin in advance, to build the necessary rapport and information, so that when a vote for a crucial piece of legislation is at hand, we have the credibility that we need to make our pitch on the specific issue.

We have to meet with people one on one, invite decision makers to have collective meetings, and provide mailings with background information. It helps to bring examples from other places or to take your representatives personally to some place in their community that affects their constituents—a project they can touch and see, a place where they can talk to the people in the neighborhood. A visit is more compelling than a dozen reports.

Elect people sympathetic to preservation. This will create a positive preservation attitude on a council, in the state legislature, or in Congress. This is what democracy is all about. There are several ways to accomplish this goal.

We can publish information on how politicians stand on issues that are important to preservation, and circulate it in our newsletters and press releases. It is important that our constituency be knowledgeable about politicians' votes, activities, and track records. It is equally important to expose bad records and commend good ones.

In addition, we must join the election fray and work for those people who support us. We need to support them when they are up for reelection. When representatives turn out to be opponents of preservation, it is time to replace them. That is how the political system works. We must find candidates whose perspectives we appreciate and get them elected. That means rolling up our sleeves and campaigning, stuffing envelopes, licking stamps, making phone calls, raising money, and walking up and down neighborhoods to hand out flyers. That is how we can get people elected.

When all else fails, we should think of running ourselves. I ran for a seat on Portland's city council after that body turned down, by a five-to-four vote, a proposal by Greater Portland Landmarks to establish a historic preservation district. I was horrified, so I ran for the council and won. It took a decade, but eventually we had a historic district ordinance in our community. If you cannot beat them, join them. It is not awful to be a politician. I was one for years. Politicians are real live human beings like you and me. And if we do not like the ones we have, we have to find new ones or do the job ourselves. It is key to be where the action is, to be part of the decision-making process.

Government is powerful and pervasive. Its impact can be positive or negative. And despite all the pundits' gloomy forecasts for the system's complete collapse, it is what we have. It is still a democracy and it is *our* government. We do have access, and there are effective tools and strategies for affecting public policy.

It is important for us to believe that we can be involved. Whether or not one of us ever ends up being president of the United States, the accumulation of our small positive political inroads will create a wave of positive action. As people who care about historic preservation, we have a responsibility to become politically involved so that the values of preservation become an everyday part of tax legislation, comprehensive planning, housing and economic development policy—in sum, a part of our democracy's definition of the future.

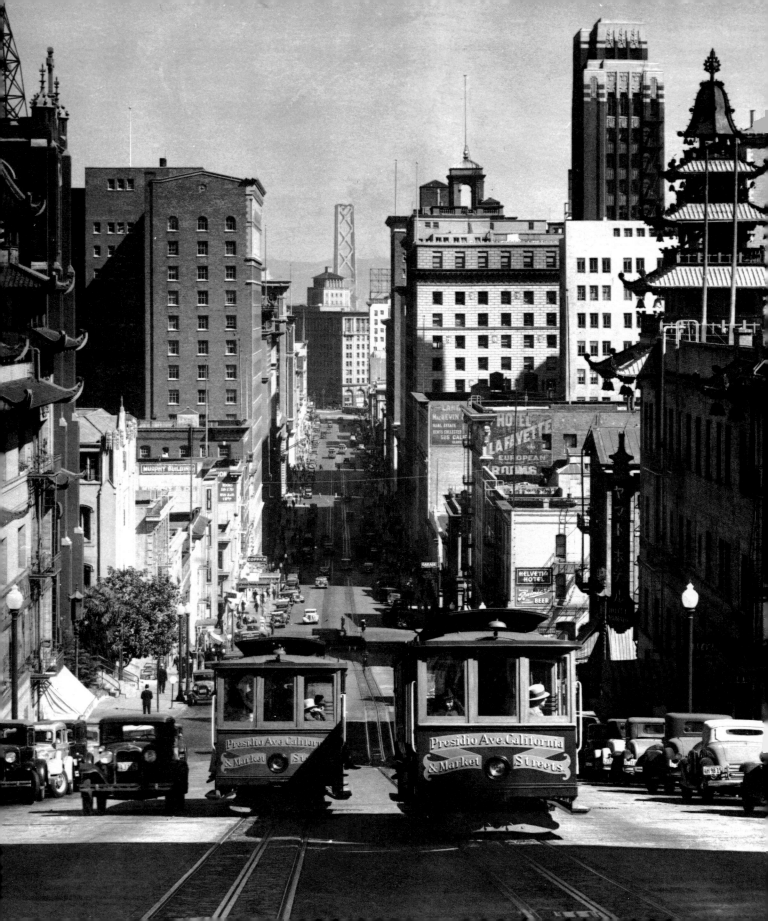

CHARTING A COURSE IN THE GOLDEN STATE

Douglas P. Wheeler

IN OCTOBER 1989 THE LOMA PRIETA EARTHQUAKE STRUCK CALIFORNIA, BRINGING CATASTROPHE. THE COSTS IN HUMAN LIFE AND WIDESPREAD DESTRUCTION OF PROPERTY WILL NOT SOON BE FORGOTTEN BY ITS CITIZENS. NEITHER WILL PRESERVATIONISTS SOON FORGET THE RUSH TO CONDEMN OLD BUILDINGS TO THE WRECKER'S BALL, EVEN LANDMARKS IN THEIR COMMUNITIES THAT COULD HAVE BEEN SALVAGED. THIS EVENT REMINDS US OF HOW MUCH MUST BE DONE TO EDUCATE THE PUBLIC AND BRING IT TO A FULLER APPRECIATION OF THE FINE OLD BUILDINGS AND NEIGHBORHOODS THAT REMAIN.

We must impress on the public that such places are finite. It is quite clear that the best interests of our environment, both historic and natural, have not been adequately served as a matter of public policy. We can and we will do better. These precious resources deserve and will receive our attention.

California is the largest, most diverse, most socially and culturally complex state in the union. New population projections for California are simply staggering. The state is growing at the rate of 600,000 people each year, and most observers anticipate that the population will reach 40 million by the year 2010. At this rate, 50 million will not be far behind. Our population growth has been explosive, our economy dynamic. The pace and magnitude of change in California have few parallels anywhere.

Stewardship of scarce resources at this point in our history

is cost-effective policy. Congestion and gridlock on our freeways, polluted air and water, a lack of affordable housing, a decaying infrastructure, loss of open space and scenic values, and the destruction of prime farmland and our unique historic resources are all signs that unplanned growth and development have begun to overwhelm our productivity. It may no longer be in the best interests of the private sector to remain in places where such conditions exist: profits decline in proportion to the rise in the cost of doing business and the cost of living. It is also becoming increasingly clear that our partners in the private sector see a cleaner and healthier environment as a recruiting inducement.

But stewardship is not passive. For while we must conserve the sources of our wealth, it is essential that we also create new wealth for the benefit of our citizens. Economic

expansion and development are inevitable and necessary if we are to improve our standard of living, provide meaningful employment to our people, and find the means to solve the host of problems facing our complex and diverse society.

Historic preservation can and should be a part of economic growth. It urgently needs a broader constituency, a reenergized state program, and new funding to be successful and regain its national prominence. Although house museums are valuable educational tools, we must move beyond the house museum approach to create preservation projects that are economically sustainable. We should find adaptive uses for old buildings that allow them to function profitably in the community. Historic buildings should be living, breathing parts of the community, not antiques roped off as curiosities. The Main Street program is an excellent approach to preservation because it recognizes property owners' needs to be able to market the historical experience.

Tourism is more and more important to California's economy. Those who pin their hopes on profit in this sector should understand the importance of historic buildings to the state's past and present identity. From the ghost town of Bodie to San Francisco's Chinatown, we are promoting assemblages of historic buildings. To lose them could be an economic catastrophe. Heritage tourism will be an important component of future directions.

Communities throughout the state have also succeeded in revitalizing their historic downtowns without a major influx of tourists. I commend them. Cities such as Santa Ana have created bustling, lively, and profitable shopping centers in their old downtowns while maintaining a strong sense of community heritage. It is the role of government and the preservation movement to provide support for people trying to breathe economic life into their preservation efforts.

Public policy in the area of land use, growth management, and historic preservation must be developed on the basis of cooperation rather than conflict. The legitimate interests of all stakeholders must be considered and respected. Only then can we achieve the broad consensus necessary to achieve our goals.

BRINGING NEW PEOPLE ON BOARD

By the beginning of the next century, people of color will account for about a third of the American population. It is essential that preservationists persuade the nation that preservation is not simply a way of glorifying a narrow tradition and history. Preservation is for all Americans. All of us, whether we are recent arrivals or life-long residents, must be brought on board as participants in preserving the past.

Here in California, a number of history-oriented projects have succeeded because of the cooperation and leadership of members of ethnic communities. The restoration of the Chew Kee store in Fiddletown, a winner of the Governor's Preservation Award, was completed with the aid of $80,000 in bond money provided by California voters in 1984. In Los Angeles, $750,000 in state money helped fund the Japanese American National Museum, with the active participation of the Japanese American community. Just across the bay in Oakland, the Liberty Hall project brought together state and local money and participants to rehabilitate a building that once housed meetings of a historically important African American self-help organization. Today the building is a community center in a predominantly African American neighborhood. It is projects like these that forge a partnership for preservation, help us maintain a sense of pride in our past, and give us all a vested interest in preserving it.

And just as we must ensure the broad participation of all ethnic groups in the decision-making process, we must also enlist the support of the private sector—the business community—in preventing the destruction of our historic environment. Preservationists and business people cannot see each other as mortal enemies if we are to progress together. The Mercy Family Plaza project in San Francisco successfully brought together developers, the state, and the Catholic Church as partners in a project that used state bond funds, yet qualified for federal investment tax credits and housing tax credits as well. Such projects help establish effective partnerships that can be critical for long-range success.

GOVERNMENT, SETTING THE TONE

All levels of government should be expected to show leadership in creating the conditions that foster healthy growth while conserving the fragile cultural and natural environment. We are therefore making a number of policy initiatives that will set a tone for the state. As one of his first acts, Governor Pete Wilson issued an executive order establishing within the administration a council on growth management. This council is chaired by Rich Sybert, director of the Office of Planning and Research. Council members include the secretaries of all agencies in the executive branch that are or may be involved with issues of growth management and resource stewardship. The council will be

Opposite: Resourceful California will benefit places associated with the state's wine industry, such as this winery in Sonoma County.

CHARTING A COURSE IN THE GOLDEN STATE

submitting a series of recommendations to the governor for a state policy on growth management by the end of this year. This council is not working in a vacuum. It is listening closely to the views of all parties, public and private, who have a major stake in this important and promising enterprise. It is asking the right questions. Preservationists are participating, and must continue participating, in this debate, which obviously has enormous implications for historic resources in this state.

After the governor receives the council's recommendations, we will all be working closely with the legislature and others to forge a consensus on a state growth-management policy, complete with specific goals and objectives. Once attainable and affordable state policies are in place, local government may implement a program of growth management suited to local conditions and in harmony with the state framework.

CREATING RESOURCEFUL CALIFORNIA

I can assure you that as we move forward in this endeavor, the conservation and protection of our important historic resources will be a priority. The positive integration of historic resource preservation into state and local growth-management and land use decisions must be a cornerstone of these efforts. Policies that favor infill development and adaptive use of historic structures are being seriously considered in the growth-management deliberations.

On April 22, 1991, Earth Day, the governor unveiled his initial plan for investing in the protection of our state's natural and cultural resources. The centerpiece of the Resourceful California initiative is a $628 million bond issue, the California Heritage Lands Bond, that will allow us to protect some of our vitally important resources for generations yet to come. It is an integrated package of 14 new conservation policies that helps address a broad range of critical environmental needs.

Under the auspices of Resourceful California, we are beginning to protect and preserve native forest lands, riparian habitat, and wetlands; improve wildlife management; promote the conservation of prime agricultural lands, many of which incorporate important historic and cultural landscapes; plan for better and wiser protection of coastal resources; reform our forestry practices; conserve our parks, open space, and scenic values; and last, but by no means least, allow for more vigilant and effective protection of the heritage resources that keep us in touch with our past and orient and inspire us toward a more noble future.

Resourceful California also has committed us to developing a comprehensive and effective state register of historic places. A preservation task force includes representatives

from the state's heritage organizations, including the National Trust for Historic Preservation, California Preservation Foundation, Society for California Archaeology, and California Council for the Promotion of History. The group has made a number of recommendations that I am committed to forward to the governor over the next few years and has also given its help on the growth-management issue.

First and foremost is an executive order from the governor—patterned somewhat after Executive Order 11593, issued by President Richard Nixon in 1971—that clearly sets forth policy in these important areas:

- It will protect those historic resources that are owned by the state of California. The new executive order will recognize that the state must get its own preservation house in order before it can effectively work with local governments and the private sector on non-state-owned properties. It will emphasize the provisions of state law that require an inventory of all historic state-owned properties and establish a review and planning process that ensures that our significant resources are not unnecessarily harmed. It will direct each state agency to appoint a preservation officer to be responsible for carrying out the provisions of this most important law

- It will also announce our intent to make administrative changes to the California Environmental Quality Act to ensure that historic and cultural resources are not needlessly demolished in the aftermath of an earthquake or an emergency declaration. This change will ensure that properties damaged in a natural disaster will receive the same protection to which they are otherwise entitled by law

- We will seek to clarify the mandatory nature of the state historic building code in all—and I emphasize the word "all"—inspections of qualified historic structures. Building inspectors throughout the state must be made aware that their role in applying the code is not simply discretionary. Only then can we be sure that seismic retrofits and other forms of rehabilitation may proceed with respect for our historic buildings

As noted earlier, we will be seeking legislation to establish a unique California register of historic places. Properties listed in the new register will be given added protection and be able to display a distinctive sign that will clearly identify them as important to our state's past. We will be developing a new emphasis on historic districts, targeting assistance and special incentives to broader areas as opposed to individual landmarks.

Financing, of course, represents a major obstacle to carrying out hundreds of worthwhile preservation projects.

California will soon have a preservation trust fund that will establish a pool of money for programs and incentives for maintaining a historic property. We hope to find models for using the "carrot" approach to encouraging preservation in California programs like the Coastal Conservancy and State Parks Foundation and other projects throughout the nation. A historic license plate fund may be able to be tapped to provide a steady source of revenue. A revolving loan fund will be part of this effort, which will address the state's prehistoric and historic resources.

Another of the task force proposals that our administration will be emphasizing is the need for changes in the California Environmental Quality Act. Much must be done to tighten up definitions and ensure that important buildings and sites do not fall through the cracks in projects that do not undergo public review. And we will be coordinating the goals and interests of American Indians and archeologists by celebrating Archeology Week in conjunction with California Indian Day in September.

The task force has suggested, and we will seriously con-sider, increasing staff and assistance for the state's Office of Historic Preservation. Many of the new directions we will be taking may require the office to expand the range of its activities. We hope to be able to provide them the necessary support.

These proposals form the kernel of California's new preservation policy. They will not be the limits of it, however. We will continue to work with the community to chart a course that will guide us through the challenges that face us in the future.

This Golden State has been, and will remain, a place where the opportunity to grow, prosper, and flourish economically, intellectually, and spiritually will abound. We will strive to be vigilant stewards of the natural and cultural wealth we are so fortunate to enjoy. We value and can benefit enormously from our growing cultural and ethnic diversity, no matter how great the challenges it may pose. Although we face sobering and monumental challenges, we have the resources, the resolve, and the energy to surmount them with sterling success.

Bodie, California, is typical of boom-and-bust western mining communities that declined when mining ceased.

PROPERTY RIGHTS AND PUBLIC BENEFITS

Joseph L. Sax

L EGAL PROTECTION OF HISTORIC PROPERTY IS A
CHILD OF PARADOX, AND THE PARADOX IS THIS: ALTHOUGH IT RESTS ON THE THINNEST STRAND
OF LEGAL THEORY, HISTORIC PRESERVATION HAS BEEN A FAVORITE OF THE COURTS,[1] INCLUDING
THE U.S. SUPREME COURT, WHICH HAS UNFAILINGLY GIVEN TO PRESERVATION ITS CONSTITU-
TIONAL SEAL OF APPROVAL.

This support dates back to the acquisition of the Gettysburg Battlefield in 1896[2] and extends to the *Penn Central* decision in 1978;[3] the overturning of the unfavorable *First Covenant*[4] decision in 1990; and the denial of review of a lower court's favorable ruling on St. Bartholomew's Church in 1991.[5] What makes this curiosity more tantalizing is to note the Court's steadfast support through liberal and conservative periods alike,[6] up to this very day when we have the most conservative federal judiciary of modern times. Property rights claims do not stand as a significant barrier to protection of cultural properties. Let me explain why such a confident conclusion is justified.

I begin with the slender theoretical thread to which I referred. It has been a central premise of American law that owners can use their property as they wish, provided only that they do no harm to others. This is the essence of the traditional legal wrong of nuisance, which early zoning laws codified. The nuisance limitation on regulation is what gave rise to the old rule that government had no authority to regulate simply for aesthetic purposes, but only to promote the public health and safety[7] against those who were harming them. The basic idea was that the task of government is not to make us good. The state's duty was only to protect us from the bad, and the proprietor's duty was only to refrain from doing harm. Owners had no obligation to contribute to the public welfare.[8]

In its starkest form, this is a very powerful idea, for it is an idea about freedom. There are not many people in America ready to embrace a government that claims it knows what is good for us. But this potent conception of freedom has in it no notion of a community, no element of a common history and experience, of a shared culture, or of a plurality of cultures within a larger community. The reconciliation of the tradition of untrammeled individual liberty with the importance of recognizing a common culture has been one of the momentous but unobtrusive tasks

of the American legal system. Nowhere can that enterprise be traced more clearly than in the evolution of the law of historic preservation.

PUBLIC RIGHTS TO OUR HERITAGE

For a good many years, courts have been wrestling with the ungainly fact that there is a material patrimony that in some sense "belongs" to the community, although, as a formal legal matter, title to material things is vested in private individuals. This idea of "belonging" is something that everyone understands—in the sense that we say Stonehenge, although it was privately owned, belongs to the British people[9]—but it is not an idea that has recognition as a legal doctrine. This theoretical gap has created a certain degree of juridical perplexity. Perhaps the best-known modern example is the dissenting opinion of Justice William Rehnquist in the celebrated *Penn Central* case, in which he observes the oddity that the reward one gleans for having built a distinguished building is loss of dominion over it. The result of historic preservation laws, he observes bitterly, is that the better one has built, the less one's rights in the building.[10]

Justice Rehnquist was simply calling attention to something that students of land use law have known for a long time. The theoretical right to use your land as you wish, provided only that you do not harm others, has given way in practice to a recognition that the public itself has rights, in its cultural heritage as well as in the protection of its landscape and natural resources.[11] Landowners do have affirmative responsibilities to protect and preserve what "belongs" to the public, and the effect of that protection is not a taking away of something from landowners, but a maintaining of something that is part of the public patrimony. This conception explains not only historic preservation ordinances, but the protection of open space, wetlands, water quality, and urban prospects, all of which are now solidly entrenched in American law. One potent contemporary example is the duty not to destroy endangered species by destroying their critical habitat, even when that habitat is found on one's own land.[12]

The implicit recognition of public rights in heritage resources explains why American land use law is not substantially different in practice from that in European countries, although the theories are quite divergent. It is customary to say that in Europe one may develop land only insofar as permission is given, while in America, one may do what one likes unless some prohibition is imposed. But as a practical matter, the European model applies here today, as every land developer knows, to his or her dismay. To be sure, land use in America is not as rigorously controlled as it is in many other countries, but that is not because the legal authority is lacking. It is because American attitudes are more resistant to pervasive regulation than are European attitudes. But where there is a will to recognize public rights (as in historic preservation), the law does not stand in the way.

Some people think the problems of land use regulation could be solved simply by compensating owners for their loss of economic opportunity resulting from regulation (such as landmark designation). Such critics have not looked deeply enough at the root understanding that underlies heritage regulation, the conception of a public entitlement, notwithstanding the claims of private property owners. Owners do not begin with a right to destroy a Stonehenge, or the biological productivity of the ocean shore, or the sources of scientific knowledge. Thus, the protection of those things does not have to be bought back.

A little history is helpful in understanding this point. A century ago in England, landowners fought against the first laws for the protection of ancient monuments because they saw in such enactments a loss of what was then viewed as the core value of private property: the right of owners to have dominion over the fate of what they owned, alone to decide its destiny.[13] The proposed ancient monument protection law was seen as taking that right from the proprietor and giving it to the government, a radical change. Landowners feared that an old family castle or an abbey on their grounds, which they saw only as their private possessions, would come to be viewed as part of a national patrimony. That result, as they conceived it, would be the end of private property. A leading opponent of the proposal said:

If they adopted the principle of the Bill in this respect, where was its application to cease? If they were going to preserve at the expense of private rights everything which happened to be of interest to the public, why should they confine the legislation to those ancient monuments? . . . Why should they not equally provide for preservation of the medieval monuments—of those old abbeys and castles which were quite as interesting as the Druidical remains? And why should they stop even there? Why not impose restrictions on the owners of pictures or statues which might be of great national interest? If the owner of the "Three Marys" or of Gainsborough's "Blue Boy" proposed to send it out of the country, were they to prevent him, on the ground that the matter was one of national concern? If they said that a certain circle of stones was of such national interest that an interference with private rights was justifiable in order to preserve it, might they not also say that a certain row of beech trees on a man's estate which gave great pleasure to persons passing by ought in the same manner to be preserved?[14]

Of course, the opponents of the first historic preservation laws were right in predicting the expansive possibilities of

the future, as the concept of heritage grew and developed. They lost out because the argument that the owner of a precious antiquity could simply dismantle the monument and sell it for paving stones or building materials seemed—even in those profoundly proprietary times—bizarrely wrong.

OWNERS AS TRUSTEES

We have absorbed the lesson, which is that the owners of patrimonial properties are, in some sense, trustees and fiduciaries of things that do not entirely belong to them. But because we have never developed a legal theory to incorporate the lesson, heritage cases lack any convincing rationale. The most famous instance is the old case sustaining a prohibition on roadside billboards, not on the ground that it is appropriate to protect the visual beauty of the landscape, but because "behind these obstructions, the lowest form of prostitution and other acts of immorality are frequently carried on, . . . they offer shelter and concealment for the criminal while lying in wait for his victim. . . . "[15] This rationale is different only in degree from the cases that sustain historic preservation ordinances on the ground that they maintain tourism or are no different from conventional nuisance zoning.

The most prominent modern instance is the majority opinion in *Penn Central*, which is at pains to treat the matter before it as an ordinary zoning case. In dissenting, Justice Rehnquist was quite right to insist that historic preservation is not just another zoning nuisance case: "[The landmark designation does] not merely *prohibit* Penn Central from using its property in a narrow set of noxious ways. Instead [New York] has placed an *affirmative* duty on Penn Central to maintain the Terminal in its present state and in 'good repair'. . . . [Penn Central is] not free to use their property as they see fit. . . ."[16] Rehnquist was quite right to note this distinction. His dismay, however, makes him sound like those who opposed England's Ancient Monuments Bill in 1873.

The U.S. Supreme Court is not the only tribunal whose decisions are important. It is not true that every significant issue of historic preservation will ultimately reach that court for resolution. Every state has its own constitution and may find that an ordinance violates state constitutional law, whether or not it also violates the federal Constitution (even if the two constitutions have identical language). A decision invalidating a law based solely on the state constitution is final and cannot be reviewed by the U.S. Supreme Court.[17] That was exactly the situation in the recent *Boyd Theater* case in Pennsylvania where the state supreme court—seemingly eager to be free of any federal court review—

emphasized that it was not resting its decision on any federal law ground.[18] With 50 state courts, anything can happen, and some pretty strange things do from time to time. There simply is no single rule that can be authoritatively stated. It is nonetheless appropriate to focus on the Supreme Court because its federal constitutional decisions tend to guide interpretations of similar state constitutional provisions. That will in all likelihood be the fate of the Pennsylvania case.[19]

Three constitutional claims are significant in evaluating preservation laws: that property has been taken without the payment of just compensation; that the laws in question exceed the proper bounds of the police power; and—in the subcategory of cases involving churches—that there has been an interference with the free exercise of religion. No historic preservation ordinance has been invalidated on any of these grounds by the U.S. Supreme Court, and the Court has recently signaled with the denial of review in the *St. Bartholomew's* case that it has no intention of changing its existing interpretations in ways that would threaten the constitutionality of historic preservation ordinances. (It should be kept in mind, however, that a designation is always subject to challenge on other grounds, such as failure to follow the local statute or factual findings about economic impact.)

It no doubt seems puzzling that the current Supreme Court, given its very conservative and property-oriented bent, is unlikely to respond favorably to property owners' objections to economically costly historic preservation ordinances. The question may seem especially perplexing when it is recalled that the famous *Penn Central* decision of 1978 was decided in favor of the ordinance by a vote of only 6-3, and that while two of the three dissenters (Rehnquist and Stevens) are still on the Court, only two of the majority (Blackmun and White) are also still there, while all five of the new sitting justices (Scalia, Kennedy, O'Connor, Thomas, and Souter) are considered very conservative.[20]

The explanation is not simply the presence of *Penn Central* as a precedent. The Court has not shown itself reluctant to reverse precedents it disapproves, even modern ones. The key to understanding is that the Court's statist tendencies override its economic sympathies. A conservative court is torn between its concern for property rights on one side and its inclination to sustain governmental authority on the other. The latter interest usually prevails. In contrast, a liberal court is—within a very broad range—less concerned about the losses property owners sustain at the hands of government regulation. And regardless of political orientation, judges generally recognize the propriety of protecting the nation's cultural heritage against claims of a right of private dominion, for the reasons stated earlier.

Thus, neither conservatives nor liberals are likely to overturn historic preservation ordinances.

Perhaps the best way to explain the situation is as follows: Virtually all regulation of property adversely affects the property's economic value. Unless courts are to invalidate all regulation, or to hold all regulation compensable (including standard pollution and safety laws), they must accept the constitutionality of some degree of economic loss. After many decades of litigation, the Court has come to the conclusion that it does not want to spend its time deciding in case after case "how much (diminution in value) is too much."[21] So it has adopted the rule that unless a property is rendered economically unviable,[22] which has come to mean virtually worthless, the mere fact of economic loss will not be decisive of constitutionality. This has been the rule for a long time,[23] and the Court has not departed from it in its most recent iteration of takings doctrine, *Lucas v. South Carolina Coastal Council*.[24]

BOUNDS OF GOVERNMENT CONTROL

Because historic preservation ordinances are exceedingly unlikely to deprive a property of all economic beneficial use, if such ordinances are to be overturned, it must be on another ground. The other possible ground is that the purpose of the ordinance exceeds the proper bounds of governmental action. Excess can arise either in general (an improper subject of regulation) or in the particular (a proper subject, but improper as applied in this particular instance). As already noted, a conservative (but not libertarian) court, such as we have today, is hardly inclined to tell legislatures that they have no authority to regulate individual conduct. This is obvious enough in areas of personal rights — abortion, drug testing, drug use, police interrogation, and searches — where the Court has given great ambit to legislative judgments about the control of private activity.[25] It would be quite odd for the Court to take an entirely different stance when it comes to a single area of individual rights — the use of property. This is what I meant earlier in speaking of the posture of a statist court.

Even if the Court were especially sympathetic to the rights of property owners, where would it draw the line in disciplining legislatures?[26] Would it overturn worker or airplane safety laws? Banking regulations? Pollution laws? Regulation of oil spills? We live in a highly regulated economy, and even with a considerable amount of (legislatively approved) deregulation there are literally thousands of regulatory laws, virtually all of which adversely affect the economic interests of someone. Neither the Congress nor state or local legislatures are inclined to abolish even a significant part of this regulation. It is simply unimaginable that the Supreme Court is going to dismantle the modern regulated economy as a matter of constitutional law and against the desires of the nation's legislatures.[27]

Assume that there was a judicial inclination to examine some legislation, or some category of legislation, on the ground that it exceeded legislative authority. Where would a court begin? The recent *Lucas* decision indicates that the Court proposes to begin and end with two very limited categories of cases: physical appropriation and regulation resulting in total loss of economic viability.

The Supreme Court has on several occasions in recent years said that it would apply a test of whether legislation substantially advanced a legitimate state interest.[28] In fact, however, it has not implemented that standard except in the most extreme settings (as where a law seems entirely unsuited to achievement of its stated purpose; or where it applies grossly excessive means).[29] Such extreme cases are very rare, and the standard cannot be applied to ordinary cases except by a court that is prepared to become a superlegislature and to decide for itself when legislation is appropriate — a most unlikely venture for a court that adheres in any way to the conventional (and conservative) virtue of judicial restraint in the face of legislative action.[30] How is a court going to embark on the process of deciding whether a law substantially advances a legitimate state interest? Shall it — and not Congress — determine the role of the Endangered Species Act as against the claims of the timber industry? Is the Supreme Court to say that cleaning up toxic waste dumps is too expensive and the risks too remote to justify what we are spending? Shall it reexamine congressional decisions about the size of deposits that federal bank insurance should cover? Or should it decide whether legislative restrictions on insider trading in the stock market advances a public interest with sufficient substantiality?

This sort of "slippery slope" problem would apply equally to a revival of the old view that regulation based solely on aesthetic considerations is invalid. Such a view would immerse the courts in cutting away at a very wide range of modern regulation. The judiciary is hardly likely to start invalidating sign control ordinances, open space zoning, and architectural review, or to begin questioning the use of the condemnation power to establish parks. What would it do about height limitations or zoning of adult bookstores? Of course, it could go back to the motorcycle-billboard approach of yore, seeking to find health and safety rationales

Opposite: The state supreme court ruled that aesthetic reasons alone could not support designation of Philadelphia's Boyd Theater.

for those amenity laws it likes and failing to find such justification for those it disapproves. Or as noted above, the courts could sift through each ordinance to decide whether the ordinance substantially advanced a legitimate state interest. But these are most unlikely and unattractive prospects for the judiciary. That is no doubt why Chief Justice Rehnquist was at pains to say, in the San Diego sign ordinance case, that even purely aesthetic justifications are sufficient to sustain legislation as within the proper scope of the police power.[31]

In summary, even the most conservative courts today are unlikely to overturn historic preservation ordinances because

- courts are generally supportive of state regulation, as against claims of individual rights
- there is no way significantly to limit the scope of the police power that does not threaten to unravel the basic structure of the modern regulatory state
- there is no workable way to decide how much is too much in terms of the adverse economic impact of regulatory ordinances

Taken together, these elements explain why the 1978 decision in *Penn Central*, although it seemed to be built on a fragile majority, is in no danger of being overturned. It explains also why the *St. Bart's* case—like *Penn Central*, also involving New York City landmarking, but this time involving a church—was decided in favor of the city at both the trial court and appellate court levels, and why the Supreme Court declined to review it. The Court's very strong support of legislative regulation, even as against First Amendment claims of free exercise of religion, also explains why the application of historic preservation land use controls to churches, as in both the *St. Bartholomew's* case and in the *First Covenant* case in Seattle, presented no risk of invalidation at the hands of the U.S. Supreme Court.

THE TAKINGS ISSUE

What about other recent Supreme Court cases in which regulations have been found to constitute unconstitutional takings of property without compensation? The answer is that none of them involved the Court in weighing and measuring the propriety of regulatory government or the limits of economic restraints. Each modern case represents a very limited danger area the Court has carved out. Basically, that area consists of situations in which government physically appropriates land from a private owner, either through exaction[32] or by compelled public access.[33] A taking also may be found where the Court is persuaded that the regulation advances no discernible public purpose;[34] or in the uncommon case where the Court finds that a property has effec-

tively been made worthless.[35] These exceptions present little risk to historic preservation ordinances.

In both *Penn Central* and *St. Bartholomew's*, the courts seem to have carved out a more restrictive diminution test than the "denies . . . economically viable use"[36] test that is generally applicable. *Penn Central* set a standard of continued operation in its originally expected use, with the ability to obtain a reasonable return on investment from that use. This is essentially a no-right-of-further-development standard, which is certainly highly favorable to historic preservation. Its only constraint is that the existing use must produce a reasonable return, while the "economically viable use" test seems to permit the regulation even if the existing use is unprofitable, so long as there is some profitable use for the land. To translate this into the formulations used in the cases, it appears that in historic preservation, the Court is applying an expectations test (based on the original, or existing but long-standing, use), while in land use regulation in general, the Court's standard is denial of all reasonable use or reasonable rate of return.

The test in the *St. Bartholomew's* case, where profit cannot be the test, is a bit unclear. It may simply ask whether the structure, as it stands or with affordable repairs, can continue to be used for the charitable purposes to which it has been put in the past.[37] But the court also speaks of a test that could be much more difficult to meet, that is, whether the existing building (as is, or with affordable repairs) is sufficient to carry out the church's present religious mission.[38] The Community House of St. Bartholomew's Church would apparently meet either test. But one might well imagine a case in which the existing building is perfectly usable for carrying out the mission, but is too small to carry out the whole of the mission, and cannot be enlarged without violating the historic preservation ordinance. Will the church then be required to acquire additional space elsewhere, or will it be allowed to demolish the existing structure and replace it?[39] This is a constitutional question the Supreme Court has yet to answer, either for nonprofit entities or for businesses, like railroads that might have outgrown their stations.

It is highly unlikely that an institution would be required to retain a structure that is unsuitable, and the lower court cases strongly suggest that no such mandate would be imposed. There may be other alternatives to a flat hardship exemption, especially where modification or demolition would cause the loss of a major structure. Efforts to find a buyer or lessee to use the existing structure, while an alternative site is sought for needed expansion, is one established technique for avoiding such ultimate decisions. The *St. Bartholomew's* case strongly indicates that continued suitability for use must

The U.S. Supreme Court found no reason to invalidate preservation controls applied to the First Covenant Church in Seattle.

be found if the restriction is to be sustained. I predict that the courts will resist being pushed any further.[40]

Reading between the lines of historic preservation cases—and that is the most rewarding way to read them—reveals that a major shift has taken place in the balance between private property rights and public claims on the use of land. The idea of heritage resources—not only historic properties but natural features and human communities of distinctive cultures as well[41]—has come into the full light of public and legal attention. The owner as a fiduciary of a trust property, obliged not only to refrain from doing harm but to act affirmatively to protect patrimonial property, is now a reality in fact, if not yet in theory. The prophetic words of Victor Hugo, written more than a century and a half ago, have become the effective rule by which we govern:

It is necessary to halt the hammer that mutilates the face of the country. . . . Whatever the rights of property may be, the destruction of a historic and monumental edifice cannot be permitted to these . . . speculators whose interests blinds their honor. Thus to destroy . . . is to exceed the right of ownership.[42]

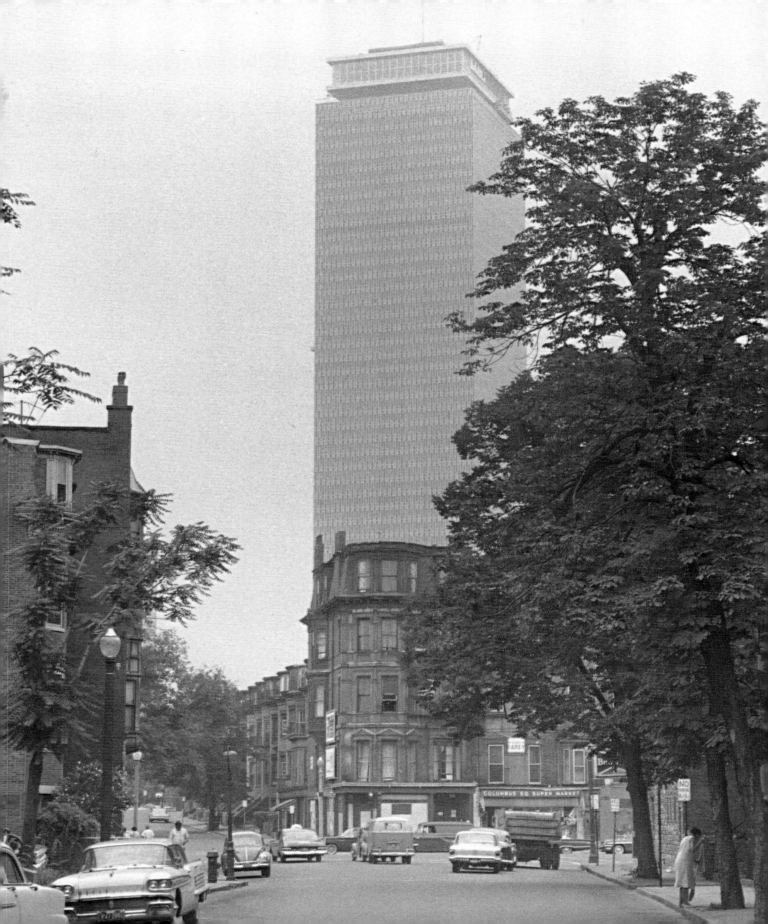

A NEW PARADIGM FOR PRESERVATION

Tersh Boasberg

IN THE PAST 25 YEARS PRESERVATIONISTS HAVE BEEN ABLE TO TAKE GREAT PRIDE IN THE EXTENSION OF PROTECTIVE MEASURES FOR HISTORIC RESOURCES TO ALL LEVELS OF GOVERNMENT. HOWEVER, THESE SAME PROTECTION STRATEGIES WILL HAVE TO BE GREATLY EXPANDED IF WE ARE GOING TO MEET THE CHALLENGES OF THE NEXT 25 YEARS.

As preservation concerns broaden to include protection of urban downtowns and neighborhoods, suburbs, and rural areas, our strategies must also expand beyond the legal controls offered by the traditional local preservation ordinance. We will have to rely much more heavily on such powerful tools as zoning codes, growth-management measures, and comprehensive state and metropolitan planning processes. At the same time, preservationists in many old areas may become less concerned with the traditional architectural controls of historic districts and more interested in the extensive environmental protection strategies available through conservation zones and special-appearance districts. All of this necessitates a much more inclusive and broadened preservation movement, close political allies, an expanded economic rationale, and a refined ethic of land stewardship.

The historic preservation movement in America has met with impressive success since passage of the 1966 National Historic Preservation Act. An extensive complex of protective measures at all levels of government has been put in place. At the federal level, the number of properties listed in and eligible for the National Register of Historic Places has jumped from 900 to 58,000. More important, perhaps, has been the stunning increase in National Register historic and archeological districts. These have grown from a handful in 1966 to nearly 8,000 today, containing more than 800,000 contributing resources. While National Register listing or eligibility does not, by itself, confer significant protection (especially from private development), it does offer great visibility and public recognition, the necessary first steps toward saving a resource. The federal government also sets the standards governing the identification and classification of historic resources, which states and local communities often follow.

At the state government level, virtually every state now has enabling legislation that provides the legal framework for local enactment of historic preservation ordinances. Moreover, almost a dozen states have land use planning statutes that require local jurisdictions to consider comprehensive

plans for the protection and enhancement of their historic as well as natural resources.

However, it is at the local level where the protection battle is really won or lost. Here, we have great reason to applaud. In 1966 there were fewer than 100 local preservation ordinances in the entire nation. Over the next 10 years the number grew to about 400. Today my best guess is that we have more than 1,700.[1] Moreover, each local preservation ordinance enacted by a community often covers numerous historic districts. In my own hometown of Washington, D.C., the citizens have caught on fast to the protective value of historic districts. In 1977 there were a total of three local districts. Now we have 21.

There are many reasons for the success of the preservation movement, but I suspect that much of it has to do with the heightened awareness that we are facing—for the first time in our country's history—profound limits on our resources. As America's population gravitates to the East and West coasts, bringing to these areas all the problems of intense metropolitan growth, air and water pollution, transportation gridlock, urban crowding, and loss of open space, it makes sense to place some limits on the wholesale destruction of our natural and historic resources through more intelligent land use planning and controls.

The vast majority of historic preservation ordinances were enacted by communities after they already had established their zoning codes and planning frameworks. Because they came later, preservation commissions tended to follow a separate regulatory path from zoning and planning boards. This was helpful to the extent that persons with preservation expertise could be appointed to the new landmark preservation commissions. Also, it meant that preservation ordinances could be drafted to respond to specific preservation issues such as demolition and the need for detailed architectural controls—concerns that were not a part of ordinary zoning matters.

USING ZONING'S CLOUT

However, as historic preservationists broadened their concerns, they became more involved with traditional zoning issues, such as height, density, and use. Moreover, as preservationists learned in the fights against urban commercial development, especially downtown high-rises, it was virtually impossible to resolve these kinds of preservation issues without reliance on the stronger and more pervasive city planning and zoning statutes. It is against this expanded and more complex background that preservationists have come to value the authority and greater political clout of the more established planning commissions and zoning boards.

Preservation efforts in Washington, D.C., owe a great deal to recognition of this lesson. Washington's old downtown still has a few squares that have retained much of their historic fabric. This area, designated 15 years ago by the city's Historic Preservation Review Board, centers around the Old Patent Office at 8th and G streets, N.W., in whose corridors Walt Whitman and Clara Barton once nursed Union soldiers during the Civil War. Surrounding this classical gem stood 231 eclectic 19th- and early 20th-century commercial buildings in a somewhat down-at-the-heels historic district. The district was located in the midst of an 88-block downtown area that was to be totally rezoned by the city's zoning commission.

Despite a relatively strong local historic preservation statute, the only way these buildings were going to be saved was by downzoning the historic district. This would remove the economic incentive to demolish the smaller historic structures to construct new buildings of greater height and density. In fact, the city's zoning commission did order such a downzoning as part of its complex and comprehensive rezoning of the entire downtown area, which also contained the downtown retail core, an arts district, Chinatown, and large areas of potential housing. The point is, of course, that the city's last remaining downtown historic district was saved *not* by a strong preservation ordinance or by an enlightened preservation review board, but by the city's zoning commission, using its broad authority under the city's comprehensive plan and zoning statute. The downzoning also included the transfer of development rights out of the historic district to other downtown areas.

Washington's story is not unique. Efforts to protect downtown historic resources have become increasingly dependent on comprehensive planning, zoning, and growth-management statutes in other cities as well. Witness the impressive preservation gains in the downtown plans enacted in the past five years by San Francisco, Boston, Seattle, and Portland.

Preservationists in rural areas, too, have felt a growing need to turn to planning and zoning mechanisms for better protection of historic resources. Outside Washington, D.C., the 18th-century village of Waterford, Virginia, provides a good example. The Waterford National Historic Landmark, located 15 miles from Dulles Airport, contains the idyllic village of Waterford, about 100 houses, surrounded by 1,500 acres of beautiful fields reaching down into the back yards of the villagers. Waterford's problem is not within the town, itself, which is protected by a perfectly adequate county historical ordinance; rather, Waterford faces the threat of intensive subdivision development on the land surrounding the village, which serves to authenticate its origins as a quintessential early American farming community.

The county's preservation ordinance does not deal with residential densities—either within the village or on Waterford's surrounding farmland. A solution beyond that offered by traditional architectural and design controls has to be found. The verdict is still out on Waterford's fate, but the lesson is clear: unless preservationists can use county zoning mechanisms and comprehensive planning tools to lower or shift densities, they cannot protect rural historic resources such as Waterford. Moreover, as many have discovered, the inherent limitations of preservation ordinances are even more obvious in the fights to protect still larger rural resources such as 1,000-acre Civil War battlefields or the most historic portions of the Piedmont or Maine's coastline or California's gold country.

EXTENDING THE BOUNDS FURTHER

Other factors as well indicate the need to go beyond preservation's traditional protective mechanisms. At the same time that preservationists have broadened their concerns in both urban and rural contexts, which will require more extensive forms of land use protection, typical local preservation ordinances are meeting with increased resistance in many communities. For example, there is much current agitation over strict preservation measures for religious properties. Chicago's fine new preservation ordinance was amended at the last minute to exempt religious properties completely from its reach. Owner-consent provisions for listing landmarks also are becoming increasingly common. The Commonwealth of Virginia now requires owner consent for designation of all new state landmarks.

Residents in Pittsburgh, who last year rejected a proposed historic district for an in-town neighborhood, say that less invasive controls, such as conservation zones, may be more attractive and more politically acceptable than preservation districts and the cumbersome architectural review process these mandate. It is hard to tell from this one example whether the educational groundwork for the historic district was poorly laid or if residents really believed the district would intrude too much on their day-to-day living. In an even more ominous act, the Pennsylvania Supreme Court ruled in July 1991 that Philadelphia's historic preservation ordinance violated the state's constitution.[2]

Furthermore, as preservationists find that their first-tier goals are being achieved—securing protection for the most obvious and most significant resources—they are extending their reach to protect less architecturally distinguished structures and districts. This is not to suggest that warehouse districts and Art Deco buildings, for example, are any less worthy of protection than 18th-century Georgian mansions,

but only that to government officials and, perhaps, to growing members of the public, preservationists may be seen as increasingly narrow, strident, and fussy.

The result of such a perception—even if totally misguided—is a concomitant loss of political power. For the historic preservation movement, never the most burning of national causes, such a comparative loss of influence can have drastic consequences: the failure to obtain favorable federal tax legislation, for example; or the loss of local protection for religious properties; or the inability to secure statewide comprehensive planning measures.

It should be made clear that if we are to seek new legal models for protecting historic resources, we must not scrap what we have so successfully constructed in the past. In many ways, the local-state-federal protection partnership anchored by local preservation ordinances, state enabling statutes, and the National Historic Preservation Act is a powerful framework. There is much to be done with the tools we have already fashioned.

However, in many cities and rural areas, preservationists will have to go well beyond the protections of the traditional preservation ordinance. We will have to master the trade of city and regional planning, and use powerful zoning and land use controls to achieve our larger purposes. At the same time, we must be willing to consider the merits of conservation zones and other protective devices that focus more on the environment, character, and visual qualities of a district than they do on its history or architecture. For example, the North Carolina legislature has provided for an "appearance commission" in each local jurisdiction, with powers over historical and environmental matters.

Professor Robert E. Stipe is ahead of the rest of us in predicting this dual approach. In his address to the School of Environmental Design at the University of Georgia in 1989, he cautioned that preservationists must continue to rely for protection on the traditional preservation ordinance, which centers on the quality of historical integrity. However, he adds:

At the same time, national, state, and local preservation programs—all of them—will have to display increased sensitivity to changing concepts of significance that have less to do with maintaining the artistic and stylistic integrity of buildings than they do with enhancing the quality of the larger environment for the daily living purposes of people. This is not to say that one objective may be substituted for the other; both will have to be pursued at the same time.[3]

At the local level, the broader concerns of preservationists must be fully integrated into a city's comprehensive plan and zoning map. This means gaining increased acceptance

of preservation principles within city planning departments, zoning and planning commissions, and especially within a city's so-called economic development administration.

In Washington, D.C., our in-town residential neighborhoods such as Cleveland Park and Dupont Circle have found that traditional historic district protection is not enough. It does not provide residents with the necessary legal tools with which to resist intense commercial pressures for new development. Both of these historic neighborhoods have also needed the assistance of the city's zoning commission. The commission has helped them secure zoning overlays to limit the height and density of new residential and commercial construction, restrict the incidence of so-called PUDs (planned unit developments) that can legally circumvent both preservation and zoning controls, and establish an overall zoning protection envelope for the entire neighborhood so that each threat to a historic building or streetscape does not force the community to commit its entire resources to yet another monumental battle.

Cities such as Boston, Portland, and Seattle have incorporated preservation policies in their recent comprehensive downtown plans and rezonings. San Francisco, perhaps more than any other large city, has chosen to protect and enhance its historic resources almost wholly within the context of its planning and zoning laws. Thus, there are few local historic districts administered as such in this city, but development both downtown and in the neighborhoods is strictly controlled by compatible height, density, and use limitations in appropriate residential, commercial, and mixed-use zoning districts.

ADDRESSING THE REALITIES

It does not matter particularly whether preservationists rely on conservation zones (which combine preservation and zoning measures) as the protective mechanism of choice—as is the case in San Francisco, Roanoke, and downtown Boston—or zoning districts alongside, or overlaid on, traditional historic districts, as is the case in Washington. What is important, however, is that the legal protective mechanism be designed to deal with the underlying realities of the district. Thus, where a wealth of architectural and historic detail is the hallmark of a particular neighborhood, then the protective mechanism (historic district or conservation zone) must have a provision for dealing with demolition, new construction, and alterations. When open space and "livability" are the identifying characteristics of a neighborhood, then such issues as density, infill, and setbacks are important. Professor Stipe refers to these pleasant but not necessarily historic areas as "pre-natal" historic districts or conservation

areas and notes that Great Britain now has more than 6,000 such areas.[4]

Successful rural preservation efforts also must go well beyond traditional landmark laws and use comprehensive planning and zoning mechanisms wherever possible. Efforts to save the largest Civil War cavalry battlefield near the village of Brandy Station in rural Culpeper County, Virginia, 75 miles southwest of Washington, point up the total inadequacy of both the county and Virginia historic preservation protection systems. In September 1990, one week after the heralded PBS Civil War documentary was aired, county authorities voted to rezone 1,500 acres in the heart of the battlefield from agricultural to industrial use.

Here, as in many rural communities, no thought whatsoever had been given to incorporating a historic resource element in the county's comprehensive plan and then providing some form of resource protection through county zoning. Worse still, in Virginia, as in other states, there is no legal requirement that a county's zoning ordinance be consistent with its comprehensive plan. In contrast, Rhode Island requires that each municipality have a historic preservation component to its comprehensive plan and that local zoning adhere to the plan.

Traditionally, states have left zoning, historic preservation, and land use ordinances to the local level. This well-established preference undoubtedly will outlast us all—even though most localities are totally ill-equipped to protect their agricultural lands and historic resources from the intense pressures of modern development. There is simply too much money at stake.

TURNING TO THE STATES AND REGIONS

Nevertheless, it is to the state level, in the direction of comprehensive planning, that preservationists should turn. States such as Florida, Oregon, Georgia, New Jersey, and Rhode Island are out in front. They are among a handful of states seeking to provide protection for historic resources in their own statewide comprehensive plans and to require that local communities consider how they too are going to protect and enhance their own resources. This kind of mandated comprehensive planning, coupled with a statewide zoning consistency requirement, should be our initial goal. Moreover, state registers of historic places, "baby" NEPAs (modeled after the National Environmental Policy Act), and Section 106-type procedures governing state funding actions also would boost protective efforts at the state and county levels.

While most current historic preservation efforts may lack regional dimensions, the writing is on the wall. Interstate

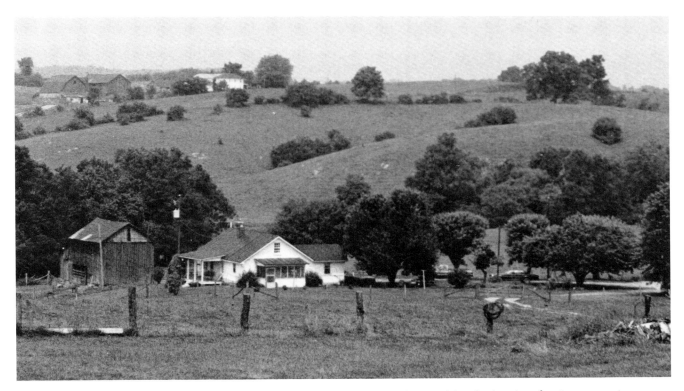

Land surrounding the village of Waterford, Virginia, sets it apart as a quintessential early American farming community.

environmental protective measures are quite commonplace. For example, the cleanup of the Chesapeake Bay and such river basins as the Delaware, Potomac, and Susquehanna are being undertaken within a regional context. As cities and suburban areas increasingly seek to protect their environmental surroundings through open space, growth management, land banking, and rails-to-trails programs, it would not be surprising to see extensive historic resources such as the Shenandoah Civil War battlefields, heritage corridors, and pioneer trails protected on a regional basis.

Finally, the federal government also should look beyond the confines of the local preservation ordinance if it is serious about protecting significant historic resources. Congress should legislate some form of protection from private development for National Register and National Historic Landmark properties. It simply makes no sense for the government to designate national landmarks or list properties in the National Register and offer them protection from destructive federal actions—and then allow private developers to destroy these same resources with impunity.

As historic treasures such as Waterford and our great 19th- and early 20th-century estates become devoured by uncontrolled private development, along with such natural resources as our coastlines, wetlands, and prairies, the federal government will come under increasing pressure to encourage comprehensive land use planning on a statewide and regional basis. Such federal efforts might take the "carrot-and-stick" approach to planning favored by the Coastal Zone Management Act, or the funding of interstate compacts used in much of the river basin legislation, or the provision of seed money to state and regional planning offices as in the area redevelopment field. Whichever mechanism is chosen, future federal preservation and environmental aid to state and local governments should be conditioned on the enactment of statewide and local preservation plans that offer real protection to historic and natural resources.

It would not be a quantum leap to expand the 1966 act's Section 106 coverage to require that federal aid to state and local communities take into account the indirect as well as the direct effects of such aid on the preservation of National Register-listed or eligible properties. In the case of Civil War battlefields, for example, it would not be enough for the U.S. Department of Transportation to consider only whether federal funds used to widen an interstate highway would damage an unacceptable additional amount of historic ground. Rather, DOT should also determine whether the widened interstate would pave the way for increased private development on the adjacent or nearby battlefield

that would destroy the site's historical integrity. In other words, federal agencies should make clear that they will consider the indirect as well as the direct result of their actions on federally designated resources.

These, then, are some of the forms that a new protection paradigm might take at the local, state, regional, and national levels:

- conservation and overlay zones that combine certain elements of both historic district ordinances and zoning codes
- comprehensive planning for historic and natural resources at the state and local levels
- increased federal support for such large-scale efforts

Most important, the new strategy should not replace but instead complement the successful use of traditional preservation laws. Any expanded approach, however, will carry with it the need for an expanded movement.

EXPANDING THE MOVEMENT IN RESPONSE

Preservationists must work much more closely with environmentalists. This is true both for political and programmatic reasons. As noted earlier, if preservationists are to build a powerful political base from which to demand more extensive resource protection, we must increase our numbers and widen our ranks.

Also, because preservation concerns have broadened to include neighborhoods, downtowns, and rural areas, it makes good programmatic sense to forge strong alliances with environmental groups of virtually every type: from those dealing with air and water pollution to those interested in open-space preservation, Civil War battlefields, land trusts, farmland preservation, and numerous other areas. Other obvious allies are landscape preservationists, from Olmsted Park protectors to landscape historians and designers, as well as garden clubs, horticulturists, and naturalists.

We also should make common cause with the growth-management movement. In most city neighborhoods and downtowns, and in many of our pristine rural areas as well, the destruction of both historic and natural resources is caused largely by unmanaged metropolitan growth. Historic preservation and growth-management supporters share the common need to secure intelligent statewide and community comprehensive planning legislation.

Growth management offers preservationists an interesting economic rationale as well. If we are to make the public case for historic preservation, we must base it not on patriotism or aesthetics, but rather on economics. Preservationists have raised economic banners before, championing such propositions as "rehabilitation generates more jobs than

new construction" and "smaller buildings are more energy-efficient than high-rises."

However, the economic rationale behind growth management is much more convincing. For example, while preservationists can thump their chests about the sanctity of Civil War battlefields, county supervisors will be much more receptive to the concept that unmanaged subdivision growth on such battlefields would ultimately cost the county more than their preservation. Rampant growth would lead to expensive rural sprawl and greatly increase the need for new schools, roads, and services for the incoming residents. At the same time, such growth would destroy a possibly lucrative tourist attraction that could have benefited the county economically without necessitating the additional costs associated with an increase in permanent residents.

Growth-management arguments can also underpin preservation efforts in urban areas. For example, there is growing disenchantment with the proposition that downtown office buildings always provide a municipal government with more taxes and jobs than the selective retention of smaller buildings and promotion of urban housing. We know for sure that downtown high-rise concentrations bring with them increased air pollution, clogged freeways and bridges, loss of light and air, destruction of smaller historic buildings, and soaring housing costs. Now experts such as MIT economist David Burch question whether high-rises actually account for as much job development as we previously had thought, in contrast to the known growth of jobs in the small-business sector. Often, this sector cannot afford the rents charged by the new high-rise office buildings, and the result is net job losses downtown—not gains.[5]

Other economic studies have shown that residential housing in downtown areas actually may benefit a city more than new office construction. This was the conclusion of the Washington, D.C., zoning commission when it recently rezoned the city's downtown to include residential development. We know, for example, that downtown residents contribute twice as much in retail purchases and sales taxes as daytime office workers. For cities such as Washington that collect personal income taxes, new downtown permanent residences will account for many more overall tax dollars than an equivalent amount of commercial office space. Moreover, additional residents will help create a lively 24-hour downtown area, with more shoppers, theatergoers, and "eyes on the street"—and that means a lot less crime.

Perhaps the best new candidates for an expanded preservation movement are minority groups. Minorities, already in control of many cities, are becoming an increasingly significant percentage of the nation's population. What is

important to them, as Antoinette J. Lee so convincingly points out in her essay here, goes well beyond the protection of traditional architecture. They are concerned with social history, intangible cultural resources, oral history, and similar endeavors. By broadening our ranks as well as our protection strategies, we can move to accommodate these new groups as well.

If growth-management theories of job creation are on target, then preservationists and minorities should be making political alliances to support job growth in the small-business sector in both downtowns and urban neighborhoods. This means minorities, as well as preservationists, can favor controls on downtown office high-rises that would result in the long-term displacement of small-business jobs, often held by minority workers. High-rises also result in soaring city housing costs because incoming office workers (mostly nonminority) will seek housing in neighborhoods near their new offices—pushing up housing prices for everyone, especially those at the bottom of the scale, who frequently are minority residents.

Of course, in the drive to widen our ranks, increase our political clout, and embrace new points of view, we risk diluting our focus. This has ever been the argument in preservation circles between the purists and the newcomers. But the movement's remarkable diversity and its ever-broadening concerns show no signs of damaging its good health.

An additional consequence of adopting new protection strategies will be the need to better define and classify historic resources. Obviously, resources of outstanding architectural and historical integrity will need the full protection of a tough preservation ordinance. However, other resources that are perhaps more cultural or "atmospheric" could make do with the somewhat lesser protection offered by a conservation zone. The Boston landmark ordinance, for example, ranks buildings in six categories ranging from "noncontributing" to "highest significance," and each cat-egory is accorded a different degree of protection. San Francisco's planning code also distinguishes between "significant" and "contributing" buildings in determining levels of protection. In Roanoke, Virginia, there are two kinds of historic districts, both fully integrated with the local zoning code, but each provides a different degree of control in the review of additions, alterations, and new construction.

We must make these kinds of distinctions if we are to succeed in broadening our political base and expanding our protective mechanisms. If preservationists are to preserve and enhance an increasing number of urban neighborhoods, downtown cores, small towns, and rural areas, we must make distinctions in the scope of protection sought for such divergent and dispersed historic resources. The public simply will not support a "save everything" approach.

None of this will be possible—not new protective strategies, not growth management, not even comprehensive planning—without a change in the way Americans value and use their land. If we are really serious about protecting our historic resources, whether New England towns, Civil War battlefields, urban neighborhoods, or 20th-century downtowns, we will have to find a better balance between private rights of ownership and the public good. In the words of British conservation planner Graham Ashworth, we will have to recognize that ". . . ownership of land carries a responsibility for stewardship and not just stewardship exercised by the few or the mighty but by everyone."[6]

Such a new land use ethic will not be soon advocated by either of our major political parties. But our ever-burgeoning population, dramatic loss of farmland, severe traffic congestion, air and water pollution, and the wholesale destruction of our historic and natural resources by uncontrolled metropolitan development surely will hasten the day of its arrival. Our job is to make sure this new land use ethic arrives while there is still something left to preserve.

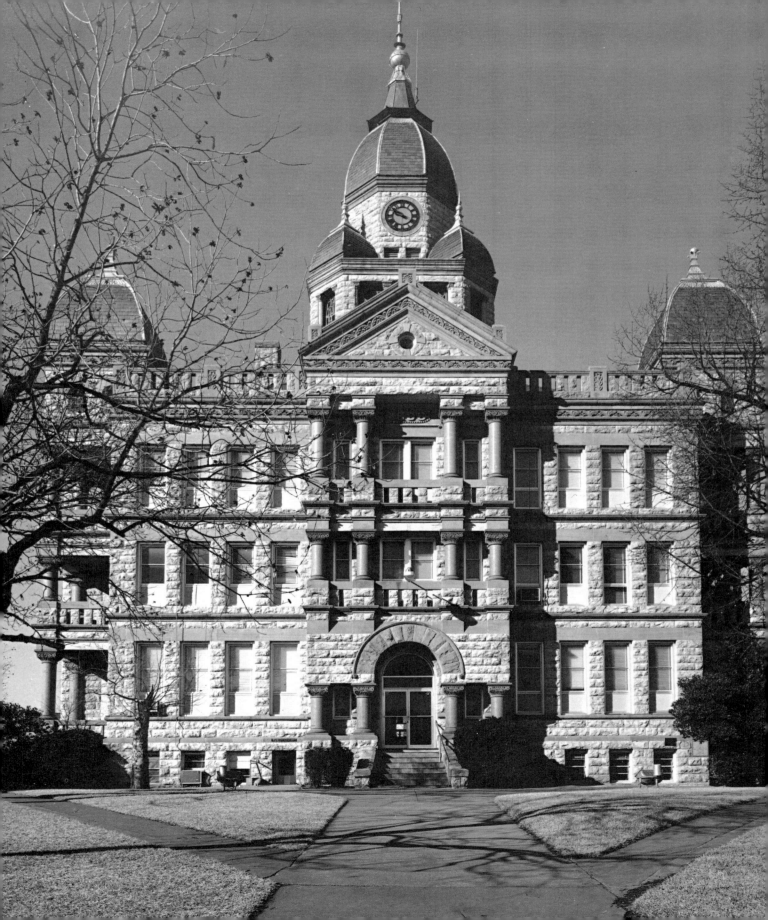

THE POWER OF A MOTIVATING MESSAGE

Larry Light

CHANGE IS A LAW OF LIFE. THAT SOUNDS LIKE A CLICHÉ. BUT REMEMBER WHAT DAG HAMMARSKJOLD ONCE SAID: "THERE IS A PROBLEM WITH BASIC TRUTHS. THEY SOUND LIKE CLICHÉS." HERE IS A BASIC TRUTH: IN A TURBULENT, DYNAMIC, CHANGING WORLD, WE NEED CONSTANTS. AND HOW THE WORLD HAS CHANGED.

I am a passionate reader of the U.S. Census. I recommend it to you. It is an absolutely fascinating document. For example, people are marrying later. Some people are choosing not to get married at all. In some communities, it seems, marriage is now the alternative lifestyle. We also have all read about the graying of America, the aging of our population.

But there is a trend that is more basic, more fundamental, more global, more significant. There is a revolution in the world, an important revolution that is affecting social, political, and public policy, and ought to affect our preservation policies: for the first time in the history of this planet, 50 percent of school-aged children are actually enrolled in school. More than half of the children of the world have the opportunity to learn the basics for turning darkness into light.

Remember these four words: smarter people live smarter. Smart is not an IQ score. Smart is an attitude about life. It means being resourceful, ingenious, competent, and re-sponsible. As education increases, attitudes toward work change from lifting things to thinking things, from pushing steel to pushing pencils. As education goes up, family size goes down. This is very smart.

Smarter people are quality-conscious. And as people get smarter, their focus changes from quantity to quality, from what something costs to what is it worth, from best price to best value. And this shift affects every aspect of our social consciousness.

Some people will tell us that value-consciousness is just an aberration, a sign of the current economic times. This is nonsense. The desire for best value is a fundamental long-term trend. But the desire for value is not new. What is new is how people define "value." My mother taught me, for example, that "best value" meant learning to compromise. Cheap is just that—cheap. And those high-priced products are high priced because you are just paying for the advertising. If you want the best value, get the best compromise.

This spirit runs through our society. Just take a look at

what is happening every day under this new philosophy. How do you stay lean and eat cuisine? Eat Lean Cuisine. You want something low in calories but high in taste? Drink Diet Coke. A tradeoff of traditional versus modern, of old-fashioned versus new. But the Smarter Generation disagrees. It thinks that the best tradeoff is no tradeoff. The best compromise is no compromise. Its view of life is "Maximize. Don't compromise."

Maximize, it says, the best of this new-fashioned world, but do it without compromising the best of the old-fashioned values. Preservation versus development? The Smarter Generation says "no conflict." Think partnership. Are preservation and development inherently opposite terms? No. Actually, to the Smarter Generation, preservation is an attitude, not merely an activity. It is an attitude about managing change in a responsible way. In a modern, dynamic, turbulent, complex, confusing, challenging, changing world, the Smarter Generation tells us, we need constants more than ever before. We need dependable, meaningful cultural signposts.

We conducted a research survey asking people what their image was of historic preservation. Historic preservation is not perceived to be essential. It is not a high priority in comparison to other causes. According to the results of this survey, preservation ranks significantly behind medical research, education, and conservation of the natural environment. As one respondent says, "First we must save the earth. Then we can worry about saving the buildings." From this perspective, it is no wonder that historic preservation is viewed as a luxury, not a necessity.

I am concerned that people see the historic preservation movement as low in importance and personal relevance. I am concerned that they think of the personality of this movement in negative terms. Ask yourself this question: if historic preservation were a person, what kind of person would it be? I am concerned that when people are asked, what is the benefit of historic preservation?, they have trouble articulating an answer. I am more concerned that when the same question is asked of people who are involved actively in the movement, they too find it difficult to articulate a consistent, focused, meaningful answer.

SPEAKING WITH ONE VOICE

This is our challenge. What should the movement's consistent, united message be? As we in marketing would say: What is the focus? What is the special niche of historic preservation as a unified movement? As a unified national force? I can tell you this: inconsistency breeds uncertainty. Uncertainty breeds confusion. Confusion builds a lack of

trust and confidence in a movement. The movement—the cause—must speak with one focused and consistent voice.

If each of the various organizations, locally and nationally, say different things, even if they think they are communicating well, the net impression to your audience will be confusion. I ask you: What is your consistent, differentiating, motivating theme, purpose, or vision for historic preservation? What are the relevant distinctive benefits of historic preservation?

Our quantitative research survey provides us with some guidance as to what those answers might be. There are several things to keep in mind in developing a motivating message. They are easy to remember and they all begin with the letter *c*.

Continuity. People tell us that they feel a need—not a want—to be connected to both the past and the future. There is a security, they tell us, in knowing our origins. There is a need for permanence, for immortality.

Several fundamental needs feed human behavior. One is the need for continuity. The other is a need for community. People do not want to die. They do not want to die alone. Historic preservation satisfies these basic human needs, providing a feeling of continuity and community. This is our mission. It is our responsibility to preserve and learn from the best of the past. It is this movement's responsibility to pass it on to the future, to responsibly manage this nation's historical legacy.

That legacy is not just the buildings, the sites, or the monuments. Survey respondents say that what really matters is what these buildings, sites, and monuments symbolize. What can we learn and appreciate from historic preservation? Tradition provides direction.

Character. The past is more than history. The past is our identity, our character. We know someone's character by questioning that person about his or her past. We get a deeper understanding of who we are by better appreciating who we were. "Our lives," says one respondent, "are richer today and will be richer tomorrow because of the historic sites that are preserved."

We develop a deeper understanding of our culture and a better appreciation of our unique character as a nation by experiencing history, not just by reading about it. We must preserve the richness and diversity of our nation's cultural character for future generations.

Content. What is the content of our character? What is the content of this movement's message? The Smarter Generation is concerned with quality. Its members believe that historic preservation's mission is to preserve the best, the most

differentiating, the most relevant qualities of the past. These people also tell us that historic preservation helps preserve an "honest picture" of America's unique heritage.

In a world of phony, fake, artificial, synthetic, and plastic, there is a growing passion for the original. A passion for authenticity. A passion for integrity. A passion for honesty. A passion for truth. You must have that same passion to protect and preserve "the real thing." But this concern for authenticity means preserving a true and genuine picture of America's diverse heritage, including those aspects that may bring discomfort to our social conscience. It is dishonest to preserve only those things with which we are comfortable.

Commitment. People do not have a great deal of commitment to, or concern for, the cause of historic preservation. So how do we increase that commitment to this important cause? The research indicates that people see the movement as distant and impersonal. People do not perceive that historic preservation will have a positive impact on their lives. They do not perceive it to be personally relevant, to be close to home. They see the cause as distant and detached.

The remedy is simple: Be visible. Demonstrate accomplishment. Be personal. Have a united national vision but be locally active. The theme for the global environmental movement is "Think globally. Act locally." The strategic theme for the historic preservation movement should be "Think nationally. Act locally. Be personal."

ACT LOCALLY, BE PERSONAL

When asked what National Trust programs they regard as most useful, people give high marks to the "eleven most endangered sites," loans and grants, and the Main Street program. Why? Because these activities suggest that preservation is a high-energy, proactive national movement that can affect people's lives where they live. National organizations are important. But the most important action is local action, whether it is taken through public policy, private policy, business policy, or nonprofit policy.

Be local. Be personal. In a world where family size is going down, the need for family is going up. The movement, however, is perceived to be an adult movement with little interest in, and little relevance to, families with children. Yet respondents tell us they would like tangible, useful, practical materials that would interest and inspire children. No wonder educational materials ranked high on the list of activities people would find most useful.

Is there a perceived benefit to all of this? Yes, there is. In addition to the important motivations listed previously, note the following: 95 percent of respondents to our survey—an astonishing number—believe that communities are made more livable if both historic and traditional architecture is respected. The Smarter Generation is on our side. Its members care about understanding and appreciating our unique heritage. They believe that there is no reason to compromise the quality of our historic environment in order maximize life in the current world. There are some marketing homogenizers who are still preaching and teaching that individuation, localization, and fragmentation are figments of marketing imagination. They talk about the global village and global standardization. They would have us believe that the world is a melting pot in which consumers are cooked into a boring, undifferentiated, homogeneous mass of standardized stew. These homogenizers are wrong.

The Smarter Generation cares about distinctions. Its members care about their unique cultural character. They care about both the special quality of the natural environment and the unique quality of the developed environment.

Historic preservation needs a consistent theme of focused vision, a relevant, differentiating message—a message that will motivate people to support this important cause. This is the cause that aims to maximize, not compromise, an honest picture of this nation's rich, diverse, and distinctive heritage.

The Smarter Generation believes that the only way to maximize appreciation of our cultural distinctiveness, to maximize understanding of our unique values, and to maximize the livability of our communities is to protect and respect our heritage. Its members want to maximize, not compromise, a strong foundation from the past to build for the future. The Smarter Generation tells us it wants exactly what we want to provide.

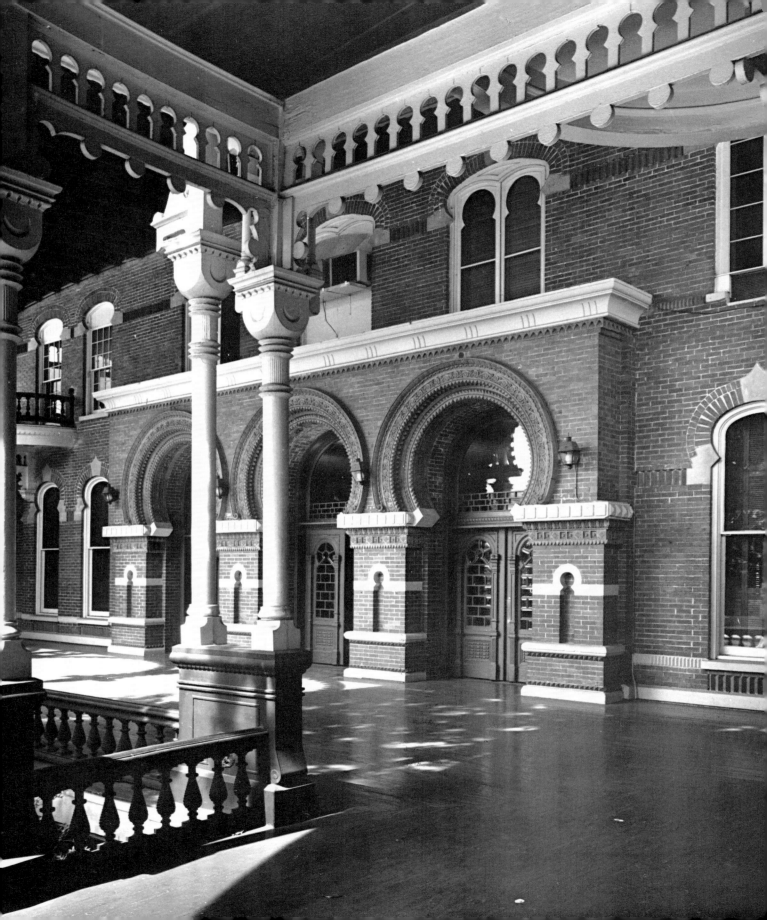

A GLOBAL PERSPECTIVE ON
AMERICAN HERITAGE

David Lowenthal

W E SAVE WHAT WE LOVE: THE HERITAGE WE CHERISH IS UNIQUELY OURS. IF OTHER PEOPLE'S LEGACY WERE THE SAME, OURS WOULD COUNT FOR LESS. AND EACH HERITAGE NEEDS ITS OWN STYLE OF STEWARDSHIP. SO FEW LOOK FOR HERITAGE GUIDANCE ABROAD.

Americans do so thanks to two unusual faiths. One concerns the youth of our heritage: excluding American Indian remains, this heritage is no more than two to four centuries old. By contrast, Europeans boast of two millennia plus a prehistory that is effectively ancestral. They connect with the remains of prehistoric peoples considered to be forebears. Like the feudal pedigrees of medieval rulers that harked back to Hector of Troy, these ancient forebears lend the Old World weight and substance.

That Europe's historic buildings and experience had much to teach Americans was the thrust of this volume's 1966 precursor. *With Heritage So Rich* termed Europe's "older vision" an authoritative guide to American preservation aims and acts.[1] Recency still humbles Americans. "Say, is this college prewar?," asks a tourist in Cambridge, England. "Ma'am," replies the porter, "it's pre-American." Americans are not the only such sufferers; a still briefer saga shames Australians. What induced a postwar Slovene migrant to guide me around Victorian neo-Gothic Melbourne? "I'm from Europe," she explained.

"The Australians are new. Only we old Europeans appreciate heritage."

They half-persuade us that this is true. When a British television journalist called his monarchy obsolete, a shocked Barbara Walters asked, "Mr. Hitchens, how can you say such an awful thing in that lovely old English accent?" Americans who term British reverence for the past "virtually a genetic trait"[2] preclude being like them. They can only smile at Old World ways, like the boss who tells his aide, "I'm off to Britain on Friday. Remind me to turn my watch back 500 years."

More useful is a second article of faith: Americans really try to learn from others. We cannot just adopt foreign heritage traits—they are embedded in whole ways of being, ways as alien to us as our open politics are in Baghdad or Moscow. Yet it pays to try to learn from others' experience, as adaptive strategies have demonstrated on American frontiers from Salem to Seattle.

American openness is a rare virtue. Europeans may pay lip service to foreign ways, but they mistrust them at heart.

Americans rightly lament that their children know little about the rest of the world, but American blindness is less total than that of others. No great power devotes more school time to places beyond its shores. Respecting Old World roots, we honor our antecedents; Americans are proud of being hyphenated to immigrant origins. Europeans prefer ethnic purity. There are no Old World equivalents of the Italian immigrant who was honored as Minnesota's "Swede of the Year" for his services to Chinese catering.

American interest in other modes of heritage is exceptional. Characteristically, two-thirds of the session arranged by US/ICOMOS (the International Council on Monuments and Sites) at the 45th National Preservation Conference in San Francisco was devoted to discussion of preservation activities abroad; at a comparable UK/ICOMOS meeting, foreign sites were scarcely mentioned. The English take pride in knowing and caring so little about the heritage of others. They remain, as Emerson found them over a century ago, "provokingly incurious about other nations."[3] And their willful ignorance extends to the heritage of recent immigrants. Britons of Indian and West Indian descent seldom get their stories into schoolbooks. As one British spokesman put it, "If people feel proud of their identity and rich in their cultural inheritance, why should they want to spend time learning about those of others?"[4]

French, Italian, and other nationals are similarly exclusive. Glorying in incomparable relics and rationales, they shun foreign modes of heritage. To be sure, Germany, like Japan, has long sought exemplars abroad. But doubts about national identity have made German borrowing more defensive and less constructive than American modes of emulation.

LISTING AND PROTECTION

What kinds of comparisons can serve us best? Not legislative ones: legal codes by themselves tell little. First, they demand a global expertise held by few; the standard compendium on heritage law already runs to almost 1,500 pages, with twice as much more to come.[5] Second, each protective act and agency has its own unique history, making comparison futile. Third, codes are usually misleading guides to heritage commitment and practice. Statements of preservation intent are honored more in the breach than the observance. Fiscal and architectural responsibility in some lands rests primarily with central governments, in others with local agencies or with private owners, occupant or absentee. Many codes lack either carrots or sticks. Some affect only state-owned property, others only private; some apply to ruins, others to habitable buildings. Of a vandalized neo-Jacobean structure recently censured as Britain's "most ne-

glected" historic building, the owner expostulates that it was already a ruin when first listed. "To say that we have neglected it is ridiculous. How do you repair a ruin?"[6]

In Italy listing is perfunctory; heritage is everywhere, yet legally nowhere. French designation ensures that buildings listed are reliably protected, but the categories under which listing is allowed are rigidly restrictive. In Spain historic structures named by Madrid are cared for (or neglected) entirely by 16 autonomous regions. New Zealand shuns listing because designators can be sued by property owners for asset loss. German listed buildings get so much state aid that some conservators fear overrestoration, except in eastern Germany, where they do not get enough.

British listing is comprehensive but ineffectual. There are half a million listed buildings and 13,000 archeological sites—soon to be 60,000—but the more there are, the less they are protected. The current doubling of historic structures endangers new and old lists alike. Britain's conservation areas are world-famous, but planning inquiries and elite influence make a mockery of protective codes. When developers can desecrate the gateway to St. Paul's Cathedral and the White Cliffs of Dover (to help pay for a "White Cliffs of Dover Heritage Experience"), no part of Britain's heritage is secure.

From these diverse consequences, what general conclusions about listing can be drawn? First, listing *is* a vital first step in any society that lacks widespread accord about which structures should be inalienable. Without listing, public consciousness cannot be secured. Second, pride should play a much more prominent role than coercive threats in the listing process. Emphasizing community benefits helps make listing widely acceptable; emphasizing private penalties engenders myriad obstacles that subvert it. Third, listing criteria must at least roughly match the feasibility of implementation. Otherwise listing will soon be dismissed as a hopelessly unrealistic exercise. And last, any program of listing must build in mechanisms for monitoring its impact and, when necessary, for reforming listing criteria and procedures.

WORDS VERSUS DEEDS

Americans often ask what planning genius saves Britain's heritage. The secret is not planning but ingrained habits of tenure and stewardship. Rural England survives *despite* planning and market forces, thanks to hereditary ownership, elite expertise, and the British view that all land needs caring for.[7] The legendary fine-textured fabric of crop and pasture, meadow and woodland, park and garden has meant England to countless celebrants. Britain has Green Belts and bans against nonfarm buildings. But legal codes neglect the land-

scape's living features. Castles and even dovecotes can be protected, but ancient trackways, hedgerows, the very grain of the land are defenseless against spoliation. Heritage guardians could not halt the foreign sale of a fossilized lizard, because this ancient treasure was ruled not a relic of culture but merely a feature of nature; only the generosity of a German museum enabled it to be kept in Britain.[8] With Americans, nature seems to fare better than culture; the snail darter and the spotted owl get more help than historic sites. (The Portuguese, as evidenced at a World Heritage Site, treat even olive trees as sacred archeological relics.[9])

Britain's is not the only chasm between words and deeds. Most heritage stewards think their own country's controls stingy and shortsighted. The British contrast cathedral largesse from Paris with neglect from London, and envy France for halting heritage drain; the French look wistfully at English aid to stately homes as living history; Italians contrast Northern European continuity of heritage care with their own casual seminegligence.

BROADER HERITAGE COMPARISONS

If legal and planning protocols do not limn a nation's heritage stance, what does? No calculus can tell what share of a country's income goes to preserve its past. No accounting can assess the varied costs and benefits of heritage for tourism, popular pride, national unity, environmental health.

Broader inquiries could throw more light on how Americans and others treat heritage. How widespread is a nation's heritage concern? In what ways is it transmitted to children? Do elite and popular, mainstream and minority heritage compete or converge? How do private and public efforts relate? What gulfs divide aims from achievements, precept from practice? Buildings aside, what legacies matter and to whom? Is the national heritage contested from within, beleaguered from without? Are there alternatives to physical preservation? What is the heritage role of fragments, images, copies, artisan skills—such as the famous artists and talented crafts people who receive state stipends as Japan's Living National Treasures? Do commemoration and reenactment assist preservation or displace it? Many of these issues were central in discussions at the San Francisco conference. Four faults and strengths strike me as especially (although by no means exclusively) American.

SOCIAL CONSENSUS

America's preservation ethos is better diffused than any other major nation's. Why? Democracy; belief in equality; our federal system; knowledge that success needs public ac-

cord. Above all, Americans more than any other people have moved from protecting great monuments to safeguarding fields of care. Two generations back, a tiny group guarded a few gracious treasures; today millions of Americans cherish a wide range of vernacular buildings and familiar locales. The American public is apt, as several plenary speakers remarked in San Francisco, to view the National Trust for Historic Preservation as exclusive and elitist. Yet the Trust's precepts and actions make it infinitely more populist than, say, Europa Nostra, the nearest equivalent transatlantic body concerned with architectural preservation.

The British contrast is especially telling. The English National Trust has two million members. But most play no active heritage role. Only a small elite have the requisite expertise and ancestral taste. At an Anglo-American strategy meeting a decade ago, British conferees at first envied American preservation tax incentives. But their treasury and heritage leaders were soon appalled; tax credits would give developers and builders a say in what to save and restore. In Britain these are heritage foes, philistine destroyers. The historic fabric belongs to the Great and the Good; heritage is the pastoral care of *gentlemen*. It was unheard of to open decision making to common commercial folk.

Dominated by a handful of well-born leaders, British heritage is innately exclusive. The roles and the rivalries among SAVE Britain's Heritage, English Heritage, the Royal Fine Arts Commission, the National Heritage Memorial Fund, the Arts Council, and the National Trust can be understood only when one is aware of their interconnecting networks.

Heritage interest in Britain *is* widespread. But only cathedrals and country houses, vintage cars, and Renaissance paintings—elite heritage—are "national." Folk heritage—including the Tower of London and Madame Tussaud's, steam railways and jousting tourneys, the old corner pub, and the old Satanic mill—is risible or peripheral.[10]

For popular public heritage, we must look instead to Scandinavia and the Antipodes. Older and deeper than American linkages are Finnish, Danish, and Norwegian folk pride in their prehistory. Restlessly mobile urban Americans cannot match that rural rootedness. Scandinavian affection for a heritage felt to belong to them more than matches American populist consensus. And it underscores the advantages of an essentially archeological heritage—one reliant on material rather than written relics, and at the same time profoundly local and everyday in character. In America, the archeological heritage could also have special resonance for minorities whose pasts are now shrouded in the silence of otherwise unsung lives.

Once Australians were colonials who scorned local heritage; today they promote their folk past with special zest.

Museums and built memories focus on migrants and new-comers, the poor and the failed, very recent times. The great early buildings are not mansions or meetinghouses; they are barracks and bridges, mines, and prisons. They celebrate what is common. Vernacular building styles like Bungalow and Federation get—and deserve—loving care. In the freedom with which they reinterpret the Venice Charter (the international preservation protocol), Australians reflect such awareness more than do Americans.[11]

LOCAL INVOLVEMENT

American heritage concern is well dispersed spatially as well as socially. Bay State and Old Dominion localities pioneered the saving of sites. Local communities everywhere now spearhead preservation. American neighborhoods innovate and influence as no others do.

Heritage in Europe is heavily centralized, dictated from London and Paris, Athens and Stockholm. Local and regional voices are potent only in Norway, Germany, Italy, and Spain. Eastern European heritage efforts concentrate in capitals and showplaces such as Prague and Krakow. Elsewhere only a few lands—Brazil, Nigeria, Canada, Australia—escape centrist controls that tend to deplete regional differences and deprive localities of distinctive pride.

Centrism reflects the national past's common symbolic weight. In America each state sets its own history curriculum and texts; abroad they are shaped and censored by guardians of national identity. Hence the public past there tends to be overwhelmingly patriotic. It is about national origins and growth, triumphs and tragedies. Above and below the national level, continental and global history and regional and local annals get short shrift.

In French schools, history is not about Europe, much less Picardy or Normandy, Alsace or the Midi. It is about immemorial France, one and indivisible. History in British schools is British or English, not East Anglian or Liverpudlian. What is acclaimed is the national past, meaning English. "When God wants a hard thing done, He tells it, not to His Britons, but to His Englishmen," rejoiced Prime Minister Stanley Baldwin.[12] One Cambridge college still "steers students away from Scottish, Irish or Welsh history if they show unhealthy interest" in peripheries.[13]

Subnational material heritage is likewise slighted. Historic buildings are seen through National Trust and English Heritage lenses rather than local ones. Prehistoric relics gravitate to the capital; few accrue to provincial museums. London-based elites lacking local ties antagonize farmers who have to look after prehistoric sites. SAVE Britain's Heritage is wholly national even though its causes are often local.

Heritage agencies have little time for community landmarks that lack national status.

Only a few other countries—notably Germany, Canada, Australia—echo our national/regional/local heritage balance. But the German *Länder* are both more potent and less similar than our states. Preservation in Quebec clashes with the Anglo-Canadian legacy. Australian heritage guardians are often at odds, state and federal agencies behaving as rivals, not allies. American state historic preservation officers, described by H. Bryan Mitchell in this book as besieged from above and below, may find life taxing, but the American federal system has special virtues. To save beloved landmarks and familiar scenes, local action groups galvanize personal heritage commitments. Local efforts mesh with state and federal agencies to secure cash and skills. Rooted in neighborhood realities, Americans are largely spared the nationalist obsessions that often cloud preservation efforts elsewhere. As William J. Murtagh explains in another chapter, American resources give private preservation efforts a uniquely important role. Together with local empowerment, private affluence shelters preservation from temptations to impose an official imprimatur.

MAINSTREAM AND MINORITY

No heritage topic now sparks more passion. Minorities bereft of all else often fasten on heritage for pride in what they once were. Minorities include both remnants of first-comers, anciently linked with land and locale, and formerly enslaved and immigrant ethnics outside the mainstream. American multicultural themes are mirrored elsewhere, notably in Australia and Canada. But minority numbers, degrees of bias and exclusion, and heritage issues vary greatly in each country.

In America the melting pot yields to a potpourri. To praise diversity today magnifies minority heritage. Americans are thought to take special pride in being multicultural. "Pluralism is now recognized as an organizing principle of this society," writes a well-known educator. Our nation's "unique feature," contends education specialist Diane Ravitch, is a "common culture formed by the interaction of its subsidiary cultures." The mix must be saved, she says, not smoothed away: "Differences among groups are a national resource rather than a problem to be solved."[14] Yet the preferred American building legacy is still largely mainstream. Indian, black, and ethnic inputs are meager and peripheral. Only a relative handful of sites memorialize the occasional African American worthy, native American victory, the unique Jewish or Italian or Polish American historic source.

Efforts to rectify this bias radically retool classrooms, museums, and the arts. But they hardly scratch the structural

This barn and outbuildings on a farm in Clare, Michigan, demonstrate the inclusiveness of American preservation concerns.

heritage. Many ethnics believe that preservation diverts from pressing social needs; it favors fabric over folk. In any case, ethnic group memories are seldom realized in stone or brick. Minority identity itself raises doubts. Native Americans were never "Indians" but Iroquois, Navajo, Sioux; newcomers lacked conscious cohesion beyond their Old World village or district; only migrant chance and mainstream cliché have made them "ethnic" nationals today.

Minority impress is slight partly because multicultural soil is stony. Outside the Southwest, indigenous houses were perishable, landscape shaping scanty. Migrant modes of living made their first homes ephemeral. Seldom stamping buildings or sites with Old World traits, migrants adopted or adapted to existing New World forms. Non-WASPS were expected to melt into the physical fabric of American life; most soon conformed, barely modifying standard forms. Polish American, Greek American, African American physical realms are not ethnically distinctive in recognizably Old

World ways; many Chinatowns are little more than Holly-wood variants; most native American villages forget or forgo ancestral forms. It is vital to celebrate local diversity. But for minority impress, we must look to other realms of culture—worship, foods, social traits, the arts. There, more than in building or landscape, ethnic America displays a dynamic living heritage.[15]

In this, America is not unique. In the Antipodes the imaginative heritage of Maoris and Aborigines also transcends built forms. Traditional painting, narrative, folklore, and the sacralized aboriginal landscape more and more lend meaning to white Australia. Aboriginal memories fuse native and newcomer life in popular plays and verse. Maori strength in bicultural New Zealand features language, folklore, and memories ancient and modern. By contrast, white American images of Indians have moved only from tomahawks, totem poles, and cigar-store figures to a simplistic pre-Columbian paradise where all Indians were born ecologists. Despite white America's new-found sympathy with native American rights, many of the old stereotypes persist; for good or for ill, the Indian is still seen as timeless, changeless, and undifferentiated. Americans should envy and might seek to emulate the wider range of aboriginal heritage understanding now evident in the Antipodes.

Australia's new Europeans—Greek, Italian, Yugoslav, Jewish—are celebrated in books and museums, cuisine, and modern art. Multicultural texts chronicle ethnic Australians far more than American Hispanics or Asian Americans. But the ethnic built heritage is as scanty and unregarded there as here. Nostalgic migrants and offspring seldom replicate Old World memories in Antipodean homes.

To cherish local diversity against global sameness is vital. But to reify the rare ethnic locale as minority heritage is a vain endeavor. In this realm, the melting pot still prevails.

ALTERNATIVE STRATEGIES

Preservation is not the only, or always the best, heritage strategy; often it is not an option at all. People celebrate legacies in other ways, too. The brevity of New World building history makes caretaking less burdensome for Americans than for some others, but much of the heritage Americans cherish lies in Old World lands. Largely exempt from the upkeep of their legacy abroad, they become perhaps more zealous about preserving what they have at home.

The richer legacies of others are often unmanageable or ruinous. Pride in prehistory stops few Guatemalans or Mexicans from dismembering relics to be smuggled abroad. Heritage hawking may seem horrendous, but should we blame a peasant who sells his past to feed his children? Most patrimony is so used, even used up. How to save an all-pervasive heritage from decay and depredation confounds Italians today. Although half of the Ministry of Culture's budget goes to heritage care, Italy, with the world's richest legacy, spends less per capita on preservation than other countries in Western Europe. To protect churches alone against theft and decay would require the whole Italian army; to staunch illicit exports would cripple the crucial tourism industry.

Preservation holds small appeal where most historic treasures have been wrecked or purloined. Partly because so much was taken away or destroyed under Danish and Swedish rule, Norwegians pay less heed to historic structures than to prehistoric remains, place and family names, folklore, and dance. Poland is famous for the speedy if sometimes slapdash restoration of Nazi-razed medieval centers deemed essential to national identity. But now Poland places "less emphasis on protecting monuments or sets of buildings than on the whole cultural landscape [along] with the thoughts and memories it evokes." For others, intangible heritage may take precedence. The Venice Charter, Europe's restoration protocol, "leaves other cultures and traditions ill at ease; *they* place more emphasis on spiritual values, on authenticity of thought, than on material symbols."[16] Heeding Kenneth B. Smith's essay in this book, many Americans, too, begin to give priority to ideas over icons.

Some cultures prefer to save images of the past in paint and print or simply as memories. The Chinese endorse tradition in language and ideas but discard material remains or let them decay. Mao's orders to demolish ancient monuments were easy to carry out; few old structures had survived recurrent iconoclasm. Revering ancestral memory, the Chinese disdain the past's purely physical traces. Old works must perish for new ones to take their place. And Confucian precepts judge material possession a burdensome vice. In the traditional Chinese view, preserving objects and buildings reduces creation to commodity; it demeans both object and owner.[17]

The famous old city of Soochow has no ancient remains. This dismays Westerners who equate antiquity with physical relics. "This house is very historical," they say. "But it was built only last year," protests the Western visitor. "Yes, but a house has stood on this site for 1,500 years." Soochow's Maple Bridge is famed in literature, but even there it is not important as a structure. "No poem refers to its physical presence; its reality is not the stones forming the span but associations realized in words."[18] The Chinese achieve immortality not in stone monuments but in imperishable words and thoughts.

Preserving is innate to life. But innovation is as com-

pelling a need. In trying to perpetuate ever more realms of nature and culture, we may upset fragile balances between saving and making. We must bear in mind the efficacy of other modes of honoring the past, too.

The other modes I have mentioned are not options freely available. They stem from perspectives unlike Americans' own. We make our past, as Marx said, but we do not make it just as we choose; we are constrained by cultural circumstances beyond our control.[19] So too with public memory: we explore what others do to throw new light on our own ways, not to find ready-made substitutes.

American ways now commit us to extensive preservation. But culture is dynamic. Awareness of other ways of cherishing heritage can fructify our own modes of salvage. For example, Americans now tend to polarize what they save: at one extreme, authentic collectors' items; at the other, remnants remade usable. But most preserved relics bridge these extremes; they serve both present utility *and* long-term stewardship. More insight into our own and others' pasts could better marry museum uses with other uses, as the philosopher-planner Jane Jacobs recognized a generation ago.[20] The revitalization of San Antonio under former Mayor Henry G. Cisneros is a case in point; how fitting that those twin features of San Antonio's heritage, River Walk and the Alamo, should be joined through the lobby of a modern new hotel!

Another case is especially apt. When the First National Bank of San Francisco went bankrupt, it was swiftly converted into a bar. A change of just two letters transformed the former bank into the First National Bar of San Francisco. And former depositors were invited in to "put your mouth where your money was."

Comparison may remind us that preservation is a means to an end. When it is made an end in itself, it disserves prime functions of use, instruction, and delight. We should not forget that preservation has served evil causes, too: Germany's modern conservators take care to distance themselves from Nazi zeal for preservation as redemptive heritage.[21]

The built heritage also encompasses far more than we would have were we limited to monuments whose builders conformed to modern morality. The Pyramids were built by slave labor to memorialize pharaonic autocrats, but we do not on this account think that we ought to tear them down; the glory of the Parthenon would remain transcendent even were it to lose credibility as an emblem of democracy.

Indeed, the past lives on with more poignant clarity in the physical reminders of its tragedies than its triumphs. The solemnity of the engraved names on the Vietnam Veterans Memorial in Washington, D.C., and the compelling silence of the French village of Oradour, left just as it was on the day the German SS systematically slaughtered all of its inhabitants, attest to the passions often evoked by memorials of collective tribulation.

PRESERVATION AS PROLOGUE

The word "preserve" contains the notion "pre-serve": an act that precedes an aim realized through it. Echoing the inscription on the National Archives building, preservation is not epilogue; it is only prologue.

Many at the San Francisco meetings urged that the American preservation movement develop a national agenda that would stress a clear and unambiguous message to all citizens; those pleas are reiterated in this book. But while Americans heed these pleas, they must take care not to jeopardize precious virtues that go beyond the national and honor what is complex rather than monolithic. Such virtues include local diversity, local awareness, and local empowerment. They also evince a concern for the global heritage of nature and culture, and for the thrill of discovery revealed by diverse inspirations and divergent explanations.

In capitalizing on this breadth of vision, preservationists gather strength in building bridges with others who are also stewards of the past—including history teachers, archeologists, museum staff, and many others. Far from becoming irresponsibly fickle in so doing, Americans remain alert to alternative ways of expressing traditional values. Searching for such connections also helps us avoid becoming entrenched in outworn ideas and ideologies. We thereby remind ourselves and our supporters that, preserve it however we will, the past is nonetheless always being remade.

The National Trust, like the preservation movement in general, has come of age. In maturing, it should preserve the youthful zest for life that has long distinguished it. The wider participation of minorities, premised by demography and promised by decisive design, will reflect the visions articulated at the San Francisco celebration. In the future as in the past, the National Trust will serve the preservation movement best through the comity and commitment, enthusiasm and empathy of its members and their chosen leaders.

WHICH SPECIAL NEEDS MUST BE MET?

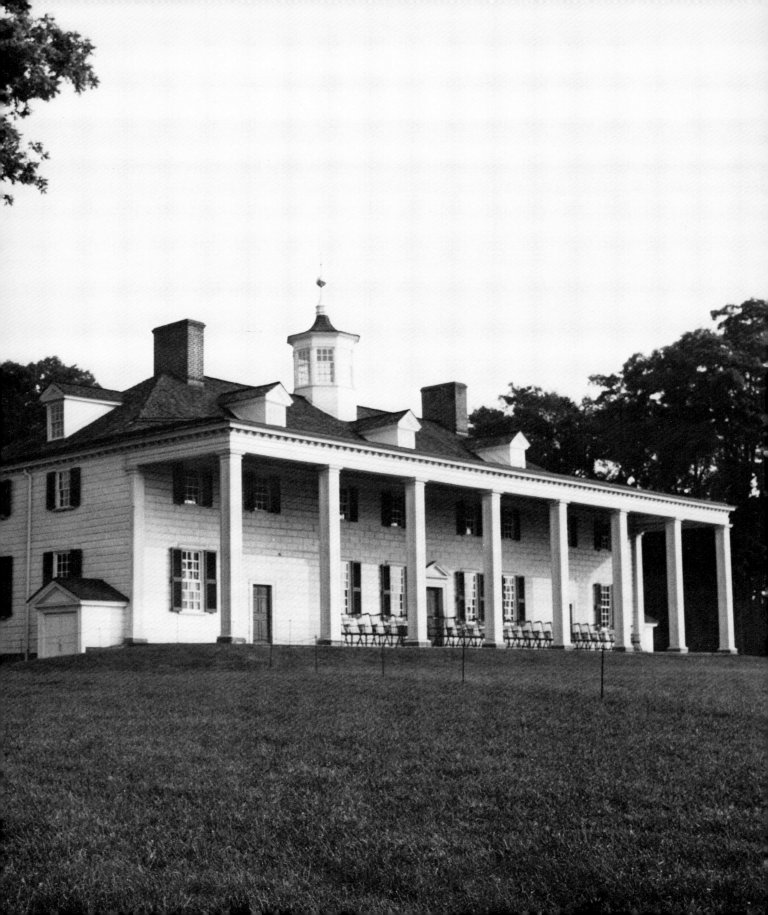

NEW DIMENSIONS FOR HOUSE MUSEUMS

Neil W. Horstman

Historic house museums are benchmarks of the past—physical remnants of the country's growth and development. They tell us what words cannot. They are three-dimensional visual textbooks of our history, owned and administered by a variety of organizations and agencies as well as individuals. House museums are pervasive throughout the nation; they can be found in nearly every sizable community. Although they vary in quality, dictated by the level of scholarship and budget, they collectively serve as tangible evidence of the past and an educational resource for the future.

The genesis of America's historic preservation movement centered on historic house museums, which resulted from the widespread public adoration of prominent figures in the country's founding, such as George Washington. In fact, the two earliest house museums were affiliated with this greatest American hero. As time went on, house museums continued to be created to honor other historic figures of national stature and, eventually, locally prominent citizens. More recently, the focus of house museums has broadened to reflect the nation's diverse population, to recognize artistic accomplishments, and to preserve a specific style or architectural achievement.

Are historic house museums still relevant, and will they serve a purpose in the future? If so, what changes must be made in existing museums and how will their newer cousins differ? To answer these questions, it helps to go back to the origins of this durable preservation form.

A quarter of a century before the United States celebrated its centennial, two historic house museums had already been established to honor the first president. Soon after George Washington's death in 1799, his many admirers began showing an almost cultlike reverence for anything associated with their hero. When it became public knowledge that the last Washington-family owner of Mount Vernon was attempting to sell this burdensome inheritance, Washington devotees became alarmed that the property might no longer be

accessible to the public if it fell into the wrong hands. Until that time, the Washington family had reluctantly permitted a steady pilgrimage of admirers to the home, even though it was private property.

Interest mounted further when, in 1834, another house associated with Washington was advertised for sale. The Jonathan Hasbrouck House in Newburgh, New York, Washington's eighth winter headquarters, went on the market when Jonathan Hasbrouck defaulted on a mortgage from the state of New York. Citizen interest in saving the house led the governor to sign into law on April 10, 1850, an "act for the preservation of Washington's Head Quarters." Thus the Jonathan Hasbrouck House became the first government-funded historic house museum.[1]

In 1853 Ann Pamela Cunningham took the first steps toward the founding of the Mount Vernon Ladies' Association, which would become the trustee of the first privately funded historic house museum. By 1858 the group succeeded in raising the $200,000 purchase price of Mount Vernon. And while citizens argued the issues that would soon result in the Civil War, the home of the person most responsible for unifying the country opened its doors to the public.

It is understandable that the first efforts to preserve early houses focused on properties associated with the Father of Our Country. Patriotism was a major motivation for action. Ann Pamela Cunningham expressed this view well: "Those who go to the Home in which he [George Washington] lived and died, wish to see in what he lived and died! Let one spot in this grand country of ours be saved from change!"[2]

BROADENED CONCERNS

Over time, the original narrow focus of house museums broadened both geographically and in subject and scope as patriotic interests merged with an interest in the architecture of early homes. For example, the restored Paul Revere House in Boston, significant because of its owner, was also the city's oldest surviving frame building.[3]

Today nearly every community of any size has a museum at a special house or the home of a significant person. In addition, we find house museums at the homes of inventors, celebrities, architects, artists, industrialists, civil rights leaders, and even the "typical" farmer or crafts person. The houses now serve to document the style, taste, and technology of earlier eras as well as educate visitors about the house, its occupants, and their contributions.

This expansion is a healthy recognition of the importance of all aspects of our cultural history, honoring both those known by all and those little known outside their local com-munities. This trend serves to breathe life into house museums; their appeal is no longer limited to those whose roots go back many generations—it is universal.

By nature, house museums often focus on the earliest settlement of an area, preserving its oldest surviving structures. It is not surprising then that they predominantly represent the Anglo-American history of many areas, simply because of the extent of this early influence. But while museum houses do display a colonial bias, what is often overlooked is that they also document other cultures, including Spanish, French, African American, and even American Indian—if you consider a pueblo a living museum.

PRESERVING PLACE AND TIME

House museums have saved a remnant of the country's past; each house preserves a place and a time. The preservation of place is obvious. Standards and approaches to the preservation of historic structures developed through their testing on historic house museums. In hindsight, many of the early philosophies and solutions were wrong. However, without this experimentation, perhaps the knowledge we now possess would be less advanced.

Some early preservation policies practiced at house museums could be dismissed as common sense, compared to what we take for granted now. It is easy to assume that the steps taken by the Mount Vernon Ladies' Association within weeks of its gaining ownership of Mount Vernon were automatic. If they were not automatic, they were at least intuitive. Directions were given to remove all fire hazards from the house immediately and store rainwater adjacent to the structure to protect against fire. Emergency repairs only were made on the worn roof until it could be determined what the appropriate replacement roof should be. Contrary to those who deemed the mansion the only important building, Cunningham resisted sizable pressures to destroy all buildings on the plantation except the mansion. The early trustees deliberated more than 80 years before deciding to remove additions to the mansion that were made after George and Martha Washington died.

A less obvious, but equally important, contribution of house museums has been to preserve time. Interpretation of time can take two directions. The first is vertical: Often a house used as a museum has a longer history than its best-known occupant. Sometimes that history predates the owner; sometimes it continues after. This vertical time line up and down the calendar places both the building and the person in the context of the continuum of time. Time can also be lateral: developing research and interpretation that places the historical figure and his or her home in the con-

text of other persons or the events and society of that time broadens what is seen by the visitor.

This brings into focus an important preservation issue: Should a building be restored to a moment in time, such as its original construction, or should it represent the evolution of time by displaying the changes and additions made by its most significant and subsequent owners? What should be the cut-off date for saving these changes? There is no single answer, of course. But house museums have provided a means for us to realize that each structure requires its own unique solution. And although the issue is usually not as clear for a generic old building as it is for a house museum, the nonmuseum, too, deserves the same unique approach to its preservation.

Decisions on what to save usually are based on architectural characteristics and not on the uses or ownership of the building through time. However, would it not be interesting to take into account the social history surrounding the building as well as the architectural features in making such a decision? Such considerations are in sharper focus for house museums, but the preservation philosophy for all significant old buildings could perhaps benefit from the scholarly exercise.

One example is Malabar Farm, the 19th-century Ohio farmhouse of author Louis Bromfield. Changes made in the 1940s to a building of this age might not typically be preserved in a restoration. However, this house museum reflects the period of time when Bromfield wrote his eloquent books about conservation of the environment and also served as best man to his long-time friend, Humphrey Bogart, when he married Lauren Bacall at the farm on May 21, 1945.

Another example of how a house museum can relate a unique history or preserve a time in a house's history other than its earliest beginnings is the manner in which the Colonial Williamsburg Foundation interprets the 18th-century Carter's Grove mansion. Built in 1751, it was the showpiece of a working plantation for many years. Then began a period of decline from the late 18th century until 1927 as the property passed through a variety of hands and fell into disrepair. In 1927 the house was purchased by Mr. and Mrs. Archibald McCrea, who corrected the damage the house had suffered over the years and enlarged it by connecting adjoining buildings on either side with hyphens and adding a third floor. In their refurnished mansion, they entertained important figures of the day, including President and Mrs. Franklin D. Roosevelt. The McCreas' comfortable, yet elegant, mixture of antique and traditional-style furnishings reflects the taste of the Colonial Revival era. It is this period of the house's history that is displayed. Thus the 1930s lifestyle of a wealthy and influential couple is viewed against a backdrop of an 18th-century mansion.

Along the same lines, during the summer of 1991 two museum houses operated by the Memphis Museum System featured a special presentation of how people coped with the summer heat before air conditioning. The display, In the Good Old Summertime, used special exhibits to demonstrate how architectural design, attire, housekeeping methods, and recreation were used to improve the comfort of the residents. Contrasts in socioeconomic groups could be derived because the two houses were a modest clapboard cottage, circa 1836, and an expansive Italianate mansion, circa 1852. Comparing the two houses graphically informed the visitor of the differences in lifestyles of two distinct 19th-century families, using the summer heat as a vehicle to convey this information. The houses and the objects in them thus contributed to an understanding of a period in time beyond their face value.

ADDRESSING MORE THAN OBJECTS

It requires research and interpretation for a house museum to address temporal and thematic relationships, not just things, to expand the meaning of place and time. As many are recognizing, it may no longer be relevant enough for the docent at furnished museum houses to point out the proverbial table with the mirror across the bottom used by ladies to adjust their petticoats. Likewise, visitors may not be totally interested in seeing *one more* demonstration of how the spinning wheel was used to make cloth. What they might rather prefer to a listing of these ubiquitous house museum objects is a discussion of the social customs of women of the time or an explanation of the necessity for farm families to make their own cloth.

Education has also been enhanced beyond objects through period interpretation. In what may be considered a cross between history and performance, first-person interpretation has added life to otherwise lifeless places. Historical interpreters, speaking from scripts or engaging in informal conversations, can often enlighten visitors more than the traditional third-person interpretations of the past.

These examples point out a fundamental change in the approach to research and interpretation that is already being implemented at many historic sites. The use of such lifestyle research and interpretation can help ensure that house museums remain relevant to a changing society. Just as schools have replaced memorization of the Gettysburg Address with explorations into President Lincoln's motivation and the circumstances surrounding the writing of the speech, so must identification of objects in house museums

be replaced with, or at least expanded to include, their inherent symbolic value.

Recent advances in research and technology also have dramatically changed the look and approach of historic house museums. Present-day interpretative methods reflect new knowledge gained from research, changes in educational emphasis, and the public's desire to be informed in an entertaining fashion. Technical advances range from behind-the-scenes structural reinforcement to the very-visible 18th-century paint colors that are startling to those accustomed to the Williamsburg palette, albeit an accurate recreation of the colors of that period. New ideas in education, together with the latest research findings to preserve time and technological advances to preserve place, suddenly have added dimension and relevance to the present and the future of house museums. A look at where these advances have taken us thus far may help predict where they will take us in the future.

ARCHEOLOGY'S NEW IMPORTANCE

Archeological research, in particular, is playing an increasingly important role for house museums. In fact, archeology may provide the only tangible means to discover new information about past lifestyles, customs, and daily life. The physical objects found and studied will greatly expand this previously hidden knowledge.

Archeological findings can directly challenge our assumptions about previous lifestyles and our perceptions of what the proper appearance of a historic site should be. For instance, our colonial ancestors often disposed of their trash only steps from their homes. In fact, excavations at a 17th-century home site in Calvert County, Maryland, revealed a trash-filled cellar under the house itself.[4] Not only is the rich array of household refuse uncovered of great interest, but the location of the hole itself is equally revealing. This practice of disposing of trash in close proximity to the home site was not confined to the lower socioeconomic classes. A recent excavation at Mount Vernon revealed a midden within 80 feet of the mansion; the midden would have been visible from the window of George Washington's study.

Such an honest presentation of historical facts is a key to the future relevance of house museums for an increasingly demanding and skeptical public. As static interpretation becomes a thing of the past, archeological investigations will become more popular and, indeed, required. A more educated public will demand a more comprehensive site interpretation—presentation backed up with actual investiga-

tions. A good example of this trend is a recent archeological excavation at Mount Vernon of a cellar area beneath a former slave dwelling, which has provided thousands of artifacts, including food-related objects such as bones, seeds, and housewares. These objects shed light on the lives of slaves who lived there and their relation to the owners. This information enriches both continuing scholarly pursuits as well as the practical information given to the visitor by expanding the meaning of inanimate objects.

In Annapolis, archeological investigations conducted by Professor Mark Leone of the University of Maryland at the Charles Carroll House unearthed pebbles, discs, bones, and crystals that were used as religious objects by household slaves. The artifacts were nearly identical to those used at the time in what is now Sierra Leone and demonstrate that African religious practices continued in the United States long after previously thought and despite efforts of slave owners to suppress them. Archeological investigations like this one reveal the survival of Old World cultures in the New World.

No doubt future technological advances in archeology will further increase our base of knowledge and allow this knowledge to be gained in a nondestructive way. These advances may include new methods of probing the earth, using remote sensing and ground-penetrating radar. Such methods would allow investigations that leave the site intact for the future, when even more sophisticated technology will reveal more than ever dreamed possible.

NEW RESEARCH AND TECHNOLOGIES

The major focus for future technical research will be a better understanding of the interaction of old and new materials. The future integrity and longevity of house museums will depend on proper application of these technological advances. Proper application should be stressed, because even though the extent of technical knowledge has rapidly expanded, the improper use of materials continues, unfortunately. One classic example is the damage caused when modern-day portland cement, used to repair old brick structures, begins to expand and contract at rates different from the mass of the bricks.

In like manner, the interaction of dense old wood with newly milled timber also can cause structural damage in a house. An obvious but overlooked solution to the old wood-new wood problem is the harvesting of centuries-old trees for use as replacement materials. An explanation is in order, to allay the fears of conservationists. There are a few

Opposite: Archeological excavations, such as this trash midden at Mount Vernon, complement above-ground evidence.

NEIL W. HORSTMAN

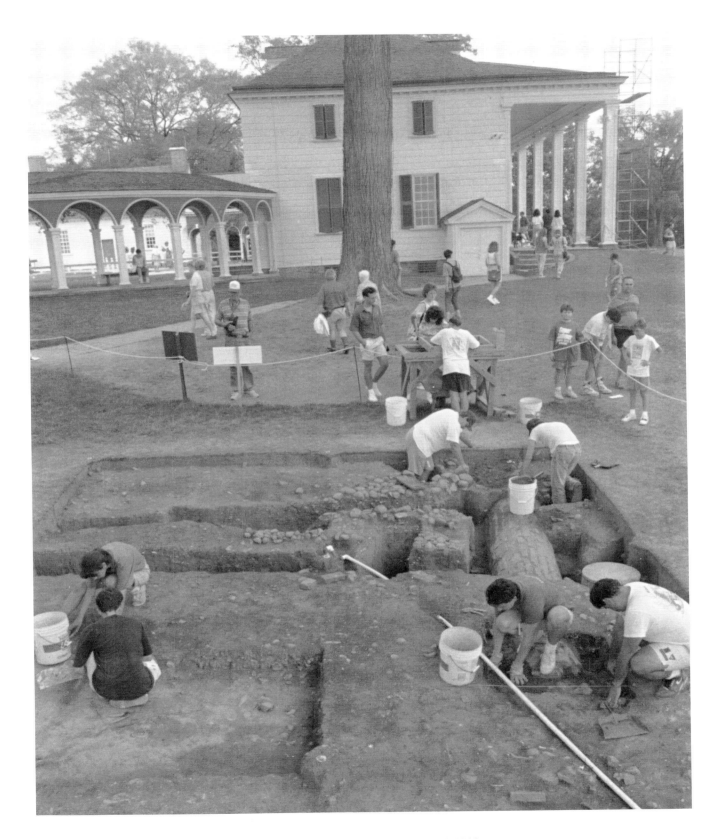

NEW DIMENSIONS FOR HOUSE MUSEUMS

fortunate historic houses whose sites include very old trees. Conservative harvesting at these sites, especially of diseased or dying trees, would be a prudent way to ensure a supply of replacement lumber. Perhaps a national bank for such supplies, as well as a forest for future generations, could be of great benefit.

Two new technologies that have proven helpful are synthetics and computers. Synthetic materials, such as consolidants, can be used to strengthen and preserve damaged wood. Computers make it much easier to conduct rapid searches of documentation for specific changes to a building. A visual record of changes is also possible through the use of computer-assisted design. Computer technology lets us develop programs to model materials and simulate their reactions over time and under various conditions. Computers can also be used to monitor environmental conditions and record their effect on historic structures.

MUSEUMS AS LABORATORIES

House museums can serve as laboratories for applying new technology to improve the historical accuracy of changes to buildings. For example, recent use of chemical analysis to determine original paint colors has not only led to dramatic changes in the decoration and appearance of historic houses but has also changed our perspective of past tastes and preferences. Some observers who have a mind-set about "colonial colors" introduced earlier in this century have even refuted these claims as a passing fad and scientific witchcraft, illustrating the revolutionary nature of these changes.

The knowledge acquired by the application of new technology to house museums can be applied to the conservation of all old buildings. With expectations that new construction will continue to increase in cost, house museums can provide a real economic benefit to our cities and towns by demonstrating how the life of all existing buildings can be extended.

ENVIRONMENTAL CONCERNS

One aspect of house museums that may look different in the future is the appearance of the surrounding grounds, which the public expects to look picture-perfect. Any lawn-care service would be proud to say that its product was used on these lawns. Today's lawn-care practices at historic house museums mirror the practices of the typical suburban homeowner. Modern-day lawns look good to our eyes because they are irrigated, treated with chemical fertilizers and weed-killers, and tidily cut with power mowers and edge trimmers.

The typical 18th-century lawn, however, would have looked different. Unaided by chemical fertilizers, it would not have been lush by today's standards and would have had a brown appearance in periods of drought. Weeds would have mingled with the grass, and mowing practices would have ranged from the use of English scythes to grazing animals, producing a look much different from that produced by modern mowers.

Changing this setting to appear as it would have during the period the house represents will challenge the most ardent staff and board of every house museum. Ironically, this change will coincide with the environmental movement's push to cut down on the use of lawn chemicals and conserve water. As this movement gains popularity, our historic lawns may begin to resemble their past appearance—not because we are being honest, but, once again, because of the influence of current trends!

STRIVING FOR RELEVANCE

All this—technology, research, archeology, and new interpretation—will surely enable us to create better house museums in the future. But will these factors ensure relevance to future generations of visitors?

One factor that will affect the future relevance of house museums is a changing cultural perspective. The new interest in multiculturalism is a response to the changing demographics of the nation. Although this country has always been a nation of immigrants, many educators believe that some immigrant groups are forgotten threads in the weaving of our historic cloth. Others, equally vocal, protest that multiculturalism is divisive and counter to the American experience as a cohesive and unified nation.

Regardless of the debate's outcome, museum houses can reflect the variety of cultures that make up this country. House museums present both the origins of the country and the relationship between cultures throughout our two centuries as a nation, and even before, without making value judgments or siding with either camp in this pivotal issue.

Ideally, it would be nice to think that all of the country's history and cultural patchwork quilt can be showcased through symbolic places such as house museums, factories, and even landscapes preserved in perpetuity. We should not be pessimistic and fear that this ideal will never be realized. Instead, we should be glad that a cultural maturity is evolving in this country. The recent public outcry over development threats to Civil War battlefields produced both public and private action and money. This kind of response occurs regularly throughout the country, not always on the national scale of the battlefields, but more

frequently on the local level, where it may be more important.

House museums have always reflected the evolving approaches to education. As the depth and breadth of scholarship and education expand, the interpretation of house museums expands with them. As we try to understand more about our past, house museums must reflect this new enlightenment to remain relevant. As interest in the cultural diversity of the country continues to grow, evidence of this diversity should be protected and highlighted in house museums as a primary means to illustrate this knowledge.

At the same time, this expansion of scholarly interests should not demean the relevance of our "founding" sites. Instead, the stewards of these sites should look for ways to more effectively communicate the history contained within their museum walls. George Washington's passion for liberty over tyranny should be as potentially relevant today to the recent immigrant from El Salvador or Vietnam as it is to the 19th-century Irish immigrant's great-grandchildren.

Whether there will be new house museums will depend on what we value and what we can afford. Few house museums can pay their way. Restoring and furnishing the house, if done properly, is obviously expensive. Consequently, much work remains to be done at existing museums, and the work done is often limited or compromised. Even if the physical work is completed, the cost of continuing research and maintaining the property often exceeds the operating revenue. Then, too, the stability of an institution that operates a house museum is often as threatened as the property it owns.

Given these hard facts, it might seem foolish to think that new house museums could be started. However, one must consider how most of the existing sites were founded. In some instances, they were the seeds of an entire area's rebirth and consequently became symbols of that area. Others were started because they commemorated the life and contributions of a person of historical significance or they simply were the only old or historic houses in town. Frequently, historic house museums serve multiple purposes; not only do they fill an educational mission, they also provide offices for historical societies and appropriate settings for special events.

House museums do not just happen. They are created through the special interest, motivation, and dedication of either someone or some group of individuals. The National Civil Rights Museum, which opened in September 1991 in Memphis, Tennessee, is an example of a special-interest museum. Therefore, it would be folly to say that no more house museums will ever be established, unless we discount the civic spirit of Americans to honor their past and preserve it for the future.

House museums can adapt to become more revealing and accurate records of our past. However, this is no assurance that they will be visited. Changing attitudes about leisure time and recreation, apathy about history, and the instantaneous gratification provided by satellite communications and computers could all spell doom for the house museum.

To avoid this demise, it will be up to house-museum advocates to promote these buildings' contributions to society. What they preserve and how they present it cannot be static, but must change as society's character changes to achieve continued relevance. This challenge will undoubtedly not be embraced by all. Some museum houses will not survive, and the contributions of others will diminish. However, those that accept the challenge, reach out beyond their walls, and creatively address changing public needs can help us prepare for the future through an honest interpretation of our past.

REVISITING PAST REHABILITATION PRACTICES

E. Blaine Cliver

THE PRESERVATION MOVEMENT ITSELF HAS BE-
COME A PART OF HISTORY, AND WITH THE PASSAGE OF TIME WE ARE IN A POSITION TO LOOK
BACK ON OUR OWN ACCOMPLISHMENTS AND FAILURES. MATURITY OPENS A NEW OPPORTUNITY
TO EVALUATE OURSELVES, TO JUDGE WHAT HAS BEEN ACCOMPLISHED, AND, IN A SENSE, TO RE-
VISIT OURSELVES.

As we glance over our shoulder, we can see a changing pattern of philosophies and approaches. New ideas and attitudes and new needs, materials, and processes have brought about this evolution—one that will continue because preservation is, of necessity, a self-defining process involved in many levels of philosophical, technological, and aesthetic issues.

Past building uses and rehabilitation treatments are a particularly good subject to revisit. Doing so gives us the opportunity to rethink our options a second time, if only to be able to apply the lessons to future needs. We should find the paths that were considered and understand why they were or were not followed. We should not second-guess the decisions made, but understand better the thinking that took place in arriving at those choices. It is the process used in making such decisions that is important.

Understanding what has occurred and why will enable us to better understand the choices that face us tomorrow. In revisiting our past, we are making value judgments about what has been done, what new approaches are needed when old solutions are found to have failed, and what changes in attitude and direction are called for in dealing with philosophical solutions that may no longer be valid.

A major problem with the preservation system we have created is its separation of the world into verbal and nonverbal components. Most regulations, guidelines, and standards are verbal, but the objects of their application are visual. Interpreting these verbal standards thus becomes critical to the process of preserving visual, tangible artifacts. Restoration judgments are made by the institution with the preservation money—usually a government agency. This situation may create ethical, aesthetic, and philosophical questions about how the work is carried out. Sometimes the result is the trivialization of architecture by creating false impressions of the past. Without understanding a building's design origins, for example, houses may be adorned with inappropriate doorways to effect the supposedly "correct

E. BLAINE CLIVER

taste." However unwitting, the resulting creation is based on a failure to comprehend architecture as history. Given that money in the form of tax incentives and grants goes to those who agree to abide by established preservation standards and guidelines, a great deal of responsibility is placed on institutions involved in the restoration process. We thus must be sensitive to the role that the institutional system plays in determining the future of preservation and remedying tendencies toward false history.

As philosophies have changed, so have preservation methods and the uses to which we have put our historic buildings. As first envisioned, preservation meant restoring a building as a historic object. Increasingly, it means finding a new use for pieces of our cultural environment. New materials for rehabilitation alone will not be preservation panaceas; good planning and the need to make new uses consistent with the fabric of the past will become ever more important. This inevitably will force us to think anew about the age-old problem of form-function relationships. In rethinking old solutions, we have the chance of finding exciting new opportunities. Working within a tradition leaves much room for discovery, invention, innovation, and creative design in adapting old buildings; otherwise there would be no traditions—only discontinuous, dead stylistic periods. To practice within a tradition, one must recognize it and be sensitive to those qualities that give tradition great visual presence, character, integrity, and life.

DOWN MEMORY LANE

Another great opportunity exists to reassess our position as architects and preservationists. Architects engaged in preservation need a balanced knowledge and a vision of history, architecture, aesthetics, and engineering. This is not easy today because we as a society are on a strange and disquieting trip down memory lane. We seem to have lost track of ourselves culturally and to have lost confidence in ourselves, and our meaning, in today's world.

The evidence for this trip is everywhere. A sign that used to say "Providence" now reads "Historic Providence." We seem to have a need for age, the older the better. An 18th-century house becomes better than a 19th-century house simply because it is older, not because it is more architecturally or historically distinctive. Age can invoke fantasy, and in the fantasy is seen what is thought to be an illustrious past. Reality is lost in this desire to create a false image. "Shop" is now spelled "shoppe" to be more historic.

This situation also can be characterized as the falsifying of

America, an attempt to freeze history. The main streets of Disneyland are an almost perfect model of this mind-set, creating a romanticized vision of our past. A parallel phenomenon in historic preservation is the attempt to freeze the character of a site or place, most commonly seen in historic districts. Such historic districts are isolated from the larger context of neighborhoods because someone saw a parallel between them and some visual conception of how they may have appeared in the past.

Real historic districts were created originally in an open and dynamic economic, political, and social context and guided by a prevailing architectural tradition. Over the years they gradually changed as the result of age, repairs, additions, alterations, and new construction. Now we have instituted preservation guidelines, standards, and other controls to direct the evolution of historic districts and areas. In doing so, we must be careful not to mistake what we have labeled "historic" for what is the true, comprehensive, and complex history of a place. We designate something as historic for reasons we can identify and acknowledge. Yet most districts have become part of history, including the good and the bad. We should be willing to acknowledge both. As we manage our architectural patrimony, we must reassess our work periodically to assure ourselves that we are not, in fact, killing the very thing we are entrusted to preserve.

An example of the dilemma we face can be seen in old San Juan, Puerto Rico. When I first visited the city 25 years ago, what is now the historic district had a character that is gone today. The city then had a larger population and a smell of garbage in the air that one finds in tropical environments—the smell of life. But there also were the smells of bakers, home cooking, and a variety of local restaurants. Today fewer affluent people live in old San Juan. Many buildings have been restored and saved. But with preservation have come the boutiques. Gone are many of the small restaurants and bars. Property values are up, but the reality of the continuity of life is lost. Ironically, in preserving old San Juan, we have changed its way of life, the way it was used. We have done the same thing with other cities. This is not necessarily wrong or unavoidable. However, we should be aware of the consequences of our actions when we start playing with history.

LEARNING FROM PAST RENOVATIONS

The next 25 years will give us the opportunity to review our past preservation decisions and reapply them or revise them where warranted. Preservation now has a past, one from

Opposite: Preservation of old San Juan saved buildings, but the way of life—the people, businesses, and community places—changed.

which we can learn but may have to alter. For example, preserving past renovations to historic buildings is important philosophically and may give us a laboratory with which to judge future techniques.

A case in point is the renovation done in the 1920s by Wallace Nutting to the 17th-century Iron Master's House in Saugus, Massachusetts. This work was considered an important part of the building's history because it illustrates preservation philosophy, techniques, and materials of its time. The 1920s-era mortar incorporated clay and lime, as did the original. Nutting's interpretation of the physical evidence was largely correct, and where elements of the building were missing, his conjectural replacements were based on research on similar structures. Later preservation of the building retained most of his work, but changes that became detrimental to the building's fabric, however, have been eliminated or reversed.

Such revisiting of past projects is occurring more often as buildings previously restored require a second generation of intervention. Aging is a directional force that cannot be reversed, and architecture is especially vulnerable to aging and weathering because it is so exposed to nature's forces and time's processes. New work of this nature, of course, will create dilemmas in dealing with our preserved past. The need to retain what we may see as ineffective preservation practices will force us to objectively compare our preservation philosophy and practices with those of an earlier generation. Differences may be tolerated, but methods that promote deterioration will have to be corrected if we are not to lose our architecture and thus our patrimony.

MAKING SENSITIVE INTERVENTIONS

Our preservation institutions will play a large role in determining what intervention takes place and how it occurs. Intervention into the fabric of a building irreversibly changes its history for all time and becomes part of its history. The challenge will continue to be the incorporation of evolving code requirements, including handicapped accessibility, and new standards in the intervention process, keeping these requirements subordinated to the main goal of preserving architecture. Our sensitivity to these issues in the past will condition our decisions in the future.

Sensitivity, not only to the past but also to the present, will be gained not by more standards—standards help only to avoid the worst—but by better education of those involved in the historic preservation process. Such education must be part of the institutional system to achieve a common understanding of what it means to be sensitive to a historic building and thus to architecture and history. Much of this sensitivity is the realization that whatever we do, whatever rules we create, and whatever incentives we apply, we cannot avoid altering the present. We can never be certain of being correct, but we must at least avoid being wrong.

Without this sensitivity to architecture and history, solutions to preservation problems cannot be properly evaluated. Achieving this goal will require close coordination between the public and private sectors of the preservation community. In this sense, we must recognize our need to build bridges between the many diverse elements working in the preservation movement. Research into treatments to retard material deterioration is being done in many laboratories; not all of the research is focused on historic preservation. During the project to preserve the Statue of Liberty, a noncombustible zinc-rich primer developed by the National Aeronautics and Space Administration was used also to treat the structural frame. Certainly, institutionalizing such information will aid in making treatment selection easier in the future.

To survive, many old buildings must be continually modified. But contemporary materials, processes, and technology gradually modify the original fabric and therefore the appearance of a building. For example, at the Brick Market in Newport, Rhode Island, much of the original material has been lost. Wooden shingles are now slate; gone are the original sash and much of the brick and wood trim. Yet the building remains an important and beautiful relic of colonial days, worthy of current preservation efforts.

Buildings slowly evolve, inevitably losing their initial appearance and, over time, their original materials. (Consider how much stone has been replaced in a French cathedral because of decay and the ravages of war. Consider how much more will have to be replaced over the next 800 years.) At some point the original material is gone, and we are left preserving past preservation efforts to continue the building's life. This is valid preservation because we still are preserving history.

AN ORGAN BANK FOR NEW USES

Some changes, though, are avoidable. A major loss of historic fabric and character is caused by introducing incompatible new uses in existing buildings. Because buildings must be used if they are to survive, the uses to which they are subjected are of critical importance. More and more historic buildings will become available for new uses. The complexity and scope of the problem require that we develop a strategy to deal with this process, not tackle it on a one-by-one basis. To find compatible uses for our historic structures, we must begin to plan on a larger scale—developing a mechanism similar to an organ bank to match structures and uses.

Architects must better understand the interrelationship of materials in a building and the impact a new use will have on the character of a historic building. The knowledge simply of how to deal with historic materials or construction techniques will not be enough. Modern mechanical and electrical systems will play an ever increasing role in our preservation efforts. Not only will we have to find ways of compatibly incorporating these systems in our historic buildings, but we will also have to evaluate whether we should have them at all.

For example, we have the means to control temperature and humidity within a building, within limits. The environmental control demands placed on the interior of a historic building are many. Visitors demand a certain level of comfort; curators need an environment that will best preserve objects placed in the building; and preservationists are concerned with the fabric of the building. Air conditioning can provide comfort and lower humidity. However, it can produce a movement of moisture through walls, causing a building to deteriorate. Buildings designed in the past can adjust only so much to incorporate new technologies for which they were not designed. Historic structures have their limits, limits that we will have to understand better in the years ahead.

For solutions, we can learn from our past. Often the needs that have created the demand for new technologies previously existed, and historic solutions existed as well. Older solutions, however, are often more labor-intensive and require greater training of personnel than the installation of modern systems. In the future, we should make better comparisons of the long-term costs of installation and operation of new systems—including the cost of damage to the fabric of the building we are trying to preserve—with the cost of simpler approaches that may require greater maintenance and human involvement.

MAINTENANCE FOR OLD AGE

Buildings, like people, have a life span. Like people, buildings must be assisted into old age, and the best assistance a building can get is ongoing maintenance. If maintained weather-tight and stable, some buildings will last a considerable time, although, inevitably, the end must come. Therefore, the use of materials and technologies cannot be judged solely on the effect that they may have on historic fabric; they must be seen in terms of a building's life span,

recognizing the need for eventual replacement. Nothing lasts forever. All materials decay at varying rates. How we replace deteriorating elements will determine if the character of the building is maintained and for how long. Reversibility of materials is an important consideration in selecting a treatment for consolidating or arresting decay. This concern is more applicable for interior elements and objects than for ones that must survive in an exterior environment. Often treatments can be judged by how well a material has worked in the past, if such a history can be found.

In terms of the risk they impart, new materials and treatments must be evaluated against other options, including no treatment at all. Doing nothing is a treatment that is irreversible. Decay will continue if not abated, and the resulting loss of building fabric cannot be reversed, except through replacement. All treatments and materials should be considered from the standpoint of the overall effect they will have on a structure. For example, some consolidants for stone may change color, affecting its appearance. Yet the treatment may also preserve the stone by reducing further deterioration. Therefore, the treatment should be judged on whether the change in appearance is an acceptable risk when compared with further deterioration of the stone. This approach provides a basis for determining which treatment will impart the longest life and which changes in appearance are acceptable in achieving longevity. Each case will be different, and evaluating each one will require increasing amounts of training and knowledge.

In assessing these problems, preservation architects must be careful not to become narrow technicians and functionary bureaucrats. They must be architects first—architects richly grounded in history and technology but, through vision, architects with the capacity to bring history and technology into that special condition we call architecture. Only then can they presume to be specialists, whether by dealing with historic buildings or by designing new ones. All must share a common ground—the love of architecture and the desire to keep architecture alive, responsive, and responsible. All have inherited a magnificent patrimony, with its many aberrations, and have the responsibility to deliver it into the future in a healthy and vigorous condition. We must continually renew and refresh our thinking so that we can keep historic architecture as a living, vital art. Otherwise, we will become embalmers of a dead history, freezers of a tradition, or morticians of meaningless remnants of our past.

ARCHEOLOGY IN THE NEXT 25 YEARS

Hester A. Davis

IRONIC THOUGH IT MAY BE FOR AN ARCHEOLO-
GIST TO PREDICT THE FUTURE, HERE IS ONE SURE BET: THE PRACTICE OF ARCHEOLOGY IN THE NEXT
25 YEARS IS GOING TO BE MARKEDLY DIFFERENT FROM WHAT IT HAS BEEN AT ANY TIME IN THE
PAST. EVEN NOW, RECENT EVENTS ARE RAPIDLY RESHAPING THE FIELD. THE MOST OBVIOUS OF
THESE IS THE PASSAGE IN LATE 1990 OF THE NATIVE AMERICAN GRAVE PROTECTION AND REPA-
TRIATION ACT. THIS ACT IS THE MOST RECENT IN A SUCCESSION OF HISTORIC PRESERVATION
LAWS AFFECTING ARCHEOLOGY THAT HAVE BEEN ENACTED SINCE 1966.

Back in 1966 archeology was included in the National His-
toric Preservation Act almost by accident. Archeologists
soon realized, however, that the processes by which arche-
ological sites could be considered significant, and therefore
protected, preserved, or excavated, were ones that could
help curtail the mass destruction of sites by public works.
Theoretical and methodological arguments raged about how
to establish the significance of sites and whether listing
archeological sites in the National Register of Historic Places
actually protected them at all. But the fact that archeologists
suddenly had to explain to others *why* a site should be pro-
tected or excavated caused profound changes in their ap-
proaches to their own databases.

The Archeological and Historic Preservation Act of 1974
(the Moss–Bennett Act) unleashed another profound change

in the world of U.S. archeology. Six years in the making,
the law politicized archeology for the first time. The pro-
fession recognized that passage would bring immediate
changes because the act authorized all federal agencies to ex-
pend funds for archeology.[1] Although the 1966 act required
federal agencies to consider historic and archeological prop-
erties, it did not provide funds for the expensive work re-
quired to consider archeological sites that might be in the
way of a project. The 1974 act authorized each agency to
spend its own project money to comply with the require-
ments of the 1966 law.

Archeologists were not adequately prepared for the con-
sequences of the 1974 legislation, and it soon became obvi-
ous that archeologists based in museums and on college
campuses could not meet the needs of federal agencies.

Some enterprising archeologists formed private companies. Others were hired by environmental firms so that they could then offer agencies a total package of cultural and natural resource assessments. To meet the stepped-up demand, "archeologists" came out of the woodwork; some were inadequately trained for what they were asked to do. The Society of Professional Archeologists (SOPA) was formed in 1975 in response to these changes. SOPA defined the training and education needed to qualify as a professional archeologist. Only those who met these minimum qualifications could be considered adequately trained to make the judgments needed to comply with preservation laws. Equally important, SOPA established a system for evaluating whether its members were performing their responsibilities in accordance with standards of research performance and a code of ethics.

Soon, federal agencies began to hire their own archeologists to help them assess the archeological research they were buying. The Forest Service and the U.S. Army Corps of Engineers, for example, had no archeologists on staff in the early 1960s; by the mid-1970s, each had dozens. The amount of archeological research being done under the historic preservation laws was tremendous. But was it really research? Did surveying a gas pipeline and identifying site locations so that the company could avoid impact by changing the pipeline route constitute "research" or even "cultural resource management"? Did agreeing beforehand how much excavation of a "significant" site constituted "mitigation of impact" really provide for recovery of appropriate data from that site? Did constraints on time to do analysis and prepare reports prohibit any real contributions to knowledge from being made through these data-recovery efforts? Did preparation of 50 copies of such reports, submitted to the agency alone, constitute appropriate "dissemination of information"? Between 1974 and 1990 many asked these substantive and administrative questions. And over the course of the years, the questions and the answers have changed the world of archeology.

The great increase in the amount of archeological work being done soon caused another crisis: what was to be done with all of the accumulating artifacts and records? Some small private companies kept the artifacts in their garages. Some official repositories were running out of space. There were no standards for the care of records, photographs, and fragile artifacts. By the late 1980s the Army Corps of Engineers and finally the National Park Service issued curatorial standards, but the problem of space and funds to provide appropriate long-term care still has not been addressed adequately.

In 1979 the Archaeological Resources Protection Act was passed, updating the 1906 Antiquities Act and providing more adequate legal protection of archeological sites on public land. The 1980 amendments to the 1966 act codified Executive Order 11593, thereby requiring federal agencies to survey their own property and nominate eligible sites to the National Register. The amendments also clarified the amount of federal project funds—one percent—that could be spent for cultural resource requirements. Both laws and additional amendments further assisted the protection of federal properties but did nothing for sites on private land.

PROTECTING INDIAN SITES

In 1988, however, the looting of a large prehistoric cemetery at Slack Farm in northern Kentucky changed attitudes toward resources on private land.[2] More than 400 graves were plundered by artifact hunters who left the site littered with bones and gaping holes. This incident outraged native Americans, archeologists, and even members of Congress. Soon legislation was drafted to prevent any such recurrence.

Years before this happened, the American Indian Movement had taken shape. In the early 1970s when the movement was beginning, native Americans across the country garnered press coverage by making noise about "archeologists digging in sacred sites" and "disturbing the bones of our ancestors." The political fruit they harvested from what were often confrontations was sweet; the public was generally sympathetic. For the first time, archeologists initiated dialogue with native Americans and learned that excavation of prehistoric burial sites was a more sensitive matter than their professors had led them to believe.

Members of native American activist organizations and the Society for American Archaeology sat down together to try to resolve who had the higher claim to ancestral remains: science or descendants. The archeological profession itself was split on the question. Native Americans held that the sites were sacred to Indians; bioarcheologists, who use data from human remains to study population dynamics over time, thought that they should not be denied access to this rich source. Various American Indian groups brought these matters to state legislatures and, more important, to Congress. Their efforts paid off. Over the past five years, more than a dozen states have passed legislation to control the disturbance of graves. And in November 1990 President Bush signed into law the Native American Grave Protection and Repatriation Act. Although excavation of burial sites is a very small part of what archeologists do, archeology will never be the same.

Given this background, then, how will the archeology of

the next 25 years continue to contribute to our understanding of the past?

There are seven areas in which archeologists' roles, attitudes, and intellectual challenges should change.

IMPROVING RELATIONSHIPS WITH OTHER PROFESSIONALS

In the coming years, archeologists must integrate their work much more closely with that of others in the preservation field, including cultural resource specialists and preservationists generally. This move will require increasing others' appreciation for the archeological components of historic sites. Cultural resources include *all* evidence of cultural activity—whether located above ground, below ground, in standing structures, or in sacred sites. Archeological sites are only one kind of cultural resource. Although those interested in buildings and those interested in archeological information have been the most active in carrying out historic preservation laws, archeology should be better integrated into all elements of historic preservation programs in the future. Its relevance to all programs must be better understood both nationally and at the state level.

The "archeological solution" of excavating sites that are in the way of a public project is not always the most appropriate, any more than is photographing and making measured drawings of a building before tearing it down. However, historic preservation laws and state historic preservation offices tend to be oriented toward the built environment, although the situation has improved greatly over the past 10 years. Archeologists and other preservation professionals must work harder to increase awareness that historic buildings and districts all have archeological (i.e., below-ground) components that require equal time for inventory, evaluation, and treatment. People should understand that these activities are time-consuming and that the techniques for recording and evaluating archeological resources differ from those required for standing structures. Both archeological and preservation leaders must see that effective integration takes place.

Archeologists must continue to be active politically on both the state and national levels largely because they have learned that the other partners in historic preservation still do not give equal attention to archeological concerns. Should not everyone working for preservation legislation consider, for example, how tax incentives might help encourage landowners to protect archeological sites as well as allow incentives for rehabilitation of historic structures?

But it will be on the state level that more legislative activity will occur in the future as more states deal both with native American concerns and with protection of all archeological resources from all manner of threats. It may well be that more states will follow California's lead and pass environmental laws that ensure that state-sanctioned activity considers all cultural resources on both state-owned and private land. This change would increase the ability to consider and protect a state's important legacy. The federal government has already demonstrated leadership by requiring that cultural resources be considered in planning all federal projects; states have been slow to follow this lead.

BUILDING OTHER NEW RELATIONSHIPS

Archeologists must devote more time to relationships with those who affect their ability to do research as well as those who are affected by their research. These groups include politicians, the media, teachers, collectors of artifacts, amateur archeologists, native Americans, African Americans, landowners, historic preservationists, and the public at large. Such efforts will be in marked contrast to the past, when archeologists have been slow to develop some of these relationships.

The change in relationship between archeologists and native Americans is of the utmost importance. True, all American Indian groups are not the same, and their relationships with archeologists vary, but the balance has shifted dramatically. For too long archeologists ignored the people whose ancestors they studied. Now, not only have these contemporary peoples guaranteed that their ancestors' graves and sacred sites will be more appropriately considered in the future, but they also are indicating in some cases that they are more qualified to shed light on their own past than are archeologists. In this arena, archeologists no longer have complete control over what they once considered to be *their* data. Politicians have proven more sympathetic toward the feelings of native Americans on these issues than they have been toward science. Congress has said, in effect, that the past belongs to the group identified as the descendants of those evidences of the past.

In most cases, archeologists will be able to study objects—and in some cases, the human remains—before they are returned to the appropriate American Indian group, but the objects will no longer belong to museums or other academic repositories where they can be held for future research. Recording information about these resources must be completed immediately.

At one time, sites were being destroyed so fast it was projected that in a quarter century, most archeological sites would be destroyed or badly disturbed.[3] At that time, archeologists consoled themselves with the assurance that collections preserved in museums could be studied. Now, much

of this material will be returned to the descendants of those who left that evidence. Working out this new relationship is going to be exciting, challenging, and frustrating, for all parties involved. It will be humbling for the archeologists, and perhaps the Indian groups will learn from the new relationships some things about themselves.

Two other relationships that are changing and that require more discussion are those with amateur archeologists and the public in general. Many more people are interested in archeology as a hobby than there are professional archeologists. Amateur archeologists collect for the pleasure of learning about the past. They may maintain personal collections that are recorded with their local or state archeological authority and give freely of their time, knowledge, and talents to archeological endeavors. This interest has never been sufficiently harnessed to the benefit of archeol-

ogy or cultural resources. The archeological profession ought to put effort into channeling this interest and enthusiasm. This connection should be done at the local and state levels, because that is how the amateurs are organized and that is largely where their interest lies.

Archeologists are beginning to put their energy and even some financial resources into communicating with the public. They have also finally realized that professionals cannot save sites wholly on their own. The people who own them, control them, or manage them must also want to save these places. The Society for American Archaeology, Society for Historical Archaeology, and some federal agencies are forming public education committees. These groups are working together to plan how best to get an archeological conservation ethic across to the general public. Acting on the belief that this ethic should be taught in the formative years,

Excavation of the Champe-Fremont Archeological Site near Omaha, Nebraska, revealed an entrance ramp, post molds, and storage pits.

they are developing educational materials for the fourth grade, eighth grade, and high school levels to help teachers get out of the "tipi syndrome." Programs are being developed about the fragile nature of the evidence of the past and the pride of native Americans in their own heritage.

Because many archeologists learned a particular scientific language in graduate school, explaining technical terms in everyday language does not come easily. But more are realizing that part of being an archeologist in the future includes learning to communicate with nonarcheologists. Archeologists should learn from the environmental movement and organize a massive assault on the public consciousness. They must transmit the message that not all sites are equally significant, but loss of sites could wipe out an essential page of history. The public, the owner of the land, and the American Indian group most closely associated with that past should share in the interest and excitement of any archeological discovery.

One of the more difficult decisions for archeologists in the future will be how best to organize the needed time and energy for these relationships with nonprofessionals. The leaderships of the various national archeological organizations must work together so as not to divide energy or duplicate tasks.

PROMOTING STRONG STEWARDSHIP

Stewardship of archeological sites is an idea whose time has come. The most vital challenge for archeologists is to make this concept a part of every person's life in this country and beyond. Some state historic preservation programs in Arizona, Kentucky, and Texas have already organized stewardship programs. Some archeological societies are catching on to this idea as well.

In Arizona and Texas, individual volunteers assume responsibility for monitoring the condition of important properties. These "stewards" make themselves known to the landowner and encourage him or her to understand the nature of the cultural resource owned. They report to the state office on the condition of the site and on any changes or threats to the property. In Kentucky, the state office recognizes individual landowners who agree to certain kinds of protective measures. Programs such as these are the only real long-term way to ensure preservation of cultural resources.

One organization is putting its money where its philosophy is, and that is the Archeological Conservancy. Working in much the same way as the Nature Conservancy, the Archeological Conservancy buys threatened archeological sites, taking them out of the private sector and putting them into the public sector for protection. At present, it is a small

organization, working with less than adequate financial resources given the work cut out for it.

From the halls of Congress to statehouses to the schoolhouse at the crossroads, the word must be spread. Without a strong stewardship program and a realistic stewardship ethic promulgated in the schools, we will only muddle along, saving things on an ad hoc, largely locally oriented basis. Without a commitment to coordinated national programs, we will surely continue to lose important properties. We must combine our energies and make some longer-range plans. We must include native Americans and other appropriate ethnic minorities to every extent possible. We must ensure that the diversity of all past human experience is available and represented in the future for the benefit of all.

ENSURING CREATIVE CURATION

Now that we have committed ourselves to the conservation ethic, how can and should we take care of the artifacts and records from the field research being done? Archeologists and federal agencies have been concerned about the curation problem for several years. However, despite warnings,[4] no long-term, creative, or nationwide solution has been achieved.

Federal agencies are responsible for the care of material and information recovered from archeological projects for which they pay. Until recently, this responsibility was passed on to contractors for the archeological work, without adequate instructions or oversight. Within the past year, the National Park Service has published curation regulations. The Corps of Engineers also has issued its own regulations. However, the real problem, which has to do with space and funds to provide adequate care for the artifacts and records, has not been addressed.

Curation often is not thought of as part of doing archeology. The profession has failed to indicate to federal agencies that curation is as much a necessity in archeological investigations as field work. Two recent studies have clearly demonstrated this lack of understanding that adequate curation must be the final act of an archeological project. Both studies revealed rotting boxes, spilled artifacts, rusted objects, and lost records in the repositories that were examined.[5] A project should not be considered complete until the proper curation is achieved.

All existing collections and records must be inventoried and their care upgraded if necessary; future collections must be appropriately curated from the beginning. However, other questions persist: Where should collections be curated, and who is to pay for care in perpetuity? Should everything be saved? Is every piece of paper generated by a project

equally important, and does it require archival-quality care? What is the life span of black-and-white photographs using present chemicals? What about color slides, so important in recording soil color changes? How long is "in perpetuity"?

Archeologists, federal agency representatives, and other appropriate groups must sit down together and create a realistic atmosphere for realistic solutions. Some federal agencies have been trying to solve their curation problem for current projects largely on a district or regional level. Logically, this could mean that the Corps of Engineers might build a curation facility for its collections and records in Arkansas, and the Forest Service might build another, and the National Park Service yet another. Is it unrealistic to think that a single federal curation facility might be built in a state or region, contributed to, and used by all agencies that need it?

Perhaps one of the most neglected parts of archeological research is care of the records. Archival-quality paper generally has never been used for primary field records, certainly not for computer printouts, much less the reports themselves. Photographs, particularly slides, have been stored in plastic sheets that contain acid. Maps have become faded or have inadequate identification. Even computer-generated analysis programs are not updated as equipment and software change. One hesitates to suggest how many keypunched cards are in boxes—with the data contained on those cards no longer retrievable because the machines to read them are obsolete.

The most obvious and most efficient way to store archeological information in perpetuity and for access by future researchers is to put it on CD-ROM discs. This is not only efficient in terms of space, but also meets the regulations that require a copy of all records to be stored separately from the original. It also means that handwritten notes, computer analysis sheets, black-and-white contact prints, color slides, and even images of artifacts themselves can all be stored together on the disc. The technology is available and it must be used. A central curation facility for a state or region could have this equipment for all to use to meet the requirements of the law.

While we are suggesting creative ways to solve this problem, let us take a hint from the Postal Service and use bar codes on the storage boxes for the federally mandated inventories of collections. Let us enlist professional archivists in our efforts to find appropriate technology and conservation procedures for care of paper materials and records. Let us give each federal agency a blueprint for the solution to this problem that it can take to Congress, saying, "We all have the same problem, and here is a cost-effective way to solve it for as far into the future as we can see. This legisla-tion requires us to cooperate with other agencies, and this appropriation is our share of the cost for the care of our nation's heritage."

PROMOTING INTELLECTUAL AND GROUND TRUTH

What will be the nature of archeological research itself in the future? The pessimists are of the opinion that there will either be no sites left from which any useful new information can be gained or that those that do remain will be protected from excavation by law. Even the collections in museums—a real source of information given new techniques of analysis—will be greatly depleted or unavailable in the near future. The optimists say that there will be plenty to keep archeologists busy for a long time to come if we work to see that appropriate sites are protected, others are excavated, and collections are cared for appropriately whether they are the responsibility of American Indian groups, museums, or other public entities. The basic need to know about the past and to provide each of us with a sense of place is not going to fade away.

The challenge to tackle more complex projects for recovery of information with state-of-the art technology will always be with us. The challenge to interpret ever more complex data and to reinterpret it in the light of new information will always be with us. The "new archeology" is now old; processual archeology is now postprocessual archeology. Archeologists should know that nothing is constant, not even their most convincing new arguments about what happened in the past, assuming that we can ever know what actually happened. Each new generation of archeologists will see the past—the single artifact, the community, the social organization of a chiefdom, the ceramic traditions—with ever increasing clarity and perception because of what has been recorded by others and because of yet-to-be-discovered techniques for analyzing the remains of human experience that are left to us.

The cycle is never complete. We must seek information that still lies in archeological sites (ground truth); we must examine it in light of past accumulated knowledge (intellectual truth), rethinking what the new data can tell us in our effort to decipher what past lives were like from the infinitesimal amount of information that survives. We must make our colleagues in allied fields part of our research projects from the very beginning, so that recovery of the soil samples, pollen cores, bones, and other evidence can be studied by the paleobotanists, physicists, and others who have expertise to help.

Even in historic times, ways of life are not normally in written documents, and our interpretations will always be

fraught with uncertainty. Can we really know how it felt to be a frontier woman, alone in a sod house with four children, when the dog starts barking on a dark night? Or how a high priest at Cahokia held his power? Neither archeology nor history may be able to shed full light on these questions. We must remember that most of the information about life in the past will never be known to us. This is why what we do have is so precious and why it is possible for two people to "see" in that information several different "truths." In the future good science and good history, however, should be able to get us closer to the past.

REDEFINING ARCHEOLOGY AS A CAREER

The future of archeology as a profession looks bright. The intellectual challenge of a B.A. and graduate degrees in anthropology, with a specialization in archeology, is popular in colleges and universities across the country. More important, there will continue to be jobs in the future. The jobs may not increase in number to the degree they did in the 1970s, but there is no question that a demand will continue for archeological compliance with historic preservation laws.

There will, however, be fewer and fewer positions in which archeologists can do full-time research. Most archeologists will be teacher-researchers or administrator-researchers. The important thing is that the basic training and experience needed to pursue a career as an archeologist, whether as a professor, employee of the Corps of Engineers, private consultant, or museum curator, must be the same. Archeologists of tomorrow must possess a strong social science background and a variety of computer skills, and they must have done fieldwork under an experienced archeologist. In addition, they must be more specialized than their counterparts a generation or two ago.

The need for specialists, in particular kinds of analysis as well as in the field of cultural resource management, may require a different curriculum. A graduate student specializing in archeology should learn concepts from political science, journalism, historical methods, and soil science, among others. It may well be that colleges and universities find themselves creating a department of archeology separate from anthropology, where archeology now lies. If this comes about, a major in the new department will need appropriate cultural and physical anthropology courses as part of the required curriculum so that students will be able to deal with native Americans, sacred sites, and traditional cultural properties. Within the subdiscipline of physical anthropology, bioarcheologists will become a part of the new archeology department.

It is interesting to note in making these projections, however, that for at least 15 years, the major job market for M.A. and Ph.D. graduates with a specialization in archeology has been in field and interpretive research for Section 106 compliance. But fewer than a dozen departments of anthropology in this country offer courses in such topics as preservation law or business administration for archeologists. This must be corrected in the future.

CLARIFYING WHO OWNS THE PAST

Ownership of the past might have been viewed as an abstract philosophical question just a few years ago, but today it has become an urgent problem, with legal, moral, and ethical—as well as philosophical—implications. The philosophy of "public archeology" is that the past belongs to everyone. Writes archeologist Charles McGimsey:

Knowledge of this past, just as knowledge about the environment, is essential to our survival, and the right to that knowledge is and must be considered a human birthright. . . . It follows that no individual may act in a manner such that the public right to knowledge of the past is unduly endangered or destroyed.[6]

This statement of principle addresses information and does not specifically mention the objects from which some information about the past is derived. And it is the objects and sometimes the sites themselves that are the greatest challenges now. As mentioned earlier, native Americans have achieved a degree of control over the objects that their ancestors made. Congress has essentially endorsed the concept that Indian groups should "own" their own past, at least as defined by objects buried in graves and on display in museums that can be traced to a specific legally recognized tribe.

But who owns the past that hides in a 1,000-year-old trash pile or the collapsed remains of a house that is on private property? By all state and federal laws, the current landowner does. Are our attitudes toward native Americans changing enough that this "sacredness" of private ownership may not apply to the evidence of the past?

Our laws and our ethics on this issue are not yet clarified. The consciousness of archeologists, preservationists, native Americans, and Congress has been raised in the last few years. What changes this bodes in law, much less attitude, cannot be foreseen. The new federal and state laws regarding protection of grave sites certainly intrude on private property. How else may the rights of landowners to their property, or the rights of the American public to information, or the rights of native Americans to their past, be affected by changes in attitude toward this question of "ownership?" Only the future will tell.

KEEPERS OF THE NATIVE TREASURES

Dean B. Suagee

DURING THE FIRST QUARTER CENTURY OF THE NATIONAL HISTORIC PRESERVATION ACT OF 1966, AMERICAN INDIAN AND ALASKA NATIVE TRIBAL GOVERNMENTS PLAYED ONLY MARGINAL ROLES IN OUR NATIONAL HISTORIC PRESERVATION PROGRAM. A GREAT MANY TRIBES AND INDIVIDUAL MEMBERS HAVE BEEN ENGAGED IN HEROIC EFFORTS TO PRESERVE THEIR HISTORIES AND THEIR LIVING CULTURES, BUT MOST OF THESE EFFORTS HAVE TAKEN PLACE OUTSIDE THE CONTEXT OF THE NATIONAL PROGRAM.

The preservation community is now beginning to rectify the omission of tribal governments, so that during the next quarter century many Indian tribes will become full partners in our national historic preservation program. This is only fitting given the status of Indian tribes as sovereign entities and the fact that Indian people have historical roots in North America that are much deeper than those of non-Indian Americans.

A substantial number of tribes, especially those with relatively large reservations, will assume a role similar to that of the state historic preservation offices and devote much of their efforts to the protection of properties that have historical significance, especially those properties that have cultural or religious importance. Other tribes will devote less attention to the Section 106 consultation process and instead will emphasize the preservation and revitalization of aspects of their living cultural heritage—language, oral tradition, arts, crafts, songs, and dance—that generally do not depend on the preservation of particular historic properties. As tribal governments take their places as partners in the national program, federal and state agencies and the private sector will find that they can complement tribal programs in many ways.

The development of tribal preservation efforts will contribute to the preservation and revitalization of tribal cultures, but tribal cultures will endure whether or not particular tribal governments become full partners in our national historic preservation program. In all likelihood, most of the "historic preservation" that will take place within Indian country during the next quarter century will occur outside the context of the national program, because tribal communities will continue, as they have for countless generations, to preserve and revitalize their unique cultures

in ways that they themselves determine to be appropriate.

The dominant society, on the other hand, seems to need the tribes to become full partners, in order to fully understand American history and to apply some of its lessons to the future. As the American people become more adept at listening to the voices of native people retelling our own histories, and as we all become better at preserving the places that are important in tribal histories, the entire country will be greatly enriched, and future generations, Indian and non-Indian alike, will share in this enrichment.

RECOGNIZING TRIBAL SOVEREIGNTY

The first step in promoting this dialogue is recognizing the basic principle of tribal sovereignty. Indian tribes are sovereign governments, described by the U.S. Supreme Court as "domestic dependent nations."[1] As governments, the tribes are distinct from both the federal government and the states, and the sovereignty they possess predates the Constitution.[2] One aspect of the tribes' inherent sovereignty is the right to enact laws controlling lands under their jurisdiction, including laws that govern the general subject matter of historic preservation. A number of tribes have done so.[3]

Although legal recognition of tribal sovereignty is a longstanding principle of federal law, federal policies meant to encourage or force Indians to give up their distinctive cultures and assimilate into the dominant society have been the rule throughout most of American history.[4] For example, during the "allotment" era, the federal government removed a substantial amount of land from tribal possession. During the "termination" era, the federally recognized status of more than 100 tribes was abruptly revoked and many other tribes were subjected to state jurisdiction without tribal consent.[5]

Although we are now entering the third decade of the "self-determination" era in federal Indian policy, jurisdictional battles between tribes and states continue. Based on experience, tribes regard the preservation of tribal sovereignty as a prerequisite for survival as distinct cultures. If tribes are to become full partners in our national historic preservation program, they must have the opportunity to become involved without compromising their sovereignty.

BRINGING TRIBES INTO THE PROGRAM

Notwithstanding their sovereign status and their legitimate concern for the subject matter, until recently Indian tribes have been virtually excluded from our national preservation program. The National Historic Preservation Act of 1966,[6] the basic charter for the program, made no mention whatsoever of Indian tribes, as it was originally enacted. This oversight is not surprising, however, given the fact that the act was passed in the waning years of the "termination" era in federal Indian policy.

In the 1980 amendments to the act, Indian tribes were added to the list of entities that are to be included in the federally proclaimed partnership for carrying out our national program.[7] The 1980 amendments also provided the secretary of the interior with express authority to make grants to tribes for "the preservation of their cultural heritage."[8] It was not until fiscal year 1990, however, that the secretary, acting through the National Park Service, finally made any such grants to tribes, and then only because of a floor amendment in the Senate that added $500,000 in appropriations for grants to tribes.[9] In addition, the accompanying Senate report directed the National Park Service to prepare a report to Congress on "the funding needs for the management, research, interpretation, protection, and development of sites of historical significance on Indian lands."[10] In response to this mandate, the Park Service consulted with Indian tribes and prepared a report, entitled *Keepers of the Treasures*,[11] which was submitted to Congress in September 1990.

Keepers of the Treasures concludes that "it is time for Indian tribes to be afforded the opportunity to participate fully in the national historic preservation program on terms that respect their cultural values and traditions as well as their status as sovereign nations."[12] One of the recommendations to Congress contained in the report is that the 1966 act should be amended "to establish a separate title authorizing programs, policies, and procedures for tribal heritage preservation and for financial support as part of the annual appropriations process."[13] This recommendation is consistent with the approach that Congress has taken in recent amendments to environmental laws, which authorize the Environmental Protection Agency to treat tribes as states.[14]

Proposed legislation would establish a separate title of the preservation act for tribal and native Hawaiian programs.[15] (Although Congress has not treated native Hawaiians as possessing retained sovereignty in the sense that Indian tribes do, the Hawaiians, like Indians, have been subjected to federal policies that were intended to extinguish their traditional culture.[16]) It appears quite likely that Congress will enact such legislation early in the second quarter century of the preservation act. If this happens, then the tribes' participation as sovereign governments in the national program will be an established fact long before the preservation movement's 50th anniversary. Tribal historic preservation programs, however, will not limit themselves to replicating the established state historic preservation programs. Rather,

The Birch Coulee School in Redwood County, Minnesota, is a historic property type found on many American Indian lands.

because tribal programs will be defined by local tribal priorities, they will exhibit a great deal of variety. As the tribal programs develop, they will remake and revitalize the national and state programs with which they will interact.

PRESERVING LIVING CULTURES

The fundamental reason why tribal historic preservation programs will differ from those of the dominant society is the transcendent concern of the tribes for the preservation of the integrity of their cultures as living cultures. In the larger American society, living culture is an area of interest for many people within the historic preservation community,[17] but the emphasis of the national program has been the preservation of historically significant properties, particularly those that qualify for listing in the National Register of Historic Places. Indians are concerned with the preservation of properties that have historical significance, but more than the preservation of properties is at stake. We are concerned with the preservation of our distinctive ways of life.

Tribal traditions do have historical significance, and all of the tribal cultures of today have deep historical roots in North America. Tribal cultures are dynamic, however, and most have changed in many ways during the generations

of contact with non-Indians. Indian people of today are not concerned so much with preserving our histories for the general good of the larger society. Although we wish the larger society were better informed about tribal cultures and histories, we reject the tendency to treat tribal cultures as relics from the past suitable for display in museums and little else. Rather, Indian people are primarily concerned with the vitality of tribal cultures in today's world. We share an understanding that each tribe has a wellspring of ancestral wisdom derived from the knowledge and experiences and values of countless generations of ancestors. What is most important, though, is that we honor our ancestors by how we live in the present, and it is only by doing so that future generations will have the opportunity to carry on these traditions.

In light of the tribal emphasis on living cultures, it was not surprising that, in the consultation meetings for the report to Congress, a number of people expressed objections to the use of the term "historic preservation" to describe the range of tribal concerns. One tribal representative said that the term suggests "something that is old, something that has happened in the past and that you want to put away on a shelf and bring out to look at every now and then."[18] Another said, "It's not history as we see it; it's

everyday life."[19] Many expressed the view that the term "historic preservation" is simply inadequate.

Tribal cultures and tribal religions are in many ways inseparable. Congress recognized this in the American Indian Religious Freedom Act, which declares that "the religious practices of the American Indian (as well as Native Alaskan and Hawaiian) are an integral part of their culture, tradition, and heritage, such practices forming the basis of Indian identity and value systems."[20] Tribal religions are not static, but they generally include teachings that were given to the people by spiritual beings so long ago that the dominant society might describe those times as mythic rather than historic or prehistoric.[21] These teachings have been transmitted through countless generations ever since in ceremonies and stories that "espouse a triplefold declaration of dependence on the surrounding world: of the individual on the community, of the community on nature, and of nature on the ultimately powerful world of spirit."[22]

Because tribal cultures exist in a religious context, Indian people regard the responsibility for preserving cultural heritage as a sacred trust, and the term "historic preservation" simply fails to convey the awesomeness of this responsibility. One tribal representative suggested that we find "a more wonderful word for the keepers of the treasures that we consider to be sacred forever."[23] The National Park Service decided to use that phrase as the title of its report to Congress, and when Indian people formed an organization to be an intertribal counterpart to the National Conference of State Historic Preservation Officers, the new organization also decided to call itself Keepers of the Treasures.

KEEPERS OF THE WHOLE CULTURE

A holistic approach is the norm for tribal efforts to maintain the integrity of tribal cultures, and most tribes are concerned with a broad range of cultural preservation activities, including efforts

. . . to preserve and transmit language and oral tradition, arts and crafts, and traditional uses of plants and land; to maintain and practice traditional religion and culture; to preserve sacred places; to record and retain oral history; to communicate aspects of tribal culture to others; and to use cultural resources to maintain the integrity of communities and advance social and economic development.[24]

Most tribes are concerned with all of these things. The programs that tribes have formally established to address these concerns vary in emphasis and approach, reflecting tribal priorities in light of the historical context and current circumstances of each tribe.[25] For many tribes, preserving native languages has served as a unifying theme for cultural heritage programs, because language is central to the collective self-identity of a people and because tribal cultures have been passed down over the generations through the use of spoken language.

In the absence of a federal assistance program, tribal governments provide the primary source of financial support for most tribal cultural preservation activities.[26] Unfortunately, tribal governments have many competing demands for their limited revenues. Over the next quarter century, federal financial assistance to tribal historic preservation programs will increase. Such assistance must be provided on a recurrent basis. As financial resources become more available for tribal programs, and as the state and federal preservation programs build cooperative relationships with tribal programs, tribal activities will grow dramatically.

In keeping with the holistic approach that is the norm for existing tribal programs, many tribal government programs will emphasize building on the institutions they have already established. Many tribes will choose to enhance the cultural components of existing tribal programs. Tribally controlled schools and colleges will perform an increasingly effective role in revitalizing the use of native languages and in the preservation and transmission of oral traditions. Tribal cultural centers and museums, with help from the National Museum of the American Indian[27] and others in the museum community, will be increasingly effective in presenting the larger society with accurate information about tribal cultures and providing markets for Indian artwork and crafts. Cooperative programs among the schools and colleges and the cultural centers and museums will help Indian young people develop a more positive self-image. There will be a great deal of sharing of information and experience among tribes, and many tribes will devise programs that in one way or another try to replicate the successes of others. But each tribal culture is unique, and while there will be significant similarities, at the 50th anniversary of the 1966 National Historic Preservation Act, tribal cultural heritage programs will reflect the diversity that exists among the indigenous tribes and nations of the United States.

INCLUDING NATIVE ALASKANS AND HAWAIIANS

Native cultures in Alaska and Hawaii merit special attention because they have had to respond to special circumstances. In some ways, federal policies toward Alaska natives have been similar to policies toward Indians in the contiguous 48 states, but there have also been significant differences. The single most important legislative act affecting native Alaskans is the Alaska Native Claims Settlement Act of 1971.[28] In several ways, the act has more in common with congressional

Kinishba Ruins in Arizona survives from a settlement that depended on agriculture and the manufacture of pottery in the 13th century.

enactments of the allotment and termination eras than it does with the current era of self-determination. The act's fundamental injustice and the continuing struggle of Alaska natives to carry on their traditional cultures in spite of it are documented in *Village Journey*,[29] a report commissioned by the Inuit Circumpolar Conference in 1983 and published in 1985.

During the next quarter century, the involvement in preservation act programs by Alaska native tribal governments,[30] as well as village and regional corporations, will increase. The 1966 act, however, may be a secondary factor in the survival of the traditional cultures of Alaska. Their cultural survival will depend more directly on the extent to which their wildlife habitat—lands and waters—can be defended against destructive resource exploitation.

As noted earlier, native Hawaiians have not been treated in federal law as retaining their original sovereignty, but, during the self-determination era, they frequently have been included in legislation for the benefit of native Americans.[31] Regardless of federal law and policies, the desires of native Hawaiians to preserve their history and culture are certainly as intense as those of American Indians and Alaska natives. In the absence of federally recognized tribal governments, a state-chartered organization, the Office of Hawaiian Affairs, has taken a leading role in advocating the interests of Hawaiians in historic preservation matters.[32] During the next quarter century, preservation programs could be instrumental in the protection of the living culture of native Hawaiians.

REPATRIATION

For many Indian and native people, the most pressing concern will continue to be the return of ancestral remains, along with funerary and other sacred objects, that are now in the possession of museums and other institutions. Congress has responded to Indian concerns by mandating the return of such remains and objects held by the Smithsonian Institution[33] and by other institutions if the remains and objects were originally taken from federal or Indian lands.[34] Preservationists who want to establish better relationships with tribal programs must learn to appreciate the sincerity and intensity of the religious beliefs of Indian people who seek the return of sacred objects or the remains of their ancestors. This applies to preservationists affiliated with federal and state agencies, as well as those in the private sector. In a country that prides itself on its tradition of religious freedom, the people who are involved in the administration of our national historic preservation program simply must learn to respect the religious freedom of American Indians, Alaska natives, and native Hawaiians.

For Indian and native people, the American tradition of religious freedom has so far been a cruel hoax. If the tribes perceive that the federal and state preservation officials do not yet respect tribal religious beliefs, the tribes are not likely to want to be full partners in the national program.

PROTECTING SACRED PLACES

Section 106 of the 1966 act[35] requires that federal agencies consult with the Advisory Council on Historic Preservation before taking actions that will affect properties that are listed in, or are eligible for listing in, the National Register of Historic Places. Regulations issued by the council[36] require consultation with the state historic preservation office, and this requirement is routinely applied to Indian lands although there is no statutory delegation of such authority to states. With respect to lands under tribal jurisdiction, the regulations require that the tribe be invited to participate in Section 106 consultations as a "consulting party"[37] and allow for a tribe to participate in the Section 106 process in lieu of the state historic preservation office, subject to that office's concurrence.[38]

If tribal governments are to become full partners in the national program, the Section 106 process must be carried out in a manner that is consistent with tribal sovereignty. With respect to lands under tribal jurisdiction, tribes must have the right to choose for themselves to perform, in lieu of the state historic preservation office, a similar role in the Section 106 process.[39] Those state offices that learn to respect tribal sovereignty may find that their expertise is sought and their views respected by tribes, but there will be little cooperation without respect for tribal sovereignty.

Tribal concerns for historic properties are not limited to the lands that are currently treated as "Indian lands."[40] Many Indian tribes were forcibly removed from their aboriginal homelands, and most tribes that have retained reservations within their aboriginal territories have had their landholdings reduced to a fraction of what they once were. Many of the properties that have historical significance for tribes are beyond the reach of tribal territorial jurisdiction. Federal agencies and the state historic preservation offices can play important roles in helping tribes protect such properties.[41] Over the next quarter century, it will become a much more common practice for federal agencies to engage in consultation with tribes, in particular, in the context of carrying out federal responsibilities under Section 110 of the 1966 act[42] and the uniform regulations implementing the Archaeological Resources Protection Act of 1979.[43]

There are a number of reasons why Indian tribes have not participated fully in the national program for identifying and protecting National Register properties. Among them are

the de facto infringement on tribal sovereignty constituted by having state historic preservation offices carry out the Section 106 consultation process on Indian lands. They also include Indian concerns about the sharing of confidential information with federal and state agencies. A more fundamental reason has to do with the widely held view among Indians that "historic preservation" misses what is most important: the sacredness of the land. Indians are intensely concerned with the preservation of sacred lands. Most sacred lands have historical significance. The history of each and every tribe is a significant part of the history of the American people. But the importance of such properties for Indian people is that they are sacred.

In several important instances, lands sacred to particular tribes have been determined eligible for the National Register, but in one such case the ultimate result was a U.S. Supreme Court decision that hurt and insulted Indians. The Court held in *Lyng v. Northwest Indian Cemetery Protective Association*[44] that the First Amendment right to freedom of religion simply does not include Indian people whose religions require the performance of ceremonies at sacred lands owned by the federal government. In a dissenting opinion, Justice William Brennan described the Court's result as "cruelly surreal," noting that even though the majority opinion accepted as a premise that the challenged government action would "virtually destroy" the tribal religion, the Court nevertheless held that the government action was not a "burden" on religion.[45] In *Lyng* the Section 106 process produced a record that supported the Indians' claim of infringement on religious freedom, but in the wake of the Court's decision, Indian people have set legislative priorities on matters other than improving the Section 106 process.

In response to the *Lyng* decision, a broad coalition of tribes and Indian organizations has been working for comprehensive amendments to the American Indian Religious Freedom Act to establish statutory rights comparable to the constitutional rights that other citizens enjoy. Whether or not this legislative effort is ultimately successful, Indian people are likely to continue to view the National Register program as being of secondary importance in the preservation of lands that have sacred importance to tribes. Just how important the National Register program ultimately becomes will depend, in large part, on the extent to which non-Indian people in the historic preservation community convince Indian people that the National Register program can indeed help protect sacred lands.

One way to build some bridges between Indians and non-Indian preservationists is for preservationists to help Indians protect and gain access to specific sacred lands. Preservationists can help, in part, by persuading government officials that it can be consistent with other important public interests for sacred lands under government ownership to be protected from destructive resource extraction and other development activities and for Indian people to have access to these lands to carry on religious practices. As a matter of public policy, we simply must be able to determine that it is in the public interest for traditional Indians to have access to public lands in order to "pray for the planet or for other people and other forms of life in the manner required by their religion."[46]

TOWARD A FULL PARTNERSHIP

The dominant American society is generally not well informed about the histories of American Indian people. The popular culture of the American frontier deals with Indians with varying degrees of authenticity, and those images and stereotypes of Indians are part of the American consciousness. Over the centuries of contact with Euro-Americans, tribal cultures have changed, in response to government policies, environmental changes caused by government policies, and a variety of other factors. Some degree of awareness of the history of federal Indian policies is necessary to appreciate the range of preservation issues that Indian communities face[47] and to appreciate Indian perspectives on American history. Knowledge of this historical context is also needed if the larger American society is to fully realize the potential enrichment that could result from full tribal partnership in the national historic preservation program. Over the next quarter century, as people of the dominant American society become better informed, stereotypes will be displaced with knowledge about particular tribes. Tribal participation in the national historic preservation program will help make this progress possible, and preservation professionals in state and federal agencies who interact with their tribal counterparts will also contribute to this progress. The long-overdue establishment of the National Museum of the American Indian will be a major factor in helping the dominant society overcome its ignorance, as the museum builds working relationships with tribal programs.

Indian people have shown a remarkable determination to remain distinct communities, and we have come to believe that we have a fundamental human right to exercise self-determination. As the people of the dominant society become reconciled to our insistence on self-determination, our tribal governments will finally be accorded widespread recognition as permanent features in the political landscape of North America. Over the next quarter century, the implementation of tribal amendments to the National Historic Preservation Act of 1966 will contribute to the acceptance of our permanence.

AMERICA'S RURAL HERITAGE

Samuel N. Stokes

IN 1966, WHEN *WITH HERITAGE SO RICH* WAS PUBLISHED, THE WHOLESALE DESTRUCTION OF HISTORIC BUILDINGS IN OUR CITIES WAS CENTRAL TO MANY PRESERVATIONISTS' CONCERNS AND GAVE THE BOOK ITS URBAN FOCUS. IN THAT ERA THERE PROBABLY WAS MORE DEMOLITION IN CITIES THAN IN THE COUNTRYSIDE—OR AT LEAST IT WAS MORE BLATANT. TODAY, ALTHOUGH WE CONTINUE TO LOSE SIGNIFICANT BUILDINGS IN CITIES, IT IS THE COUNTRYSIDE THAT IS AT GREATEST RISK.

America's rural areas have a tremendous wealth of historic resources: not just mansions but farmhouses, barns, one-room schoolhouses, mills, mine structures, and truss bridges, to mention but a few. And the cultural landscape, land shaped by generations of farmers and other rural residents, is as important a resource as the buildings. It includes New England pastures enclosed by stone walls, ranches in the foothills of the Rockies, pecan orchards in Louisiana, irrigated taro fields in Hawaii, and wheat fields in Washington's Palouse.

These buildings, structures, and landscapes are under siege almost everywhere from new development, changes in agricultural practice, and shifts in the economy. Historic resources give our rural communities their special identity. If they are to survive beyond museum walls and fenced-off parks, it will take concerted action by preservationists and their allies. During the next quarter century, preservationists must give the same attention to rural historic resources that they have given to urban landmarks since 1966.

Fortunately, Americans are beginning to realize the significance of their rural heritage, and they have devised some effective means of conserving that heritage. By drawing on the accomplishments of national, state, and local programs in protecting both historic resources and natural areas, we can make great strides in the 25 years to come. Our efforts will meet with success if

- preservationists generally, and state historic preservation offices specifically, increase their commitment to inventorying and documenting rural historic resources
- preservationists forge more alliances with those concerned with the protection of the natural environment and the viability of agriculture

- preservation supporters work with those promoting rural economic development and improved housing
- local governments and states enact strong legislation to protect historic resources and open space
- federal agencies give greater attention to mitigating the indirect effects of major federal actions on rural historic resources
- the National Park Service works with the states to protect outstanding landscapes beyond park boundaries

DOCUMENTING RURAL HISTORIC RESOURCES

Only after states and communities know the extent and significance of their historic resources will they be fully motivated to plan for their protection. Unfortunately, in many parts of the country, we are still losing historic resources faster than they can be documented. Local citizens, as well as architectural historians, should become involved in the inventory process. It is through helping document their resources that citizens in Oley, Pennsylvania, Lake City, Iowa, and other rural communities have become educated about those resources and committed to devising ways to protect them.

Since the passage of the National Historic Preservation Act in 1966, thousands of rural buildings, sites, and structures have been listed in the National Register of Historic Places. Rural historic properties, however, have been less well represented in the National Register than urban resources. Moreover, rural surveys have tended to concentrate on farmhouses and such other noteworthy buildings as granges, one-room schoolhouses, and churches. The surveys may include barns but usually leave out smaller agricultural structures and give little attention to landscape features.

There are several reasons why relatively few rural properties have been surveyed. Rural surveys are expensive, because the resources are so spread out. Also, rural areas tend to have a great variety of structures, particularly those associated with agriculture and the extraction of natural resources. And while settings of buildings are important in the city, they are of greater importance in the countryside, where the land itself gave rise to the wealth and particular needs that produced the structures. The mark people have left on the land is generally much more subtle and transitory than buildings. It can take considerable detective work to figure out how the land was used and what nonstructural features are of cultural significance.[1]

For thorough documentation of rural resources to take place, state historic preservation offices must aggressively encourage rural surveys and nominations to the National Register. Rural communities need assistance from preservation specialists who are sensitive to their history and concerns.

Each state should have at least one staff member who is expert in rural cultural resources. Such staff should have experience in reading the regional landscape, know how land in the state was used, understand the history of rural enterprise in the state, and be familiar with the uses of typical farm or ranch structures. The National Park Service could set standards for rural experts, as it does for other specialists, and assist with their training.

FORGING ALLIANCES

Over the past 25 years environmental, farm, and historic preservation organizations have increasingly recognized the interrelationships among natural areas, farmland, and historic resources. Many rural scenes incorporate both cultural and natural elements, important to both the historic preservationist and the environmentalist. For the preservationist, farmland and wooded hillsides, like the Vermont farm view that opens this essay, provide the setting for agricultural buildings and represent the historic source of the farm owners' livelihood: the fields allowed them to raise crops and pasture livestock; the forest provided lumber for construction, wood for the stove, habitat for game, and sap for maple sugar. For the lover of the natural environment, the farm is a welcome transition—and buffer—between the city and the forest. If these same buildings were in the midst of a subdivision, they would lose much of their cultural meaning and visual appeal.

National, state, and local preservation organizations working in rural areas in the past two decades have given new emphasis to the protection of land. For instance, the Cranbury Historical and Preservation Society in New Jersey, founded in 1967 to preserve historic buildings, has since the early 1980s broadened its concern to include the protection of farmland in the surrounding countryside. The National Trust for Historic Preservation established a rural program in 1979 to demonstrate what rural communities could do to protect both their historic and open space resources. In recent years this program has also encouraged cooperation between preservationists and those concerned with rural economic development.

This same period has seen a tremendous growth of nonprofit land trusts dedicated to preserving open space. Close to 900 have protected more than 2.7 million acres. Sometimes the land trusts have acquired property outright, although increasingly they have accepted donations of easements on properties that remain in private ownership but have restrictions on development in perpetuity.[2] Many of the regions protected, such as the California coast south of Monterey, where the Big Sur Land Trust has been active, include both natural and historic elements.

Surveys of rural resources require some detective work and should include features such as these hedgerows in Mecklenberg, New York.

Particularly encouraging during the past 20 years has been the establishment of new nonprofit organizations with broad agendas, encompassing historic preservation, natural areas protection, and farmland retention. The Piedmont Environmental Council, for example, was founded in 1972 to preserve the historic resources, farmland, and streams of northern Virginia. Another example is the Canal Corridor Association, established in 1982 to preserve and revitalize historic communities and landscapes along the Illinois and Michigan Canal. At the national level, the Conservation Fund, founded in 1985, has a wide range of programs. These include the protection of fresh-water ecosystems, the preservation of Civil War battlefields, and the conservation of greenways along trails and rivers that incorporate both natural and historic resources.

As more communities consider ways to protect the environment, they should be encouraged to establish broad-based organizations that address all of a community's land and building resources. Some preservation and conservation organizations have good reasons to focus more narrowly on what they do best: the Nature Conservancy's work to protect habitats for endangered species comes to mind. Yet a greater realization and stronger message that we are all ultimately working to protect the same larger environment would bring more public support to all of our causes.

WORKING WITH ECONOMIC AND HOUSING ACTIVISTS

Rural preservationists also should work with advocates for economic development and improved housing. This is particularly true in areas that are losing population, such as many rural counties of the Great Plains states. As farm incomes decline, owners frequently cannot afford to keep up farm buildings, many of which are deteriorating. Also, as farms are consolidated and farm populations decrease, farmsteads are abandoned. Too often, they are either left to deteriorate or are burned or bulldozed. Such patterns make the boarded-up stores of crossroads communities such as Lima, Montana (population 265), increasingly common. While a town of 2,500 may be able to support a high school, supermarket, bank, hardware store, garage, cafe, and variety store, it can be difficult for a town of 500 or fewer residents to compete with a mall located even 50 miles away.

It is challenging for historic preservationists to suggest preservation solutions for areas that are in economic decline, but it can be done. Some notable successes have occurred at both the local and national levels. Preservationists in Washakie County, Wyoming, have surveyed the county's rural historic buildings and persuaded the county assessors to reduce real estate taxes on unused historic agricultural buildings. In cooperation with *Successful Farming* magazine and agricultural engineers working for the Cooperative Extension Service, the National Trust in 1987 established the Barn Again program to advise farmers on how architecturally significant but underutilized farm buildings can be adapted for new agricultural uses. The Trust receives more than 400 inquiries a year about the program from interested farmers.[3]

Even small towns can prosper if they can draw customers from a wider area by promoting small-scale industry or by offering special services not otherwise available in the area. The historic character of a small town can be used to promote community identity and spark economic recovery. In Bonaparte, Iowa (population 489), the mayor and business leaders have promoted the town's historic buildings and marketed its tourist facilities. An organization of Bonaparte residents known as Township Stores, Inc., has purchased unused historic commercial buildings and successfully rehabilitated them for commercial use and housing.[4] The National Trust's Main Street program, which has demonstrated how historic preservation can promote economic development in larger towns, has recently started assisting Bonaparte and similar small towns.

Tourism has great potential in rural areas and can be used to promote preservation and economic development. Rural communities such as Bishop Hill, Illinois, Harrisville, New Hampshire, the Amana colonies in Iowa, and Rugby, Tennessee, have invested considerable funds in building restoration and now attract many visitors. Foreign visitors, for instance, having seen the sights of the big cities, are showing increased interest in visiting the "real" America—the rural communities written about by Twain, Faulkner, and others. Tourism, however, is not without its disadvantages. With their relatively small populations, historic rural areas such as California's Napa Valley can easily become overwhelmed with tourists, detracting from the quality of life for residents and visitors alike.

Federal agencies, which are the major source of funding for rural economic development and housing, could do much more to foster historic preservation. With the exception of the Community Development Block Grant Program, rural development assistance programs have done little to encourage the use of historic resources.[5] Farmers Home Administration officials, for instance, generally prefer to fund new housing rather than rehabilitate historic houses, often assuming—falsely—that it will be too expensive to meet rehabilitation standards. Preservationists must show federal housing officials and developers constructing federally assisted housing how historic buildings can be rehabilitated in a cost-effective manner.

The Cooperative Extension Service, which has a man-

Boarded-up stores and underused buildings in Lima, Montana, are typical of many rural areas experiencing population declines.

date to work in rural development and has agents in virtually every county in the United States, is in an excellent position to provide historic preservation assistance. A few Extension Service community-development specialists—in Searcy, Arkansas, and Manson, Iowa, for instance—have given historic preservation advice, but many more could do so. If the Extension Service were to provide encouragement, training, and publications on preservation to its agents, they could have a major impact on the revitalization of historic rural communities across the country.

Federal agencies could also promote historic preservation by choosing to locate their offices in historic buildings. All too few agencies have considered purchasing or leasing historic buildings when they need new space, as required by Section 110 of the 1966 National Historic Preservation Act. In rural county seats such as Jamestown, South Dakota, and Hope, Arkansas, the Department of Agriculture has missed opportunities to help preserve historic structures and revitalize downtowns. Rather than place their offices in available historic buildings, the department has built or leased new buildings on the outskirts of town. The Postal Service also often opts to build new structures on the edge of town, rather than rehabilitate downtown facilities. This practice only contributes to the erosion of the economy in the historic downtown.[6]

In the nonprofit sector, alliances between those concerned with housing needs and the environment hold exciting possibilities. One of the most innovative alliances is the Vermont Housing and Conservation Trust Fund, established in 1987. When advocates of affordable housing found themselves competing with state conservationists for state financial support, the two interest groups decided that they would fare better if they formed an alliance to lobby for a fund that would support both groups' goals. The fund is supported by state appropriations and a real estate transfer tax. Local organizations can apply for assistance in acquiring land for conservation, historic resources in need of protection, and buildings appropriate for affordable housing. In several cases the fund has been used to rehabilitate historic buildings to provide housing.

ENACTING LOCAL AND STATE LAWS

In areas that are gaining population, zoning and subdivision ordinances can be effective in protecting historic buildings by regulating local land use. Such ordinances have been of limited value, however, in protecting rural areas where large amounts of open space must be preserved to ensure profitable agriculture. In areas where the typical farm size is 100 acres or more, minimum lot sizes usually run from two to four acres. In a farming region it is almost impossible to preserve the historic character of the land—let alone profitable agriculture—with four-acre lots.

In some cases, zoning can contribute to sprawl and visual disharmony. In contrast to the situation in a farming region, in-town zoning regulations often require *larger* lots than those associated with historic houses already in the community. This makes it impossible to concentrate development in the way it was done historically, for example, in the compact New England village.[7] Similarly, subdivision ordinances

may require wider streets or greater setbacks than were traditional in a community, making it difficult to harmonize new housing with the old.

Cluster development is a technique that encourages developers to concentrate allowable development in those areas where it is most appropriate and to dedicate the remaining land to open space.[8] Applying the principles of cluster development may make it possible to hide houses from public view in a wooded or hilly landscape. In a flat prairie or desert environment, however, cluster development may have little effect on protecting views. Even when houses can be hidden, it is difficult to avoid their impact on a community's agricultural economy, roads, and services.

A transfer-of-development-rights (TDR) program expands the concept of cluster development: TDR allows owners in areas that the local government has designated for conservation, the "sending areas," to sell their development rights to owners of property in "receiving areas" where the local government has determined that development is appropriate. Although it is not a widely used technique, some jurisdictions—notably Montgomery County, Maryland— have found it useful. TDR has limitations, however, not the least of which is that there may be no appropriate receiving area within the political jurisdiction.

To protect rural resources, a fundamental shift is needed in how land use decisions are made. Generally, the burden of proof is on preservationists and environmentalists to demonstrate that a proposed development will harm the environment.[9] It should be up to the developer, however, to show that a project will not do harm. A few jurisdictions, such as Hardin County, Kentucky, have instituted "performance zoning." This approach allows developers a fairly free hand if they can prove that their plans will be consistent with the protection of the environment. Performance zoning can be complicated to administer and requires detailed data on the local environment. If properly implemented, performance zoning does hold promise because it should allow development only in those areas where it is appropriate.

Land use ordinances will continue to be vital in protecting rural historic resources, but they cannot do the job alone. State laws governing land use are increasingly necessary. According to land use experts Robert Healy and John Rosenberg, effective state land use policy should require local planning and land regulation, and give the state the power to review certain land use decisions, particularly those that affect more than one jurisdiction.[10] State land use legislation also should specifically mention the need to protect historic resources.

Florida, Georgia, Hawaii, Maine, New Jersey, Oregon, Rhode Island, Vermont, and Washington have state land use laws, and a handful of other states are considering such legislation.[11] In Oregon, under the provisions of the 1973 Land Conservation and Development Act, communities are required to prepare plans that protect critical resources and delineate urban growth boundaries. These plans must be consistent with state goals, and small-lot development generally must take place within the growth boundaries. In Vermont, Act 250, passed in 1970, requires that all subdivisions of more than 10 units, and most commercial development, be reviewed by a district environmental commission appointed by the governor. The commission can deny a permit if the proposed development will "have an undue adverse effect on the scenic or natural beauty of the area, esthetics, historic sites, or rare and irreplaceable natural areas." While state land use laws have helped avoid grossly inappropriate development, they have still allowed considerable construction to occur where it can damage historic resources, prime farmland, and environmentally sensitive areas.

To protect rural cultural resources and open space in areas that are gaining in population, we need more effective statewide protection programs and greater coordination of efforts by states. It is nearly impossible for rural political jurisdictions in high growth areas to protect the cultural landscape on their own. Such efforts invariably draw protests from local landowners who claim that they are being treated unfairly in comparison with those in neighboring, more lenient jurisdictions, and from developers and business people who complain that they are losing business to their competitors. If, however, the state sets equitable standards for land development throughout the state, developers are less likely to find fault. As long as their competitors must play by the same rules, no one obtains an unfair advantage. If some areas of a state cannot support further development, statewide TDR systems should be considered.

MITIGATING FEDERAL ACTIONS

While local governments and the states have the primary responsibility for protecting rural resources, the federal government has a role as well. Through its grant programs, technical assistance, and the issuance of permits, the federal government plays an enormous role in shaping the future of private rural lands. Virtually every rural community in America is affected by federal actions, including new highways, sewer lines, dams, licenses for coal mines, and advice on farming practices.

Section 106 of the 1966 National Historic Preservation Act requires federal agencies "to take into account the effect of the[ir] undertaking[s]" on historic resources. Federal agencies must consult with the Advisory Council on His-

toric Preservation and the state historic preservation offices before any undertaking involving sites listed in or eligible for the National Register of Historic Places. In recent years, federal agencies working in rural areas generally have complied with the regulations. In many cases, they have complied by avoiding historic resources.[12] Avoidance of archeological sites may be the best way to protect them: if the artifacts are buried and their location is not divulged, there is less chance that they will be looted. Avoidance, however, does not necessarily help historic buildings, many of which could benefit from federal funds for rehabilitation. For example, as mentioned earlier, many opportunities are missed to rehabilitate historic buildings for housing.

Useful as it has been in protecting rural historic resources from the direct effects of proposed federal actions, Section 106 has been much less effective in curbing indirect adverse effects, which can be enormous in rural areas. For instance, it may be possible to build new interstate highways in such a way as to minimize direct impacts on cultural resources within the right-of-way. Because such highways place cultural landscapes in range of city commuters and weekend visitors, many subdivisions and resort communities have been developed where they would not have been profitable before. The new development may have a devastating impact on historic farms and other rural landscapes, but this indirect effect rarely comes under Section 106 review. Federal grants for sewer construction can have similar indirect effects by making it possible to build new homes that would not otherwise have had access to sewers. The federal agencies responsible for the development, the Advisory Council on Historic Preservation, and the state historic preservation offices should give much more attention to indirect effects and prepare more specific guidelines for considering and dealing with them.

PROTECTING OUTSTANDING LANDSCAPES

The National Park Service, since its establishment in 1916, has had a special role in protecting outstanding natural and cultural resources. The agency currently manages 359 park units, 125 of which are primarily of historical significance. It is obviously impossible and undesirable, however, for the National Park Service, or the states and land trusts, to protect through ownership all outstanding resources, particularly those that derive a large measure of their interest from the fact that they are still lived in and worked in. Nor can all of these resources be adequately protected by local ordinances and state laws. To address the needs of such landscapes, the National Park Service is experimenting with the concept of "heritage areas."

Heritage areas are composed largely of resource-rich private property that is protected in a variety of ways. The areas are managed as partnership projects involving collaboration among the National Park Service, state and local governments, and nonprofit organizations. In the case of the Illinois and Michigan Canal, established in 1984, the National Park Service agreed to provide technical assistance and limited funding for heritage area management. Management is primarily the responsibility of a local commission, and land within the corridor is protected through state and local law.

The National Park Service is considering a legislative proposal to establish a procedure for creating more heritage areas. As envisioned, the legislation would permit states to propose new heritage areas that would then be reviewed by the National Park Service and approved by Congress. The states would commit to using their programs and authorities to protect land within heritage areas. The National Park Service would provide technical assistance, limited funding, and national recognition to approved projects. Land within a heritage area could be protected from adverse federal action much in the way that historic buildings and sites are protected by Section 106 of the 1966 National Historic Preservation Act. Within heritage area boundaries, nonprofit organizations could receive federal assistance for their conservation work, and landowners could qualify for income tax deductions or credits for protecting land and historic resources.

LARGE-SCALE STRATEGIES NEEDED

Achieving full protection for our rural historic resources will continue to take many strategies: federal, state, municipal, nonprofit, and for-profit. Most preservation activity will and should remain at the local level. No matter how effective their efforts have been, however, local governments and nonprofit organizations never believe that they have been fully successful in preserving the overall cultural landscape: their successes may be significant, but they are geographically limited. To protect large-scale landscapes and the historic buildings associated with them, we need large-scale strategies to complement the local ones.

Clearly, leadership and technical assistance are needed from the state and national levels. The Advisory Council on Historic Preservation, National Trust, National Park Service, and state historic preservation offices have urged greater protection of rural resources. Still, they and their national partners in the environmental community must make a more sustained institutional commitment of funds, staff, and publicity if we are ultimately to succeed in protecting our nation's rural heritage.

RETHINKING ECONOMIC VALUES

Donovan D. Rypkema

I N 1966 *WITH HERITAGE SO RICH* SCARCELY MADE MENTION OF ANY ECONOMIC CONSIDERATIONS OF HISTORIC PRESERVATION. CERTAINLY PHRASES LIKE "DEPRECIATION SCHEDULE," "PASSIVE ACTIVITY LOSS LIMITATION," "DIFFERENTIATED ASSESSMENT PROVISION," AND "TAX CREDIT PASS-THROUGH" STIRRED FEW MEN'S (OR WOMEN'S) SOULS OUTSIDE OF THE HOUSE WAYS AND MEANS COMMITTEE AND THE INSTITUTE OF CERTIFIED PUBLIC ACCOUNTANTS.

But over the last 25 years, the preservation movement has broadened and diversified, and the mention of historic preservation and dollars in the same sentence is no longer considered too crass for discussion in polite company. This sometimes grudging acceptance of the pecuniary possibilities of preservation is a result of four lessons that have been learned during this quarter century.

- There are far more important historic properties than can be used for museums
- There will never be sufficient public monies to undertake all of the historic preservation that ought to occur
- Historic preservation and economic development can be consistent and mutually beneficial public and private goals
- A historic preservation developer is not a contradiction in terms

Underlying these lessons is one basic axiom: historic preservation will not take place in the private sector on a sustained basis unless it makes economic sense. While that premise is accepted by most preservationists, it is not widely understood. Until there is a broadened understanding among preservationists and by developers (a point that will be returned to later), conflict between the two groups will persist and historic buildings will continue to be lost.

While there are certainly exceptions, capital is a fundamentally bias-free commodity. Capital moves to where there is money to be made. There is no better evidence of this economic principle than the federal rehabilitation tax credits. Beginning in 1981 when preservation was greatly tax advantaged, literally billions of dollars (a very small percentage of which, one supposes, came from "preservationists") were invested in historical rehabilitation. Even more quickly, when the tax code was changed in 1986, those

sources of investment capital dried up virtually overnight. It was not that less money was available; the money simply went elsewhere. Even when the nature of the investment was significantly constrained (by compliance with the Secretary of the Interior's Standards for Rehabilitation), private capital moved to historic preservation when it made economic sense to do so and away when it did not. For preservationists to insist on such investment when it does *not* make economic sense is neither rational public policy nor a recipe for broad-based, long-term support of preservation goals.

MAKING PRESERVATION MAKE SENSE

The question, then, is simple: how do we make historic preservation make economic sense? There are short, intermediate, and long-term answers to that question. A prerequisite to formulating those answers, however, is the acceptance of a four-part syllogism.
1. Historic preservation primarily involves buildings
2. Historic buildings are real estate, and real estate is a commodity
3. For a commodity to attract investment capital, it must have economic value
4. Therefore, to attract private investment to historic preservation, it is necessary first to create and then to enhance economic value

Preservationists often talk about the "value" of historic properties: the social value, cultural value, aesthetic value, urban context value, architectural value, historical value, the value of sense of place. In fact, one of the strongest arguments for preservation ought to be that a historic building has multiple layers of "value" to its community. Each of those types of "values" has its own attributes, many of which are identified elsewhere in this book.

Likewise, "economic value" has its attributes. These include the elements of value that are necessary for economic value to exist at all and forces of value that operate to enhance (or reduce) economic value. Both the elements of value and the forces of value must be reckoned with if historic preservation is to have sustainable economic value.

From where does economic value originate? For any commodity, including real estate, to have economic value, four characteristics must be in place: scarcity, utility, desire, and purchasing power. These are known as the elements of value. All four must be present (although likely in differing degrees) for any economic value to exist. Consider a historic building in this context. It certainly has scarcity. That is one of the primary reasons preservationists want the building saved. And at least in America the purchasing power exists. Capital is available—it is just being invested elsewhere.

What will most often be lacking in historic structures are utility and desire. Occasionally, the use for which the building was constructed (its utility) simply no longer exists. Unless and until a substitute use can be created, the building will not have economic value. Again, the absence of *any one* of the elements of value will preclude the existence of economic value for the property. More often there is a (perceived or real) diminished utility because the design, configuration, equipment, or amenities of an older structure differ from those of a contemporary building.

However, a major benefit of the amount of historic preservation activity over the past 25 years has been the demonstration that there is, in fact, an alternate use for virtually every kind of structure. Furthermore, good architects around the country have devised innovative ways to mitigate or overcome what might otherwise be defined as utility-diminishing design deficiencies of old buildings. Because these adaptive use success stories are so numerous and so widely dispersed geographically, preservationists often assume that this lesson has already been learned, at least by the design professionals. Unfortunately, that is not sufficiently the case. A recent letter opposing historic district designation written by an architect illustrates this point. The letter says that a structure's " . . . small rentable area and less than optimum conditions in the interior spaces (low ceilings, numerous posts and columns, few windows) does not bode well for the future of the building as a long-term investment." This statement says less about the historic building than about the lack of imagination of the architect. But it does not much matter if the lack of utility is real or imagined; if utility is perceived to be absent, the building will not have economic value.

There is an old saying in real estate that "more buildings are torn down than fell down." That has to be true to the magnitude of 1,000. Whenever a building is razed (whether or not it is a historic structure), that act is the manifestation of the owners' judgment that the land vacant is worth more than the land and building combined. The owner has concluded that the contributory economic value of the building is less than zero, at least to the extent of the demolition costs. In other words, the value of the vacant land plus the cost of demolition was calculated to be greater than the value of the property when it included the building.

Along with utility, desire is the element of value deemed absent from many historic structures. It is not sufficient that preservationists "desire" that the building be saved. That desire has to come from a broad segment of users of real estate in the marketplace. And this desire cannot be in the metaphysical abstract. It has to be expressed with a checkbook. When sufficient numbers of tenants declare a *preference* for

restored historic structures as opposed to new buildings, and when that declaration is reinforced with rental dollars, capital will flow from new buildings to old. By extension, when customers and clients vote for historic buildings with their purchases of goods and services, building owners and occupants will get the message.

In brief, then, scarcity already exists and purchasing power is available. For historic buildings to have economic value into the next century, it will be necessary for us to advance up the learning curve of building utility and to better communicate the lessons learned to design professionals, contractors, and developers. And it will be essential to spread the desire for rehabilitated historic structures beyond preservationists to building owners, owner-occupants, customers, and tenants.

ENHANCING THE RELATIVE VALUE

But it is rarely argued that historic buildings have no utility or that there is no desire in the marketplace for their use. Rather, the contention is that the economic value of these structures is less than the alternative. Sometimes that alternative is a new building; sometimes it is nothing at all. Thus the challenge is less the creation of some modicum of value than the enhancement of the relative economic value of historic properties so that they are economically competitive in the marketplace. This requires the application of the forces of value. In economics, the four forces that affect the value of a property are social, economic, political, and physical. If preservationists are going to methodically approach the economic value enhancement of historic properties, it has to be through the systematic application of these forces.

Existing incentives for historical rehabilitation investment can be categorized by these four forces. Federal tax credits and local low-interest loan pools are both uses of the economic force to affect value. Historic districts and local limitations on demolition represent the use of the political force of value. Educational outreach by preservationists to explain to the community the importance of historic structures is a use of the social force of value. Public improvements and updated infrastructure in historic districts are uses of the physical force to enhance the value of individual historic buildings.

But important historic structures continue to be lost. By definition, this means that the existing incentives for preservation are inadequate to raise the economic value of a historic structure to a competitive level with the alternative. New approaches must be tried. Here are some modest proposals, both short-term and long-term, that might be considered.

CHANGES IN PROPERTY ASSESSMENT PROCEDURES

This policy has been adopted in a few taxing jurisdictions. Local property taxes are a major cost of owning investment real estate. While there is a wide variation between one locale and another, annual property taxes generally run between 1.5 and 2.5 percent of the market value of a property. This typically represents somewhere between 10 and 18 percent of the gross annual revenues that a property generates.

In most jurisdictions, the methodology for tax assessment begins with the valuation of land "as if developed to its highest and best use." Here, highest and best use is defined as "the most profitable likely use to which a property may be placed." When there is strong demand and the zoning ordinance permits greater development intensity than is being used by an existing historic structure—for example, a two-story historic building sitting where a 10-story building would be permitted—the highest and best use value of the land will most likely be far greater than its existing use value. Without some financial mitigation, this means that the historic property will be significantly overtaxed in comparison to the alternative: a new building filling the zoning envelope. If, for example, property taxes on the land were $1 per square foot of permitted density, the historic structure might be paying five times the land taxes per square foot of building than a new structure.

Procedurally, a relatively simple change could be made by local taxing authorities. Land under historic buildings could be taxed based on how it *is* developed instead of how it *might be* developed. At least this would reduce the disincentive to maintain a lower development intensity than that permitted by the zoning ordinance.

DEMAND-SIDE INCENTIVES

Currently nearly every preservation incentive is directed to the supply side of the demand-supply equation. Federal tax credits, depreciation deductions, local tax abatements, rehabilitation grants, and low-interest loans are all geared to increasing and maintaining the supply of space in historic structures. Almost nothing is available to increase the demand for the space within those buildings. Yet it is the increase in the demand (or the reduction of competitive supply) that will ultimately increase the economic value of historic properties.

Perhaps it is time for Congress to consider tax credits for tenants of historic buildings. An annual tax credit of, say, 15 percent of the rent paid by a tenant in a historic building could substantially increase demand for that space.

Three incidental benefits would flow from this approach.

First, there are far more tenants than landlords. This incentive would spread tax advantages much more broadly. Second, this tax credit would compensate for any real or imagined reduced utility of the old building versus the new. Third, historic preservation as a public policy should not be narrowly defined only as saving old buildings. It ought to be used to encourage private reinvestment in areas appropriately targeted for public intervention: inner cities, small-town downtowns, old commercial neighborhoods. It is in these areas where the vast majority of America's nonresidential historic properties are located. But a rehabilitated empty building does not particularly add to an economic revitalization strategy in those areas; that building filled with tenants does. People and economic activity, not paint and plumbing fixtures, ultimately add economic value. Demand-side incentives would encourage *both* paint and economic activity.

CONSISTENT PUBLIC POLICY

The biggest success of preservationists in the last 25 years may be the fact that today every level of government pays at least lip service to the importance of historic preservation. Over the same period, but particularly in the past 10 years, the phrase "fiscal responsibility" has been the slogan not just of conservative Republicans but also of liberal Democrats and virtually everyone in between. And for good reason. In the next 25 years it is highly unlikely that any level of government—federal, state, or local—will have an excess of funds.

But there have been too few efforts to tie together historic preservation and fiscal responsibility. The federal government continues to build post offices at the edge of town, abandoning not only important historic structures but, equally important, the commercial neighborhoods of which the old post offices were important components. The Carter administration issued a directive that federal agencies give priority to historic structures when looking for additional office space. The evidence that any of them actually do that today is virtually nonexistent. Similarly, state governments continue to build new (and usually undistinguished) buildings to house public employees, when in the same communities important historic structures sit empty. Local governments are probably the worst offenders. Peripheral development is not only tolerated but often encouraged with significant public subsidies, all at the expense of historic buildings in the city's core. When municipal public agencies necessitate acquiring, by purchase or lease, addi-

tional real estate, rarely do local governments even consider historic buildings, let alone give them priority.

This countervailing public policy is fiscal irresponsibility at its greatest. No longer can any level of government afford to spend scarce public resources to serve only one purpose. When the public sector needs additional space, and historic buildings in the community are underused, these two needs should be addressed with one expenditure. The policy statement in favor of historic preservation is admirable, but unless it is followed with public occupancy of those same buildings, scarce tax dollars are being wasted.

CONTINUED ADAPTIVE USE LEARNING CURVE

Not every incentive for preservation requires the expenditure of public dollars. The marketplace usually responds creatively when given an opportunity. Among the most valuable economic incentives to historic preservation over the last two decades are the lessons learned by architects, structural engineers, contractors, and manufacturers about building rehabilitation. Examples include windows that are both consistent with the Secretary of the Interior's Standards and energy efficient; retrofitted heating, ventilation, and air-conditioning systems that do not adversely affect the architectural integrity of historic buildings; appropriate handicapped-access accommodation; and building insulation systems. Once developed, innovations in these and other areas have quickly become cost-effective alternatives to new construction.

But for design and construction innovations to occur, historic preservation has to occur. The mere existence of rehabilitation activity provides the marketplace the opportunity to develop its own incentives—cost-effective technologies—thereby enhancing the economic value of preservation.

As far as long-term proposals are concerned, the word "proposals" is probably a misnomer. What follows is not so much a list of suggestions for statutory amendments as it is a framework for altering the fundamental perspective from which we view real estate in general and historic property in particular.

UNDERSTANDING REAL ESTATE'S REAL VALUES

Consider first how most building owners' perceptions of the value of their property diverge from reality. Most property owners believe that it is the four walls and the roof that give their building value. The ego of ownership has created the

Opposite: Slender papyrus columns announce the entrance to the rehabilitated Barney Ford Building in Denver.

myth that the value of the asset somehow emerges from within the property boundaries. Nothing could be further from the truth. The value of real estate comes primarily from the investments others have made: taxpayers, other property owners, employers. Take away a community's sidewalks, streets, sewage disposal system, water plant, police protection, jobs, and people, and what is the value of any building? Virtually zero. The generation of economic value in real estate is largely external to the lot lines.

The owner is certainly entitled to a return on his or her investment. But the investment that others have made, allowing the building to have value at all, also merits a return. This is the economic justification for land use controls: zoning, subdivision ordinances, and historic districts. It is not an issue of property rights; it is a question of equity, fairness, and return on *everybody's* investment.

Another misguided view shared by many landowners is that land use controls represent the public sector's clash with the private sector. Wrong. The economic, physical, social, and political context within which a building exists gives it value. The economic purpose of land use controls is to create and maintain a context that sustains and reinforces the *composite* value of the area. While a well-drawn historic district ordinance, for example, may diminish the maximum value of any single property, it will enhance the cumulative sum of values within the area. The ordinance is not a case of the public versus the private sector; it is the communal economic benefit of *all* of the owners versus the economic windfall of a single owner.

This is a crucial concept to grasp because, unlike most other investments, buildings are interdependent assets. The quality, condition, maintenance, and management of nearby properties will have a direct effect on the value of a given building. And still most owners are afflicted with lot-line myopia. This viewpoint is bolstered by real estate appraisals that deal only with the quantification of the deed holder's share of the property's value. The return on the individual owner's investment comes from cash flow and proceeds when the property is sold. It is partly through land use controls that other investors—other building owners, the city, taxpayers—get their share of the return.

One other characteristic distinguishes real estate. Unlike other types of investments, real estate is imposed on others 24 hours a day, 365 days a year. Simple fairness demands that the public have some control over the nature of that imposition.

Until property owners—and bankers, appraisers, real estate brokers, and city officials—broaden their understanding of the source of the economic value of real estate and its interdependence as an asset, these inane and spurious debates about "what gives you the right to tell me what I can do with my property" will continue. Enlightenment in the near term is unlikely.

FEDERAL TAX TREATMENT

A second broad area to be addressed in the long term is the treatment of real estate in the federal tax code. For tax purposes, real estate is assigned a "depreciable life" (the period over which a building is presumed to have economic value) of 31.5 years at present. What a patently absurd assumption! And yet that begins to mold one's thinking; it makes the asset disposable. Depreciation is justified based on real estate's definition as a "wasting asset." Thus it becomes a wasted asset, razed generations before its physical life is over. Buildings are torn down not because their physical life is over but because their remaining economic life is deemed to be limited. The rebirth of economic life is reinvestment, not demolition.

This concept of real estate as Kleenex affects not only historic structures. It also reduces the quality of new buildings being built. Why spend the time and money to design and erect a structure to enable it to last 100 years, when its anticipated life is 31 ("and anyway, my accountant says I should sell it seven years from now")?

Capital-gains taxes likewise do a disservice to both historic structures and quality new buildings. If a developer builds a quality building with a long economic life, maintains it well, and therefore is able to sell it at a profit (and remember, if a given property has increased in value, its neighbors are economic beneficiaries), he or she is penalized with taxes. On the other hand, if the owner builds a cheap building and lets it decline through lack of maintenance, all at the expense of surrounding properties, he or she is rewarded by being permitted to deduct the losses. Furthermore, if the owner chooses to tear down a building, even though it may have considerable remaining value, both to the community and as an income-producing asset, he or she is entitled to take a tax deduction in the amount of the building's book value. The whole thing is backwards.

If Congress and the public are serious about fiscal responsibility, serious about the conservation of scarce resources, serious about inner-city revitalization, and serious about historic preservation, the tax code could be adjusted to more effectively support these goals:

■ Eliminate depreciation altogether so that real estate becomes a renewable capital asset, not a "wasting" one
■ Eliminate capital-gains taxes on the sale of real estate. This would encourage reinvestment and reward owners who erect and maintain quality buildings

- Eliminate the deductibility of capital losses on the sale of real estate. Again, reinvestment and maintenance would be encouraged, while vacancy, abandonment, and demolition by neglect would be discouraged. This would also stimulate building owners to have more concern for the context within which their building exists—that is, the neighborhood—and to take actions to reduce negative impacts on the area that could adversely affect their property's value
- Provide a reinvestment tax credit equal to the owner's ordinary tax rate. For example, an individual in the 28 percent tax bracket would receive a 28 percent tax credit for every dollar reinvested in an existing property. The rationale would be as follows: if, rather than spend your earnings, you reinvest them in a building, thereby extending its economic life and conserving resources, that portion of your income will not be taxed. For historic buildings, the Secretary of the Interior's Standards could be applied to this credit, as is now the case
- Eliminate all income taxes on earnings from buildings of, say, 100 years old or older. The basis of this policy would be that, after a century, the property has "paid its dues" and is entitled to a tax-free retirement. This last provision could be mirrored for property taxes on the local level

What would be the consequences of these actions? The incentive to tear down quality old buildings and replace them with cheap new ones would be greatly reduced. A strong motivation would be provided both to reinvest in existing buildings and to maintain them. Wider acknowledgment would be given to building interdependence, leading to greater cooperation among property owners for their mutual benefit. Private investment would take place where it is in the greatest public interest for it to occur: in central cities, in declining commercial neighborhoods, and in downtowns. Historic preservation would occur, not because of the granting of a specific tax-favored status, but because the entire tax code changed its focus.

What would be the cost of these actions to the federal treasury? That is a question that is certainly worthy of investigation. With the elimination of depreciation and the deductibility of capital losses, the effect could well be tax neutral. But the overall cost to society would certainly be less than it is currently.

AWARENESS OF PRESERVATION'S VALUE

The last of the long-term "proposals" is merely for heightened awareness on the part of city officials, bankers, investors, economic development advocates, real estate brokers, and others of another basic economic principle. In economics, it is the differentiation of a product that commands a monetary premium. Real estate is a commodity; our communities are also commodities. Our built environment and, particularly, our historic structures express better than anything else our diversity, our identity, our individuality, our differentiation. To homogenize our cities by demolishing historic buildings and replacing them with derivative architectural eunuchs is to sacrifice the economic premium our community and its investors are seeking. The economic value of historic preservation will be a foregone opportunity.

WHEN THE PRESENT BECOMES THE PAST

Richard Longstreth

T HE FEDERAL LEGISLATION OF 1966, WHICH TRANSFORMED HISTORIC PRESERVATION INTO A NATIONAL MOVEMENT, ALSO BORE RATHER OMINOUS IMPLICATIONS FOR THE TRADITIONAL CONCEPT OF PROGRESS. ALTHOUGH NOT DIRECTLY STATED, AN UNDERLYING RATIONALE FOR THE NATIONAL HISTORIC PRESERVATION ACT WAS THAT CONTEMPORARY ACHIEVEMENTS IN ARCHITECTURE, PLANNING, AND OTHER FIELDS THAT SHAPED THE BUILT ENVIRONMENT WERE INFERIOR TO THOSE OF THE PAST.

Regret over the loss of old buildings had been voiced in the United States since at least the mid-19th century, but that sentiment was generally subsumed by the belief that what replaced them would be "better" and indeed necessary if the nation was to advance. The properties that *were* preserved, through organized activity or otherwise, tended to lie outside the mainstream of development: in bypassed quarters of the city, in towns themselves bypassed, or in depressed rural areas. Historic resources in places considered prime targets for more intense, "improved" development stood little chance of survival.

The 1966 law was a benchmark not only because it reinforced the belief that more of the built environment should be preserved than traditionally had been the case, but also because it laid the groundwork for protecting many places that stood directly in the path of "progress." For the first time, a nationwide system of checks and balances was created to mitigate what were then major thrusts in development: highway programs, urban renewal, and subsidized housing. Thus preservation no longer had to be confined to peripheral areas; it could become a significant factor in planning for the future.

The rise of preservation as a proactive movement was fueled in part by the understanding that old things can continue to function in practical as well as culturally enriching ways. However, the impetus for protecting large segments of the past also was bolstered by a dislike for work of the present: shopping malls and commercial strips, new residential tracts and high-rise apartment complexes, office and industrial parks, and the ever more ambitious roadways that served all of them. Reacting both to modernist design and the very nature of decentralized development, preservationists often found widespread support for their assertions that contemporary building lacked the character, scale,

Designed by Louis Justement (1936–38), the Falkland Apartments outside Washington, D.C., have been assailed as nonhistoric.

variety, and even the sense of purpose possessed by the standard products of earlier generations.[1] New things were not rejected altogether, yet it was believed that stringent constraints were necessary if such work was to assume a respectable form in historic areas. Confidence in the new was tentative at best.

Twenty-five years later, of course, much of what was then seen in the present tense has begun to assume the aura of the past. From the perspective of commercial real estate investment, properties then new are now beyond their prime, if not completely outmoded. Institutional owners may take a similar view, particularly with buildings such as hospitals, which must adapt to fast-changing technologies. The residential subdivision that attracted young married couples in the early 1960s now houses people nearing retirement age or may even be host to a markedly different kind of population. Seldom does the landscape created during the post–World War II era still seem young. The changes that have occurred may be more a matter of perception than reality, but often the fabric itself has been altered in conspicuous ways, sometimes beyond the point of easy recognition.

Popular interest in the environment of the recent past is

thus, not surprisingly, on the ascent.[2] While the primary thrust of this phenomenon may be fueled by nostalgia, a concern for rethinking the substance rather than just resurrecting selected images of this legacy also is on the rise. Calls to address the issue are more frequent than they were even a decade ago and less subject to dismissal as eccentric offshoots of preservation. Campaigns have been launched in a number of communities to protect mid-20th-century buildings, even whole districts.[3] Much of the initiative comes from people in their late 30s and 40s who have witnessed the destruction or denaturing of work that they remember as new from childhood. For others who were infants or not even born in 1966, probing into the mid-20th century may seem as natural a course of action as protecting the work of earlier centuries.

Under the circumstances, no serious obstacles may arise to block the preservation movement from embracing the recent past; however, ample indication exists that this shift in outlook may remain outside the mainstream of practice for some time to come. Indifference, if not open hostility, to the mid-20th century could persist, paralleling attitudes that long festered toward the Victorian world. Like many

other people, preservationists are inclined to think of a work as "historic" when it not only differs from present tendencies in design, but also represents ones that were ostensibly better. The products of the recent past, on the other hand, tend to be seen simply as no longer new and are still tainted by association with a world that people would like to improve. Victorian development likewise was scorned as early as the late 19th century, when proponents of the academic and City Beautiful movements were certain that their own agenda in shaping the environment was far better. Several decades later, both eras were debunked by modernists who saw the previous 100 years as bestowing a legacy on the nation that was wrong in fundamental ways. Not until the 1950s, when the impact of modernism itself began to be questioned, did a concerted effort take form to protect work beyond the neoclassical period.

At present, many preservationists, young as well as not-so-young, view the recent past as an alien environment. For them, the vast landscape created during the mid-20th century seems antithetical to the places they seek to protect. The strength of these feelings runs deep, affecting the core of preservation policy and practice. The root question is thus whether the movement can succeed in turning serious attention to the kinds of work that it has ignored, even vehemently opposed. Can what has been cast as an affront to the senses, a blight on the landscape, become regarded as an inheritance worthy of protection? The matter is hardly a trivial one; it entails the capacity of preservation as a viable force in managing a major portion of the built environment—places that make up much of the world as we know it. If the movement is to meet this challenge, a number of changes must be undertaken, not just in routine activities, but in attitudes concerning what preservation is and the degree to which it can play an active role in shaping the future.

REMOVING TASTE FROM DECISIONS

Among the most fundamental changes for which there is an urgent need is the expunging of taste, or current aesthetic predilections, as a force in decision making. While taste is not an official criterion for listing historic properties, anyone who has worked in the preservation field knows that it is an underlying factor and may surface openly to influence the debate. Preservation has long been affected by contemporary aesthetic concerns, and although there is nothing wrong with people working to protect things they find appealing, this sentiment must not supplant professional judgment. Tastes vary; tastes change. Historical significance, which embraces tangible no less than intangible realms, must provide the basis for consistent, even-handed, and profes-

sionally valid evaluation.[4] Otherwise, strong arguments can be made against as well as for almost any cultural resource.

Matters of taste are usually not expressed as such; they tend to be coded in jargon or made implicit rather than explicit in statements. The disguise becomes much more thinly veiled, however, when the resources in question are considered recent. Then, taste may indeed emerge as the dominant force. In places where a distant past (by American standards) retains mythic proportions, even work from 1900 or 1910 can be seen as a lesser sequel to "old and historic" traditions, rendering the entire 20th century as an epilogue.[5] Where the 20th century is acknowledged as a more significant contributor to the past, nervousness may still exist toward all but the most purportedly stylish examples erected within the last 50 to 75 years. Initiatives undertaken in the Washington, D.C., metropolitan area over the last decade well illustrate such attitudes at play. Washington's local record in preserving work erected since 1930 is impressive; few communities have accomplished more in this realm.[6] Yet some of these efforts have entailed open conflict among preservationists, with results that have compromised the process. This problem is by no means unusual; it can occur anywhere unless responsible parties are frank in exposing subjective criticism for what it is and reaffirm historicity as the basis for evaluating work of all periods.

During the mid-1980s a grass-roots effort to secure landmark designation for the Falkland Apartments (1936–38), located just beyond the District of Columbia line in Montgomery County, Maryland, was assailed by a small legion of preservationists. The complex, it was maintained, was of debased design, with a trivialized use of Georgian motifs endemic to run-of-the-mill "suburban architecture" from the mid-20th century. This "ordinary" group of buildings was mere "public housing"; to consider it historically significant would undermine the true objectives of historic preservation. The facts that any form of housing may possess historical significance and that this complex was undertaken for middle-income households; that it was one of the first garden apartment projects realized under the Federal Housing Administration's insured mortgage program, which effectively injected the housing-reform concepts of Clarence Stein and Henry Wright into the marketplace; that it was much publicized in its day and influenced many subsequent endeavors nationwide—all appear to have eluded the professed experts.[7]

About a year later a similar assault was launched against Washington's Governor Shepherd apartment house (1938–39), an important work of a local architect, Joseph Abel, who gained national prominence for his integration of avant-garde design principles with the practical requirements of

multiple-unit housing. The thrust of the accusations had a familiar ring: the building was "ugly;" it was not a "pure" example of the International Style; Abel did "better" (that is, better-looking) buildings at that same time. Ignored were the significant place of this work in the emergence of modernism locally and elsewhere in the United States; the ingeniousness of its plan, drawing from recent work abroad to provide an unusual degree of spaciousness in efficiency units; and the scheme as a benchmark in the maturing approach of its architect.[8]

In both cases, historicity was given scant account by those arguing against designation. The past presented by them was not one founded on thorough research or a command of the particular subject; it was an assumed past, tinged heavily by personal taste. The assailants also conveniently ignored the applicable criteria, instead making comparisons with inter-nationally renowned work of the period. Had the demands for significance made on the Falkland Apartments been the actual ones required for landmark status in Montgomery County, it is doubtful whether *any* property could pass muster. Ironically, when considered from a national perspective, the complex ranks among the most significant properties in the county, but arriving at this assessment necessitates more than connoisseurship.

The subject of 1930s apartment buildings may be considered "safer" than it was a half dozen years ago as the work is now more than 50 years old, but the problem of taste remains acute for properties of more recent vintage when a constructive precedent has yet to be established in the field. Major monuments of the post–World War II era—a Lever House or Dulles Airport—are accepted by the preservation community in large part because of the enormous amount

The razed Governor Shepherd apartments (1938–39), Washington, D.C., were viewed as an impure example of the International Style.

Top: The 1932 Ford Motor assembly plant in Alexandria, Virginia, was considered inconsequential and ripe for extensive remodeling.
Above: A campaign to save buildings such as the Burlington Federal Savings and Loan Association (1958) in Burlington, Vermont, is rare.

of acclaim they have received.[9] Likewise, key structures of the space program are of such obvious importance to events of the past several decades that it is impossible to dispute their historical merits.[10] An occasional roadside building of a type now so rare that it might as well be a survival from ancient Rome also can elicit sympathy. However, most representative work of the same period exists beyond the threshold of knowledge or concern. The campaign to save a much less exotic design such as the Vermont National Bank's Burlington office (1958) is extremely rare.[11] For most preservationists, such buildings simply are not thought of in historical

terms, but rather as the sort of thing that led to creating historic districts in the first place—an intrusive, discordant legacy that the movement has stood stalwartly against.

Even when properties of the recent past receive protection—more often as contributing parts of a historic district than as individual landmarks—changes may be allowed that would never be tolerated in older buildings. In Alexandria, Virginia, local, state, and federal preservation agencies repeatedly snubbed efforts to prevent an extensive remodeling of a 1932 Ford Motor Company plant designed by Albert Kahn, who ranks among the most distinguished

architects of industrial buildings to have practiced in the United States. The building's rarity as an intact example of his work from the period on the East Coast, combined with the protective covenants established when it was transferred from federal to private ownership, should have assured a safe future for this contributing property to Alexandria's historic district. Furthermore, the proposed new project not only reduced the original to facadism-in-the-round, but also included condominiums rising high above the parapet that were so incompatible in character it seemed unlikely the design would gain approval. Yet representatives of the organizations involved made it quite clear that they considered the matter inconsequential. Dubious claims that the building had lost its integrity were later substituted by assertions that it was not a significant contributor to the heritage of Alexandria or Virginia.[12] Such condescension toward the recent past is commonplace. Often there is no controversy; the fact that a double standard is employed and that a historic resource is trivialized beyond recognition may not even enter the minds of preservationists.

IMPROVING SCHOLARSHIP

Equally important and closely related to the matter of taste is the need to improve the role of scholarship in preservation. When sound historiographic practices are adequately emphasized, the question of significance is seldom difficult to resolve. But as taste has long been an undercurrent in preservation, so scholarship has generally been accorded marginal support. Decision makers in the field often view historical research and analysis as a hurdle through which the process must pass rather than a vital and dynamic engine of the process itself.

Probably more by accident than design, preservation did emerge as a vehicle for discovery when hundreds of jobs were created as an outgrowth of the 1966 act. Many of these positions were taken by young scholars who believed that much of what was worth saving had been ignored by academe as well as by their elders in the field. By the late 1970s preservation had become an important contributor to understanding the history of America's built environment, based on the serious study of previously neglected subjects and new methods developed to analyze them.[13] In this way, the movement began to have an impact on academia as well as the public arena. Preservationists' initiatives changed how people thought about the world around them.

During the last decade, however, preservation has lost its drive as a stimulus to learning more about the built environment. Despite the emphasis the National Park Service

has given to "context"—an elementary part of historiographic method—survey projects tend to focus on the gathering of data rather than on its substantive interpretation. The mood among many preservationists has become increasingly skeptical and reactive toward types of historic resources that are not well recognized. Supplanting original research, the printed word has been relied on to codify what (and, by implication, what should not) be protected. Publications on the built environment are thus used less as a stimulus to further study than as a substitute.

Similarly, preservationists are often nervous about scholarship in progress because they lack the judgmental base to determine its merits on their own. These circumstances are especially detrimental to saving resources of the recent past because so much research remains to be done in this realm. The need for thorough research is unquestionable, but the passive mode of waiting for others to prepare the way is unwarranted. We still have enormous gaps in our knowledge of work from all periods. The fact that scholarly literature on 19th-century retail facilities, for example, is meager has not prevented campaigns to document and protect hundreds of them nationwide. Claims that preservationists must be told what to preserve, that they are incapable of determining historical significance without some formularized recipe, erode the field's credibility.[14] Had the movement been characterized by such timid attitudes a quarter century ago, it never would have amounted to much of consequence.

SEEING HISTORY AS A CONTINUUM

Another argument often raised against directing preservation effort toward the mainstream of the recent past is that insufficient time has elapsed to form a truly historical perspective. Such thinking ignores the fact that scholars of the built environment have increasingly focused on phenomena of the postwar years.[15] In the pursuit of understanding a subject, it is pointless to quibble over time frames. History is a continuum; it has no end. The issue is not when something becomes "historic," but instead when an adequate historical perspective can be gained on a particular kind of phenomenon. If the topic entails patterns or attitudes that are sufficiently different from those now common, it can be analyzed as a thing of the past.

The threshold of historicity can differ with the work in question. For example, it was not difficult to prepare a landmark nomination for architect I. M. Pei's Third Church of Christ, Scientist (1969–71) in Washington, D.C., primarily on the basis of its formal design qualities, for both thinking and practice in that realm of architecture have changed

markedly since.[16] For the historian, the particulars of inquiry always vary with the subject at hand. Each aspect of the investigation process, from the kinds of questions posed to the analysis of material gathered, should be framed accordingly. But such specific adjustments do not alter the fundamentals of technique. To the contrary, examining the recent past should be guided by the same basic historiographic methods used to study earlier periods.[17]

IMPROVING MANAGEMENT ATTITUDES

Even if scholarship supplants taste, much of preservation's potential to protect the recent past will go unrealized unless there is an equally emphatic shift in attitudes toward management. The more widespread an activity preservation becomes, the more numerous and diverse are the parties involved, the more complex the problems and the greater the competition among initiatives themselves. All these factors make sound management practices imperative for setting and maintaining standards, establishing priorities, disseminating information, and coordinating efforts. Assuming these responsibilities is important not just for government agencies, but for private-sector groups as well if broad-based programs are to succeed.

But management also has become an excuse for passivity. Many preservationists in the public sector, at least, have come to believe that all of the major challenges in preservation have been successfully met. The role of the bureaucrat, in other words, is no longer to launch major new initiatives, but to maintain current ones. From this viewpoint, preservation can rapidly devolve from an opportunity to a task: the more numerous the historic resources, the greater that task. The fact that so much of the built environment dates from the mid-20th century makes the challenge of documenting, assessing, and taking steps to protect it seem a chore in some official circles. The unstated, but emphatic, reluctance of at least one state preservation office to consider nominations to the National Register of Historic Places of almost anything from the 20th century may be extreme, but it is symptomatic of an outlook found in many other quarters as well.

If the role of management in preservation is to remain purposeful, it must be directed anew toward expanding the base of activity. The field has only begun to make more inroads on the policies and practices that affect the environment. Among the numerous challenges in this sphere, none is as pressing as the need to broaden the conservation of historic resources before they have to be retrieved from states of neglect and decay. Much more can be saved by this method, but the most compelling reason

is to foster preservation's role as a basic instrument of planning that affects places that are an integral part of many people's lives. Preservation must become seen generally as a natural course of action to protect the valued qualities of landscapes that most people may take for granted but that will not maintain their desirable qualities without a concerted effort and that cannot be replaced in kind, should they be lost.

PLANNING AHEAD FOR CHANGE

The imperative to expand the role of planning in preservation is nowhere more apparent than in dealing effectively with the recent past. As places dating from the mid-20th century begin to be studied in earnest, many of them will indeed prove historically significant. Among the definitive components of the decentralized, low-density landscape created during this period are the freestanding, single-family house and garden apartment complex, surrounded by open space to a degree never before attained in major metropolitan areas. The pattern is urban in its extent, complexity, and scope of infrastructure, yet it also embodies notions of individual independence in density and spatial freedom that are traditional to small towns and rural areas. Never before had such a great segment of society been able to partake of this kind of environment, nor will it again in the foreseeable future. Increases in land values, construction costs, and population size have led to a markedly denser use of land for new residential development in recent decades. Although it was once fashionable to deride mid-20th-century housing tracts, the time has come to take serious account of this legacy from a historical perspective and to understand the importance of both its physical and social attributes.

The urgency of addressing such matters is apparent when one remembers that most residential areas remain in their prime during the first and often the second generation of occupancy; that is, for somewhere between 30 to 60 years. Thereafter, confidence begins to lessen, and decline eventually assumes concrete forms. This cycle is not necessary; it does not take place in tracts that were carefully planned, with covenants governing use and appearance.[18] Nor does decline occur in places that have instituted comparable measures at a later date. Historic district designation falls within the latter category; its effectiveness lies in generating confidence that the desired qualities of the neighborhood will remain and in enabling residents to take an active part in the process of guiding future change. The belief that ongoing investment in property is warranted, coupled with supportive policies from local governments and lending institutions, can affect the future of residential areas more than any other factor.

Since the proliferation of historic district designations began in the 1960s, the process has demonstrated how effective it can be as a safeguard against neighborhood decline. Indeed, the surge can be attributed largely to the realization among residents that historical designation can give them more of a voice in shaping the future of where they live than almost any other governmental mechanism. But while numerically impressive, the gains encompass only a tiny percentage of the nation's eligible housing stock. Vast areas developed since the mid-19th century lie unprotected, and many of them have experienced needless decay. Many more, including tracts built after World War II, will follow suit over the next 25 years if preservationists do not broaden their sights.[19] To achieve this goal, the preservation process should be emphasized as an incentive for continued investment, not as a set of unwarranted, time-consuming restrictions. While the history of a neighborhood can engage the interest of many residents, a participatory plan to safeguard the things they value spurs concrete action.

MAINTAINING BUSINESS DISTRICTS

The future of residential areas is closely linked to that of the commercial precincts developed to serve them. Decline in a neighborhood business district may not at first have a measurably adverse impact on the property values of nearby dwellings, but the effect will be felt in time and may become devastating. Despite this integral relationship, the record for long-term performance of outlying commercial districts is poor. Places that maintain their prime as trade magnets for more than 25 years are the exception. Far more commonly, the district is upstaged by newer developments. After two or three decades, the stores that gave the district its initial draw begin to relocate. Strong alternative plans for commercial use are seldom devised; maintenance levels are lowered; cheap, expedient remodeling becomes the norm.

Although centers of trade situated near the periphery of urban settlement were created as early as the colonial period, most outlying business districts date from the 20th century. The number of such places has increased enormously since 1920, as has the range of their size, configuration, character, and specialized functions. Many examples are modest in scope, serving the routines of a localized audience. At the other end of the spectrum are business centers that afford a full range of goods and services: places intended to rival the function of the urban core began to emerge after World War I and include Jamaica on Long Island, Upper Darby near Philadelphia, the Uptown district in Chicago, and Hollywood in Los Angeles. Since that time, the collective importance of outlying business districts relative to the downtown area has steadily risen to the point where they are overwhelmingly dominant. Yet the fact that, unlike the traditional urban center, few outlying districts experience substantive renewal carries ominous implications for the stabil-

Between the late 1930s and the early 1950s, Clarendon, Virginia, became a primary business district in the Washington, D.C., area.

ity of metropolitan areas as a whole. Most places of this kind created during the interwar decades or even the immediate post–World War II years have experienced substantial decline. There is good reason to fear that, a quarter century hence, many outlying centers that are currently flourishing will be of marginal value, if they continue to exist at all.[20]

Numerous initiatives have been launched in recent decades to revitalize outlying business centers. Often the strategy has focused on cosmetics, to little effect. In other cases, measures taken have been more profound, yet still failed as remedies. By the mid-1970s, for example, Clarendon Center, which had emerged only a quarter century earlier as one of the primary business districts in northern Virginia, was considered outmoded—a place no longer able to compete with newer regional shopping malls. Demolition of existing structures began in 1974, first for a Metro subway station, later for the more intense, profitable development the rapid transit line was predicted to stimulate. Little now remains of the old district, and relatively little has been built in its stead. The idea that Clarendon could be preserved, with new specialized shopping facilities in place of its original ones, was summarily dismissed by local officials.[21]

The loss of places such as Clarendon is as unnecessary as it is unfortunate, for preservation has demonstrated that commercial districts can far outlast their normal life spans. Since it was established in 1980 the National Trust's Main Street program has given new vitality to more than 750 business centers and has provided an indirect model for many hundreds more. The program has succeeded both in bolstering economically fragile districts and in reviving ones that conventional wisdom would have dismissed as hopeless. Indeed, as a strategy for revitalization, the program stands as the single most effective one that has been applied to existing retail centers in the United States since the Depression. To date, most of the communities targeted have been rural centers of comparatively modest size; only a handful of outlying districts in larger communities have benefited.[22]

The need for a major initiative to stabilize and reinvigorate outlying business centers grows continually as these places account for an ever greater percentage of the nation's aging commercial fabric. The Main Street program affords an important model, not only in economic terms, but also in underscoring the importance of history rather than taste as a guide. Many places that have participated in the program would never qualify under the canons of beauty that once pervaded the preservation field. Fifty years ago the term "main street" was used as a synonym for visual chaos, tawdriness, stagnation, and even decay.[23] Preservationists must work just as hard now to overcome stereotyped views of mid-20th-century arterial development, to explore how many of these places can and should stay economically sound on a long-term basis, and to understand their historical significance in the context of urban decentralization.[24]

Today Clarendon shows the gradual destruction of its physical fabric. County planners rejected its preservation as a means of renewal.

Mid-20th-century arterials such as the Burbank Theatre and store group in San Jose, California, can become economically sound again.

TAKING AN INCLUSIVE APPROACH

To support more than an occasional foray into the mid-20th century, preservationists must begin to look at the landscapes involved and to collect information about them in a systematic and comprehensive way. Many state and locally sponsored surveys are hopelessly out of date; often only a small part of the 20th century is covered; sometimes it is not included at all. Survey programs would do well to follow the example of the Rhode Island Historical Preservation Commission, which sets no time limits on the detailed and inclusive surveys it has been conducting, community by community, for more than 15 years.[25] The task ahead is enormous for those parties that have insisted that "history" begins only 50, 75, or 100 years ago. But no state can afford to defer the matter; a major new initiative is needed now no less than after passage of the 1966 act.

Another important and much more quickly achievable step is to eliminate denoting a period of significance for protection purposes in historic districts. Such a change should not undermine the recognition of a given time span that may be the seminal one for a district; it would, however, recognize the fact that significant work seldom ceased altogether in subsequent years. Thus proposals made for modifications to *all* properties would be evaluated on a consistent basis, irrespective of date. A 1960s storefront in a commercial area developed primarily between 1880 and 1915 would be assessed on its *own* intrinsic merits—that is, as it relates to its own type and period as well as to the local context—rather than being automatically dismissed as a noncontributing entity. The process would not, of course, be aimed at saving every shred of fabric. The underlying

concern would remain the character of the district as a whole. At the same time, the method would be less formulaic and recognize that designs that diverge from the dominant patterns can nonetheless be enhancing.[26]

Under current practice, historic districts tend to become artificially homogeneous over time, with many small pieces that are not of the "right" period removed or altered beyond recognition. Sometimes, even important individual works are lost in this way. The Penn Theatre (1935), designed by the renowned New York firm of John Eberson and long a major landmark in Washington's Capitol Hill neighborhood, was demolished except for fragments of its facade simply because the historic district's period of significance was determined to have ended at 1920.[27] The remains have been denatured to the point where it is difficult to decipher much about their past or even that they are of the past. The collective result of this and other nearby projects is that a whole era in the historic district's past is being expunged, as if it never existed.

The 50-year provision of the National Register is much less crucial to change because newer properties can be nominated when they possess exceptional significance at the *local level*. This provision can entail a broad spectrum of properties and be quite inclusive: the largest, most acclaimed middle-income housing tract erected during the post–World War II era in the vicinity of Long Beach, California; a 1960 bank that was the first and, for a long time, the only tall commercial building built after 1930 in Fort Smith, Arkansas; an open-air frozen-custard stand that is the last surviving example of its type in Fairfax County, Virginia.[28]

Far more important is revising those local practices that

Deemed a noncontributing property in its historic district, the Penn Theatre was reduced to a facade in a 1983–85 renovation project.

give preservation its protective muscle. In some communities, little from the 20th century meets the criteria of the local preservation ordinance, just by virtue of age. In many other places, the rules are somewhat more flexible, but focusing on 20th-century resources is openly discouraged. Such a posture can be tantamount to aggression, creating greater mischief than benign neglect. The fundamental problem with any demarcation line—100, 50, or fewer years—is that it encourages people to conceive history as something not linked to the present. The framework functions as a conceptual wedge as well as a proverbial excuse for not thinking beyond designated realms.

If the recent past can be effectively addressed by preservation, the central issue remains whether the will exists to do so. The matter extends well beyond the logistics of adding yet more to the purview of an already expansive program, for the resistance to the recent past indeed appears grounded in more fundamental attitudes toward the 20th century and preservation's role in contemporary life. The mission of providing a sane, rational means to protect large parts of the built environment must be reinvigorated. If preservation has lost its nerve, if most of the 20th century

remains ignored or disparaged, then the movement will lose ever more touch with the physical world and the people who live in it. The aim of maintaining a sense of continuity with the past will become ever less attainable, for the past as defined by preservation will become an increasingly limited and distant thing. The shift could eventually result in the insulated antiquarianism that defined most preservation efforts a century ago.

What is needed instead is an integrative, holistic view of the past, one that looks with equal seriousness at all periods, phases, episodes, and phenomena that have ceased their currency. If the record of preservation gives cause for concern in this regard, it also affords glimmers of hope. Since 1966 the scope of things preserved has expanded dramatically. There is no reason why the momentum cannot be renewed if preservationists focus more on understanding the built environment, on fostering a sense of continuity with the work of previous generations, and on a more comprehensive approach to planning. The next quarter century, indeed the next decade, will be a crucial one for what is saved and for the role this enterprise plays in our lives, as more and more of the present becomes the past.

Below: The last open-air frozen custard stand (1950) in Fairfax County, Virginia, designed by Mayhew W. Seiss, is a rare survivor of its type.
Opposite: Prominent modern buildings such as the First Federal Savings Building (1960) in Fort Smith, Arkansas, are often overlooked.

WHEN THE PRESENT BECOMES THE PAST

EMERGING COMPUTER TECHNOLOGY

Jeanne Mansell Strong

IMAGINE THAT YOU ARE SITTING IN YOUR HOME OR OFFICE. YOU PLACE AN ELECTRONIC BAND ON YOUR HEAD AND IMMEDIATELY YOU ARE THRUST INTO THE PAST. SUDDENLY YOU ARE A VISITOR AT MOUNT VERNON, AND MARTHA AND GEORGE WASHINGTON GUIDE YOU ON A TOUR OF THEIR HOME. HAVE YOU ENTERED A TIME MACHINE? NO, BUT YOU HAVE ENTERED CYBERSPACE.

Your computer has assisted you in experiencing the newest technology involving a reality-altering computer environment. You appear to become a part of the scene you are viewing. You can actually move through the space, move items in the scene, and even interact with holographic images of historical figures that have been programmed to react as we would expect them to act. Cyberspace, virtual space, or artificial reality are computer technologies that are actually in early stages of development today and that we can realistically expect to have applications for historic preservation and heritage education in the future.

The world today is in the midst of a technological revolution of the magnitude of the Industrial Revolution—we are living in the Computer Age or the Information Age, in which the advancements in information handling are revolutionary. The enormous capabilities of today's computers were undreamed of when scientists developed the first electronic computers in the 1940s. Early relics from the birth of

the Computer Age today look to us like electronic dinosaurs or a set from *Flash Gordon*. The 18,000 tubes required to drive machines that weighed more than 30 tons have today been replaced by tiny printed circuit chips in a laptop computer no larger than a notebook.

Even 10 years ago, most people in this country could not imagine that they would use computers in shopping malls or an on-line terminal in their home to do their banking. They could not imagine that, soon, typewriters would become almost passé. The idea that business travelers could carry with them a notebook that could compute millions of pieces of information at great speeds was futuristic. Today these are common occurrences.

As the attempted military coup in the Soviet Union began to unfold in August 1991, Boris Yeltsin used a personal computer in his office to provide him access to the citizens of Russia and the world. He began communicating with the thousands of confused Russians waiting in the streets and

passed along information to millions of interested people all over the world. Using his small personal computer combined with a telephone and modem, Yeltsin was able to rally the support needed to put down the would-be coup. A personal computer will go down in history as an important tool used to defeat hard-line Communists' attempt to reclaim the Soviet Union's former power base.

STATE-OF-THE-ART INFORMATION MANAGERS

The power of the computer is difficult to comprehend at times. Many of us are caught in a technology warp and feel uneasy about our lack of understanding of computers and how they work. Professionals and volunteers in historic preservation have been even slower than those in many other disciplines in exploring and adopting new technologies. What was once a very complex specialty, understood by only a handful of computer wizards, is becoming more easily accessible to the average person. One no longer needs an advanced degree in computer science, engineering, or mathematics to understand and use a computer. Preservationists can and will be trained to apply existing and future technology to assist in the preservation of our built environment.

What might this great period in human advancement have to do with the preservation of historic resources? Predicting technology's impact and direction in the next century is difficult, but already computers can assist preservation efforts at all levels. Computers can help preservationists better handle the ever increasing amounts of data on historic structures, districts, sites, objects, and buildings. Computers are state-of-the-art information managers, and preservationists collect and use vast amounts of information. Many computer advancements can be used by preservationists immediately.

Three factors determine how widely computer technology is used by preservation organizations today: the machines' cost and availability, their programs' cost and availability, and the need for trained operators. Computers today are affordable—a rare example of an area in which prices seem to be decreasing rather than increasing. Inexpensive machines are capable of doing great amounts of work. The proliferation of the personal computer has put powerful and advanced technology within the reach of almost everyone.

Management of information is becoming an ever increasing concern for historic preservation. Data have been collected by the National Park Service on hundreds of thousands of structures, districts, sites, objects, and buildings, and this number increases daily. Organizations such as the National Trust for Historic Preservation and the National Park Service manage many of their preservation programs and much of their data by computer, often using programs specifically de-signed for the use of their organization. These programs frequently do not allow others with different systems to share information. A goal of the preservation network should be to adopt compatible systems that national, state, regional, and local organizations could access. Local organizations attempting to pass preservation ordinances, for example, might be able to get national information concerning the economic benefits of local ordinances by accessing a national database. In return, a national organization could receive data from local organizations to update its numbers.

Many commercial software programs can be easily adopted for use in historic preservation. Thousands of packages are on the market, and more are introduced every day. Packaged software or prewritten programs are available to everyone, but software also can be written to address specific needs. Software is generally divided into three categories: operating systems, developmental software, and application software, such as for word processing, desktop publishing, and database management.

Today most large organizations already use word processing programs in their daily work, but small, local organizations, for the most part, do not have computers for even basic word processing. Investment in small computer systems and simple software, along with proper training, can assist local groups to better handle day-to-day communications. Available programs are easily learned and embraced by preservation professionals. The ease of converting these programs to formats used by other computers meets one major need of historic preservation: the ability to share information with different software users.

The decreased costs of personal computer systems have made desktop publishing available even to small organizations, bringing with it the ability to produce reports, brochures, and educational materials. Desktop publishing, one of the fastest-growing segments of personal computing, allows the user to write, design, lay out, and print many pieces for less cost and time than once needed. Publishing power is now available to almost any organization. Preservationists should realize, however, that high-quality products are the result of gifted designers, using desktop publishing as their tool—materials produced by desktop publishing are only as good as their designers. In today's world of slick Madison Avenue advertising, it is important to package information as attractively as possible. Budgetary constraints affecting most preservation organizations require that public information literature be kept reasonably inexpensive. When local historic preservation commissions make aesthetic decisions about their communities, poorly designed materials could undermine their credibility.

Programs that store and manipulate large amounts of data

are referred to as database-management programs. Such systems are software packages designed to store an integrated collection of data and facilitate access to it. Many database-management programs have been developed, and each has strengths in performing selected functions. One of the important aspects of a database-management program is the amount of information it accommodates and the speed with which it can be handled. Users should therefore choose a database-management system for its ease and speed of use.

If a database of historic properties is being established, the data files might be a list of all the properties within a historic district. The information pertaining to one property would be one record within the database. The individual pieces of information about each property, such as the owner's name or address or the roof type, would be contained in what is called a field. Within each record, comparable information must be entered in the same field. With a properly structured database, reports can be generated and data can be searched for specific relationships quickly and efficiently.

There are many advantages for preservationists to use databases. Storage of information in a database allows an organization to rearrange information entered in many categories. For example, the state of Georgia has implemented a tax incentive program for property owners who substantially rehabilitate historic properties. To notify the target audience, staff could send out a mailing to all property owners listed in their database as owning historic buildings in Georgia. A local nonprofit preservation organization could track membership information and generate renewal information using a database program.

Organizations such as the National Park Service and the National Trust already have established databases. State historic preservation offices are entering state survey data into computer programs. The goal of these organizations should be to share information with national, regional, and local organizations. The use of database software in historic preservation appears to be one of the most frequent and widely accepted applications.

COMPUTER IMAGING

Because much of preservation involves making decisions based on visual information, a software application that could be adopted to help in preservation decisions is computer imaging. Computer imaging involves the combination of two technologies: a computer painting or drawing program and videotaping. Paint programs are electronic tools that allow freehand drawing and painting on the screen combined with special effects. Imaging can be divided into two basic steps: images are first videotaped, then displayed on a computer monitor and altered using the paint program. The results of this manipulation of an image can be excellent but, as with any artistic endeavor, results are only as good as the operator or artist using the program.

An obvious application of this technology is to assist in evaluating the visual impact of changes to historic properties or districts. Proposed changes can be superimposed on an actual image of the historic resource so that the impact of a proposed change can be evaluated. Concerns such as proportion, setback, rhythm, and relationships can be evaluated before approval is given. Showing the impact of a nine-story building on a commercial district where four stories is the maximum existing height could lead to a decision that would disallow such an incongruous structure. Computer imaging also can be used to illustrate the visual impact of historically accurate renovations of commercial buildings for downtown revitalization efforts, as well as to show the impact of removing confusing signage and replacing poor graphics with signs that enhance a historic area.

Imaging centers with talented operators could be funded and available to small organizations at low, or no, cost. Images can be transmitted almost anywhere through telephone modems or possibly radio signals. Programs as sophisticated as these imaging programs were once available only to the largest organizations, but lower costs today allow use of this technology by practically any group. Communities all over the nation could tie into these imaging centers simply by having access to a telephone and personal computer.

GEOGRAPHIC INFORMATION SYSTEMS

Geographic information systems are software packages for the personal computer designed to store, enhance, and process information gathered through remote sensing and photogrammetry techniques. It is a tool that combines computerized mapping with database management, integrating graphic and nongraphic data. Maps are digitized or traced and encoded. Nongeographic data are linked to the graphic information. The capacity to sustain an interactive relationship between graphics and information is at the center of geographic information systems. The user must have a basic knowledge of mapping, planning, and database management to analyze and manipulate information with these systems.

Geographic information systems technology is an excellent planning tool, one that is being adopted by large agencies such as departments of transportation. By including historic properties on maps and then referring to resource data, new roads can be planned to minimize impact on identified historic resources. Local organizations such

as historic preservation commissions should explore any existing mapping systems to determine if historic properties should and could be included.

COMPUTER SIMULATION

Planning for change in historic preservation involves evaluating how society can continue to grow without destroying the special places that surround and nourish us. Computer simulation, a high-tech set of programs designed to help evaluate the impact of change, is under development at two universities: the University of California, Berkeley, and the New School for Social Research in New York City. The programs being researched may help communities visualize the impact of change in making land use decisions.

Simulation laboratories, using state-of-the-art computer graphics, are able to model three-dimensional representations of buildings, blocks, topography, open space, and transportation arteries. These models are being constructed to assist communities in designing and planning and also to help train future planning and design professionals. Models created using simulation technology will help planners prevent inappropriate changes to historic areas.

The institutions currently working with this technology are combining database software with sophisticated imaging programs to create comprehensive geographic information systems. These are used to prepare three-dimensional computer models of a city that combine visual data with nonvisual information such as census, environmental, infrastructure, and economic data. Photogrammetry technology is one of the tools used to collect data and assist in three-dimensional modeling. This technology allows topographical as well as structural information to be used as the basic data needed to build models of a surveyed area. Computer-built models can simulate options such as the effect on historic neighborhoods of road construction that may isolate one area from another. After the proposed road is allowed in the simulation, visual impact and economic ramifications can be projected. New locations can be tried as necessary to find a site with the fewest negative consequences.

The ability to relate and express nonvisual information in a visual way will change many of the established planning tools used today. Simulation will simplify complex perceptual and analytical problems. Planning decisions concerning historic resources will be assisted by helping people understand and focus on real choices. Data used to create computer models will be traditional survey information combined with social information such as census data and property assessments. Using information from these various sources will provide insight into both the social and the structural impact

of change. Decision makers can be assisted by using on-screen and videotaped "walk-throughs" of affected areas. They can see many scenarios, even hear the noise level of passing automobiles, and measure the pollution from the gasoline fumes. They can figure the cost of building in the area and determine any inherent difficulties in constructing in a specific topographic area. The complex interdependent nature of change can, and will, be better understood.

Simulation technology is ready for use today. It will make three-dimensional computer models, unified databases, computer simulation, and environmental assessment techniques future tools of planning agencies and historic preservation commissions. The ability of the computer to handle vast amounts of information will place planning at a new, higher level and enhance our decision-making process by enabling people to understand and focus their attention on real choices and real impacts.

BROADER APPLICATIONS

Future applications of computer technology to the preservation field may be even broader. Available technology could be used to provide assistance in completing forms for preservation tax incentives and nominations to the National Register of Historic Places. When consultants or planners prepare applications, direct access to national computer programs through modems could reduce the necessary review time. Review workloads of state historic preservation offices could be greatly reduced. Developers often have a great deal of money at stake, and speeding up the review process could provide an additional incentive for rehabilitation projects.

Video technology combined with computers could eventually change the way we survey and identify historic properties. A video image of a historic structure could be fed directly into a computer that has been equipped with a video capture board. A specialized software program could be designed to examine the image and then complete survey forms, making decisions as to style, form, and other required information. This use of computers would speed up the survey process by allowing completion of forms in the field, and a survey record could become available in a fraction of the time now required. The consistency of decisions and interpretation of sites would be better controlled. An accurate map could be entered into the program and the map location computerized. Pictures taken through computer-video technology could be printed directly onto the form, bypassing the need for negatives and prints. Computerized records of the surveys could be immediately available to local governments and agencies.

A simple software program could be designed to manage

the cyclic maintenance of historic properties. Maintenance that must be completed on a daily, weekly, monthly, yearly, or other basis could be planned on a calendar so that workers know exactly what chores should be completed daily. A comprehensive plan could avert costly repairs that result from deferred maintenance. Within the program, instructions for specific jobs or delicate adjustments could be stored and accessed by both workers and supervisors. This could cut down on the amount of time required to train employees and ensure a level of quality and consistency.

Several on-line interactive information systems such as CompuServe and Prodigy offer subscribers hundreds of services such as an encyclopedia and employment service. Preservation centers could join existing services or start their own service to provide public access to preservation, restoration, and heritage education. Through such a service, users could find an expert to answer a question, consult a list of professional crafts persons, or request videos on how to evaluate a property, regrout tile, or restore a historic building. Many existing services provide public bulletin boards where subscribers and experts from all over the country ask and answer questions. A preservation bulletin board could be established on existing services or on a new preservation interactive service. Issues and information concerning heritage education should also be incorporated into a preservation computer service.

Pseudohuman thinking computers like Hal in *2001: A Space Odyssey* do not exist today, but they may become tomorrow's realty. The human brain solves problems by trying alternative solutions until it finds one that works. The next time that person is faced with a similar problem, the brain remembers what worked before and tries that approach, building on past experiences. In other words, humans learn from making mistakes. Efforts are under way today to design computer systems that work and make decisions based on the human model. These technologies are classified as artificial intelligence.

Expert systems are one attempt to make artificial intelligence available to computer users. These systems have a software package that encodes the knowledge and decision-making rules of specialists. Access to the information allows the user to tap into the skills of experts. Preservation could use expert systems to ensure that a crafts person's techniques remain available to future generations. Artificial intelligence will have applications in the future that we cannot even imagine at this time.

Another technology beginning to emerge is computer disc read-only memory, or CD-ROM. These discs store encyclopedic amounts of information on an optical disc, which is then read by laser beams that send digital signals to the computer. Compact discs produced using similar technol-

ogy have all but replaced vinyl records in the music business. Entire state surveys could be stored on compact discs and easily distributed to local organizations and agencies that could use the information to protect historic resources.

Interactive video discs also could be used by preservation organizations to store and access survey information. Interactive video discs merge video with audio and personal computers, using an analog laser video disc player and a digital computer interface. One disc will store 30 minutes of motion video with audio per side. This medium could be useful in doing survey work and also in preserving restoration skills that may be lost. Interactive video disc technology is available now but expensive. As the technology improves and costs drop, the preservation community will be able to benefit from new storage-recording systems.

User interface is another area that will help make computers more user-friendly. With current technology, most data are entered through keyboards, and typing can be an obstacle to data entry. Scanners allow text to be entered reliably, but voice input or just a blink of one's eyes may be input methods of the future. This technology is in its infancy now, but like other computer technologies, the software and hardware will get better and the price will decrease. A preservation professional in the future may be able to inspect a structure, report findings to a portable computer, and, upon completion, have a full report.

Although the benefits of computers are many, cautions should be considered when adopting any new technologies. Care should be taken to understand the human reaction to new situations. Many people are confused and intimidated by computers and the jargon associated with describing and using computers. Many fear losing all their work or pushing the wrong button and causing costly harm to the hardware. Computer terms and workings should be explained and understood by preservationists.

Many of us find that when we use computers, we feel caught up in a standardized, depersonalized world. There is a real danger that using computers to help make aesthetic judgments can lead to standardized decisions rather than creative solutions to design issues such as design guidelines for historic districts.

But we must remember that computer technology will become a part of the field whether we embrace and exploit it or let it be imposed on us. The field of preservation, like any other field, must be proactive and futuristic to be excellent. Preservationists must sharpen their business skills and become secure in using new technology in their efforts to maintain and preserve historic resources. Let us not be stuck primarily in the past; let us begin to explore the most effective ways to deal with preservation issues in the future.

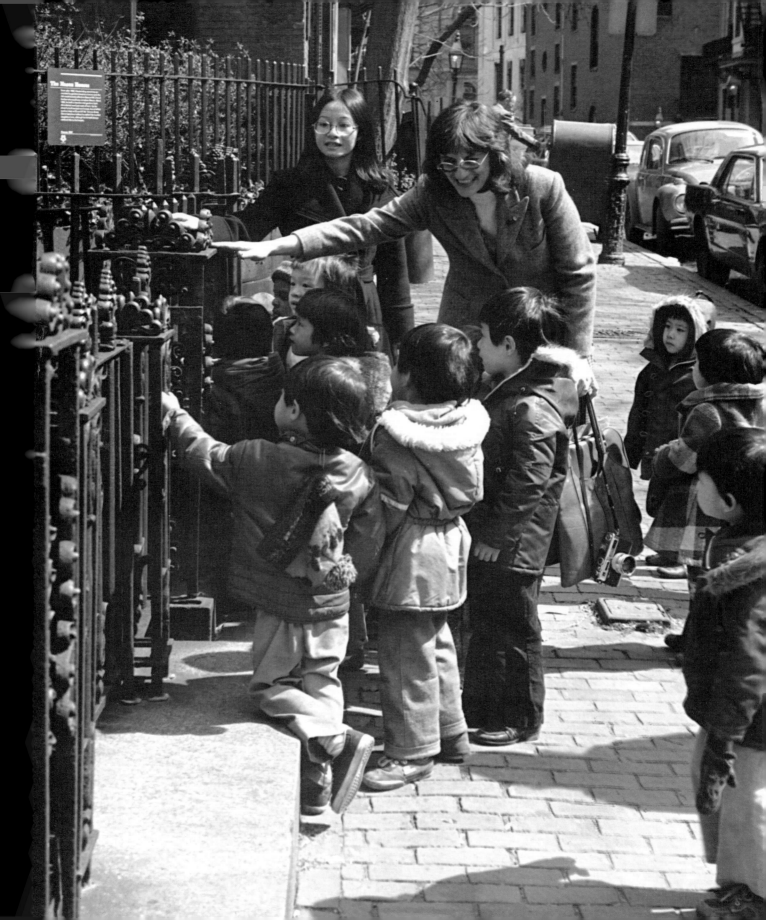

TANGIBLE TEXTS FOR HERITAGE EDUCATION

Kathleen A. Hunter

WHAT ATTRACTS THE PUBLIC TO HISTORIC PRESERVATION? IN 1991 THE NATIONAL TRUST FOR HISTORIC PRESERVATION UNDERTOOK AN EXTENSIVE RESEARCH STUDY TO ANSWER THAT QUESTION. FROM THAT STUDY, WE LEARNED A GREAT DEAL THAT CAN GUIDE THE HISTORIC PRESERVATION MOVEMENT OVER THE NEXT 25 YEARS. WE LEARNED THAT THE PUBLIC WANTS HISTORIC SITES AND ARTIFACTS SAVED BECAUSE THEY TEACH US SOMETHING ABOUT OUR HISTORY AND CULTURE. THAT IS THE BASIC IDEA BEHIND HERITAGE EDUCATION—AN APPROACH TO TEACHING AND LEARNING THAT VIEWS THE NATURAL AND BUILT ENVIRONMENTS AND MATERIAL CULTURE AS DOCUMENTS OF OUR HISTORICAL EXPERIENCES AND CULTURAL EXPRESSIONS.

The preservation community can use heritage education to further its goals in a number of ways. First, instilling an appreciation for the historical and cultural significance of a site engenders motivation for protecting that site. Thus heritage education is a powerful support for preservation advocacy. This is particularly the case if people feel emotionally attached to the site and if they can relate it to their personal, family, community, regional or national heritage. The successful grass-roots and national campaign to protect the Manassas Civil War battlefield in the 1980s gives witness to the intrinsic link between preservation advocacy and heritage education. If we want people to get involved in protecting their historic and cultural resources, we must help them recognize these places as a part of their heritage. "Don't tear down our history!" can be a rallying idea for local preservation advocacy.

Second, decisions about how to go about the actual work of preservation depend on heritage education to understand the historical or cultural significance of a site. If a preserved structure, streetscape, or seaport is going to present an honest picture of some aspect of our heritage, we must employ the best scholarship to fully appreciate the events, people, issues, and themes documented at that site.

Third, once we have protected and preserved the places of history, these places must be available to the public to

enrich their understanding of their heritage. Beginning with careful interpretation of what is presented at the site, the heritage education approach links the specific site to the broader events and themes of which it is a part. On one hand, residents can learn how their Washington, D.C., neighborhood is a part of Pierre L'Enfant's grand design for a capital city, or how the layout of their Wisconsin farming community links this generation to their Swiss ancestors. On the other hand, tourists to an area can explore how the pattern of events and recurrent themes of national and international consequence played out in a local context.

The last way in which heritage education can support the goals of historic preservation is by ensuring that future generations recognize historic places as important records of their heritage. We teach young people to respect the written records of their past, such as the Bill of Rights and the Gettysburg Address. We should nurture the same respect for the physical records of their history, such as Independence Hall and the San Antonio missions. We can do that by making heritage education an integral part of the way we teach and learn about history and culture in school.

During the 1980s several events occurred in the education community that will continue to influence the direction of public education in the United States well into the 21st century. All of these events have significance for those of us concerned with protecting and teaching about historic places.

A NATION AT RISK

By the beginning of the decade, educators, parents, employers, and community leaders recognized that the nation's public education system was in a downward spiral. Student performance and job preparation were declining, while drug use, teenage pregnancy, and youth violence were competing for the attention of classroom teachers, superintendents, and school boards. In 1983 Secretary of Education Terrell Bell released A Nation at Risk. This report sounded the alarm for what has become known as the education reform movement. The report focused on the overall poor academic performance of students, the dangers of an uneducated work force and electorate to the nation's economic and social well-being, and the loss of core civic and academic values among communities, families, children, and youth.

A key concept in A Nation at Risk is that no nation before has attempted universal education to the extent to which the United States aspires.[1] The challenge for this nation is to provide for quality education for *all* citizens. *A Nation at Risk* precipitated a decade of studies, reports, commissions, and public debate in search of an answer to the crisis in public education.

In 1987 Chairman Lynne Cheney of the National Endowment for the Humanities released *American Memory*. The report reflected a growing movement to restore solid content to the school curriculum—particularly the liberal arts—that presents students with the universal ideals, values, and body of knowledge on which the nation's constitutional democracy was founded. *American Memory* used information from the National Assessment of Educational Progress to tell a dismal tale of student ignorance about fundamental facts, people, and issues that should be a part of America's collective memory.[2]

Teaching and learning about history have been major focuses of several substantive commissions and studies that have produced changes in the history, geography, and social studies curricula. The push for solid content in the school curriculum occurred concurrently with a new national debate on how to foster basic values in students and involve parents and communities in shaping their children's education. Although often controversial, the debate brought about a recognition by communities that their schools were essential partners in nurturing the commonly held civic values needed for a healthy nation.

A partial answer to the challenge of a universal, high-quality education has been offered by an interesting partnership of instructional theorists and new-age technologies that matured during the 1980s. Potentially, we now can bring highly effective instruction to students anywhere in the United States through distance learning networks and computer-based programs that use video disc and CD-ROM technologies. Through these technologies, a student in remote Nevada can study Latin and advanced physics, take an electronic field trip to a southern plantation, or talk with engineers and crafts people repairing the damage to a historic building from California's Loma Prieta earthquake. The harnessing of instructional theory to new delivery systems is dramatically influencing teaching approaches and materials in the classrooms.

The professional and administrative underpinnings of America's schools have not escaped scrutiny in the education reform debate. Empowering teachers with the academic training and institutional status to become true professionals in the classroom is the shared concern of teacher preparation institutions, state accrediting agencies, and professional associations. Encouraging businesses, community groups, public agencies, museums, and libraries to join in the education enterprise follows close behind. In the ideal school, a principal-manager oversees master teachers in the classroom, who are supported by technicians, aides, and specialists throughout the school system. These teachers are continuing their professional training in their subject areas, and they are working

with a broad group of resources within their communities as coteachers and student mentors.

As the 1980s ended America's different cultural groups found their voice. Stimulated by democratic idealism, a visceral instinct for cultural survival, or raw socioeconomic realities, they are challenging the nation and its schools to affirm the contributions of all those who are a part of our national heritage as we shape our common values and ideals. How our schools engage a newly arrived student from Southeast Asia in an appreciation of constitutional principles laid down 200 years ago or how they empower an American Indian or African American child with legitimacy in the American experience may be the most profound and critical challenge of the educational reform movement. The challenge goes to the very heart of *A Nation at Risk*. Statisticians tell us that by the year 2000, the majority of school-age children will be from non-Euro-American backgrounds. These children must come to see themselves as a part of the American heritage if the nation is going to survive.

LEARNING FROM PRIMARY SOURCES

A fundamental rationale for historic preservation is that the natural and built environments teach us something about our history and culture. The places of history are the most immediate, visible, and real reflections of a community's heritage. A knowledge of our heritage provides continuity and context for communities and orients them in their decision making. The historic preservation community, therefore, can be a powerful ally to the education community in achieving its education reform goals. Conversely, education leaders should be strong advocates for historic preservation because it supports their cause.

In 1989 the nation's governors revisited the challenge of *A Nation at Risk* and set national education goals. Their third goal states:

By the year 2000, American students will leave grades four, eight, and twelve having demonstrated competency in challenging subject matter including English, mathematics, science, history, and geography; and every school in America will ensure that all students learn to use their minds well, so they may be prepared for responsible citizenship, further learning, and productive employment in our modern economy.[3]

The governors set down three objectives for achieving this goal. America, they said, must
- strengthen basic and cognitive learning skills
- nurture habits of citizenship, community service, and personal responsibility

- expand knowledge about the diverse cultural heritage of this nation and the world community [4]

We can help schools strengthen their academic programs if we look at places, buildings, and structures as historical documents, very much like written documents that can be analyzed and interpreted. By studying the Brooklyn Bridge, for example, students can learn things about history, geography, social studies, and science that they will not learn from a textbook or written document alone. This means that historical societies and preservationists must use the best available research and scholarship in documenting and interpreting the places of history.

Not only can heritage education enrich the content of students' academic programs, it also can strengthen basic and cognitive skills. Students can learn to read a building much as they learn to read a text. Observing, investigating, analyzing, and interpreting the natural and built environments calls on students to assemble data, explore hypotheses, track change over time, and link particular incidents with general principles. Without exception, during the last decade, virtually every study and commission on teaching history and social studies has emphasized the importance of using primary source material in the classroom as a way of sharpening students' critical thinking skills. There are simply no primary source materials more readily available to teachers and students than those preserved in their own communities.

The preservation movement is largely a local phenomenon. It has identified the historic and cultural resources close to home. Local and state history are usually taught in early and upper elementary school. Teachers and students, therefore, can be introduced to their nearby history at an early age. Local historical societies and preservation groups can become practiced at showing the link between local historical experiences and the national experience or even world history. A train station in a Minnesota farming community may be a lovely example of period architecture, and there may be significant local events or persons associated with it. Possibly it was the railroad that created the town. But the railroad and train station also may link this community to the history of westward expansion, the arrival and settlement of European immigrants, the shipping of agricultural supplies during World War I, or the return of GI's after World War II.

Teachers want students to know about key events in American history, grasp the basic chronology of those events, and understand fundamental issues and themes about the nation's history and culture. The places of history can help them do that. There is not a neighborhood or community in America that does not have places that speak to the connection between local history, the region, and the nation.

For many years, historic preservation and heritage education programs have tended to overemphasize the stylistic elements of architecture and design. However, design has a far deeper significance in understanding our heritage—it is a wonderful way to talk about how the environment reflects our beliefs, values, creative expressions, and technical capacity at a place and time in history. Design is central to the curriculum in many subject areas. At Monticello, for example, we can appreciate Thomas Jefferson's expression of neoclassical architecture, but we can also explore the extraordinary workings of Jefferson's mind. Ford Motor Company's River Rouge factory near Detroit gives witness to the highest expression of the American factory system, as well as the history of design in the auto industry. A layout of farms in Ohio reflects the origins of the immigrants who settled there.

Heritage education is able to integrate art history with the humanities, social, and natural sciences. The National Endowment for the Arts recognized the importance of this kind of interdisciplinary approach to art education in its report *Towards Civilization*.[5] All teachers need better preparation in arts education, the report suggests, and art teachers need better preparation in the humanities. A good example of the blending of these two fields occurred in the 1991 publication of a curriculum guide for European history by the National Center for History in the Schools. The guide was entitled *Crowning the Cathedral of Florence: Brunelleschi Builds His Dome*. In Brunelleschi's extraordinary architectural achievement, the historic moment of Renaissance Florence is discovered.[6] Mesa Verde, South Carolina's rice plantations, and the Gothic castle Lyndhurst in New York all lend themselves to the same kind of interdisciplinary study.

An honest portrayal of American history includes teaching and learning about America's culturally diverse heritage. Historic preservation and heritage education cannot address all of the issues related to cultural diversity in the United States. We are in a unique position, however, to contribute to an accurate and complete accounting of cultural diversity in the American experience. Most people's roles in this nation's heritage will never be documented in written records, but they are often recorded in places of history. The pre-Columbian irrigation systems of the pueblos that continue to carry water to the fields and a stone wall in New England that still marks a boundary line are eloquent testimony to the people who have lived in those places.

The places of history unite the particular experiences of individuals and groups with the larger, unifying experiences of the region and nation. The Empire State Building, the St. Lawrence Seaway, and California's Central Valley record a vision of ourselves as a nation. They also tell personal and dramatic stories about the people who built these places, worked in them, and lived in them. Historic places also document the continuum of human experience. In the layering of architectural styles, the naming of streets and buildings, and the use of space, we can explore the contributions of any one group within the context of an urban neighborhood's ongoing life.

The challenge to historic preservation and heritage education over the next 25 years will be to reevaluate what we are preserving and to reconsider how we talk about the places of history. Telling the whole story, even if awkward or painful, is essential to the integrity of the preservation movement. In that way, we affirm our national vision of unity within diversity, and we become a meaningful partner in protecting and stabilizing the neighborhoods and communities that reflect the varied expressions of the American heritage.

Heritage has gotten a bad name lately. For many, it denotes a sentimental or superficial attachment to symbols of America. Heritage has become an elitist tag, a badge for announcing membership in a controlling class. Heritage education has the opportunity to change that image. The real meaning of heritage is inheritance—what previous generations have passed down to us as stewards of the nation's collective memory. Heritage education can foster in the American public an appreciation for the unique participation of each individual and group in our shared inheritance.

A RECEPTIVE AUDIENCE

Young people have three qualities that make them naturally responsive to a heritage education approach to learning about their history and culture. One, they are experiential learners who like to be actively involved in what they are studying. They like to investigate, explore, and solve problems. They like concrete learning environments in which they can touch, see, listen, and manipulate the information. They want to move from idea to action. The built environment allows that kind of learning.

Two, young people like a sense of place and participation. They are collectors. They create special, secret places for themselves as clubs and forts. If you can remember your own childhood, memories of place, family, and community are almost indistinguishable. During our youth we develop an overwhelming attachment to place as central to our well-being.

Three, young people's values are immediate and personal:

Opposite: Young people are receptive to preservation because they have a deep attachment to places and objects with special meaning.

KATHLEEN A. HUNTER

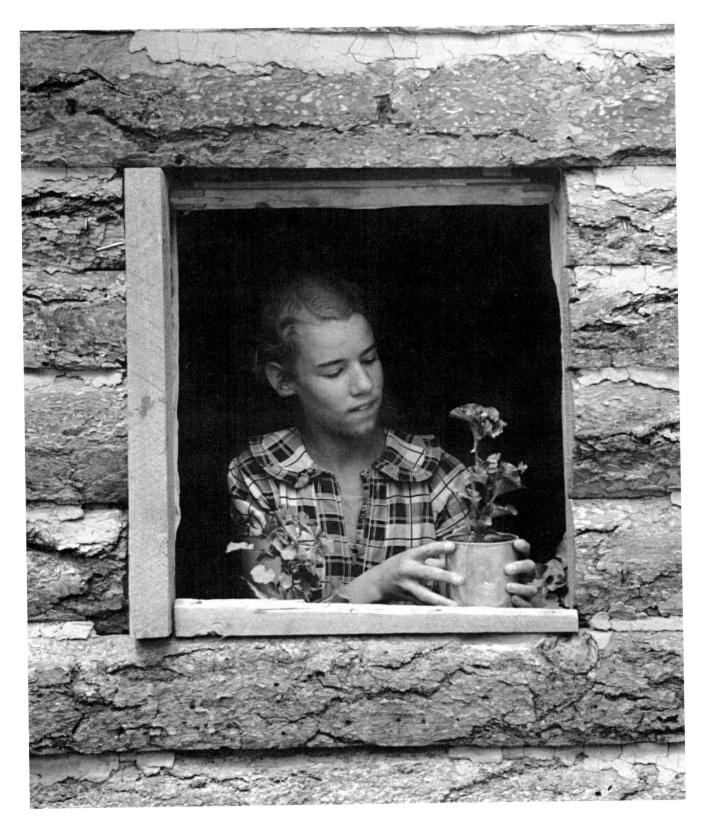

They speak of "my family," "my friend," "my house," and "my ball field." They have a deep and tender altruism that draws them towards the fragile, precious, and threatened. Perhaps because of their own vulnerability, they are far better than adults at sensing when something they value is in danger. Sadly, they learn from the adults around them to disassociate themselves from their surroundings.

Every culture and society has recognized the importance of harnessing these instinctual qualities of youth into social responsibility. Religions have formal rites of passage. Scouting, 4-H, and youth clubs all work to direct youthful curiosity and high ideals toward civic action. We should use heritage education for getting young people involved in every aspect of historic preservation in their community—advocacy, craftsmanship, interpretation, and conservation of the land—so that they can act out the relationship between heritage and commitment to their communities.

Perhaps we are fortunate that heritage education did not become an entrenched part of the school program before the 1990s. We may have become locked into an approach to teaching and learning about history and culture that is quickly disappearing. Until recently, classroom instruction in history, geography, and social studies has been driven by systemwide textbooks that tried to do the whole job under one cover. Individual teachers might provide some supplemental information through films, slides, videos, transparencies, and wall charts. A teacher might take the class on a local field trip.

Now, thanks to changes in curriculum, changes in the role of teachers, and new technologies, the one-textbook approach is quickly disappearing. The school system's curriculum specialists, the library, and the resource center help teachers enrich a core textbook through a variety of instructional approaches. Soon, interactive videos, CD-ROM, and computer-based instructional programs and educational kits will provide in-depth instruction on specific events, themes, issues, and people touched on in the textbook. Teachers will expect students to work with primary source materials rather than the secondhand and thirdhand interpretations in textbooks. Students, working alone or in small groups, may undertake intensive investigations of such subjects as the founding period in American history, the routes of the Spanish explorers, or the patterns of America's work places and work forces. They may read the documents of the founding period, study the maps of the explorers, or visit work sites in their region.

Heritage education lends itself well to these new instructional methods. Historic places are visual, three-dimensional spaces that are natural subjects for intensive study and a multimedia presentation. They document layers of meaning that can be nicely adapted to computer-based instructional programs, allowing students to thoroughly explore one aspect of the site and then another. The annual field trip that was as much a day of scheduled hookey as it was learning can become an integral part of the instructional program, presenting students with new primary source materials for analysis.

The strength of the historic preservation movement is that it is local. Even if they do not all have a formally organized preservation group, there are few communities without their resident historians who take an active interest in protecting local historic sites. This grass-roots involvement is the keystone to successful introduction of heritage education in the schools.

Although some informal cross-fertilization occurs between local preservationists and educators, it is often limited to an effort by a single teacher and a preservationist to meet and try out an idea. We are beginning to see some extraordinary examples of systemic cooperation and coordination between these two groups, and these can become models for all communities. In Georgia, South Carolina, and Louisiana, for example, the state education departments are working with preservation organizations to include the use of historic places in the state curriculum guides. In the Philadelphia area, preservation organizations are working directly with teachers and curriculum specialists to integrate local historic sites into their history and social studies courses.

Not only should preservationists strive for stronger partnerships directly with the schools, but they also can become a catalyst for expanded partnerships with the business community, public agencies, civic organizations, museums, libraries, and colleges. Preservationists can become the rallying group for community-wide projects such as heritage tourism, restoration of a school building or neighborhood park, and a local heritage interpretive center. Such projects engage teachers and their students in all of the activities the education community is seeking: academic content and skills, mutual respect among groups, citizenship values, innovative instructional approaches, and community involvement in schools.

JOINT PROFESSIONAL DEVELOPMENT

Professional development is also critical. I leave it to the end not because it is the least significant, but because it is the bottom line if we are going to be successful in bringing heritage education to the classroom. We have a two-way barrier to that goal. Teachers are not trained in how to use historic and cultural resources in their classrooms, and

preservation groups are not trained in how to present these resources in terms of the school curriculum. Only a small percentage of heritage education programs designed by the preservation community see themselves as teaching existing subjects in the school curriculum. The same study that produced this finding also showed that only five percent of these heritage education programs had been adopted by the schools they were intended to serve.

We know that heritage education can strengthen academic programs and community and citizenship values. We know that it can take advantage of the most avant-garde instructional approaches. Preservationists, site interpreters, and museum educators have the same goals as classroom teachers, but they do not know how to work together to accomplish those goals. What we need is an intensive emphasis on joint professional development in heritage education for all of these groups, an activity that can be delivered as a part of their professional training and development. The program should be professionally accredited by schools of education and delivered as for-credit courses, summer institutes, and short workshops.

When designing professional training and development programs in heritage education, it is important for the preservation community to remember that heritage education includes more than information from the natural and built environments and material culture. It includes written records, oral histories, music, dance, drama, and community practices and traditions. Scholars and practitioners from all of these fields should participate in designing a heritage education curriculum framework.

A SCENARIO FOR 2015

Here is my fantasy for heritage education in the next quarter century:

In the year 2010, an eighth-grade American history class in a rural, west Kentucky town is studying the westward movement. The teacher is a member of the local historical society and preservation organization. Last summer, he and the president of the preservation association took a summer course on heritage education offered by the National Trust at a local community college. They decide to develop a curriculum unit together on how their region of Kentucky participated in and was influenced by the westward movement from the Revolutionary War until 1890. They learn that many settlers came from Virginia and that some moved on to Texas, and then Wyoming and Montana. With the help of the state education agencies and state historic preservation offices, they set up cooperative study projects with communities in these states. Teachers, preservationists, and museums from these states share instructional materials and documentation on the subject. Together, they locate scholars and experts to be guest presenters and project mentors.

Students from the participating states trace the stories of individuals, families, and groups who moved westward along this route, and they explore similarities and differences in patterns of housing, farming, commerce, and social customs. With the help of county and state records, students locate significant historic sites related to the story of the westward movement in their communities. Students in each of the partner communities prepare an interpretive marker program for their historic sites. The markers present information about individuals and groups in the community, the significance of the sites in community history, and the way in which this related to important events occurring beyond the community, such as the Revolutionary and Civil wars, the opening of the Cumberland Gap, the building of railroads and roadways, and commerce on the Mississippi and Ohio rivers. A business or civic organization sponsors construction and stewardship for each marker, and pays one student's way on an exchange field trip to the participating communities in the five states.

In Kentucky in the summer of 2015, two of the participating students have summer jobs in a sponsoring bank between their freshman and sophomore years at the state college; four have jobs at sponsoring businesses in town and are attending the community college; and another student is on a scholarship to a historically black college in Virginia. A group of five students from Texas are working with a state university to restore a Spanish mission site, and two students from Virginia are spending the summer repairing fences on a Montana ranch.

NOTES

A SENSE OF TIME AND PLACE
David McCullough

1. Robert Louis Stevenson, *Edinburgh: Picturesque Notes* (London, 1879).

FORGING NEW VALUES IN UNCOMMON TIMES
W. Brown Morton III

1. T. S. Eliot, *Four Quartets* (London: Folio Society, 1968), p. 11.

2. Ibid., pp. 49–50.

3. Ibid., pp. 52, 54, 55.

PRESERVATION PRACTICE COMES OF AGE
Michael A. Tomlan

1. Charles B. Hosmer, Jr., *Preservation Comes of Age: From Williamsburg to the National Trust, 1926–1949*, 2 vols. (Charlottesville: University Press of Virginia for the National Trust for Historic Preservation, 1981), vol. 2, p. 1043.

2. "Rehab Tax Credits Attract Big Money, Shut Out the Little Guys," *Urban Conservation Report* 6, no. 7 (April 15, 1982): 1.

3. "Construction Slump," *U.S. News & World Report* 92 (February 8, 1982): 81.

4. During the last decade, 15 state capitol restoration committees were established.

5. Timothy J. Conlan et al., *Taxing Choices. The Politics of Tax Reform* (Washington, D.C.: Congressional Quarterly Press, 1990), pp. 232, 250.

6. "Passive Investor Rules," *Urban Conservation Report* 10, no. 10 (October 31, 1986): 4.

7. Bernard J. Frieden and Lynne Sagalyn, *Downtown, Inc.: How America Rebuilds Cities* (Cambridge, Massachusetts: MIT Press, 1989).

8. M. Demarest, "He Digs Downtown," *Time* 118 (August 24, 1981): 42–44; A. Pawlyna, "James Rouse, A Pioneer of the Suburban Shopping Center, Now Sets His Sights on Saving Cities," *People* 16 (July 6, 1981): 63–64.

9. Robert K. Landers, "The Conscience of James Rouse," *Historic Preservation* 37, no. 6 (December 1985): 60–63; John Gregerson, "The Evolution and Growth of the Festival Marketplace," *Building Design and Construction* 29, no. 2 (February 1988): 72–77. The most notable projects are Faneuil Hall, Boston (1976); Harborplace, Baltimore (1980); South Street Seaport, New York (1983); Riverwalk, New Orleans (1984); Jacksonville Landing, Jacksonville, Florida (1987); and Bayside Marketplace, Miami (1987).

10. J. Jackson Walter, "Introduction: Preservation Is Everybody's Business," and Margaret Opsata, "How Pros Play the

Rehab Game," *Historic Preservation* 39, no. 3 (May–June 1987): 33–37.

11. Andre Shashaty, "The Deal Makers," *Historic Preservation* 35, no. 3 (May–June 1983): 14–23.

12. Robert Miller, "Big Deals. With Skill, Megabucks and Sometimes Sheer Nerve, Rehabbers Tackle the Nation's Grandest Projects," *Historic Preservation* 41, no. 3 (May–June 1989): 38–41.

13. Betsy Chittenden and Jacques Gordon, *Older and Historic Buildings,* Information Series (Washington, D.C.: National Trust for Historic Preservation, 1983); Sally Oldham, "The Business of Preservation Is Bullish and Diverse," *Preservation Forum* 3, no. 4 (Winter 1990): 14–19.

14. Kurt Anderson, "Spiffing Up the Urban Heritage," *Time* 130, no. 21 (November 23, 1987): 72–83.

15. "San Francisco Curbs Development, Outlaws Glass Box," *Urban Conservation Report* 9, no. 8 (September 10, 1985): 2.

16. Robert Campbell, "Overbuilt Boston," *Boston Globe Magazine* (February 19, 1984), p. 58.

17. Anthony J. Yudis, "Curbs Urged on Hub Growth," *Boston Globe* (May 10, 1984), p. 1.

18. Robert Campbell, "Parachute Plans Landing in Boston," *Boston Globe* (September 18, 1984), pp. 11, 13.

19. "Is Landmark Designation Finished?" *Village Views* 4, no. 1 (Winter 1987): 39–44; William J. Conklin, "New York: The Historic City" (New York: Prepared for the New York City Landmarks Commission, 1989). The Conklin Report is the most recent study; it includes a brief history of the commission. For a critique, see Anthony Max Tung, "The Historic City Report: Ignoring the Lessons of History," *Village Views* 5, no. 4 (Fall 1989): 3–6.

20. Catherine Fox, "With Preservation Ordinance in Place, It's a Whole New Ball Game for UDC," *Atlanta Journal* (June 24, 1990), p. 2.

21. "Weak Links in Atlanta's Preservation Effort," *Atlanta Constitution* (December 27, 1990), sec. A, p. 8.

22. During the last decade, conflict resolution was introduced and gradually blossomed in the preservation field. The "Future Directions" session of the National Preservation Conference in San Francisco in 1979 included an address by John Busterud, president of RESOLVE, Center for Environmental Conflict Resolution, in Palo Alto, California. "Future Directions in Historic Preservation," *Preserva-*

tion and Conservation in Partnership (Washington, D.C.: National Trust for Historic Preservation, 1979), p. 19.

23. "Partial Designation Returns to Chicago," *Landmarks Preservation Council of Illinois* 10, no. 1 (January–February 1989): 1.

24. Ron Powers, *Far From Home. Life and Loss in Two American Towns* (New York: Random House, 1991).

25. Jonathan Walters, "Main Street Turns the Corner," *Historic Preservation* 33, no. 6 (November–December 1981): 37–45. Downtown revitalization programs begun earlier in Corning, New York, and Chillicothe, Ohio, were expanded by the Main Street staff in three pilot Midwest towns: Galesburg, Illinois; Hot Springs, South Dakota; and Madison, Indiana. Kim Keister, "Main Street Makes Good," *Historic Preservation* 42, no. 5 (September–October 1990): 44–50, 83.

26. Marilyn Hoffman, "New Life for Old Buildings," *Christian Science Monitor* (March 6, 1989), p. 12; John Howard Joynt, "Small Towns Are Finding Preservation Is Salvation," *Washington Post* (June 10, 1989), p. 1. One of the high points of the center's activities occurred in 1984, when it used satellite hookups to beam interactive programming to 21,000 people in more than 400 towns and villages throughout the nation.

27. Thomas J. Colin, "Mall Mentality at Manassas," *Historic Preservation* 40, no. 4 (July–August 1988): 2; Betty Rankin and Annie Snyder, "The Third Battle of Manassas," *Forum* 3, no. 1 (Spring 1989): 2–7.

28. Samuel N. Stokes et al., *Saving America's Countryside* (Baltimore: Johns Hopkins University Press for the National Trust for Historic Preservation, 1989).

29. Marilyn Hoffman, "Barns Reborn," *Christian Science Monitor* (January 18, 1989), p. 12.

30. My comment here is based on a review of more than 230 abstracts prepared for the National Preservation Conference in 1991.

31. Byrd Wood and Emma Jane Saxe, Appendix, *Historic Preservation in American Communities* (Washington, D.C.: National Trust for Historic Preservation, 1987), p. 9.

32. Chester H. Liebs, "The Assessment of American Roadside Architecture," *Forum, Bulletin of the Committee on Preservation* (Philadelphia: Society of Architectural Historians), vol. 2, no. 1 (June 1980): 1–2; Chester H. Liebs, *Main Street to Miracle Mile: American Roadside Architecture* (Boston: Little, Brown and Company, 1985).

33. William J. Murtagh, "The Meaningful Assessment of the Built Environment," *Forum, Bulletin of the Committee on Preservation* (Philadelphia: Society of Architectural Historians), vol. 1, no. 2 (December 1979): 1–2.

34. Robin G. Collingwood, *The Principles of Art* (New York: Oxford University Press, 1958), p. 280.

35. John Dewey, *Art as Experience* (New York: Minton, Balch and Company, 1934), pp. 4,5; Thomas M. Alexander, *John Dewey's Theory of Art, Experience and Nature. The Horizons of Feeling* (Albany: State University of New York Press, 1987), pp. xi, xvii; Robert W. Westbrook, *John Dewey and American Democracy* (Ithaca, New York: Cornell University Press, 1991).

36. John J. Costonis, *Icons and Aliens: Law, Aesthetics, and Environmental Change* (Urbana: University of Illinois Press, 1989), pp. 11, 61.

37. Ibid., p. xv.

38. Linda Greenhouse, "Court Ends Tower Plan at St. Bart's," *New York Times* (March 5, 1991), sec. B, p. 1; Paul Goldberger, "Two Reasons for Dancing in the Streets," *New York Times* (March 17, 1991), sec. H, p. 36; Todd S. Purdum, "Church as Landmark: Battle Rejoined," *New York Times* (April 13, 1991), p. 27.

39. John Holusha, "Detroit Catholics Wary on Closing," *New York Times* (October 5, 1988), sec. A, p. 23. In Chicago, the diocese proposed the closing of about 30 churches and six schools. See "Churches to Close in Chicago," *New York Times* (January 22, 1990), sec. A, p. 10.

40. Dave Condren, "5 Parish Schools to be Consolidated into 2," *Buffalo News* (December 23, 1989), sec. C, p. 1; Ari Goldman, "Poor Catholic Schools Hope to Avoid Closings," *New York Times* (March 8, 1991), sec. B, p. 2.

41. Comments to the author, August 15, 1991.

42. One of the most important developments in the public sector has been the defederalization of programs. The 1980 amendments to the National Historic Preservation Act of 1966 turned over a number of previously federal and state responsibilities to Certified Local Governments.

43. Joanne Ditmer, Rachel Cox, and Alice L. Powers, "The New Professionals," *Historic Preservation* 38, 3 (May–June 1986): 26–31.

44. Richard F. Wacht, *Financial Management in Nonprofit Organizations* (Atlanta: Georgia State University Press, 1984). Wacht's book is the first text to address the finan-

cial management of these groups. For a clearer picture of some of the employment statistics in the field, see Greg Coble, "Salary Survey of Nonprofit Preservation Groups," *Preservation. Forum* 5, no. 3 (May–June 1991): 4–5; Office of Human Services, "Survey of Compensation: Nonprofit State and Local Preservation Organizations" (Washington, D.C.: National Trust for Historic Preservation, 1990), pp. 1–15.

BRIDGING AMERICA'S VISIONS
Henry G. Cisneros

1. Robert F. Kennedy, *To Seek a Newer World* (Garden City, N.Y.: Doubleday, 1967).

MULTICULTURAL BUILDING BLOCKS
Antoinette J. Lee

1. Ben J. Wattenberg, quoted in "Census Shows Profound Change in Racial Makeup of the Nation," *New York Times* (March 11, 1991): 1.

2. "More Pluribus, More Unum," *New York Times* (June 23, 1991): 14.

3. Langston Hughes, quoted by Martin Luther King, Jr., in "A Time to Break Silence," *A Testament of Hope*, ed. James M. Washington (New York: Harper San Francisco, 1986), p. 234.

4. United Way of America, *What Lies Ahead: Countdown to the 21st Century* (Alexandria, Virginia: United Way Strategic Institute, 1989).

5. "Reconfiguring the Cultural Mission: A Report on the First National Cultural Conservation Conference," *Folklife Center News* 12 (Summer–Fall 1990).

6. Ibid., p. 4.

CARING FOR OUR COMMUNITIES
Kenneth B. Smith

1. Jim Chard and John York, eds., *Urban America: Crisis and Opportunity* (Belmont, California: Dirkenson Publishing Company, 1969), pp. 1–2.

2. Joseph Hough, "Enlarging Human Freedom," in *Urban America: Crisis and Opportunity*, pp. 22–23.

3. Ibid., p. 23.

4. Marian Wright Edelman, *Families in Peril: An Agenda for Social Change* (Cambridge, Massachusetts: Harvard University Press, 1987), p. 103.

5. Ibid., p. 104.

6. W. Brown Morton III, quoted by H. Grant Dehart in "Key Issues for the Future of the Preservation Movement" (background paper for the 45th National Preservation Conference, San Francisco, October 1991), p. 2.

7. Arthur Schlesinger, Jr., "The Cult of Ethnicity, Good and Bad," *Time* (July 8, 1991): 21.

8. Ibid., p. 21.

9. Ibid., p. 21.

10. Paul Gray, "Whose America?" *Time* (July 8, 1991): 13.

11. Constantinos A. Doxiadis, *Between Dystopia and Utopia* (Hartford, Connecticut: Trustees of Trinity College, 1966), p. 48.

12. C. S. Lewis. *Surprised by Joy: The Shape of My Early Life* (New York: Harcourt, Brace and World, 1956), p. 238.

PROPERTY RIGHTS AND PUBLIC BENEFITS
Joseph L. Sax

1. City of New Orleans v. Pergament, 198 La. 852, 5 So.2d 129 (1941) is one of the earliest American cases sustaining a local preservation ordinance (in Vieux Carré). See also Maher v. New Orleans, 516 F.2d 1051 (5th Cir. 1975), cert. denied 426 U.S. 905 (1976).

2. United States v. Gettysburg Electric Ry., 160 U.S. 668 (1896).

3. Penn Central Transportation Co. v. New York, 438 U.S. 104, 98 S.Ct. 2650, 57 L.Ed.2d 631 (1978).

4. First Covenant Church of Seattle v. Seattle, 114 Wash.2d 392, 787 P.2d 1352 (1990), vacated summarily, 111 U.S. 1097 (1990), on the authority of Employment Division, note 24 infra.

5. Rector, etc., of St. Bartholomew's Church v. New York, 728 F.Supp. 958 (S.D.N.Y. 1990), afrd 914 F.2d 348 (2d Cir. 1990), cert. denied 111 S.Ct. 1103 (1991).

6. Although the case was not a historic preservation case, the sustaining of aesthetic regulation in Berman v. Parker, 348 U.S. 26 (1954), should be counted as an important legal landmark in this area of law.

7. "Health, safety, and welfare" is the standard phrase, but welfare was not very broadly interpreted.

8. Philosophically, the line between doing harm and refraining from doing good is unclear at best. (Is demolition of your historic building a harmful act or the mere cessation of a beneficent act?) But the distinction is one that the law has long recognized under the rule that one had no duty to be a good samaritan.

9. See Sax, "Is Anyone Minding Stonehenge? The Origins of Cultural Property Protection in England," 78 Calif.L.Rev. 1543 (1990); Saunders, "A Century of Ancient Monuments Legislation, 1882–1982," 63 *The Antiquaries Journal* 11 (1983).

10. 438 U.S., at 146.

11. On the public trust in natural resources, see Sax, "The Public Trust Doctrine in Natural Resource Law: Effective Judicial Intervention," 68 Mich.L.Rev. 471 (1970).

12. § 9, 16 U.S.C. § 1538(a)(1)(B). This "sleeper" provision of the Endangered Species Act has not yet been interpreted by the U.S. Supreme Court.

13. See Sax, note 9 supra. The bill provided some compensation. It authorized the government to designate monuments and to prohibit their destruction.

14. Ibid., at 1551.

15. St. Louis Gunning Adv. Co. v. St. Louis, 137 S.W. 929 (Mo. 1911), appeal dismissed 231 U.S. 761 (1913).

16. 438 U.S., at 146.

17. Conversely, a law that passes muster under the state constitution may still be reviewed by the U.S. Supreme Court to determine whether it violates the federal constitution.

18. United Artists Theater Circuit v. City of Philadelphia, ___ Pa.___, 595 A.2d 6 (1991). The court appears to be reverting to the old view that aesthetic reasons alone are not enough to support an exercise of the police power, or alternatively holding the more substantial, but equally unconventional, view that a historic preservation ordinance is, in effect, an exaction that compels the owner "to dedicate his property without compensation for public historical, aesthetic, educational, and museum purposes, which in reality are public uses." (p. 7).

19. Special note should be taken of free exercise problems, such as that presented by First Covenant, supra note 4, are more complicated. While churches are not generally held immune from land use controls, such controls cannot be

applied when they genuinely interfere with a church's ability to perform its mission. For example, see in re Westchester Reform Temple v. Brown, 22 N.Y.2d 488, 239 N.E.2d 891, 293 N.Y.S.2d 297 (1968). Here, a growing congregation needs to expand, and the setback restriction must be modified.

20. The Pennsylvania court granted reargument on August 30, 1991. As of July 1992, no revised opinion had been issued.

21. See Sax, "Property Rights in the U.S. Supreme Court: A Status Report," 7 U.C.L.A J.Env.L. & Policy 139, 149–50 (1988).

22. United States v. Riverside Bayview Homes, 474 U.S. 121, 127 (1985); Pennell v. San Jose, 108 S.Ct. 849, 861 (1988) (Scalia, dissenting).

23. In Hadacheck v. Sebastian, 239 U.S. 394, 408–09 (1915), the Court sustained a regulation that reduced the value of the property by 90 percent.

24. 1992 WL 142517 (U.S.S.C.). Lucas was decided on June 29, 1992, many months after the meeting at which this paper was delivered. As the first major takings decision of the new very conservative Supreme Court, it deserves and will receive far more extensive commentary than can be provided here.

The crucial high points are these: (1) Lucas governs only cases where the owner of land is left without any economically beneficial uses, typically cases where land is required to be left in its natural condition. Historic preservation cases will virtually never be of this sort. (2) While the rhetoric of the decision is extremely favorable to property ownrs, hinting that only nuisance-type conduct can be regulated without compensation having to be paid, the majority opinion gives no signal whatever that it intends to apply the Lucas rule to anything but total or virtually total economic loss cases. It specifically eschews application of the rule to regulation of business such as sales and manufacturing. The U.S. Supreme Court opinion in Penn Central is cited sevral times, and there is no whisper of a suggestion that it is liable to overruling on the basis of Lucas. (3) Lucas nicely exemplifies the tension between statism and economic conservatism. The Court is expounding very strong pro-property doctrines, but applying them to a very restricted class of cases. In this way it can be ideologically pure without seriously threatening the regulatory state. At the same time its warnings will no doubt deter regulators from being too bold or too innovative in restricting property uses.

25. For example, Employment Division, Department of Human Resources v. Smith, 494 U.S., 110 S.Ct. 1595, 108 L.Ed.2d 876 (1990) holds valid the criminalization of peyote use by American Indians, as against a claim of interference with the free exercise of religion.

26. Downzoning is usually not a taking unless a development project has progressed so far—for example, construction has begun—that it constitutes a vested property right. See, for example, William C. Haas & Co. v. San Francisco, 605 F.2d 1117 (9th Cir. 1979); County of Kauai v. Pacific Standard Life Insurance Co., 65 Haw. 318, 653 P.2d 766 (1982), app. dismissed 460 U.S. 1077 (1983). Not every state is so generous: see Parkridge v. City of Seattle, 573 P.2d 359 (Wash. 1978).

The U.S. Supreme Court holds that there is no constitutional bar to retroactive laws imposing civil (not criminal) liability. See, for example, Usery v. Turner Elkhorn Mining, 428 U.S. 1 (1976).

27. The Court frequently sustains economically costly regulation against claims of unconstitutional taking. See, for example, Connolly v. Pension Benefit Guarantee Corp., 475 U.S. 211 (1986). Here, employers were required to transfer assets to benefit employees of a terminated pension plan, under a law enacted after the pension plan was contracted for.

28. Agins v. Tiburon, 447 U.S. 255, 260 (1980).

29. See, for example, Webb's Fabulous Pharmacies v. Beckwith, 449 U.S. 155, 161 (1980).

30. Justice Rehnquist affirms judicial deference in Keystone Bituminous Coal Assn. v. DeBenedictis, 480 U.S. 470, 511, n. 3 (1987); see Justice Scalia's denial of strict scrutiny in land use cases in Nollan v. California Coastal Comm'n, 107 S.Ct. 3141, 3147, n. 3 (1987). Where other very important interests are at stake, the Court will scrutinize legislative justification more closely. See, for example, City of Cleburne v. Cleburne Living Center, 473 U.S. 432 (1985), a case involving mental retardation; Schad v. Borough of Mount Ephraim, 452 U.S. 61 (1981), a case involving free speech; and Moore v. City of East Cleveland, 431 U.S. 494 (1977), a case involving family rights.

31. "In my view, the aesthetic justification alone is sufficient to sustain a total prohibition of billboards within a community. . . ." Rehnquist, J., in Metromedia, Inc. v. San Diego, 453 U.S. 490, 573 (1981).

32. Nollan, note 30 supra. See also Keystone, note 30 supra, held not to be a taking by a close vote. The case was probably seen by dissenters as a physical appropriation of land. Pennsylvania Coal Co. v. Mahon, 260 U.S. 393 (1922).

33. Loretto v. Teleprompter, 458 U.S. 419 (1982); Kaiser Aetna v. United States, 444 U.S. 164 (1979).

34. For example, Webb's Fabulous Pharmacies, Inc. v. Beckwith, 449 U.S. 155, 101 S.Ct. 446, 66 L.Ed.2d 358 (1980).

35. Lucas, note 24, supra.

36. Agins v. Tiburon, 447 U.S. 255, 260 (1980).

37. 914 F.2d, at 356. This is the nonconstitutional test of the New York ordinance. Ibid., at 352, note 1.

38. 914 F.2d, at 355.

39. The New York court answered this question in the church's favor in Lutheran Church in America v. New York, 35 N.Y.2d, at 132, 316 N.E.2d 305, 359 N.Y.S.2d 7 (1974). But see Society for Ethical Culture v. Spatt, 415 N.E.2d 922 (N.Y. 1980), where demolition was not considered the only solution to the building's inadequacy.

40. See the cases cited in the dissent in the First Covenant case, 787 P.2d, at 1364–65.

41. Preservation of human communities is still in an emergent stage. Protection of subsistence lifestyles in Alaska, 16 U.S.C. §3111, is perhaps the most prominent example. See also Sax, "Do Communities Have Rights? The National Parks as a Laboratory of New Ideas," 45 U.Pitt.L.Rev. 499 (1984).

42. Victor Hugo, "Sur la destruction des monuments en France," in Œuvres Completes, ed. J. Massin (1967), vol. 2, p. 569.

A NEW PARADIGM FOR PRESERVATION

Tersh Boasberg

1. Survey by National Trust for Historic Preservation, 1991.

2. United Artists Theater Circuit v. City of Philadelphia, ___Pa.___, 595 A.2d 6 (1991).

3. Robert E. Stipe, "Preserving Historical and Cultural Landscapes: Some Emerging Issues," Vincent Lecture, School of Environmental Design, University of Georgia, May 17, 1989.

4. Ibid.

5. Tim Redmond and David Goldsmith, "The End of the High-Rise Jobs Myth," *Planning* (April 1986): 19.

6. Graham Ashworth, "A New Land Use Ethic for the U.S.A.," lecture, Leesburg, Virginia, 1987.

A GLOBAL PERSPECTIVE ON AMERICAN HERITAGE

David Lowenthal

1. Robert R. Garvey, Jr., "Europe Protects Its Monuments" and "Findings and Recommendations," in *With Heritage So Rich* (New York: Random House, 1966), pp. 151–61, 203–11.

2. Thomas J. Colin, "Heroic Efforts," *Historic Preservation* (November–December 1989): 4.

3. Ralph Waldo Emerson, "English Traits" (1856), in *The Portable Emerson* (New York: Viking, 1946), p. 425.

4. Jim Murphy, Henley Centre for Forecasting, quoted in *The Observer* (London) (December 10, 1989): 16.

5. P. J. O'Keefe and L. V. Prott, *Law and the Cultural Heritage*, vol. 1 (Abingdon, England, 1984), vol. 3 (London: Butterworths, 1989); vols. 2, 4, 5 forthcoming.

6. George Phillipson, quoted in John Young, "Stable Ruins Win Dubious Honour," *The Times* (London) (November 14, 1991): 3.

7. David Lowenthal, "British National Identity and the English Landscape," *Rural History* 2 (1991): 205–30.

8. Ian Rolfe, "Fossil Trade," *New Scientist* (June 22, 1990): 76; William Brown, "Export Control on Works of Nature Rejected," *New Scientist* (August 17, 1991): 7.

9. João Rosado Correia, "Protection of the Historical Landscape in the Planning Scheme of Montsaraz." Paper given at the Council of Europe colloquy on Management of Public Access to the Heritage Landscape, Dublin, September 16, 1991.

10. David Lowenthal, "Conserving the Heritage: Anglo-American Comparisons," in John Patten, ed., *The Expanding City: Essays in Honour of Jean Gottmann* (London: Academic Press, 1983), pp. 225–76.

11. Graeme Davison and Chris McConville, eds., *A Heritage Handbook* (North Sydney, Australia, 1991); John Rickard and Peter Spearitt, eds., "Packaging the Past? Public Histories," *Australian Historical Studies* 24, no. 96 (1991).

12. Stanley Baldwin, *On England and Other Addresses* (London, 1926), p. 1.

13. J. G. A. Pocock, "England," in Orest Ranum, ed., *National Consciousness, History, and Political Culture in Early-Modern Europe* (Baltimore: Johns Hopkins University Press, 1975), p. 100.

14. Diane Ravitch, "Multiculturalism: E Pluribus Plures," *American Scholar* 59 (1990): 337–54.

15. Wilbur Zelinsky, "Seeing Beyond the Dominant Culture," *Places* 7, no. 1 (1990): 32–35.

16. Olgierd Czerner, "Communal Cultural Heritage in a Unified Europe." Speech at Poland/ICOMOS meeting, June 1990, excerpted in *ICOMOS News* 1 (March 1991): 25.

17. Pierre Ryckmans, *The Chinese Attitude Towards the Past* (Canberra: Australian National University, 1986); Wang Gungwu, "Loving the Ancient in China," in Isabel McBryde, ed., *Who Owns the Past?* (Melbourne: Oxford University Press, 1985), pp. 175–95; Joseph A. Reaves, "The 'Uglification' of Beijing's Past Glory," *Preservation News* (July 1987): 5.

18. F. W. Mote, "A Millennium of Chinese Urban History: Form, Time, and Space Concepts in Soochow," *Rice University Studies* 59, no. 4 (1973): 49–53.

19. Karl Marx, "The Eighteenth Brumaire of Louis Napoleon" (1852), in *Selected Writings of Karl Marx* (Oxford, 1977), p. 100.

20. Jane Jacobs, *The Death and Life of Great American Cities* (New York: Random House, 1961).

21. Rudy J. Koshar, "Altar, Stage and City: Historic Preservation and Urban Meaning in Nazi Germany," *History and Memory* 3 (1991): 30–59.

NEW DIMENSIONS FOR HOUSE MUSEUMS
Neil W. Horstman

1. Jack G. Waite and Paul R. Huey, *Washington's Headquarters, the Hasbrouck House: An Historic Structure Report* (Albany, New York: New York State Historic Trust, 1971)

2. Ann Pamela Cunningham, farewell address recorded in minutes of the Mount Vernon Ladies' Association of the Union, June 1874, p. 5.

3. William J. Murtagh, *Keeping Time: The History and Theory of Preservation in America* (Pittstown, New Jersey: Main Street Press, 1988).

4. Dennis J. Pogue, *King's Reach and 17th Century Plantation Life* (Annapolis, Maryland: Maryland Historical and Cultural Publications, 1990), p. 15.

REVISITING PAST REHABILITATION PRACTICES
E. Blaine Cliver

The author is indebted to Irving Haynes, FAIA, for his thoughts and contributions to this article.

ARCHEOLOGY IN THE NEXT 25 YEARS
Hester A. Davis

1. William D. Lipe and Alexander J. Lindsey, Jr., *Proceedings of the 1974 Cultural Resource Management Conference* (Flagstaff: Museum of Northern Arizona, 1974), Technical Series no. 14.

2. Harvey Arden, "An Indian Cemetery Desecrated: Who Owns the Past?" *National Geographic* (March 1989): 376–92.

3. Charles R. McGimsey III, *Public Archeology* (New York: Academic Press, 1972), p. 3.

4. William H. Marquardt, *Regional Centers in Archaeology: Prospects and Problems* (Columbia, Missouri: Missouri Archaeological Society, 1977), Research Series no. 14.

5. Edward B. Jelks, *Curation of Archeological Collections of the Southwest Division of the U.S. Army Corps of Engineers* (Report for Southwest Division, U.S. Army Corps of Engineers, 1989); Michael Trimble and Thomas B. Meyers, *Saving the Past from the Future: Archeological Curation in the St. Louis District of the U.S. Army Corps of Engineers* (Report for St. Louis District, U.S. Army Corps of Engineers, 1991).

6. McGimsey, *Public Archeology*, p. 5.

KEEPERS OF THE NATIVE TREASURES
Dean B. Suagee

1. Cherokee Nation v. Georgia, 30 U.S. (5 Pet.) 1, 17 (1831); Oklahoma Tax Commission v. Citizen Band Potawatomi Indian Tribe of Oklahoma, ___ U.S. ___, 112 L.Ed.2d 1112, 1119 (1991).

2. United States v. Wheeler, 435 U.S. 313, 323–24 (1978). See also Felix Cohen, *Handbook of Federal Indian Law* (Charlottesville, Virginia: Michie, Bobbs-Merrill, 1982), pp. 229–35.

3. For example, Navajo Nation Cultural Resources Protection Act, Tribal Council Resolution CMY-19-88; and Colville Cultural Resources Protection Ordinance, both reprinted in *Preservation on the Reservation: Native Americans, Native American Lands, and Archaeology*, ed. A. Klesert (Window Rock, Arizona: Navajo Nation Archeology Depart-

ment, with Navajo Nation Historic Preservation Department, 1990); and A. Downer, Navajo Nation Papers in Anthropology, no. 26 (1990), pp. 433–65. Many tribes have a standing committee of the tribal governing body that deals with cultural issues, whether or not tribal legislation has been enacted.

4. See Cohen, *Handbook of Federal Indian Law*, pp. 62–206.

5. The grant of jurisdiction in the statute commonly known as Public Law 280, Act of Aug. 15, 1953, ch. 505, 67 Stat. 588 (codified as amended at 18 U.S.C. §1162, 25 U.S.C. §§1321–26, 28 U.S.C. §§1360, 1360 note), has been construed not to include civil regulatory jurisdiction. Bryan v. Itasca County, 426 U.S. 373 (1976); California v. Cabazon Band of Mission Indians, 480 U.S. 202 (1987). As amended in 1968, the assumption of jurisdiction by a state now requires tribal consent. 25 U.S.C. §1326. See also Cohen, *Handbook of Federal Indian Law*, pp. 362–76.

6. Pub. L. No. 89–644, 80 Stat. 915 (codified as amended at 16 U.S.C. §§470 to 470w–6).

7. Pub. L. No. 96–515, §101(a), 94 Stat. 2988 (codified at 16 U.S.C. §470–1).

8. Pub. L. No. 96–515, §201(a) (codified at 16 U.S.C. §470a(d)(3)(B)). In all, there were three express references to Indian tribes in the 1980 amendments, the third being in the definitions section of the NHPA. Pub. L. 96–515, §501 (codified at 16 U.S.C. §470w(4)).

9. Interior and Related Agencies Appropriations Act, Pub. L. No. 101–121, 103 Stat. 701. The floor amendment was sponsored by Senator Wyche Fowler (D-Georgia).

10. S. Rep. No. 85, 101st Cong., 1st Sess., at 21–22.

11. U.S. Department of the Interior, National Park Service, *Keepers of the Treasures: Protecting Historic Properties and Cultural Traditions on Indian Lands* (Washington, D.C.: U.S. Government Printing Office, 1990).

12. Ibid., p. 181. The secretary of the interior's 20th anniversary report on the National Historic Preservation Act includes a similar recommendation, on pp. 34–35.

13. Ibid., p. 177.

14. Safe Drinking Water Act Amendments of 1986, Pub. L. No. 99–339, §302(a), 100 Stat. 665 (codified at 42 U.S.C. §300j–11(1988)); Clean Water Act Amendments of 1987, Pub. L. No. 100–4, §506, 101 Stat. 76, amended by Pub. L. No. 100–581, §207, 102 Stat. 2940 (codified at 33 U.S.C. §1377 (1988)); Superfund Amendments and Reauthoriza-

tion Act of 1986, Pub. L. No. 99–499, §207(e), 100 Stat. 1706 (codified at 42 U.S.C. §9626 (1988)); Clean Air Act Amendments of 1990, Pub. L. No. 101–549, §107, 104 Stat. 2399 (codified at 42 U.S.C. §7601(d)).

15. S. 684, introduced March 19, 1991, sponsored by Senator Wyche Fowler, 137 Cong. Rec. S. 3567 (daily ed., March 19, 1991). A bill containing similar provisions for tribal programs was introduced in the 101st Congress, before the preparation of *Keepers of the Treasures*. S. 1579, introduced August 4, 1989.

16. Cohen, *Handbook of Federal Indian Law*, pp. 797–810.

17. U.S. Library of Congress, in cooperation with the American Folklife Center, *Cultural Conservation: The Protection of Cultural Heritage in the United States*, coordinated by Ormond H. Loomis, 1983, p. v. *Cultural Conservation* recommended that "folklife and related traditional lifeways" be treated as cultural resources for purposes of the National Historic Preservation Act.

18. Parris Butler of the Fort Mohave Tribe, quoted in *Keepers of the Treasures*, p. 5.

19. Governor Calvin Tafoya, Santa Clara Pueblo, quoted in *Keepers of the Treasures*, p. 5.

20. S.J. Res. 102, August 11, 1978, Pub. L. 95–341, 92 Stat. 469 (codified in part at 42 U.S.C. §1996n). The quoted language is from one of the uncodified "whereas" clauses.

21. Calvin Martin, "The Metaphysics of Writing Indian-White History," in Calvin Martin, ed., *The American Indian and the Problem of History* (New York: Oxford University Press, 1987).

22. Christopher Vecsey, "Envision Ourselves Darkly, Imagine Ourselves Richly," in Martin, *The American Indian*, p. 125.

23. Ellen Hays, Tlingit-Haida, quoted in *Keepers of the Treasures*, p. 14.

24. *Keepers of the Treasures*, p. 67.

25. In the first year of funding, fiscal 1990, tribes submitted 270 applications requesting a total of $10 million. Of these applications, 137 were proposals for the development of tribal historic preservation plans, ordinances, and offices; 139 were education-related proposals for language preservation, oral history, tribal-specific curriculum development, and archives and museum projects; 64 were proposals for identification of on- and off-reservation sites of religious and historical significance; and 31 were proposals for training

tribal members in preservation and archeological skills to lessen reliance on non-Indians. In the second year of funding, fiscal 1991, Congress increased the appropriations for grants to tribes to $750,000. Tribal applications were similarly varied.

26. See *Keepers of the Treasures,* p. 169.

27. W. Richard West, "From *Cherokee Nation v. Georgia* to the National Museum of the American Indian: Images of Indian Culture," 15 Amer. Indian L. Rev. 409 (1991). The establishment of this new museum was authorized in the National Museum of the American Indian Act, Pub. L. No. 101–185, 103 Stat. 1336 (1989) (codified at 20 U.S.C. §§ 80q to 80q–15).

28. Pub. L. No. 92–203, 85 Stat. 688 (codified as amended at 43 U.S.C. §§1601–1629e). See also Cohen, *Handbook of Federal Indian Law,* pp. 739–70.

29. Thomas R. Berger, *Village Journey: The Report of the Alaska Native Review Commission* (New York: Hill and Wang, 1985). See also Julia A. Bowen, "The Option of Preserving a Heritage: The 1987 Amendments to the Alaska Native Claims Settlement Act," 15 Amer. Indian L. Rev. 391 (1991).

30. Native village sovereignty over cultural artifacts has been upheld by the courts. Chilkat Indian Village v. Johnson, 870 F.2d 1469 (9th Cir. 1989).

31. Cohen, *Handbook of Federal Indian Law,* pp. 797–810. See also Haunani-Kay Trask, "From a Native Daughter," in Martin, *The American Indian.*

32. State of Hawaii, Office of Hawaiian Affairs, "Native Hawaiian Historic Preservation Task Force: Interim Report, as Requested by HCR [House Concurrent Resolution] 136" (1989).

33. National Museum of the American Indian Act, Pub. L. No. 101–185 (codified at 16 U.S.C. §§ 80q–9, 80q–11).

34. Native American Grave Protection and Repatriation Act (NAGPRA) of 1990, Pub. L. No. 101–601, 104 Stat. 3048 (to be codified at 25 U.S.C. §§3001–3013).

35. 16 U.S.C. §470f.

36. 36 C.F.R. Part 800.

37. 36 C.F.R. §800.1(c)(2)(iii).

38. Ibid.

39. Section 7 of the pending legislation would provide for this. S. 684, supra note 15.

40. The term "Indian country" is defined in federal law to include all lands within the limits of any Indian reservation, all dependent Indian communities, and all Indian allotments. 18 U.S.C. § 1151.

41. U.S. Department of the Interior, National Park Service, *Guidelines for Evaluating and Documenting Cultural Properties,* National Register Bulletin no. 38.

42. 16 U.S.C. §470h–2.

43. Pub. L. No. 96–95, 93 Stat. 721 (codified at 16 U.S.C. §§470aa–470 ll); the uniform regulations codified at 18 C.F.R. Part 1312, 32 C.F.R. Part 229, 36 C.F.R. Part 296, and 43 C.F.R. Part 7. A.R.P.A. provides that, before issuance of a permit to conduct archeological work at a site that has religious or cultural importance for an Indian tribe, federal land management agencies must give notice to any such tribe. The uniform regulations require that federal land management agencies initiate communication with tribes having aboriginal or historic ties to lands under federal agency jurisdiction so that they will have sufficient information to enable them to comply with the notice requirement.

44. 485 U.S. 439 (1988).

45. Ibid., at 472 (Brennan, J., dissenting).

46. Vine Deloria, "Sacred Lands and Religious Freedom," 16 NARF [Native American Rights Fund] L.Rev. 2 (Summer 1991).

47. See *Keepers of the Treasures,* pp. 18–32.

AMERICA'S RURAL HERITAGE
Samuel N. Stokes

I am indebted to H. Grant Dehart, Marilyn Fedelchak, Mary M. Humstone, Shelley Mastran, and Elizabeth Watson, all of whom have given considerable thought to rural historic preservation needs and shared their ideas with me freely for this essay. While archeological remains, folkways, and natural areas are all integral to our rural heritage, this essay focuses on historic buildings and structures and cultural landscapes. "Rural" is defined loosely as any area, beyond the city and its suburbs, where a significant portion of the local economy is based on agriculture or the use of natural resources.

1. There is one good publication on the subject: *Guidelines for Evaluating and Documenting Rural Historic Landscapes,* National Park Service, Linda Flint McClelland et al., National Register Bulletin no. 30 (Washington, D.C.: U.S. Government Printing Office, 1990).

2. Land Trust Alliance, news release, June 26, 1991.

3. Telephone conversation with Mary M. Humstone, National Trust for Historic Preservation, February 1, 1992.

4. Michael T. Gunn, "Bonaparte, Iowa: Rebirth of a Small Town," *Main Street News* (November 1990).

5. Marilyn Fedelchak et al., *A Thirst for History: An Assessment of the Compatibility of Federal Rural Development Programs and Historic Preservation* (Washington, D.C.: National Trust for Historic Preservation, 1991), p. 133.

6. Ibid., pp. 72, 133.

7. Robert D. Yaro et al., *Dealing with Change in the Connecticut River Valley: A Design Manual for Conservation and Development* (Amherst, Massachusetts: Center for Rural Massachusetts, 1988), p. 13.

8. For a full explanation of the techniques described in this and the next two paragraphs, see Samuel N. Stokes et al., *Saving America's Countryside: A Guide to Rural Conservation* (Baltimore: Johns Hopkins University Press for National Trust for Historic Preservation, 1989), pp. 144–53.

9. See Peter H. Brink and H. Grant Dehart, "Introduction"; and W. Brown Morton III, "Forging New Values in Uncommon Times," *Past Meets Future*, pp. 18, 38–39.

10. Robert G. Healy and John S. Rosenberg, *Land Use and the States* (Baltimore: Johns Hopkins University Press, 1979), pp. 259–62.

11. *Developments: Newsletter of the National Growth Management Leadership Project* (Summer 1991), chart opposite p. 17.

12. *A Thirst for History*, pp. 133–34.

WHEN THE PRESENT BECOMES THE PAST
Richard Longstreth

I am grateful to a number of people who gave me information and insights that were useful in this essay: Stephen Dennis, Teresa Grimes, Steven Levin, Chester Liebs, Gwen Marcus, Christopher Martin, Richard Striner, Ann Swallow, de Teel Patterson Tiller, Michael Tomlan, Richard Wagner, Diane Wray, and Nancy Witherell.

1. This sentiment was seldom expressed in print by more than passing inferences. For an exception, unusual too because of its recent vintage, see Allan Greenberg, "Why Preserve Old Buildings?," *Connecticut Preservation News* 14 (March–April 1991): 1–3.

2. For purposes of discussion here, I use the term "recent past" to indicate a period characterized by attitudes and practices that differ in some substantial way from those now current but that remain within living memory of many people. It is, of course, impossible to establish precise points at which such a period begins or ends, but for present-day purposes, the time frame would certainly encompass the mid-20th century—that is, from the 1930s through the 1960s.

3. One of the earliest calls in writing for preservationists to address work of the mid-20th century came from Chester Liebs. See his "Accepting Our Aging Century," *Possibilities* 1, no. 3 (1976): 1; and "Remember Our Not-So-Distant Past," *Historic Preservation* 30 (January–March 1978): 30–35. For recent examples, see "Razing Youngsters," *Preservation News* 30 (January 1990): 4; and Grace Gary, "It's Time to Evaluate Our Past," *Preservation News* 30 (December 1990): 4.

Probably the most ambitious local project to date has been the creation of the so-called Art Deco District, comprising some 20 square blocks in Miami Beach. For a detailed account, written by the architect of the initiative, see Barbara Baer Capitman, *Deco Delights* (New York: E. P. Dutton, 1988). Elsewhere the focus tends to be on individual properties, but seldom on post–World War II work. The Los Angeles Conservancy has compiled a list of more than 350 buildings, vernacular as well as high style, constructed in its metropolitan area between the mid-1940s and mid-1960s, and it has taken steps to save threatened examples among them. The Denver-based Modern Architecture Preservation League is perhaps unique in addressing modernist work beyond the realm of Art Deco as its primary mission.

4. For further discussion, see Richard Longstreth, "The Significance of the Recent Past," *APT Bulletin* 23, no. 2 (1991): 12–24. Here, as well as in that essay, I use the term "historic" to denote both tangible and intangible attributes of things. The practice in preservation of limiting "historical significance" to the associational realm and using "architectural significance" to define the physical realm (where does one place works of engineering, gardens, parkways, or the cultural landscape generally?) is arcane and needlessly divisive because knowledge of one is often central to understanding the other.

5. Ironically, the "historic" landscape that is the focus of some studies often has been shaped to a considerable degree by preservation efforts over the past century, yet such changes tend to be ignored. As an example, see Christopher Weeks, *Where Land and Water Intertwine: An Architectural History of Talbot County, Maryland* (Baltimore: Johns

Hopkins University Press, 1984). The author pays scant attention to how places in this Eastern Shore area have been transformed through gentrification beginning in the late 19th century. Many properties whose character owes at least as much to that still continuing process as to their initial period of development are presented as if they had changed little since the time when they were built. Scholarly studies focusing on how preservation has altered the historic landscape are rare. For an exception, see William Butler, "Another City upon a Hill: Litchfield, Connecticut and the Colonial Revival," in Alan Axelrod, ed., *The Colonial Revival in America* (New York: W. W. Norton, 1985), pp. 15–51.

6. Since 1980 protection has been secured for numerous buildings erected in the Washington area after 1930, including a public school in Greenbelt, Maryland (1936–37); a radio transmitting facility in Wheaton, Maryland (1939); National Airport in Arlington, Virginia (1939–40); and, in the District of Columbia, two prototypical drive-in shopping centers (1930, 1935–36); the Greyhound Bus depot (1939–40); model low- and middle-income housing projects for blacks (1935–38, 1942–46); and the region's first branch department store (1941–42) in the District of Columbia. Landmark applications also have been filed for warehouses serving the city's two leading department stores (1936–37, 1937–38). See also notes 7 and 16 below.

7. Only one building (the most elaborate) in the complex secured designation; most of the other units won a reprieve through an agreement between the owner and the county's Housing Opportunities Commission. The complex will remain rental property through the year 2010, by which time arguments over its historical significance will, one hopes, be in the distant past.

Less controversy surrounded the slightly earlier designation of Colonial Village in Arlington (1935–37), which served as the prototype for the Falkland and many others of its kind nationwide. Currently, landmark status is being pursued for another important Arlington example, Buckingham Village (1937–41).

8. For a critique of the case, see Richard Striner, "Hired 'Cains' Slew Abel's Governor Shepherd Apartments," *Trans-Lux* 3 (Summer 1985): 3; and letters sent in response, *Trans-Lux* 3 (Fall 1985): 2–3. Published by the Art Deco Society of Washington, *Trans-Lux* affords one of the most interesting chronicles of efforts to preserve the recent past that have occurred during the 1980s. See also Richard Striner, *Reflections on the Work of Historic Preservation in Washington. D.C.* (Washington, D.C.: Art Deco Society of Washington, 1990).

The building failed to win designation and was demolished soon thereafter, constituting one of the major losses of an individual work locally during the decade, as may be gathered from James M. Goode, *Best Addresses: A Century of Washington's Distinguished Apartment Houses* (Washington, D.C.: Smithsonian Institution Press, 1988), pp. 347–50.

9. Two articulate calls for greater attention to preserving such work are Bradford Perkins, "Preserving the Landmarks of the Modern Movement," *Architectural Record* (July 1981): 108–13; and Susan Benjamin, "Underage Landmarks," *Inland Architect* 32 (January–February 1988): 4, 7, 9. For a sampling of individual cases, see Claudia H. Allen, "N.Y.C. Backs Up Designation of Modern Landmark," *Preservation News* 23 (May 1983): 3; Michael Leccese, "Egos and the IDS," *Preservation News* 24 (May 1984): 1; Kim Keister, "Where Will It Go? Marin Countians Debate Jail at Wright Landmark," *Preservation News* 30 (April 1990): 3, 17; Eliot Nusbaum, "Urban Treasure?," *Des Moines Register* (March 2, 1992), pp. 1T, 2T.

The interest among architects in the future of modernist landmarks is considerable if coverage by the professional press is any indication. See, for example, the following pieces in *Progressive Architecture*: 66 (July 1985): 23; 66 (September 1985): 25; 67 (May 1986): 25, 32, 34; 68 (March 1987): 40, 43; 68 (April 1987): 27, 29; 69 (April 1988): 25, 30; 69 (September 1988): 24; 69 (October 1988): 34; 70 (April 1989): 24; 70 (October 1989): 27; 71 (March 1990): 23; 71 (April 1990): 30–31.

10. National Park Service, *Man in Space: Study of Alternatives* (Washington, D.C.: U.S. Government Printing Office, 1987); *Balancing Historic Preservation Needs with the Operation of Highly Technical or Scientific Facilities* (Washington, D.C.: Advisory Council on Historic Preservation, 1991).

11. For background, see Sam Hemingway, "Bank Building Not a Beauty, But Historic," *Burlington Free Press* (October 29, 1989); Amy Worden, "Vt. Defends Good Old Modern," *Preservation News* 30 (January 1990): 1, 6; "Bank's Image," *Burlington Free Press* (February 26, 1990); Ann E. Dolan, "Vt. National Gets Face Lift OK," *Burlington Free Press* (August 27, 1991); and Amy Worden, "Vermont Court Okays Aging of 1950s Bank," *Preservation News* 31 (December 1991): 16.

In this case, local decision makers, many of whom had some exposure to advanced course work in preservation, displayed an unusual degree of sophistication in avoiding the issue of taste. At the same time, a primary reason for saving the building was cited as being the rarity of its kind at the local and state levels. Had a number of comparable exam-

ples existed in Vermont, the initiative might never have advanced very far.

Sometimes efforts of this kind focus on land use concerns, pure sentiment, or other forces rather than an interest in the work itself. See, for example, Thomas W. Sweeney, "Detroiters Protest Ford Auditorium Razing Plan," *Preservation News* 30 (November 1990): 10.

One of the most interesting preservation efforts to focus on a work of the recent past is the campaign launched in 1973 to save Connecticut's Merritt Parkway (1934–40); see Arnold Berke, "Merritt Parkway Rebuilding Plan Sparks Opposition," *Preservation News* 30 (July 1990): 1, 3; Catherine Lynn, "Golden Anniversary for the Merritt Parkway," and "Department of Transportation Presents Preliminary Merritt Road-Widening Studies," *Connecticut Preservation News* 13 (September–October 1990): 1–2, 4–5; Lynn, "Nominating Merritt Parkway to National Register Brings New Information to Light," *Connecticut Preservation News* 14 (January–February 1991): 3–4; and Lynn, "Preservation Week 1991: Merritt Parkway Listed on National Register," *Connecticut Preservation News* 14 (May–June 1991): 1–2.

12. For background, see Arnold Berke, "A Ford Plant in Their Future? Rehab of Landmark Factory Sparks Discord," *Preservation News* 29 (March 1989): 3, 23; and Richard Striner, "Disgrace in Alexandria: The Architectural Mutilation of the Old Ford Plant," *Trans-Lux* 7 (Spring 1989): 4–6.

13. A number of historians who have been instrumental in the study of vernacular architecture during the last 10 to 15 years began their careers in state preservation offices. A by no means comprehensive list would include Catherine Bishir, Edward Chappell, Chester Liebs, Carl Lounsbury, Orlando Ridout V, Dell Upton, and Camille Wells. While some scholars of distinction remain with preservation offices, many more have left, a trend that reflects conditions discussed in the following paragraph.

14. See, for example, Joseph A. Tainter and G. John Lucas, "Epistemology of the Significance Concept," *American Antiquity* 48 (October 1983): 707–19.

The extent to which the salient issues can get clouded in such cases is illustrated by an opinion piece written by architecture professor and *Washington Post* columnist Roger K. Lewis. See Lewis, "Save a Shopping Center? What's Next?," reprinted in *Preservation News* 26 (November 1986): 5. From a national perspective, the complex in question stands among the most historically significant commercial properties in the city. It has been saved and was restored in 1991 to serve once again as a locus of trade for the community.

15. A comprehensive bibliography on the subject would be vast; only a few indications of the scope of work are given here, and for purposes of brevity, I have not cited any of the numerous articles or scholarly papers that address aspects of the subject.

Detailed studies of architects, a major portion of whose practice occurred after World War II, include Thomas S. Hines, *Richard Neutra and the Search for Modern Architecture* (New York: Oxford University Press, 1982); Franz Schulze, *Mies van der Rohe: A Critical Biography* (Chicago: University of Chicago Press, 1985); David G. DeLong, *Bruce Goff: Toward an Absolute Architecture* (New York and Cambridge, Massachusetts: Architectural History Foundation and MIT Press, 1988); Carol Herselle Krinsky, *Gordon Bunshaft of Skidmore, Owings and Merrill* (New York and Cambridge, Massachusetts: Architectural History Foundation and MIT Press, 1988); Victoria Newhouse, *Wallace K. Harrison, Architect* (New York: Rizzoli, 1989); and David Brownlee and David G. DeLong, *Louis I. Kahn: In the Realm of Architecture* (New York: Rizzoli, 1991).

Building-type studies include Chester H. Liebs, *Main Street to Miracle Mile: American Roadside Architecture* (Boston: New York Graphic Society, 1985)(hereafter cited as *Main Street*); Philip Langdon, *Orange Roofs, Golden Arches: The Architecture of American Chain Restaurants* (New York: Alfred A. Knopf, 1986); Rosemarie Haag Bletter et al., *Remembering the Future: The New York World's Fair from 1939 to 1961* (New York: Rizzoli, 1989); John Coolidge, *Patrons and Architecture: Designing Art Museums in the 20th Century* (Fort Worth: Amon Carter Museum, 1989); and Esther McCoy et al., *Blueprints for Modern Living: History and Legacy of the Case Study Houses* (Cambridge, Massachusetts: MIT Press, 1989).

16. The landmark nomination for the church was submitted by the Committee of 100 on the Federal City in January 1991. Not surprisingly, it elicited numerous informal comments from people to the effect that they did not "like" brutalist architecture. Not all parties share this view. The building was the only one erected since the Depression to be covered in the Commission of Fine Arts's detailed surveys of 16th Street and Massachusetts Avenue. See Sue A. Kohler and Jeffrey R. Carson, *Sixteenth Street Architecture*, 2 vols. (Washington, D.C.: U.S. Government Printing Office, 1978, 1988), vol. 2, pp. 106–19; and Benjamin Forgey, "Thoroughly Modern History," *Washington Post* (January 11, 1992), pp. G1, G5.

17. Certainly there is no need to modify the broad criteria established for the National Register of Historic Places to encompass the recent past.

18. Extensive use of such covenants began to be devised as a key component of planned residential communities at the turn of the 20th century. These provisions were then considered an important marketing tool for attracting purchasers, and they are a central reason why the communities remain highly desirable places of residence today. Study of the subject from a historical perspective has only begun. See, for example, Patricia Burgess Stach, "Deed Restrictions and Subdivision Development in Columbus, Ohio, 1900–1970," *Journal of Urban History* 15 (November 1988): 42–48; William S. Worley, *J. C. Nichols and the Shaping of Kansas City* (Columbia: University of Missouri Press, 1990), especially chapters 5 and 6; and Roberta M. Moudry, "Gardens, Houses and People: The Planning of Roland Park, Baltimore" (M.A. thesis, Cornell University, 1990).

19. For a thoughtful introductory discussion of the subject, see Marc Denhez, "Bungalows in Trouble," *Canadian Heritage* 15 (Winter 1989): 16–19, 21.

20. Little has been published on the history of major outlying business centers developed during the 1920s. The comments offered here are derived from some 20 years of first-hand observation in a number of these places and from recent research for a forthcoming study of decentralization in retail development between the 1920s and 1950s.

21. For background on the district, see Arlington County, Virginia, Historic Affairs and Landmark Review Board, "Historic Resources in the Clarendon Commercial District," May 1985.

22. For background on the program, see Linda S. Glisson, *Main Street: Open for Business* (Washington, D.C.: National Trust for Historic Preservation, 1984); *Main Street at Work*, 3 vols. (Washington, D.C.: National Trust for Historic Preservation, 1985); and Richard Wagner and Ted Miller, *Revitalizing Downtown, 1976–1986* (Washington, D.C.: National Trust for Historic Preservation and Urban Institute, 1988). The National Main Street Center established an urban demonstration program in 1984; however, activity in this sphere has been limited. One of that program's most innovative projects has been in the Nob Hill district of Albuquerque, revitalizing arterial development from the mid-20th century along former U.S. Route 66. For background, see City of Albuquerque, New Mexico, Economic Development Department, "Nob Hill Study," prepared by Mary Rose Szoka, February 1985.

23. See, for example, "Drafting and Design Problems: Neighborhood Shopping Centers," *Architectural Record* 71 (May 1932): 325; Clarence S. Stein and Catherine Bauer, "Store Buildings and Neighborhood Shopping Centers," *Ar-*

chitectural Record 75 (February 1934): 178; and Jack Hyde, "Find Concern in Retailing on Hollywood Boulevard," *Women's Wear Daily* (July 6, 1949), p. 13.

24. Liebs, *Main Street*, provides an excellent introduction to understanding the historical significance of such work. See also Daniel Prosser, "The New Downtowns: Commercial Architecture in Suburban New Jersey, 1920–1970," in Joel Schwartz and Daniel Prosser, eds., *Cities of the Garden State: Essays in the Urban and Suburban History of New Jersey* (Dubuque: Kendall/Hunt Publishing, 1977), pp. 109–28. Scholarship on the history of the shopping center remains in a nascent phase. See Meredith L. Clausen, "Northgate Regional Shopping Center—Paradigm from the Provinces," *Journal of the Society of Architectural Historians* 43 (May 1984): 144–61; Howard Gillette, Jr., "The Evolution of the Planned Shopping Center in Suburb and City," *Journal of the American Planning Association* 51 (Autumn 1985): 449–60; Richard Longstreth, "J. C. Nichols, the Country Club Plaza, and Notions of Modernity," *Harvard Architectural Review* 5 (1986): 120–35; and Richard Longstreth, "The Planned Neighborhood Shopping Center in Washington, D.C., 1930–1941," *Journal of the Society of Architectural Historians* 51 (March 1992): 5–34.

25. Equally significant is the fact that the findings of these surveys are published and widely distributed to a local audience. To date, the Rhode Island office has issued more than 40 such books. Examples that give a detailed discussion of the recent past include Richard Longstreth, *East Providence . . .* (1976); Stephen J. Roper, *Pawtucket . . .* (1978); Ellen Weiss, *North Kingston . . .* (1979); Robert Elliot Freeman, *Cranston . . .* (1980); Robert O. Jones, *Warwick . . .* (1981); and Wm McKenzie Woodward and Edward F. Sanderson, *Providence . . .* (1986). A few published surveys focus on communities of comparatively recent vintage and include work built through the early 1950s. See, for example, *Historic Preservation Inventory and Planning Guidelines: City of Las Vegas* (San Francisco: Charles Hall Page and Associates, 1978).

States and localities west of the Mississippi River have tended to be the most aggressive in examining the recent past, a mode some preservationists elsewhere attribute to the absence of much that is older. People prone to such snobbery should remember that their European colleagues traditionally have felt much the same way toward almost everything in the United States.

26. Regulations drawn under these circumstances would have to ensure that the concern for inclusiveness did not lead to ossifying the district and hence preclude needed and acceptable changes to its fabric. Perhaps a moratorium of 10

to 20 years could be provided so as to avoid arguments over alterations to more or less contemporary work.

27. At the local level, the Capitol Hill Historic District has never had an official period of significance. The end date of 1920 was determined through an appeals hearing in a federal tax incentives case and stood as precedent because of the unique relationship between "local" and "state" preservation programs in Washington. The problem, nevertheless, extends far beyond such special circumstances.

28. To my knowledge, no one has proposed nominating any of these properties to the National Register; however, some effort has been made to protect the Virginia building.

TANGIBLE TEXTS FOR HERITAGE EDUCATION
Kathleen A. Hunter

1. U.S. Department of Education, National Commission on Excellence, *A Nation at Risk: The Imperative for Educational Reform* (Washington, D.C.: U.S. Government Printing Office, 1983).

2. Lynne V. Cheney, *American Memory: A Report on the Humanities in the Nation's Public Schools* (Washington, D.C.: National Endowment for the Humanities, 1987).

3. *A Nation at Risk.*

4. Lamar Alexander, *America 2000: An Education Strategy Sourcebook* (Washington, D.C.: U.S. Government Printing Office, 1991).

5. National Endowment for the Arts, *Towards Civilization: A Report on Arts Education* (Washington: U.S. Government Printing Office, 1988).

6. Linda Symcox, *Crowning the Cathedral of Florence: Brunelleschi Builds His Dome. A Unit of Study for Grades 7–10* (Los Angeles: National Center for History in the Schools, University of California, Los Angeles, and National Endowment for the Humanities, 1991).

NATIONAL HISTORIC PRESERVATION ACT

of 1966, as amended (16 U.S.C. § 470)

SHORT TITLE; CONGRESSIONAL FINDING AND DECLARATION OF POLICY

(a) This subchapter may be cited as the "National Historic Preservation Act."

PURPOSE OF THE ACT

(b) The Congress finds and declares that—

(1) the spirit and direction of the Nation are founded upon and reflected in its historic heritage;

(2) the historical and cultural foundations of the Nation should be preserved as a living part of our community life and development in order to give a sense of orientation to the American people;

(3) historic properties significant to the Nation's heritage are being lost or substantially altered, often inadvertently, with increasing frequency;

(4) the preservation of this irreplaceable heritage is in the public interest so that its vital legacy of cultural, educational, aesthetic, inspirational, economic, and energy benefits will be maintained and enriched for future generations of Americans;

(5) in the face of ever-increasing extensions of urban centers, highways, and residential, commercial, and industrial developments, the present governmental and nongovernmental historic preservation programs and activities are inadequate to insure future generations a genuine opportunity to appreciate and enjoy the rich heritage of our Nation;

(6) the increased knowledge of our historic resources, the establishment of better means of identifying and administering them, and the encouragement of their preservation will improve the planning and execution of Federal and federally assisted projects and will assist economic growth and development; and

(7) although the major burdens of historic preservation have been borne and major efforts initiated by private agencies and individuals, and both should continue to play a vital role, it is nevertheless necessary and appropriate for the Federal Government to accelerate its historic preservation programs and activities, to give maximum encouragement to agencies and individuals undertaking preservation by private means, and to assist State and local governments and the National Trust for Historic Preservation in the United States to expand and accelerate their historic preservation programs and activities.

■ 16 U.S.C. § 470-1. DECLARATION OF POLICY OF THE FEDERAL GOVERNMENT

DECLARATION OF POLICY

It shall be the policy of the Federal Government, in cooperation with other nations and in partnership with the States, local governments, Indian tribes, and private organizations and individuals to—

(1) use measures, including financial and technical assistance, to foster conditions under which our modern society and

our prehistoric and historic resources can exist in productive harmony and fulfill the social, economic, and other requirements of present and future generations;

(2) provide leadership in the preservation of the prehistoric and historic resources of the United States and of the international community of nations;

(3) administer federally owned, administered, or controlled prehistoric and historic resources in a spirit of stewardship for the inspiration and benefit of present and future generations;

(4) contribute to the preservation of nonfederally owned prehistoric and historic resources and give maximum encouragement to organizations and individuals undertaking preservation by private means;

(5) encourage the public and private preservation and utilization of all usable elements of the Nation's historic built environment; and

(6) assist State and local governments and the National Trust for Historic Preservation in the United States to expand and accelerate their historic preservation programs and activities.

■ 16 U.S.C. § 470a. HISTORIC PRESERVATION PROGRAM

(a) National Register of Historic Places; designation of properties as historic landmarks; properties deemed included; criteria; nomination of properties by States, local governments or individuals; regulations

NATIONAL REGISTER OF HISTORIC PLACES, EXPANSION AND MAINTENANCE

(1)(A) The Secretary of the Interior is authorized to expand and maintain a National Register of Historic Places composed of districts, sites, buildings, structures, and objects significant in American history, architecture, archeology, engineering, and culture.

NATIONAL HISTORIC LANDMARKS, DESIGNATION

(B) Properties meeting the criteria for National Historic Landmarks established pursuant to paragraph (2) shall be designated as "National Historic Landmarks" and included on the National Register, subject to the requirements of paragraph (6). All historic properties included on the National Register on December 12, 1980, shall be deemed to be included on the National Register as of their initial listing for purposes of this subchapter. All historic properties listed in the Federal Register of February 6, 1979, as "National Historic Landmarks" or thereafter prior to the effective date of

this Act are declared by Congress to be National Historic Landmarks of national historic significance as of their initial listing as such in the Federal Register for purposes of this subchapter and sections 461 to 467 of this title; except that in cases of National Historic Landmark districts for which no boundaries have been established, boundaries must first be published in the Federal Register and submitted to the Committee on Energy and Natural Resources of the United States Senate and to the Committee on Interior and Insular Affairs of the United States House of Representatives.

CRITERIA FOR NATIONAL REGISTER AND NATIONAL HISTORIC LANDMARKS AND REGULATIONS

(2) The Secretary in consultation with national historical and archaeological associations, shall establish or revise criteria for properties to be included on the National Register and criteria for National Historic Landmarks, and shall also promulgate or revise regulations as may be necessary for—

(A) nominating properties for inclusion in, and removal from, the National Register and the recommendation of properties by certified local governments;

(B) designating properties as National Historic Landmarks and removing such designation;

(C) considering appeals from such recommendations, nominations, removals, and designations (or any failure or refusal by a nominating authority to nominate or designate);

(D) nominating historic properties for inclusion in the World Heritage List in accordance with the terms of the Convention concerning the Protection of the World Cultural and Natural Heritage;

(E) making determinations of eligibility of properties for inclusion on the National Register; and

(F) notifying the owner of a property, any appropriate local governments, and the general public, when the property is being considered for inclusion on the National Register, for designation as a National Historic Landmark or for nomination to the World Heritage List.

NOMINATIONS TO THE NATIONAL REGISTER

(3) Subject to the requirements of paragraph (6), any State which is carrying out a program approved under subsection (b) of this section, shall nominate to the Secretary properties which meet the criteria promulgated under subsection (a) of this section for inclusion on the National Register. Subject to paragraph (6), and any property nominated under this paragraph or under section 470h-2(a)(2) of this title shall be included on the National Register on the date

forty-five days after receipt by the Secretary of the nomination and the necessary documentation, unless the Secretary disapproves such nomination within such forty-five day period or unless an appeal is filed under paragraph (5).

NOMINATIONS FROM INDIVIDUALS AND LOCAL GOVERNMENTS

(4) Subject to the requirements of paragraph (6) the Secretary may accept a nomination directly from any person or local government for inclusion of a property on the National Register only if such property is located in a State where there is no program approved under subsection (b) of this section. The Secretary may include on the National Register any property for which such a nomination is made if he determines that such property is eligible in accordance with the regulations promulgated under paragraph (2). Such determination shall be made within ninety days from the date of the nomination unless the nomination is appealed under paragraph (5).

APPEALS OF NOMINATIONS

(5) Any person or local government may appeal to the Secretary a nomination of any historic property for inclusion on the National Register and may appeal to the Secretary the failure or refusal of a nominating authority to nominate a property in accordance with this subsection.

OWNER PARTICIPATION IN NOMINATION PROCESS

(6) The Secretary shall promulgate regulations requiring that before any property or district may be included on the National Register or designated as a National Historic Landmark, the owner or owners of such property, or a majority of the owners of the properties within the district in the case of an historic district, shall be given the opportunity (including a reasonable period of time) to concur in, or object to, the nomination of the property or district for such inclusion or designation. If the owner or owners of any privately owned property, or a majority of the owners of such properties within the district in the case of an historic district, object to such inclusion or designation, such property shall not be included on the National Register or designated as a National Historic Landmark until such objection is withdrawn. The Secretary shall review the nomination of the property or district where any such objection has been made and shall determine whether or not the property or district is eligible for such inclusion or designation, and if the Secretary determines that such property or district is el-

igible for such inclusion or designation, he shall inform the Advisory Council on Historic Preservation, the appropriate State Historic Preservation Officer, the appropriate chief elected local official and the owner or owners of such property, of his determination. The regulations under this paragraph shall include provisions to carry out the purposes of this paragraph in the case of multiple ownership of a single property.

REGULATIONS FOR CURATION, DOCUMENTATION, AND LOCAL GOVERNMENT CERTIFICATION

(7) The Secretary shall promulgate, or revise, regulations—

(A) ensuring that significant prehistoric and historic artifacts, and associated records, subject to section 470h-2 of this title, the Act of June 27, 1960 (16 U.S.C. 469c) (16 U.S.C. 469 et seq.), and the Archaeological Resources Protection Act of 1979 (16 U.S.C. 470aa and following) are deposited in an institution with adequate long-term curatorial capabilities;

(B) establishing a uniform process and standards for documenting historic properties by public agencies and private parties for purposes of incorporation into, or complementing, the national historical architectural and engineering records within the Library of Congress; and

(C) certifying local governments, in accordance with subsection (c)(1) of this section and for the allocation of funds pursuant to section 470c(c) of this title.

STATE HISTORIC PRESERVATION PROGRAMS

(b) Regulations for State Historic Preservation Programs; periodic evaluations and fiscal audits of State programs; administration of State programs; contracts and cooperative agreements with nonprofit or educational institutions; treatment of State programs as approved programs

(1) The Secretary, in consultation with the National Conference of State Historic Preservation Officers and the National Trust for Historic Preservation, shall promulgate or revise regulations for State Historic Preservation Programs. Such regulations shall provide that a State program submitted to the Secretary under this section shall be approved by the Secretary if he determines that the program—

DESIGNATION OF THE STATE HISTORIC PRESERVATION OFFICER (SHPO)

(A) provides for the designation and appointment by the Governor of a "State Historic Preservation Officer" to ad-

minister such program in accordance with paragraph (3) and for the employment or appointment by such officer of such professionally qualified staff as may be necessary for such purposes;

(B) provides for an adequate and qualified State historic preservation review board designated by the State Historic Preservation Officer unless otherwise provided for by State law; and

(C) provides for adequate public participation in the State Historic Preservation Program, including the process of recommending properties for nomination to the National Register.

REVIEW OF STATE PROGRAMS

(2) Periodically, but not less than every four years after the approval of any State program under this subsection, the Secretary shall evaluate such program to make a determination as to whether or not it is in compliance with the requirements of this subchapter. If at any time, the Secretary determines that a State program does not comply with such requirements, he shall disapprove such program, and suspend in whole or in part assistance to such State under subsection (d)(1) of this section, unless there are adequate assurances that the program will comply with such requirements within a reasonable period of time. The Secretary may also conduct periodic fiscal audits of State programs approved under this section.

SHPO RESPONSIBILITIES

(3) It shall be the responsibility of the State Historic Preservation Officer to administer the State Historic Preservation Program and to—

(A) in cooperation with Federal and State agencies, local governments, and private organizations and individuals, direct and conduct a comprehensive statewide survey of historic properties and maintain inventories of such properties;

(B) identify and nominate eligible properties to the National Register and otherwise administer applications for listing historic properties on the National Register;

(C) prepare and implement a comprehensive statewide historic preservation plan;

(D) administer the State program of Federal assistance for historic preservation within the State;

(E) advise and assist, as appropriate, Federal and State agencies and local governments in carrying out their historic preservation responsibilities;

(F) cooperate with the Secretary, the Advisory Council on Historic Preservation, and other Federal and State agencies local governments, and organizations and individuals to ensure that historic properties are taken into consideration at all levels of planning and development;

(G) provide public information, education, and training and technical assistance relating to the Federal and State Historic Preservation Programs; and

(H) cooperate with local governments in the development of local historic preservation programs and assist local governments in becoming certified pursuant to subsection (c) of this section.

ARRANGEMENTS WITH NONPROFIT ORGANIZATIONS

(4) Any State may carry out all or any part of its responsibilities under this subsection by contract or cooperative agreement with any qualified nonprofit organization or educational institution.

APPROVAL OF EXISTING PROGRAMS

(5) Any State historic preservation program in effect under prior authority of law may be treated as an approved program for purposes of this subsection until the earlier of—

(A) the date on which the Secretary approves a program submitted by the State under this subsection, or

(B) three years after December 12, 1980.

CERTIFICATION OF LOCAL GOVERNMENTS

(c) Certification of local governments by State Historic Preservation Officer; transfer of portion of grants; certification by Secretary; nomination of properties by local governments for inclusion on National Register

(1) Any State program approved under this section shall provide a mechanism for the certification by the State Historic Preservation Officer of local governments to carry out the purpose of this Act and provide for the transfer, in accordance with section 103(c), of a portion of the grants received by the States under this Act, to such local governments. Any local government shall be certified to participate under the provisions of this section if the applicable State Historic Preservation Officer, and the Secretary, certifies that the local government—

(A) enforces appropriate State or local legislation for the designation and protection of historic properties;

(B) has established an adequate and qualified historic

preservation review commission by State or local legislation;

(C) maintains a system for the survey and inventory of historic properties that furthers the purposes of subsection (b) of this section;

(D) provides for adequate public participation in the local historic preservation program, including the process of recommending properties for nomination to the National Register; and

(E) satisfactorily performs the responsibilities delegated to it under this subchapter.

Where there is no approved State program, a local government may be certified by the Secretary if he determines that such local government meets the requirements of subparagraphs (A) through (E); and in any such case the Secretary may make grants-in-aid to the local government for purposes of this section.

PARTICIPATION OF CERTIFIED LOCAL GOVERNMENTS IN NATIONAL REGISTER NOMINATIONS

(2)(A) Before a property within the jurisdiction of the certified local government may be considered by the State to be nominated to the Secretary for inclusion on the National Register, the State Historic Preservation Officer shall notify the owner, the applicable chief local elected official, and the local historic preservation commission. The commission, after reasonable opportunity for public comment, shall prepare a report as to whether or not such property, in its opinion, meets the criteria of the National Register. Within sixty days of notice from the State Historic Preservation Officer, the chief local elected official shall transmit the report of the commission and his recommendation to the State Historic Preservation Officer. Except as provided in subparagraph (B), after receipt of such report and recommendation, or if no such report and recommendation are received within sixty days, the State shall make the nomination pursuant to subsection (a) of this section. The State may expedite such process with the concurrence of the certified local government.

(B) If both the commission and the chief local elected official recommend that a property not be nominated to the National Register, the State Historic Preservation Officer shall take no further action, unless within thirty days of the receipt of such recommendation by the State Historic Preservation Officer an appeal is filed with the State. If such an appeal is filed, the State shall follow the procedures for making a nomination pursuant to subsection (a) of this section. Any report and recommendations made under this section shall be included with any nomination submitted by the State to the Secretary.

(3) Any local government certified under this section or which is making efforts to become so certified shall be eligible for funds under the provisions of section 470c(c) of this title, and shall carry out any responsibilities delegated to it in accordance with such terms and conditions as the Secretary deems necessary or advisable.

GRANTS AND LOANS

(d) Matching grants-in-aid to States for programs and projects; matching grant-in-aid to National Trust for Historic Preservation in the United States; program of direct grants for preservation of properties included on National Register; grants or loans to Indian tribes and ethnic or minority groups for preservation of cultural heritage

GRANTS TO STATES

(1) The Secretary shall administer a program of matching grants-in-aid to the States for historic preservation projects, and State historic preservation programs, approved by the Secretary and having as their purpose the identification of historic properties and the preservation of properties included on the National Register.

GRANTS TO THE NATIONAL TRUST

(2) The Secretary shall administer a program of matching grants-in-aid to the National Trust for Historic Preservation in the United States, chartered by sections 468 to 468e of this title, for the purposes of carrying out the responsibilities of the National Trust.

DIRECT GRANTS FOR THREATENED NATIONAL HISTORIC LANDMARKS, DEMONSTRATION PROJECTS, TRAINING, AND DISPLACEMENT PREVENTION

(3)(A) In addition to the programs under paragraphs (1) and (2), the Secretary shall administer a program of direct grants for the preservation of properties included on the National Register. Funds to support such program annually shall not exceed 10 per centum of the amount appropriated annually for the fund established under section 470h of this title. These grants may be made by the Secretary, in consultation with the appropriate State Historic Preservation Officer—

(i) for the preservation of National Historic Landmarks which are threatened with demolition or impairment and for the preservation of historic properties of World Heritage significance;

(ii) for demonstration projects which will provide information concerning professional methods and techniques having application to historic properties;

(iii) for the training and development of skilled labor in trades and crafts, and in analysis and curation, relating to historic preservation; and,

(iv) to assist persons or small businesses within any historic district included in the National Register to remain within the district.

GRANTS AND LOANS TO MINORITY GROUPS

(B) The Secretary may also, in consultation with the appropriate State Historic Preservation Officer, make grants or loans or both under this section to Indian tribes and to nonprofit organizations representing ethnic or minority groups for the preservation of their cultural heritage.

(C) Grants may be made under subparagraph (A)(i) and (iv) only to the extent that the project cannot be carried out in as effective a manner through the use of an insured loan under section 470d of this title.

PROHIBITION ON COMPENSATING INTERVENORS

(e) Prohibition of use of funds for compensation of intervenors in preservation program

No part of any grant made under this section may be used to compensate any person intervening in any proceeding under this subchapter.

GUIDELINES FOR FEDERAL AGENCY RESPONSIBILITIES

(f) Guidelines for Federal agency responsibility for agency-owned historic properties

In consultation with the Advisory Council on Historic Preservation, the Secretary shall promulgate guidelines for Federal agency responsibilities under section 470h-2 of this title.

PRESERVATION STANDARDS FOR FEDERALLY OWNED PROPERTIES

(g) Professional standards for preservation of federally owned or controlled historic properties

Within one year after December 12, 1980, the Secretary shall establish, in consultation with the Secretaries of Agriculture and Defense, the Smithsonian Institution, and the Administrator of the General Services Administration, professional standards for the preservation of historic properties in Federal ownership or control.

TECHNICAL ADVICE

(h) Dissemination of information concerning professional methods and techniques for preservation of historic properties

The Secretary shall develop and make available to Federal agencies, State and local governments, private organizations and individuals, and other nations and international organizations pursuant to the World Heritage Convention, training in, and information concerning, professional methods and techniques for the preservation of historic properties and for the administration of the historic preservation program at the Federal, State, and local level. The Secretary shall also develop mechanisms to provide information concerning historic preservation to the general public including students.

■ 16 U.S.C. § 470a-1. WORLD HERITAGE CONVENTION

U.S. PARTICIPATION IN WORLD HERITAGE CONVENTION

(a) United States participation

The Secretary of the Interior shall direct and coordinate United States participation in the Convention Concerning the Protection of the World Cultural and Natural Heritage, approved by the Senate on October 26, 1973, in cooperation with the Secretary of State, the Smithsonian Institution, and the Advisory Council on Historic Preservation. Whenever possible, expenditures incurred in carrying out activities in cooperation with other nations and international organizations shall be paid for in such excess currency of the country or area where the expense is incurred as may be available to the United States.

NOMINATION OF PROPERTY TO WORLD HERITAGE COMMITTEE

(b) Nomination of property to World Heritage Committee

The Secretary of the Interior shall periodically nominate properties he determines are of international significance to the World Heritage Committee on behalf of the United States. No property may be so nominated unless it has previously been determined to be of national significance. Each such nomination shall include evidence of such legal

protections as may be necessary to ensure preservation of the property and its environment (including restrictive covenants, easements, or other forms of protection). Before making any such nomination, the Secretary shall notify the Committee on Interior and Insular Affairs of the United States House of Representatives and the Committee on Energy and Natural Resources of the United States Senate.

NOMINATION OF NON-FEDERAL PROPERTY

(c) Nomination of non-Federal property to World Heritage Committee

No non-Federal property may be nominated by the Secretary of the Interior to the World Heritage Committee for inclusion on the World Heritage List unless the owner of the property concurs in writing to such nomination.

■ 16 U.S.C. § 470a-2. FEDERAL UNDERTAKINGS OUTSIDE UNITED STATES; MITIGATION OF ADVERSE EFFECTS

This text is referred to as "Section 402" of NHPA; it was designated as Section 402 of the NHPA Amendments of 1980, Pub. L. No. 96–515, December 12, 1980, 94 Stat. 3000.

FEDERAL UNDERTAKINGS OUTSIDE U.S.

Prior to the approval of any Federal undertaking outside the United States which may directly and adversely affect a property which is on the World Heritage List or on the applicable country's equivalent of the National Register, the head of a Federal agency having direct or indirect jurisdiction over such undertaking shall take into account the effect of the undertaking on such property for purposes of avoiding or mitigating any adverse effects.

■ 16 U.S.C. § 470b. REQUIREMENTS FOR AWARDING OF GRANT FUNDS

GRANTS REQUIREMENTS

(a) Grant applications; amounts; reports; conditions

No grant may be made under this subchapter—

(1) unless application therefor is submitted to the Secretary in accordance with regulations and procedures prescribed by him;
(2) unless the application is in accordance with the comprehensive statewide historic preservation plan which has been approved by the Secretary after considering its rela-

tionship to the comprehensive statewide outdoor recreation plan prepared pursuant to the Land and Water Conservation Fund Act of 1965 (78 Stat. 897) (16 U.S.C. 460l-4 of this title);

(3) for more than 50 per centum of the aggregate cost of carrying out projects and programs specified in section 470a(d)(1) and (2) of this title in any one fiscal year, except that for the costs of State or local historic surveys or inventories the Secretary shall provide 70 per centum of the aggregate cost involved in any one fiscal year.

(4) unless the grantee has agreed to make such reports, in such form and containing such information as the Secretary may from time to time require;

(5) unless the grantee has agreed to assume, after completion of the project, the total cost of the continued maintenance, repair, and administration of the property in a manner satisfactory to the Secretary; and

(6) until the grantee has complied with such further terms and conditions as the Secretary may deem necessary or advisable.

Except as permitted by other law, the State share of the costs referred to in paragraph (3) shall be contributed by non-Federal sources. Notwithstanding any other provision of law, no grant made pursuant to this subchapter shall be treated as taxable income for purposes of title 26.

WAIVER FOR THE NATIONAL TRUST

(b) Waiver

The Secretary may in his discretion waive the requirements of subsection (a), paragraphs (2) and (5) of this section for any grant under this subchapter to the National Trust for Historic Preservation in the United States, in which case a grant to the National Trust may include funds for the maintenance, repair, and administration of the property in a manner satisfactory to the Secretary.

(c) Repealed. Pub. L. No. 96–515, title II, 202(c), December 12, 1980, 94 Stat. 2993

MEETING THE REMAINING COST OF THE PROJECT

(d) Remaining cost of project

No State shall be permitted to utilize the value of real property obtained before October 15, 1966, in meeting the remaining cost of a project for which a grant is made under this subchapter.

■ 16 U.S.C. § 470b-1. GRANTS TO NATIONAL TRUST FOR HISTORIC PRESERVATION

APPORTIONMENT OF GRANTS

(a) Authority of Secretary of Housing and Urban Development; renovation or restoration costs; terms and conditions; amounts

The Secretary of Housing and Urban Development is authorized to make grants to the National Trust for Historic Preservation, on such terms and conditions and in such amounts (not exceeding $90,000 with respect to any one structure) as he deems appropriate, to cover the costs incurred by such Trust in renovating or restoring structures which it considers to be of historic or architectural value and which it has accepted and will maintain (after such renovation or restoration) for historic purposes.

AUTHORIZATION OF APPROPRIATIONS

(b) Authorization of appropriations

There are authorized to be appropriated such sums as may be necessary for the grants to be made under subsection (a) of this section.

■ 16 U.S.C. § 470c. APPORTIONMENT OF GRANT FUNDS

ASSISTANCE FROM OTHER FEDERAL PROGRAMS

(a) Assistance from other Federal programs

No grant may be made by the Secretary for or on account of any survey or project under this subchapter with respect to which financial assistance has been given or promised under any other Federal program or activity, and no financial assistance may be given under any other Federal program or activity for or on account of any survey or project with respect to which assistance has been given or promised under this subchapter.

APPORTIONMENT OF PROJECT AND PROGRAM GRANTS

(b) Basis; notification to State; reapportionment

The amounts appropriated and made available for grants to the States for projects and programs under this subchapter for each fiscal year shall be apportioned among the States by the Secretary in accordance with needs as disclosed in approved statewide historic preservation plans. The Secretary shall no-

tify each State of its apportionment under this subsection within thirty days following the date of enactment of legislation appropriating funds under this subchapter. Any amount of any apportionment that has not been paid or obligated by the Secretary during the fiscal year in which such notification is given, and for two fiscal years thereafter, shall be reapportioned by the Secretary in accordance with this subsection.

TRANSFER OF FUNDS TO CERTIFIED LOCAL GOVERNMENTS

(c) Transfer of funds to certified local governments

A minimum of 10 per centum of the annual apportionment distributed by the Secretary to each State for the purposes of carrying out this subchapter shall be transferred by the State, pursuant to the requirements of this subchapter, to local governments which are certified under section 470a(c) of this title for historic preservation projects or programs of such local governments. In any year in which the total annual apportionment to the States exceeds $65,000,000, one half of the excess shall also be transferred by the States to local governments certified pursuant to section 470a(c) of this title.

GUIDELINES FOR APPORTIONMENT TO LOCAL GOVERNMENTS

(d) Guidelines for use and distribution of funds to local governments

The Secretary shall establish guidelines for the use and distribution of funds under subsection (c) of this section to insure that no local government receives a disproportionate share of the funds available, and may include a maximum or minimum limitation on the amount of funds distributed to any single local government. The guidelines shall not limit the ability of any State to distribute more than 10 per centum of its annual apportionment under subsection (c) of this section, nor shall the Secretary require any State to exceed the 10 per centum minimum distribution to local governments.

■ 16 U.S.C. § 470d. LOAN INSURANCE PROGRAM FOR PRESERVATION OF PROPERTY INCLUDED ON NATIONAL REGISTER

INSURED LOANS FOR NATIONAL REGISTER PROPERTIES

(a) Establishment

The Secretary shall establish and maintain a program by

which he may, upon application of a private lender, insure loans (including loans made in accordance with a mortgage) made by such lender to finance any project for the preservation of a property included on the National Register.

REQUIREMENTS

(b) Loan qualifications

A loan may be insured under this section only if—

(1) the loan is made by a private lender approved by the Secretary as financially sound and able to service the loan properly;

(2) the amount of the loan, and interest rate charged with respect to the loan, do not exceed such amount, and such a rate, as is established by the Secretary, by rule;

(3) the Secretary has consulted the appropriate State Historic Preservation Officer concerning the preservation of the historic property;

(4) the Secretary has determined that the loan is adequately secured and there is reasonable assurance of repayment;

(5) the repayment period of the loan does not exceed the lesser of forty years or the expected life of the asset financed;

(6) the amount insured with respect to such loan does not exceed 90 per centum of the loss sustained by the lender with respect to the loan; and

(7) the loan, the borrower, and the historic property to be preserved meet other terms and conditions as may be prescribed by the Secretary, by rule, especially terms and conditions relating to the nature and quality of the preservation work.

INTEREST RATES

The Secretary shall consult with the Secretary of the Treasury regarding the interest rate of loans insured under this section.

LIMITATION ON LOAN AUTHORITY

(c) Limitation on amount of unpaid principal balance of loans

The aggregate unpaid principal balance of loans insured under this section and outstanding at any one time may not exceed the amount which has been covered into the Historic Preservation Fund pursuant to section 470h of this title and subsections (g) and (i) of this section, as in effect on

December 12, 1980, but which has not been appropriated for any purpose.

ASSIGNABILITY AND EFFECT

(d) Assignability of insurance contracts; contract as obligation of United States; contestability

Any contract of insurance executed by the Secretary under this section may be assignable, shall be an obligation supported by the full faith and credit of the United States, and shall be incontestable except for fraud or misrepresentation of which the holder had actual knowledge at the time it became a holder.

METHOD OF PAYMENT FOR LOSSES

(e) Conditions and methods of payment as result of loss

The Secretary shall specify, by rule and in each contract entered into under this section, the conditions and method of payment to a private lender as a result of losses incurred by the lender on any loan insured under this section.

PROTECTION OF GOVERNMENT'S FINANCIAL INTERESTS; FORECLOSURE

(f) Protection of financial interests of Federal Government

In entering into any contract to insure a loan under this section, the Secretary shall take steps to assure adequate protection of the financial interests of the Federal Government. The Secretary may—

(1) in connection with any foreclosure proceeding, obtain, on behalf of the Federal Government, the property securing a loan insured under sections 470a to 470h-3 of this title; and

(2) operate or lease such property for such period as may be necessary to protect the interest of the Federal Government and to carry out subsection (g) of this section.

CONVEYANCE OF FORECLOSED PROPERTY

(g) Conveyance to governmental or nongovernmental entity of property acquired by foreclosure

(1) In any case in which a historic property is obtained pursuant to subsection (f) of this section, the Secretary shall attempt to convey such property to any governmental or

nongovernmental entity under such conditions as will ensure the property's continued preservation and use; except that if, after a reasonable time, the Secretary, in consultation with the Advisory Council on Historic Preservation, determines that there is no feasible and prudent means to convey such property and to ensure its continued preservation and use, then the Secretary may convey the property at the fair market value of its interest in such property to any entity without restriction.

(2) Any funds obtained by the Secretary in connection with the conveyance of any property pursuant to paragraph (1) shall be covered into the historic preservation fund, in addition to the amounts covered into such fund pursuant to section 470h of this title and subsection (i) of this section, and shall remain available in such fund until appropriated by the Congress to carry out the purposes of this subchapter.

FEES

(h) Assessment of fees in connection with loans

The Secretary may assess appropriate and reasonable fees in connection with insuring loans under this section. Any such fees shall be covered into the Historic Preservation Fund, in addition to the amounts covered into such fund pursuant to section 470h of this title and subsection (g) of this section, and shall remain available in such fund until appropriated by the Congress to carry out purposes of this subchapter.

LOANS TO BE CONSIDERED NON-FEDERAL FUNDS

(i) Treatment of loans as non–Federal funds

Notwithstanding any other provision of law, any loan insured under this section shall be treated as non-Federal funds for the purposes of satisfying any requirement of any other provision of law under which Federal funds to be used for any project or activity are conditioned upon the use of non-Federal funds by the recipient for payment of any portion of the costs of such project or activity.

APPROPRIATION AUTHORIZATION

(j) Authorization of appropriations for payment of losses

Effective after the fiscal year 1981 there are authorized to be appropriated, such sums as may be necessary to cover payments incurred pursuant to subsection (e) of this section.

PROHIBITION AGAINST ACQUISITION BY FEDERAL FINANCING BANK

(k) Eligibility of debt obligation for purchase, etc., by Federal Financing Bank

No debt obligation which is made or committed to be made, or which is insured or committed to be insured, by the Secretary under this section shall be eligible for purchase by, or commitment to purchase by, or sale or issuance to, the Federal Financing Bank.

■ 16 U.S.C. § 470e. RECORDKEEPING; RECIPIENTS OF ASSISTANCE; AUDIT

RECORDKEEPING

The beneficiary of assistance under this subchapter shall keep such records as the Secretary shall prescribe, including records which fully disclose the disposition by the beneficiary of the proceeds of such assistance, the total cost of the project or undertaking in connection with which such assistance is given or used, and the amount and nature of that portion of the cost of the project or undertaking supplied by other sources, and such other records as will facilitate an effective audit.

■ 16 U.S.C. § 470f. EFFECT OF FEDERAL UNDERTAKINGS UPON PROPERTY LISTED IN NATIONAL REGISTER; COMMENT BY ADVISORY COUNCIL ON HISTORIC PRESERVATION

This text is referred to as "Section 106" of NHPA.

ADVISORY COUNCIL ON HISTORIC PRESERVATION; COMMENT ON FEDERAL UNDERTAKINGS ON PROPERTIES ELIGIBLE FOR THE NATIONAL REGISTER

The head of any Federal agency having direct or indirect jurisdiction over a proposed Federal or federally assisted undertaking in any State and the head of any Federal department or independent agency having authority to license any undertaking shall, prior to the approval of the expenditure of any Federal funds on the undertaking or prior to the issuance of any license, as the case may be, take into account the effect of the undertaking on any district, site, building, structure, or object that is included in or eligible for inclusion in the National Register. The head of any such Federal agency shall afford the Advisory Council on Historic Preservation established under sections 470i to 470v of this title a reasonable opportunity to comment with regard to such undertaking.

WHITE HOUSE, SUPREME COURT, U.S. CAPITOL NOT INCLUDED

Nothing in this subchapter shall be construed to be applicable to the White House and its grounds, the Supreme Court building and its grounds, or the United States Capitol and its related buildings and grounds.

■ 16 U.S.C. § 470h. HISTORIC PRESERVATION FUND; ESTABLISHMENT; APPROPRIATIONS; SOURCE OF REVENUE

ESTABLISHMENT OF HISTORIC PRESERVATION FUND; AUTHORIZATION FOR APPROPRIATIONS

To carry out the provisions of this subchapter, there is hereby established the Historic Preservation Fund (hereafter referred to as the "fund") in the Treasury of the United States. There shall be covered into such fund $24,400,000 for fiscal year 1977, $100,000,000 for fiscal year 1978, $100,000,000 for fiscal year 1979, $150,000,000 for fiscal year 1980, and $150,000,000 for fiscal year 1981, and $150,000,000 for each of fiscal years 1982 through 1992, from revenues due and payable to the United States under the Outer Continental Shelf Lands Act (67 Stat. 462, 469), as amended (43 U.S.C. 1338), and/or under section 7433(b) of title 10, notwithstanding any provision of law that such proceeds shall be credited to miscellaneous receipts of the Treasury. Such moneys shall be used only to carry out the purposes of this subchapter and shall be available for expenditure only when appropriated by the Congress. Any moneys not appropriated shall remain available in the fund until appropriated for said purposes: Provided, that appropriations made pursuant to this paragraph may be made without fiscal year limitation.

■ 16 U.S.C. § 470h-1. ACCEPTANCE OF PRIVATELY DONATED FUNDS BY SECRETARY

DONATIONS TO THE SECRETARY

(a) Authorization; use of funds

In furtherance of the purposes of this subchapter, the Secretary may accept the donation of funds which may be ex-

pended by him for projects to acquire, restore, preserve, or recover data from any district, building, structure, site, or object which is listed on the National Register of Historic Places established pursuant to section 470a of this title, so long as the project is owned by a State, any unit of local government, or any nonprofit entity.

EXPENDITURE OF DONATED FUNDS

(b) Consideration of factors respecting expenditure of funds

In expending said funds, the Secretary shall give due consideration to the following factors: the national significance of the project; its historical value to the community; the imminence of its destruction or loss; and the expressed intentions of the donor. Funds expended under this subsection shall be made available without regard to the matching requirements established by section 470b of this title but the recipient of such funds shall be permitted to utilize them to match any grants from the Historic Preservation Fund established by section 470h of this title.

TRANSFER OF FUNDS DONATED FOR THE NATIONAL PARK SERVICE

(c) Transfer of unobligated funds

The Secretary is hereby authorized to transfer unobligated funds previously donated to the Secretary for the purposes of the National Park Service, with the consent of the donor, and any funds so transferred shall be used or expended in accordance with the provisions of this subchapter.

■ 16 U.S.C. § 470h-2. HISTORIC PROPERTIES OWNED OR CONTROLLED BY FEDERAL AGENCIES

This text is referred to as "Section 110" of NHPA.

FEDERAL AGENCIES' RESPONSIBILITY TO PRESERVE AND USE HISTORIC BUILDINGS

(a) Responsibilities of Federal agencies; program for location, inventory and nomination

(1) The heads of all Federal agencies shall assume responsibility for the preservation of historic properties which are owned or controlled by such agency. Prior to acquiring, constructing, or leasing buildings for purposes of carrying out agency responsibilities, each Federal agency shall use, to the maximum extent feasible, historic properties available to the agency. Each agency shall undertake, consistent with the

preservation of such properties and the mission of the agency and the professional standards established pursuant to section 470a(f) of this title, any preservation, as may be necessary to carry out this section.

PROTECTION AND NOMINATION TO THE NATIONAL REGISTER OF FEDERAL PROPERTIES

(2) With the advice of the Secretary and in cooperation with the State historic preservation officer for the State involved, each Federal agency shall establish a program to locate, inventory, and nominate to the Secretary all properties under the agency's ownership or control by the agency, that appear to qualify for inclusion on the National Register in accordance with the regulations promulgated under section 470a(a)(2)(A) of this title. Each Federal agency shall exercise caution to assure that any such property that might qualify for inclusion is not inadvertently transferred, sold, demolished, substantially altered, or allowed to deteriorate significantly.

RECORDATION OF HISTORIC PROPERTIES PRIOR TO DEMOLITION

(b) Records on historic properties to be altered or demolished; deposit in Library of Congress or other appropriate agency

Each Federal agency shall initiate measures to assure that where, as a result of Federal action or assistance carried out by such agency, an historic property is to be substantially altered or demolished, timely steps are taken to make or have made appropriate records, and that such records then be deposited, in accordance with section 470a(a) of this title, in the Library of Congress or with such other appropriate agency as may be designated by the Secretary, for future use and reference.

DESIGNATION OF FEDERAL AGENCY PRESERVATION OFFICERS

(c) Agency Preservation Officer; responsibilities; qualifications

The head of each Federal agency shall, unless exempted under section 470v of this title, designate a qualified official to be known as the agency's "preservation officer" who shall be responsible for coordinating that agency's activities under this subchapter. Each Preservation Officer may, in order to be considered qualified, satisfactorily complete an appropriate training program established by the Secretary under section 470a(g) of this title.

CONDUCT OF AGENCY PROGRAMS CONSISTENT WITH ACT

(d) Agency programs and projects

Consistent with the agency's missions and mandates, all Federal agencies shall carry out agency programs and projects (including those under which any Federal assistance is provided or any Federal license, permit, or other approval is required) in accordance with the purposes of this subchapter and, give consideration to programs and projects which will further the purposes of this subchapter.

TRANSFER OF SURPLUS FEDERAL HISTORIC PROPERTIES

(e) Review of plans of transferees of surplus federally owned historic properties

The Secretary shall review and approve the plans of transferees of surplus federally owned historic properties not later than ninety days after his receipt of such plans to ensure that the prehistorical, historical, architectural, or culturally significant values will be preserved or enhanced.

FEDERAL UNDERTAKINGS AFFECTING NATIONAL HISTORIC LANDMARKS

(f) Planning and actions to minimize harm to National Historic Landmarks

Prior to the approval of any Federal undertaking which may directly and adversely affect any National Historic Landmark, the head of the responsible Federal agency shall, to the maximum extent possible, undertake such planning and actions as may be necessary to minimize harm to such landmark, and shall afford the Advisory Council on Historic Preservation a reasonable opportunity to comment on the undertaking.

PRESERVATION ACTIVITIES AS AN ELIGIBLE PROJECT COST

(g) Costs of preservation as eligible project costs

Each Federal agency may include the costs of preservation activities of such agency under this subchapter as eligible project costs in all undertakings of such agency or assisted by such agency. The eligible project costs may also include amounts paid by a Federal agency to any State to be used in carrying out such preservation responsibilities of the Federal

agency under this subchapter, and reasonable costs may be charged to Federal licensees and permittees as a condition to the issuance of such license or permit.

PRESERVATION AWARDS PROGRAM

(h) Annual preservation awards program

The Secretary shall establish an annual preservation awards program under which he may make monetary awards in amounts of not to exceed $1,000 and provide citations for special achievement to officers and employees of Federal, State, and certified local governments in recognition of their outstanding contributions to the preservation of historic resources. Such program may include the issuance of annual awards by the President of the United States to any citizen of the United States recommended for such award by the Secretary.

APPLICABILITY OF NATIONAL ENVIRONMENTAL POLICY ACT

(i) Environmental impact statement

Nothing in this subchapter shall be construed to require the preparation of an environmental impact statement where such a statement would not otherwise be required under the National Environmental Policy Act of 1969 (42 U.S.C. 4321 et seq.), and nothing in this subchapter shall be construed to provide any exemption from any requirement respecting the preparation of such a statement under such Act.

WAIVER IN THE EVENT OF NATURAL DISASTER

(j) Waiver of provisions in event of natural disaster or imminent threat to national security

The Secretary shall promulgate regulations under which the requirements of this section may be waived in whole or in part in the event of a major natural disaster or an imminent threat to the national security.

■ 16 U.S.C. § 470h-3. LEASE OR EXCHANGE OF HISTORIC PROPERTY

This text is referred to as "Section 111" of NHPA.

LEASES OR EXCHANGES OF FEDERAL HISTORIC PROPERTIES

(a) Authorization; consultation with Advisory Council on Historic Preservation

Notwithstanding any other provision of law, any Federal agency may, after consultation with the Advisory Council on Historic Preservation, lease an historic property owned by the agency to any person or organization, or exchange any property owned by the agency with comparable historic property, if the agency head determines that the lease or exchange will adequately insure the preservation of the historic property.

USE OF PROCEEDS

(b) Proceeds of lease for administration, etc., of property; deposit of surplus proceeds into Treasury

The proceeds of any lease under subsection (a) of this section may, notwithstanding any other provision of law, be retained by the agency entering into such lease and used to defray the costs of administration, maintenance, repair, and related expenses incurred by the agency with respect to such property or other properties which are on the National Register which are owned by, or are under the jurisdiction or control of, such agency. Any surplus proceeds from such leases shall be deposited into the Treasury of the United States at the end of the second fiscal year following the fiscal year in which such proceeds were received.

MANAGEMENT CONTRACTS

(c) Contracts for management of historic property

The head of any Federal agency having responsibility for the management of any historic property may, after consultation with the Advisory Council on Historic Preservation, enter into contracts for the management of such property. Any such contract shall contain such terms and conditions as the head of such agency deems necessary or appropriate to protect the interests of the United States and insure adequate preservation of the historic property.

■ 16 U.S.C. § 470i. ADVISORY COUNCIL ON HISTORIC PRESERVATION

ADVISORY COUNCIL ON HISTORIC PRESERVATION; MEMBERSHIP

(a) Establishment; membership; Chairman

There is established as an independent agency of the United States Government an Advisory Council on Historic Preservation (hereinafter referred to as the "Coun-

cil") which shall be composed of the following members:

(1) a Chairman appointed by the President selected from the general public;

(2) the Secretary of the Interior;

(3) the Architect of the Capitol;

(4) the Secretary of Agriculture and the heads of four other agencies of the United States (other than the Department of the Interior) the activities of which affect historic preservation, appointed by the President;

(5) one Governor appointed by the President;

(6) one mayor appointed by the President;

(7) the President of the National Conference of State Historic Preservation Officers;

(8) the Chairman of the National Trust for Historic Preservation;

(9) four experts in the field of historic preservation appointed by the President from the disciplines of architecture, history, archeology, and other appropriate disciplines; and

(10) three at-large members from the general public, appointed by the President.

DESIGNEES

(b) Designation of substitutes

Each member of the Council specified in paragraphs (2) through (8) other than (5) and (6) of subsection (a) of this section may designate another officer of his department, agency, or organization to serve on the Council in his stead, except that, in the case of paragraphs (2) and (4), no such officer other than an Assistant Secretary or an officer having major department-wide or agency-wide responsibilities may be so designated.

TERM OF OFFICE

(c) Term of office

Each member of the Council appointed under paragraph (1), and under paragraphs (9) and (10) of subsection (a) of this section shall serve for a term of four years from the expiration of his predecessor's term; except that the members first appointed under that paragraph shall serve for terms of one to four years, as designated by the President at the time of appointment, in such manner as to insure that the terms of not more than two of them will expire in any one year. The members appointed under paragraphs (5) and (6) shall serve for the term of their elected office but not in excess of

four years. An appointed member may not serve more than two terms. An appointed member whose term has expired shall serve until that member's successor has been appointed.

VACANCIES

(d) Vacancies; term of office of members already appointed

A vacancy in the Council shall not affect its powers, but shall be filled not later than sixty days after such vacancy commences, in the same manner as the original appointment (and for the balance of any unexpired terms). The members of the Advisory Council on Historic Preservation appointed by the President under this subchapter as in effect on the day before December 12, 1980, shall remain in office until all members of the Council, as specified in this section, have been appointed. The members first appointed under this section shall be appointed not later than one hundred and eighty days after December 12, 1980.

VICE CHAIRMAN

(e) Designation of Vice Chairman

The President shall designate a Vice Chairman, from the members appointed under paragraph (5), (6), (9), or (10). The Vice Chairman may act in place of the Chairman during the absence or disability of the Chairman or when the office is vacant.

QUORUM

(f) Quorum

Nine members of the Council shall constitute a quorum.

■ 16 U.S.C. § 470j. FUNCTIONS OF COUNCIL; ANNUAL REPORT TO PRESIDENT AND CONGRESS; RECOMMENDATIONS

DUTIES OF COUNCIL

(a) Duties

The Council shall—

(1) advise the President and the Congress on matters relating to historic preservation; recommend measures to coordinate activities of Federal, State, and local agencies and private institutions and individuals relating to historic preservation; and advise on the dissemination of information pertaining to such activities;

(2) encourage, in cooperation with the National Trust for Historic Preservation and appropriate private agencies, public interest and participation in historic preservation;

(3) recommend the conduct of studies in such areas as the adequacy of legislative and administrative statutes and regulations pertaining to historic preservation activities of State and local governments and the effects of tax policies at all levels of government on historic preservation;

(4) advise as to guidelines for the assistance of State and local governments in drafting legislation relating to historic preservation;

(5) encourage, in cooperation with appropriate public and private agencies and institutions, training and education in the field of historic preservation;

(6) review the policies and programs of Federal agencies and recommend to such agencies methods to improve the effectiveness, coordination, and consistency of those policies and programs with the policies and programs carried out under this subchapter; and

(7) inform and educate Federal agencies, State and local governments, Indian tribes, other nations and international organizations and private groups and individuals as to the Council's authorized activities.

ANNUAL AND SPECIAL REPORTS

(b) Annual report

The Council shall submit annually a comprehensive report of its activities and the results of its studies to the President and the Congress and shall from time to time submit such additional and special reports as it deems advisable. Each report shall propose such legislative enactments and other actions as, in the judgment of the Council, are necessary and appropriate to carry out its recommendations and shall provide the Council's assessment of current and emerging problems in the field of historic preservation and an evaluation of the effectiveness of the programs of Federal agencies, State and local governments, and the private sector in carrying out the purposes of this subchapter.

■ 16 U.S.C. § 470k. COOPERATION BETWEEN COUNCIL AND INSTRUMENTALITIES OF EXECUTIVE BRANCH OF FEDERAL GOVERNMENT

INFORMATION FROM AGENCIES

The Council is authorized to secure directly from any department, bureau, agency, board, commission, office, independent establishment or instrumentality of the executive

branch of the Federal Government information, suggestions, estimates, and statistics for the purpose of sections 470i to 470v of this title; and each such department, bureau, agency, board, commission, office, independent establishment or instrumentality is authorized to furnish such information, suggestions, estimates, and statistics to the extent permitted by law and within available funds.

■ 16 U.S.C. § 470l. COMPENSATION OF MEMBERS OF COUNCIL

COMPENSATION OF MEMBERS

The members of the Council specified in paragraphs (2), (3), and (4) of section 470i(a) of this title shall serve without additional compensation. The other members of the Council shall receive $100 per diem when engaged in the performance of the duties of the Council. All members of the Council shall receive reimbursement for necessary traveling and subsistence expenses incurred by them in the performance of the duties of the Council.

■ 16 U.S.C. § 470m. ADMINISTRATION

EXECUTIVE DIRECTOR

(a) Executive Director of Council; appointment; functions and duties

There shall be an Executive Director of the Council who shall be appointed in the competitive service by the Chairman with the concurrence of the Council. The Executive Director shall report directly to the Council and perform such functions and duties as the Council may prescribe.

GENERAL COUNSEL AND ATTORNEYS

(b) General Counsel; appointment; functions and duties

The Council shall have a General Counsel, who shall be appointed by the Executive Director. The General Counsel shall report directly to the Executive Director and serve as the Council's legal advisor. The Executive Director shall appoint such other attorneys as may be necessary to assist the General Counsel, represent the Council in courts of law whenever appropriate, including enforcement of agreements with Federal agencies to which the Council is a party, assist the Department of Justice in handling litigation concerning the Council in courts of law, and perform such other legal duties and functions as the Executive Director and the Council may direct.

APPOINTMENT AND COMPENSATION OF STAFF

(c) Appointment and compensation of officers and employees

The Executive Director of the Council may appoint and fix the compensation of such officers and employees in the competitive service as are necessary to perform the functions of the Council at rates not to exceed that now or hereafter prescribed for the highest rate for grade 15 of the General Schedule under section 5332 of title 5: Provided, however, That the Executive Director, with the concurrence of the Chairman, may appoint and fix the compensation of not to exceed five employees in the competitive service at rates not to exceed that now or hereafter prescribed for the highest rate of grade 17 of the General Schedule under section 5332 of title 5.

APPOINTMENT AND COMPENSATION OF ADDITIONAL PERSONNEL

(d) Appointment and compensation of additional personnel

The Executive Director shall have power to appoint and fix the compensation of such additional personnel as may be necessary to carry out its duties, without regard to the provisions of the civil service laws and chapter 51 and subchapter III of chapter 53 of title 5.

CONSULTANTS

(e) Expert and consultant services; procurement

The Executive Director of the Council is authorized to procure expert and consultant services in accordance with the provisions of section 3109 of title 5.

FINANCIAL AND ADMINISTRATIVE SERVICES

(f) Financial and administrative services; Department of the Interior

Financial and administrative services (including those related to budgeting, accounting, financial reporting, personnel and procurement) shall be provided the Council by the Department of the Interior, for which payments shall be made in advance, or by reimbursement, from funds of the Council in such amounts as may be agreed upon by the Chairman of the Council and the Secretary of the Interior: Provided, That the regulations of the Department of the Interior for the collection of indebtedness of personnel resulting from erroneous payments (5 U.S.C. 5514(b)) shall apply to the collection of erroneous payments made to or on behalf of a Council employee, and regulations of said Secretary for the administrative control of funds (31 U.S.C. 1513(d), 1514) shall apply to appropriations of the Council: And provided further, That the Council shall not be required to prescribe such regulations.

PROVISION OF ASSISTANCE BY MEMBERS

(g) Use of funds, personnel, facilities, and services of Council members

The members of the Council specified in paragraphs (2) through (4) of section 470i(a) of this title shall provide the Council, with or without reimbursement as may be agreed upon by the Chairman and the members, with such funds, personnel, facilities, and services under their jurisdiction and control as may be needed by the Council to carry out its duties, to the extent that such funds, personnel, facilities, and services are requested by the Council and are otherwise available for that purpose. To the extent of available appropriations, the Council may obtain, by purchase, rental, donation, or otherwise, such additional property, facilities, and services as may be needed to carry out its duties and may also receive donations of moneys for such purpose, and the Executive Director is authorized, in his discretion, to accept, hold, use, expend, and administer the same for the purposes of this subchapter.

■ 16 U.S.C. § 470n. INTERNATIONAL CENTRE FOR STUDY OF PRESERVATION AND RESTORATION OF CULTURAL PROPERTY

INTERNATIONAL CENTRE FOR THE STUDY OF THE PRESERVATION AND RESTORATION OF CULTURAL PROPERTY; AUTHORIZATION

(a) Authorization of participation

The participation of the United States as a member in the International Centre for the Study of the Preservation and Restoration of Cultural Property is hereby authorized.

MEMBERS OF OFFICIAL DELEGATION

(b) Official delegation

The Council shall recommend to the Secretary of State, after consultation with the Smithsonian Institution and other public and private organizations concerned with the technical

problems of preservation, the members of the official delegation which will participate in the activities of the Centre on behalf of the United States. The Secretary of State shall appoint the members of the official delegation from the persons recommended to him by the Council.

AUTHORIZATION FOR MEMBERSHIP PAYMENT

(c) Authorization of appropriations and payments

For the purposes of this section there is authorized to be appropriated an amount equal to the assessment for United States membership in the Centre for fiscal years 1979, 1980, 1981, and 1982: Provided, That no appropriation is authorized and no payment shall be made to the Centre in excess of 25 per centum of the total annual assessment of such organization. Authorization for payment of such assessments shall begin in fiscal year 1981, but shall include earlier costs.

■ 16 U.S.C. § 470o. TRANSFER OF PERSONNEL, PROPERTY, ETC., BY DEPARTMENT OF THE INTERIOR TO COUNCIL; TIME LIMIT

TRANSFER OF FUNDS

So much of the personnel, property, records, and unexpended balances of appropriations, allocations, and other funds employed, held, used, programed, or available or to be made available by the Department of the Interior in connection with the functions of the Council, as the Director of the Office of Management and Budget shall determine, shall be transferred from the Department to the Council within 60 days of the effective date of this Act.

■ 16 U.S.C. § 470p. RIGHTS, BENEFITS, AND PRIVILEGES OF TRANSFERRED EMPLOYEES

RIGHTS OF COUNCIL EMPLOYEES

Any employee in the competitive service of the United States transferred to the Council under the provisions of this section shall retain all the rights, benefits, and privileges pertaining thereto held prior to such transfer.

■ 16 U.S.C. § 470q. OPERATIONS OF COUNCIL; EXEMPTION

EXEMPTION FROM FEDERAL ADVISORY COMMITTEE ACT

The Council is exempt from the provisions of the Federal Advisory Committee Act (86 Stat. 770), and the provisions of subchapter II of chapter 5, and chapter 7, of title 5 shall govern the operations of the Council.

■ 16 U.S.C. § 470r. TRANSMITTAL OF LEGISLATIVE RECOMMENDATIONS, OR TESTIMONY, OR COMMENTS, TO ANY OFFICER OR AGENCY OF THE UNITED STATES PRIOR TO SUBMISSION THEREOF TO CONGRESS; PROHIBITION

SUBMISSION TO THE CONGRESS

No officer or agency of the United States shall have any authority to require the Council to submit its legislative recommendations, or testimony, or comments on legislation to any officer or agency of the United States for approval, comments, or review, prior to the submission of such recommendations, testimony, or comments to the Congress. In instances in which the Council voluntarily seeks to obtain the comments or review of any officer or agency of the United States, the Council shall include a description of such actions in its legislative recommendations, testimony, or comments on legislation which it transmits to the Congress.

■ 16 U.S.C. § 470s. RULES AND REGULATIONS; PARTICIPATION BY LOCAL GOVERNMENTS

REGULATIONS FOR SECTION 106; LOCAL GOVERNMENT PARTICIPATION

The Council is authorized to promulgate such rules and regulations as it deems necessary to govern the implementation of section 470f of this title. The Council shall, by regulation, establish such procedures as may be necessary to provide for participation by local governments in proceedings and other actions taken by the Council with respect to undertakings referred to in section 470f of this title which affect such local governments.

■ 16 U.S.C. § 470t. BUDGET; AUTHORIZATION OF APPROPRIATIONS

COUNCIL APPROPRIATION AUTHORIZATION

(a) Time of submission; related department; authorized appropriations

The Council shall submit its budget annually as a related agency of the Department of the Interior. To carry out the provisions of sections 470i to 470v of this title, there is authorized to be appropriated not more than $2,500,000 for each of the fiscal years 1985 through 1989.

CONCURRENT SUBMISSION OF BUDGET TO CONGRESS

(b) Transmittal of copies to Congressional committees

Whenever the Council submits any budget estimate or request to the President or the Office of Management and Budget, it shall concurrently transmit copies of that estimate or request to the House and Senate Appropriations Committees and the House Committee on Interior and Insular Affairs and the Senate Committee on Energy and Natural Resources.

■ 16 U.S.C. § 470u. REPORT BY SECRETARY TO COUNCIL

REPORTS FROM SECRETARY AT REQUEST OF COUNCIL

To assist the Council in discharging its responsibilities under this subchapter, the Secretary at the request of the Chairman, shall provide a report to the Council detailing the significance of any historic property, describing the effects of any proposed undertaking on the affected property, and recommending measures to avoid, minimize, or mitigate adverse effects.

■ 16 U.S.C. § 470v. EXEMPTION FOR FEDERAL PROGRAMS OR UNDERTAKINGS; REGULATIONS

EXEMPTIONS FOR FEDERAL ACTIVITIES FROM PROVISIONS OF THE ACT

The Council, with the concurrence of the Secretary, shall promulgate regulations or guidelines, as appropriate, under which all programs or undertakings may be exempted from any or all of the requirements of subchapter when such exemption is determined to be consistent with the purposes of subchapter, taking into consideration the magnitude of the exempted undertaking or program and the likelihood of impairment of historic properties.

■ 16 U.S.C. § 470w. DEFINITIONS

DEFINITIONS

As used in this subchapter, the term—

AGENCY

(1) "Agency" means agency as such term is defined in section 551 of title 5, except that in the case of any Federal program exempted under section 470v of this title, the agency administering such program shall not be treated as an agency with respect to such program.

STATE

(2) "State" means any State of the United States, the District of Columbia, the Commonwealth of Puerto Rico, Guam, the Virgin Islands, American Samoa, the Commonwealth of the Northern Mariana Islands, and the Trust Territories of the Pacific Islands.

LOCAL GOVERNMENT

(3) "Local government" means a city, county, parish, township, municipality, or borough, or any other general purpose political subdivision of any State.

INDIAN TRIBE

(4) "Indian tribe" means the governing body of any Indian tribe, band, nation, or other group which is recognized as an Indian tribe by the Secretary of the Interior and for which the United States holds land in trust or restricted status for that entity or its members. Such term also includes any Native village corporation, regional corporation, and Native Group established pursuant to the Alaska Native Claims Settlement Act (43 U.S.C. 1601 et seq.).

HISTORIC PROPERTY; HISTORIC RESOURCE

(5) "Historic property" or "historic resource" means any prehistoric or historic district, site, building, structure, or object included in, or eligible for inclusion on the National Register; such term includes artifacts, records, and remains which are related to such a district, site, building, structure, or object.

NATIONAL REGISTER; REGISTER

(6) "National Register" or "Register" means the National Register of Historic Places established under section 470a of this title.

UNDERTAKING

(7) "Undertaking" means any action as described in section 470f of this title.

PRESERVATION; HISTORIC PRESERVATION

(8) "Preservation" or "historic preservation" includes identification, evaluation, recordation, documentation, curation, acquisition, protection, management, rehabilitation,

restoration, stabilization, maintenance and reconstruction, or any combination of the foregoing activities.

CULTURAL PARK

(9) "Cultural park" means a definable urban area which is distinguished by historic resources and land related to such resources and which constitutes an interpretive, educational, and recreational resource for the public at large.

HISTORIC CONSERVATION DISTRICT

(10) "Historic conservation district" means an urban area of one or more neighborhoods and which contains (A) historic properties, (B) buildings having similar or related architectural characteristics, (C) cultural cohesiveness, or (D) any combination of the foregoing.

SECRETARY

(11) "Secretary" means the Secretary of the Interior except where otherwise specified.

STATE HISTORIC PRESERVATION REVIEW BOARD

(12) "State historic preservation review board" means a board, council, commission, or other similar collegial body established as provided in section 470a(b)(1)(B) of this title—

(A) the members of which are appointed by the State Historic Preservation Officer (unless otherwise provided for by State law),

(B) a majority of the members of which are professionals qualified in the following and related disciplines: history, prehistoric and historic archaeology, architectural history, and architecture, and

(C) which has the authority to—

(i) review National Register nominations and appeals from nominations;

(ii) review appropriate documentation submitted in conjunction with the Historic Preservation Fund;

(iii) provide general advice and guidance to the State Historic Preservation Officer; and

(iv) perform such other duties as may be appropriate.

HISTORIC PRESERVATION REVIEW COMMISSION

(13) "Historic preservation review commission" means a board, council, commission, or other similar collegial body which is established by State or local legislation as provided in section 470a(c)(1)(B) of this title, and the members of which are appointed, unless otherwise provided by State or local legislation, by the chief elected official of the jurisdiction concerned from among—

(A) professionals in the disciplines of architecture, history, architectural history, planning, archaeology, or related disciplines, to the extent such professionals are available in the community concerned, and

(B) such other persons as have demonstrated special interest, experience, or knowledge in history, architecture, or related disciplines and as will provide for an adequate and qualified commission.

■ 16 U.S.C. § 470w-1. AUTHORIZATION FOR EXPENDITURE OF APPROPRIATED FUNDS

AUTHORITY TO EXPEND FUNDS FOR PURPOSES OF THIS ACT

Where appropriate, each Federal agency is authorized to expend funds appropriated for its authorized programs for the purposes of activities carried out pursuant to this subchapter, except to the extent appropriations legislation expressly provides otherwise.

■ 16 U.S.C. § 470w-2. DONATIONS AND BEQUESTS OF MONEY, PERSONAL PROPERTY AND LESS THAN FEE INTERESTS IN HISTORIC PROPERTY

DONATIONS TO SECRETARY; MONEY AND PERSONAL PROPERTY

(a) The Secretary is authorized to accept donations and bequests of money and personal property for the purposes of this subchapter and shall hold, use, expend, and administer the same for such purposes.

DONATIONS OF LESS THAN FEE INTERESTS IN REAL PROPERTY

(b) The Secretary is authorized to accept gifts or donations of less than fee interests in any historic property where the acceptance of such interests will facilitate the conservation or preservation of such properties. Nothing in this section or in any provision of this subchapter shall be construed to affect or impair any other authority of the Secretary under other provision of law to accept or acquire any property for conservation or preservation or for any other purpose.

■ 16 U.S.C. § 470w-3. INFORMATION RELATING TO LOCATION OR CHARACTER OF HISTORIC RESOURCES, DISCLOSURE TO PUBLIC

CONFIDENTIALITY OF LOCATION OF SENSITIVE HISTORIC RESOURCES

The head of any Federal agency, after consultation with the Secretary, shall withhold from disclosure to the public, information relating to the location or character of historic resources whenever the head of the agency or the Secretary determines that the disclosure of such information may create a substantial risk of harm, theft, or destruction to such resources or to the area or place where such resources are located.

■ 16 U.S.C. § 470w-4. ATTORNEYS' FEES AND COSTS TO PREVAILING PARTIES IN CIVIL ACTIONS

ATTORNEYS' FEES

In any civil action brought in any United States district court by any interested person to enforce the provisions of this subchapter, if such person substantially prevails in such action, the court may award attorneys' fees, expert witness fees, and other costs of participating in such action, as the court deems reasonable.

■ 16 U.S.C. § 470w-5. NATIONAL MUSEUM FOR THE BUILDING ARTS

NATIONAL MUSEUM FOR THE BUILDING ARTS

(a) Cooperative agreement between Secretary, Administrator of General Services Administration and Committee for National Museum of the Building Arts; purposes

In order to provide a national center to commemorate and encourage the building arts and to preserve and maintain a nationally significant building which exemplifies the great achievements of the building arts in the United States, the Secretary and the Administrator of the General Services Administration are authorized and directed to enter into a cooperative agreement with the Committee for a National Museum of the Building Arts, Incorporated, a nonprofit corporation organized and existing under the laws of the District of Columbia, or its successor, for the operation of a National Museum of the Building Arts in the Federal Building located in the block bounded by Fourth Street, Fifth Street, F Street, and G Street, Northwest in Washington, District of Columbia. Such museum shall—

(1) collect and disseminate information concerning the building arts, including the establishment of a national reference center for current and historic documents, publications, and research relating to the building arts;

(2) foster educational programs relating to the history, practice and contribution to society of the building arts, including promotion of imaginative educational approaches to enhance understanding and appreciation of all facets of the building arts;

(3) publicly display temporary and permanent exhibits illustrating, interpreting and demonstrating the building arts;

(4) sponsor or conduct research and study into the history of the building arts and their role in shaping our civilization; and

(5) encourage contributions to the building arts.

COOPERATIVE AGREEMENT

(b) Provisions of cooperative agreement

The cooperative agreement referred to in subsection (a) of this section shall include provisions which—

(1) make the site available to the Committee referred to in subsection (a) of this section without charge;

(2) provide, subject to available appropriations, such maintenance, security, information, janitorial and other services as may be necessary to assure the preservation and operation of the site; and

(3) prescribe reasonable terms and conditions by which the Committee can fulfill its responsibilities under this subchapter.

GRANTS TO COMMITTEE

(c) Matching grants-in-aid to Committee; limitation on amounts

The Secretary is authorized and directed to provide matching grants-in-aid to the Committee referred to in subsection (a) of this section for its programs related to historic preservation. The Committee shall match such grants-in-aid in a manner and with such funds and services as shall be satisfactory to the Secretary, except that no more than $500,000 may be provided to the Committee in any one fiscal year.

SITE RENOVATION

(d) Renovation of site

The renovation of the site shall be carried out by the Administrator with the advice of the Secretary. Such

renovation shall, as far as practicable—

(1) be commenced immediately,
(2) preserve, enhance, and restore the distinctive and historically authentic architectural character of the site consistent with the needs of a national museum of the building arts and other compatible use, and
(3) retain the availability of the central court of the building, or portions thereof, for appropriate public activities.

ANNUAL REPORT

(e) Annual Committee report to Secretary and Administrator

The Committee shall submit an annual report to the Secretary and the Administrator concerning its activities under this section and shall provide the Secretary and the Administrator with such other information as the Secretary may, from time to time, deem necessary or advisable.

DEFINITION OF "BUILDING ARTS"

(f) "Building arts" defined

For purposes of this section, the term "building arts" includes, but shall not be limited to, all practical and scholarly aspects of prehistoric, historic, and contemporary architecture, archaeology, construction, building technology and skills, landscape architecture, preservation and conservation, building and construction, engineering, urban and community design and renewal, city and regional planning, and related professions, skills, trades, and crafts.

■ 16 U.S.C. § 470w-6. EFFECTIVE DATE OF REGULATIONS

TRANSMITTAL OF REGULATIONS TO CONGRESSIONAL COMMITTEES

(a) Copy to Congress prior to publication in Federal Register; effective date of final regulations

At least thirty days prior to publishing in the Federal Register any proposed regulation required by this subchapter, the Secretary shall transmit a copy of the regulation to the Committee on Interior and Insular Affairs of the House of Representatives and the Committee on Energy and Natural Resources of the Senate. The Secretary also shall transmit to such committees a copy of any final regulation prior to its publication in the Federal Register. Except as provided in

subsection (b) of this section, no final regulation of the Secretary shall become effective prior to the expiration of thirty calendar days after it is published in the Federal Register during which either or both Houses of Congress are in session.

EMERGENCY REGULATIONS

(b) Effective date of final regulation in case of emergency

In the case of an emergency, a final regulation of the Secretary may become effective without regard to the last sentence of subsection (a) of this section if the Secretary notified in writing the Committee on Interior and Insular Affairs of the United States House of Representatives and the Committee on Energy and Natural Resources of the United States Senate setting forth the reasons why it is necessary to make the regulation effective prior to the expiration of the thirty-day period.

DISAPPROVAL BY CONGRESS

(c) Disapproval of regulation by resolution of Congress

Except as provided in subsection (b) of this section, the regulation shall not become effective if, within ninety calendar days of continuous session of Congress after the date of promulgation, both Houses of Congress adopt a concurrent resolution, the matter after the resolving clause of which is as follows: "That Congress disapproves the regulation promulgated by the Secretary dealing with the matter of _____, which regulation was transmitted to Congress on _____," the blank spaces therein being appropriately filled.

INACTION BY CONGRESS

(d) Failure of Congress to adopt resolution of disapproval of regulation

If at the end of sixty calendar days of continuous session of Congress after the date of promulgation of a regulation, no committee of either House of Congress has reported or been discharged from further consideration of a concurrent resolution disapproving the regulation, and neither House has adopted such a resolution, the regulation may go into effect immediately. If, within such sixty calendar days, such a committee has reported or been discharged from further consideration of such a resolution, the regulation may go into effect not sooner than ninety calendar days of continuous session of Congress after its promulgation unless disapproved as provided for.

(e) Sessions of Congress

For the purposes of this section—

(1) continuity of session is broken only by an adjournment sine die; and
(2) the days on which either House is not in session because of an adjournment of more than three days to a day certain are excluded in the computation of sixty and ninety calendar days of continuous session of Congress.

EFFECT OF CONGRESSIONAL INACTION

(f) Congressional inaction or rejection of resolution of disapproval not deemed approval of regulation

Congressional inaction on or rejection of a resolution of disapproval shall not be deemed an expression of approval of such regulation.

SPONSORS

When Past Meets Future
45th National Preservation Conference
October 16–20, 1991, San Francisco

SPONSORS

National Trust for Historic Preservation
Robert M. Bass, Chairman of the Board
J. Jackson Walter, President

National Park Service
Hon. Manuel Lujan, Jr., Secretary of the Interior
James J. Ridenour, Director
Jerry L. Rogers, Associate Director for Cultural Resources

Advisory Council on Historic Preservation
John F. W. Rogers, Chairman
Robert D. Bush, Executive Director

COOPERATING SPONSORS

American Association for State and Local History
American Institute of Architects
American Planning Association

Association for Preservation Technology International
Land Trust Alliance
League of Historic American Theaters
National Alliance of Preservation Commissions
National Association of Neighborhoods
National Building Museum
National Center for Preservation Law
National Conference of State Historic Preservation
Officers
National Council for Preservation Education
National Alliance of Statewide Preservation Organizations
National League of Cities
National Parks and Conservation Association
Partners for Livable Places
Preservation Action
Scenic America
Society for American Archaeology
Society for Historical Archaeology
Society for Industrial Archeology
U.S. Committee, International Council on Monuments
and Sites
U.S. Conference of Mayors
Waterfront Center

CONTRIBUTORS

Robert M. Bass of Houston is chairman of the board of trustees of the National Trust for Historic Preservation

Tersh Boasberg is a preservation lawyer and chairman of the District of Columbia Zoning Commission

Peter H. Brink is vice president for preservation programs, services, and information, National Trust for Historic Preservation

Henry G. Cisneros is the former mayor of San Antonio

E. Blaine Cliver is chief of the Preservation Assistance Division, National Park Service

Hester A. Davis is an archeologist with the Arkansas Archeological Survey

H. Grant Dehart is director of Program Open Space, Maryland Department of Natural Resources

Christopher J. Duerksen is an attorney in Denver

Patricia H. Gay is executive director of the Preservation Resource Center, New Orleans

Neil W. Horstman is resident director of the Mount Vernon Ladies' Association

Kathleen A. Hunter is director of education and federal liaison for the National Trust for Historic Preservation

Antoinette J. Lee is a historian with the National Register of Historic Places, Interagency Resources Division, National Park Service

Larry Light is president of the Arcature Corporation in Stamford, Connecticut

Richard Longstreth is director of the Graduate Program in Historic Preservation at the George Washington University

David Lowenthal is professor emeritus of geography at University College, London

David McCullough is a social historian, author, and narrator of the PBS series "The Civil War"

H. Bryan Mitchell is deputy director of the Virginia Department of Historic Resources

W. Brown Morton III is an associate professor in and chairman of the Department of Historic Preservation at Mary Washington College

William J. Murtagh is the former director of the Pacific Preservation Consortium at the University of Hawaii and was the first keeper of the National Register of Historic Places

Peter Neill is president of the South Street Seaport Museum

Pamela Plumb is the former mayor of Portland, Maine

Jerry L. Rogers is associate director for cultural resources, National Park Service

John F. W. Rogers is under secretary of state for management and the former chairman of the Advisory Council on Historic Preservation

Donovan D. Rypkema is a real estate consultant in Washington, D.C.

Randall T. Shepard is chief justice of the Indiana Supreme Court

Joseph L. Sax is professor of law at the University of California, Berkeley

Kenneth B. Smith is president of the Chicago Theological Seminary in Chicago

Samuel N. Stokes is program manager of State River Conservation in the Recreation Resources Assistance Division, National Park Service

Jeanne Mansell Strong is an adjunct instructor with the School of Environmental Design at the University of Georgia and a preservation consultant

Dean B. Suagee is an attorney with Hobbs, Straus, Dean and Wilder of Washington, D.C.

Michael A. Tomlan is director of the Preservation Planning Program at Cornell University

J. Jackson Walter is the former president of the National Trust for Historic Preservation

Douglas P. Wheeler is secretary for resources, State of California

Arthur P. Ziegler, Jr., is president of the Landmarks Development Corporation and past president of the Pittsburgh History and Landmarks Foundation

PHOTOGRAPHS

279

Page 82: *Mesa Verde, Colorado, one of the country's earliest and most spectacular native landmarks, was the first cultural property in the United States designated a World Heritage Site. (National Park Service)*

Page 84: *The River Walk in San Antonio is the city's central defining artery and a key to its success as a tourist center. (Al Rendon)*

Page 92: *The New Florida Bakery in the Little Haiti section of Miami exhibits the imprint of the very recent immigrant experience. (Charles Kelley)*

Page 98: *These vacant lots and poorly maintained housing in New York City provide a challenge for urban activists and preservationists. (Library of Congress)*

Page 104: *In Baltimore, Maryland, an urban homesteading program aimed at providing low- and moderate-income housing has helped reclaim old rowhouse neighborhoods such as this. (Library of Congress)*

Page 108: *The Egyptianesque facade of the Pennsylvania Mutual Life Insurance Company (1838) in Philadelphia was incorporated into the new Penn Mutual Tower in 1975, a type of "preservation" called facadism. (Rollin R. La France)*

Page 116: *Landmarks such as the Jethro Coffin House (c. 1686), Nantucket, Massachusetts, easily gain preservation proponents because of their great age and colonial associations. (Cortlandt V. D. Hubbard, Historic American Buildings Survey)*

Page 120: *Victorian residences like the Queen Anne–style Tacon-Gordon House in Mobile, Alabama, have galvanized preservation interest in the past quarter century. (Jack E. Boucher, Historic American Buildings Survey)*

Page 126: *Public policy—in this case, the preservation tax incentives—helped revitalize the historic commercial district of Portland, Maine. (Richard Longstreth)*

Page 130: *This 1934 view of California Street and its cable cars in San Francisco's Chinatown illustrates the city's enduring role as a multicultural city, one that benefits from heritage tourism. (S. Bloom)*

Page 136: *Grand Central Terminal (1903–13) in New York City was the focus of the U.S. Supreme Court's 1978 Penn Central decision, one of the foundation stones for the legal protection of historic property. (Richard Longstreth)*

Page 144: *Without the inclusion of preservation in planning and zoning activities, downtown high-rises will threaten the character of small-scale historic areas, as can be seen in this view of Boston. (Library of Congress)*

Page 152: *Local landmarks such as the Seagram County Courthouse in Denton, Texas, fill the human need for continuity and community. (Frank Gohlke, Seagram County Court House Archives, Library of Congress)*

Page 156: *The Moorish–style Tampa Bay Hotel, Tampa, Florida, illustrates the transfer of architectural ideas from the Old World to America. (Walter Smalling, Jr., National Register of Historic Places)*

Page 166: *The origins of the historic house museum in America lie in George Washington's Virginia home, Mount Vernon. (Mount Vernon Ladies' Association)*

Page 174: *Work undertaken by Wallace Nutting on the Iron Master's House at the Saugus Ironworks, Saugus, Massachusetts, shows 1920s preservation philosophy, techniques, and materials used to restore an important 17th-century structure. (E. Blaine Cliver)*

Page 180: *A succession of historic preservation legislation since the 1966 act has affected the protection of archeological properties, such as these remains of masonry dwelling walls at the San Juan Mesa Ruin, Sandoval County, New Mexico. (National Register of Historic Places)*

Page 188: *These pictographs of human and animal forms at Black Dragon Canyon in Emery County, Utah, recall the deep historical roots of the Indians in North America. (E. S. Lohse, Utah State Historical Society)*

Page 196: *Those concerned with historic perservation, natural-area conservation, and farmland retention are uniting their efforts to protect landscapes such as this at the Howe Farm in Tunbridge, Vermont. (Vermont Travel Division)*

Page 204: *The Drhumor Building, Asheville, North Carolina, was seen to have economic value in part because of its utility, scarcity, and desirability. (Randall Page, North Carolina Division of Archives and History)*

Page 212: *The Virginia Forest subdivision in Falls Church, Virginia, developed between 1940 and the early 1950s, is typical of decentralized, low-density communities created during the World War II era. (Richard Longstreth)*

Page 226: *Mar-a-Lago (1923–27) in Palm Beach, Florida, is an exuberant Mediterranean-style estate that remains a challenge to maintain and protect appropriately. (Library of Congress)*

Page 232: *Heritage education programs, such as this group of schoolchildren touring Boston's North End, ensure that future generations recognize historic places as important records of their heritage. (Elizabeth Reinhardt)*

INDEX